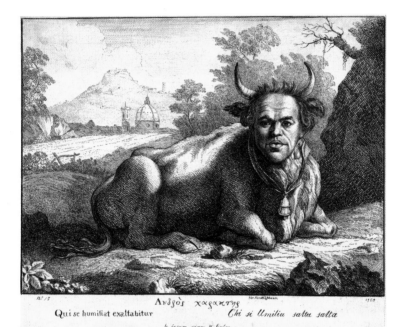

N.º 13 Ανδρὸς χαρακτηρ Sic Novit Manus 1750
Qui se humiliat exaltabitur Chi si Umilia salta salta

Se Ipsum pinx. H. Sculp.

THE SELF-PORTRAIT

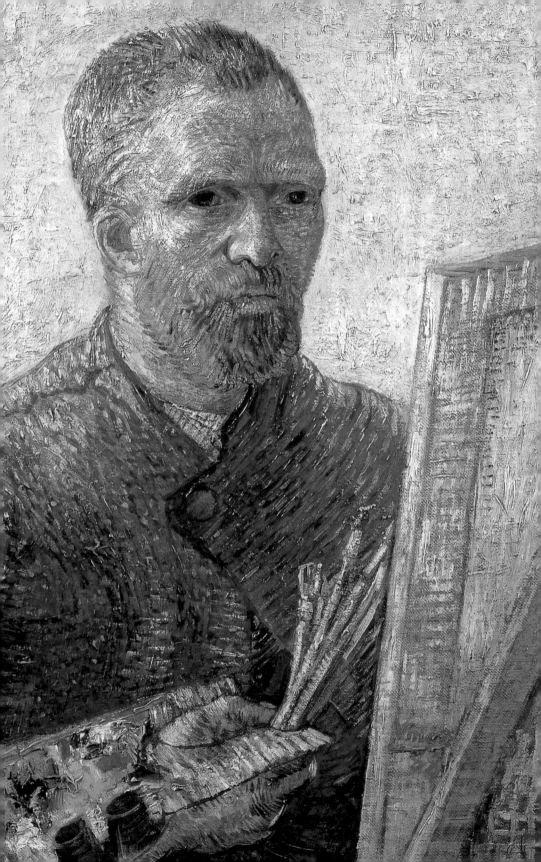

James Hall

THE SELF-PORTRAIT
A CULTURAL HISTORY

120 illustrations, 109 in color

Thames & Hudson

To Benjamin, Joshua and Alice Hall

First published in 2014 in hardcover in the United States of America by
Thames & Hudson Inc., 500 Fifth Avenue, New York, New York 10110

thamesandhudsonusa.com

Library of Congress Catalog Card Number 2013930838

ISBN 978-0-500-23910-0

Printed and bound in China by C&C Offset Printing Co. Ltd

Half-title page:
Thomas Patch, *Self-Portrait as an Ox*, 1768–9, see page 107
Title page:
Vincent van Gogh, *Self-Portrait at the Easel*, 1887–8 (detail), see page 208

CONTENTS

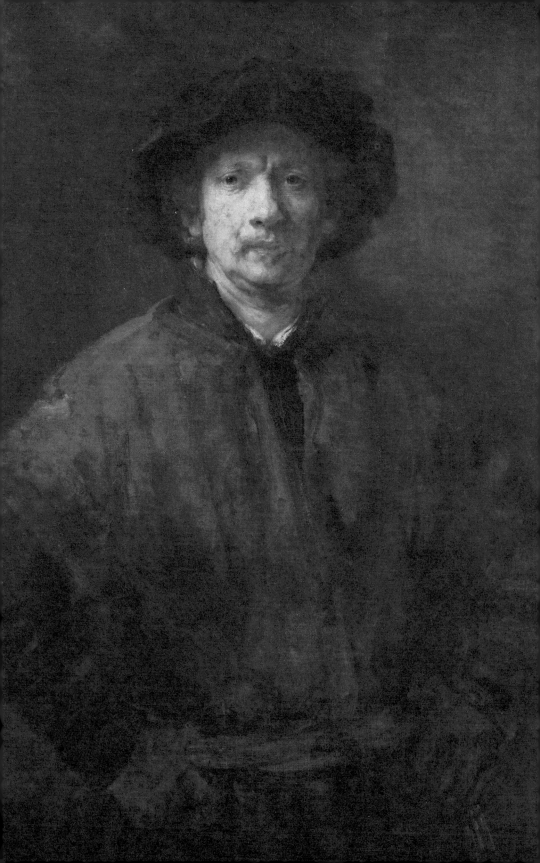

INTRODUCTION

∽

Michelangelo, on being asked why the painter had made the ox more lifelike
than the rest, said: 'Any painter can make a good portrait of himself'.
GIORGIO VASARI, *Lives of the Artists* (1568)

The self-portrait is the one form of easel painting that resists being owned.
PHILIP FISHER, *Making and Effacing Art* (1991)

SELF-PORTRAITURE HAS BECOME the defining visual genre of our confes-
sional age: the sheer volume of contemporary self-portraits defies enumeration.
More of us, from more countries, are more interested in self-portraiture than
ever before. Self-portraits have migrated far beyond the church, palace, studio,
academy, museum, gallery, plinth and frame. Nowadays photographic and filmed
self-portraits flood the internet, and school children are required to make them.
It is widely assumed – and hoped – that self-portraits give privileged access to the
sitter's soul, and thereby overcome the alienation and anonymity experienced by
so many in modern urbanized societies.

In Europe, genuine (as well as mistaken and fake) self-portraits have been
collected and venerated since the sixteenth century. But past interest in the genre
is overshadowed by the obsession with self-portraiture during the last forty years.
Today in cities across the globe there are artists whose entire careers are forged on
self-portraiture.

Exhibitions of old and modern masters are routinely prefaced by a self-
portrait; or, in the case of artists who made several self-portraits, by a room of
self-portraits, as if these were the first pictures they painted. Rembrandt, Reynolds,
Courbet and Munch have had full exhibitions dedicated to their self-portraits.
And wherever an artist has inconsiderately failed to make any, or sufficient,
self-portraits, Freudian analysis fills the breech. So we find *subconscious, disguised*

Rembrandt, *Self-Portrait*, 1652 (detail), see page 156

and *surrogate* self-portraits: the *Mona Lisa* becomes a Leonardo self-portrait in drag. Self-portraiture is the magical Fifth Element, first among equals with the four traditional genres (histories, portraits, landscapes and still lifes). Depending on who you talk to, it is an inspiring symbol of artistic freedom or a symptom of what has been dubbed 'the culture of narcissism'. Few are indifferent to self-portraits, and the claims that are made for them.

The Self-Portrait: A Cultural History maps the genre from the Middle Ages to the prolific self-image making of today's contemporary artists. It is divided into ten broadly chronological chapters, each focusing on key themes. Within these thematic overviews are detailed discussions of particular artists and works. But the aim is to create much more than a 'greatest hits' of familiar masterpieces. Instead this book looks at famous self-portraits in a fresh way, drawing on ideas and anecdotes from the artists' own times, while also exploring works that deserve to be better known. Rather than over-emphasizing the artist's pursuit of an accurate likeness, it looks at the many competing motivations for making and shaping a self-portrait.

Conventional wisdom has it that in around AD 1500 individualism was born, and good quality crystal glass mirrors invented, thereby allowing people to see themselves clearly for the first time. From this perfect cultural storm came the irresistible rise of self-portraiture. There is undoubtedly an element of truth to this: the 1490s were a crucial decade, and there was growing interest in distinguishing the personality and style of individual artists. But it ignores what came before in the medieval period, and smoothes out what came after. Developments in mirror technology are largely irrelevant, and this 'mirror myth' has clouded discussions of the genre. Good mirrors of polished metal had existed since antiquity and continued to be used well into the seventeenth century. So, too, convex mirrors, which were still being used by Caravaggio – not least because their large field of vision compensated for the generally small size of flat mirrors. It is only in the eighteenth century that complaints start to be made about mirrors usurping paintings as fashionable wall decoration.

This is the first history of self-portraiture to celebrate – unapologetically – the Middle Ages. Portraiture may have been pioneered by the Egyptians, Greeks and Romans, but in the Middle Ages self-portraiture becomes very much a Christian concern, connected with personal salvation, honour and love. The two medieval legends of St Veronica and King Abgar, in which Christ presses his face to a piece of cloth, leaving an imprint, posited Christ as a self-portraitist. No great self-portraitist is of higher status than St Dunstan (909–88), prostrate on a mountain

top, making himself both high and low (see page 23); and no funnier self-portrait exists than that of 1136 of Hildebertus, throwing a sponge at a mouse stealing his lunch (see page 28). Like all the best jokes, it makes a profound point.

It is during the Middle Ages that mirrors become powerful cultural symbols, metaphors for all kinds of knowledge, both of self and others. But the Renaissance 'mirror myth' has obscured the contribution of the Middle Ages and limited our appreciation of what a self-portrait can be. It has led us to assume that self-portraits were almost exclusively concerned with giving an accurate likeness. But the self-portrait – more so than a portrait – is primarily a product of memory and imagination. If naturalism had been the principal goal, it would make more sense to have a portrait painted or life cast made. In the first philosophical discussion of self-portraiture, by the influential Plotinus (AD third century), self-portraits are produced not by looking out at a mirror, but by withdrawing into the self. During the Renaissance, one of the main theories of self-portraiture was the catchphrase 'every painter paints himself': this meant that all artists unwittingly imbue all the figures they make with something of themselves, so all bear a 'family resemblance'. Once again, mirrors are marginal.

One of the wonders of self-portraits is their capacity to induce unique levels of uncertainty in the viewer. Is the artist looking at us with a view to portraying or judging us? Is the artist looking at a mirror, with a view to portraying or judging themselves? Is the artist creating a persona to serve specific ends? Or have they delved into the book of memory, myth and imagination to create a work personal in its meaning?

This book features bystander self-portraits, in which the artist appears as a face in the crowd or as part of a multi-figure narrative; group self-portraits, in which the artist appears with family, associates or even the Virgin Mary; and independent self-portraits, discrete images depicting only the artist. Whatever the type, the artist strives to find the perfect image, whether profile, oblique or frontal. The first 'independent' self-portrait is a fine example of this. It is a medal by the archetypal 'Renaissance man' Leon Battista Alberti, in which he depicts himself in profile (see page 45). Arranged either side of his head are several examples of his personal symbol, a winged eye. It is with these shamanistic flying eyes that he sees the whole world – and that includes the back of his head and neck, his knobbly ear and severe haircut.

We tend to assume that post-1500, self-portraiture becomes a natural and uncontroversial thing for an artist to do, almost like sketching. Yet one of the most crucial aspects of the history of self-portraiture is understanding why and

when self-portraits are made – and not made. Not all artists are 'fond' of making self-portraits, as the novelist Nathaniel Hawthorne insouciantly put it when writing about the vast Uffizi self-portrait collection in 1860. Neither do they create them at any stage in their career. They rarely say, as the famous *New Yorker* cartoon about Rembrandt had it: 'Hendrickje, I feel another self-portrait coming on. Bring in the funny hats'.

Rembrandt had in fact painted and etched more than half his eventual output of self-portraits by the time he was thirty. He hardly made any in the 1640s. Titian only started making self-portraits when he was about sixty, and his are the first 'old age' self-portraits. Prior to Titian, most artists made self-portraits when they were young and/or in rude health (hence a section devoted to 'child prodigy' self-portraits). Dürer's three independent painted self-portraits were all made before he was thirty. By the same token, Leonardo never made a self-portrait (though the search is still on), and neither did the great artist-autobiographer Benvenuto Cellini. Sculpted self-portraits pretty much disappear from view between 1600 and 1770.

The history of self-portraiture is also the history of collecting, displaying, publishing and faking self-portraits. So here the presentation of self-portraits is explored – from their first appearance in artists' homes and in private and royal collections, through to their inclusion in museums, temporary exhibitions, catalogues and even as public monuments.

Vasari has a central, and very creative, role here. The second edition of his *Lives of the Artists* (1568) featured engraved self-portraits of the artists. In most cases, self-portraits did not exist, so Vasari assumed that any person looking out of a multi-figure artwork or who looked individualized must be the artist. No self-portraits were credited to Giotto in the first edition; but in the second edition he was credited with three. From the Romantic era onwards, with its emphasis on art-as-autobiography, there has been a gold rush of prospecting for self-portraits. More recently, there has been a countervailing tendency to demote self-portraits to portraits 'of an unknown sitter'.

When discussing self-portraiture, the modern cult of the artist makes it hard to avoid becoming overly reverential, speaking as if in hushed tones. As a result, insufficient attention has been paid to the fascinating subject of comic and caricatural self-portraits. This sub-genre takes off in the era of the Renaissance superstar-artist. Just as kings demonstrate their majesty by inviting the mockery of their fools, so an artist like Michelangelo can alternate between heroic and mock-heroic self-portraits. When painting the Sistine ceiling he drew the first

ever caricatural self-portrait, depicting himself in deformed action, daubing like a child. Artists were traditionally ranked at courts with 'entertainers' such as buffoons, dwarfs, wits and fools. This is how Velázquez still situates himself in his astonishing *Las Meninas*, next to but distinct from other court entertainers – dwarves, jesters, dogs – and a royal child.

Much of the best modern self-portraiture could be described as exuberantly caricatural, and in order to be so has moved decisively away from respectable head-and-shoulders self-portraiture. The body has become more important than the face, in keeping with Nietzsche's call, in *The Birth of Tragedy*, for a 'new world' of symbols in which the 'entire symbolism of the body would be called into play, not the mere symbolism of the lips, face and speech'. This, too, is why the history of self-portraiture has to begin properly in the Middle Ages, with St Dunstan, prostrate on a mountain top, and Hildebertus, chastising that mouse.

Calling this book a *cultural* history is not meant to give the impression that self-portraits are passive reflections of their own societies. On the contrary, they have often been in the vanguard of cultural developments, influencing their own society's sense of identity and selfhood. There is a tendency for some scholars to assume that the history of self-portraiture follows in the wake of literature, especially in relation to concepts such as 'inwardness' and 'subjectivity', which are often assumed to begin with Montaigne's semi-autobiographical essays and Descartes's 'I think therefore I am' – only later cropping up in the self-portraits of Rembrandt. Yet the influence works the other way: Montaigne and Descartes continually had recourse to metaphors taken from the visual arts to express ideas of the self and the development of consciousness. In the preface to the *Essays*, Montaigne tells us that he is 'painting' his own self, and later justifies his enterprise by citing the example of the painter King René of Anjou (1409–80):

> I saw one day in Bar-Le-Duc King Francis II being presented with a self-portrait by King René as a souvenir of him. Why is it not equally permissible to portray yourself with your pen as he did with his brush?

Montaigne believed – like so many since – that self-portraits are uniquely direct, vivid, intimate and honest.

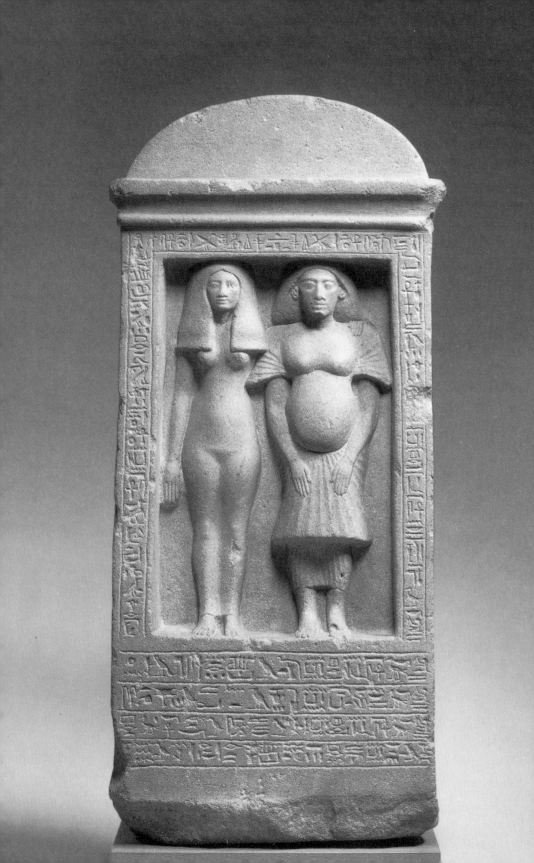

PRELUDE: SELF-PORTRAITURE IN ANTIQUITY

∽

ALTHOUGH WE CAN SEE ARTISANS hard at work in artefacts from ancient Egypt, Greece and Rome, bona fide self-portraits from antiquity are few and far between. The earliest to survive come from Egypt. The best are by Bak, chief sculptor to the Egyptian pharaoh Akhenaten, whose reign (1353–1336 BC) saw the culmination of a short-lived naturalistic style with a wider range of subject matter.

In a self-portrait carved on a quartzite stela, Bak shows himself as a successful courtier and family man. He stands to attention next to his wife Taheri in a shallow niche. She is dressed, as befits convention, in a wig and a body-hugging full-length dress. Bak wears court dress that opens to display the naked distended belly and breasts of the prosperous well-fed.

Bak also appears in a relief with a broadly dynastic purpose. It shows him and his sculptor father Men in a kind of diptych; each is depicted (though at a much smaller scale) along with the pharaoh he served. Akhenaten is making offerings to the sun god, whose rays end in hands – an iconographic innovation of the period. An inscription states that Akhenaten taught Bak how to make art, and this may be more than just praise for 'inspiring' patronage.

Akhenaten introduced religious reforms focusing on the radiant sun disc, the Aten, the sole deity and creator of all things. His name can be translated as 'shining spirit of the Aten', and he was the sole intermediary between god and people, a revolutionary idea that did away with the need for priests. Akhenaten may have

Bak, *Self-Portrait with His Wife Taheri*, c. 1353–1336 BC, quartzite

emulated the Aten's dextrous creative power by becoming actively involved in art – and his example may have improved the status of artists. With Akhenaten's death, and the ascension to the throne of Tutankhamun, possibly his son, the old gods and hierarchies regained their power and Egyptian art reverted to its formulaic, hieratic style.

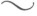

Classical antiquity represented an ideal to be emulated for many European artists from around 1500 until the nineteenth century. But while Greece and especially Rome offer plenty of stirring examples of portraiture – in coins, medals and busts – self-portraiture is conspicuous by its near total absence. Some self-portraits may have been produced in ancient Greece (artists' signatures appear from the sixth century BC), but our only evidence is references to self-portraits in texts written hundreds of years later.

In the sections on the visual arts in Pliny the Elder's *Natural History* (*c.* AD 77–9) only two self-portraits are mentioned alongside countless portraits. The architect and sculptor Theodorus (sixth century BC) made a miniature bronze self-portrait statuette, whose most interesting feature was a tiny model of a horse-drawn chariot, which the subject held by 'three fingers of the left hand', and which had been stolen as a marvel of littleness. The thief, however, left behind the self-portrait statuette (34: 83).

The second self-portrait mentioned by Pliny is by a woman artist, Iaia of Cyzicus (first century BC). She 'never married' and chiefly painted 'portraits of women…and also a portrait of herself, done with a mirror' (35: 147–8). Her unrivalled skill brought her fame and money, but her pioneering attempt at self-portraiture is given no greater importance than her virgin state (*perpetua virgo*) and her decorous focus on female portraiture. This is the first mention of a self-portrait being made with a mirror, and in antiquity mirrors – usually of polished metal – were largely owned by women, and used for cosmetic purposes. So there is a cultural inevitability about Iaia's mirror-assisted self-portrait that would not have been the case with a male painter like Apelles.

Pliny's contemporary Plutarch, in his *Life of Pericles* (AD 75), mentions a more daring and controversial self-portrait from the fifth century BC. Plutarch claims that the enemies of Pericles, the leading statesman of Athens, had his architect and sculptor Phidias imprisoned for including his own self-portrait, and a portrait of Pericles, in the decoration of the armed cult statue of Athena in the Parthenon:

'in making a relief of the battle of the Amazons on [Athena's] shield, he included a figure of himself as a bald old man lifting up a stone with both hands'.[1] Modern scholars doubt if the bald old man who does seem to have been on the shield really was a self-portrait (a copy survives in the British Museum), but the anecdote implies disdain for the artist – and his appearance, as baldness was despised in antiquity. Plutarch may well have made up the story of the shield; early on in his biography of Pericles he showed his contempt for artists:

> No gifted young man, upon seeing the Zeus of Phidias at Olympia, ever wanted to be Phidias.... For it does not necessarily follow that, if a work is delightful because of its gracefulness, the man who made it is worthy of our serious regard.[2]

These prejudices against manual labour were widely held in antiquity, and it explains why there is so little sustained theoretical discussion of the visual arts, let alone histories of art and artists. Artists appear in the geological section of Pliny's *Natural History*, grouped according to the stones, metals and pigments they used. That is not to say that patrons did not take an active interest. Alexander the Great was reputed to have given his mistress to his favourite court painter Apelles, and this era saw the development of an art market, private collectors and even art tuition for the elite. However, there is no reference to Apelles or the court sculptor Lysippos having made a self-portrait.

The philosopher Plato staged the most elaborate and influential dismissal of the visual arts in the tenth book of *The Republic* (*c.* 380 BC), and self-portraiture is shot down in the process. For Plato, artworks are mere imitations of the external world, which is itself a weak reflection of the ultimate reality – the world of 'ideas' and 'ideal forms'. Painters are conjurers who trade in illusions and pretend they can make anything in nature. Their trickery is little better than what you can achieve with a revolving mirror: 'by turning a mirror round and round you would soon enough make the sun and the heavens, and the earth and yourself, and other animals and plants' (602: c–d). This is the first literary allusion to the possibility of making a self-portrait – yet Plato's painter is an indiscriminate transcriber of random visual phenomena and his self-portrait has no special importance.

So while antiquity offers us a few self-portraits, it does not offer a starting point for a coherent history of self-portraiture. For that we must move on to the Middle Ages.

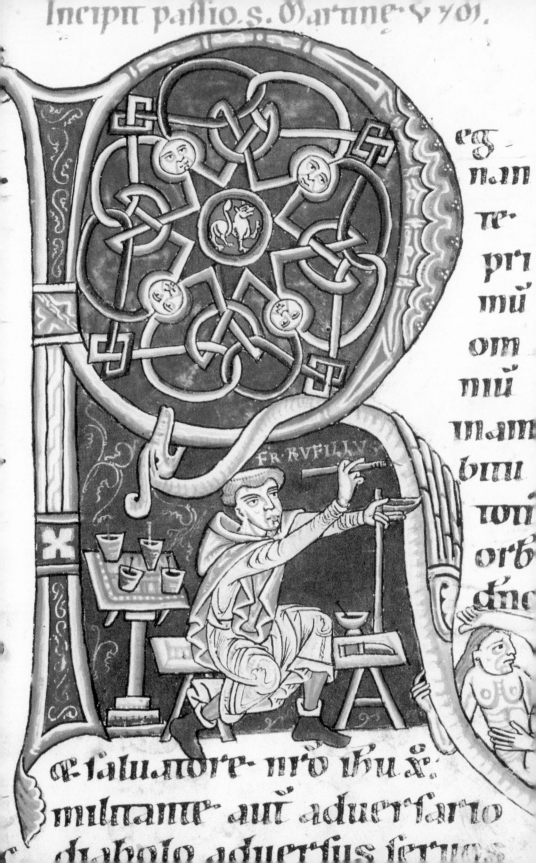

eg
nam
te
pri
mũ
om
niũ
mam
bm
tou
orb
dñc

FR. RVFILLVS

Et ſalu amore nr̃o īhū x̃.
militante auũ aduerſario
diabolo aduerſus ſeruos

1.

MEDIEVAL ORIGINS

∾

BOOKS ON SELF-PORTRAITURE tend to give the Middle Ages short shrift, pausing only to observe that during this thousand-year-long 'dark age' beginning with the fall of the Roman Empire, the genre of independent, naturalistic self-portraiture did not exist – that development had to wait until the 'Renaissance' of the fifteenth century. It is widely assumed that medieval artists were content to be anonymous dogsbodies, at worst slavishly following time-honoured conventions; at best subservient conduits for God's will – painting, as it were, by divine numbers. They would thereby conform to the strictures of the *Rule of St Benedict* (*c.* 480–547), the standard guide for monastic communities, which urged monastic craftsmen to 'pursue their crafts with all humility'.[1] Yet it is in the Christian Middle Ages – preoccupied with personal salvation and self-scrutiny – that we see the start of a coherent tradition of self-portraiture.

The neglect of medieval self-portraiture is usually part of a larger argument that naturalistic portraiture did not exist during the Middle Ages. It is certainly true that in late antiquity the classical belief in the 'science' of physiognomy, whereby character can be read off from a person's face, had been challenged by the Neoplatonic and Christian belief that the imperishable, invisible soul rather than the corruptible visible body is the true measure of man. In art, people are often identified more by attributes, scale, position and gesture rather than facial particularities (bigwigs generally being bigger, central and full frontal). You don't,

Father Rufillus of Weissenau, *Self-Portrait Illuminating the Initial 'R'*, *c.* 1170–1200 (detail), see page 26

as it were, put a name to a medieval face; rather, you put a name to a crown, heraldic symbol, iconographic prop or inscription.[2] Yet the artist's face is not necessarily the most interesting part of a self-portrait. The brilliance of Velázquez's *Las Meninas* (see Chapter 6) does not lie in the depiction of the painter's face (which is blankly impassive) but in the interplay of full-length figures, setting and props. The same is true of medieval self-portraits, where the *mise-en-scène* is often crucial.

The loss of so much medieval art, and the accidents of survival, make it hard to generalize. But it comes as quite a shock to discover just how many medieval self-portraits do survive, and to see how imaginative, intelligent, varied and even witty they can be. The first significant clusters date from the tenth century. The faces may not be especially naturalistic, but that does not prevent the images in their entirety being informative, idiosyncratic and particularized.

It is Plotinus (AD 204–70), the last great philosopher of antiquity and the first to treat aesthetics as a distinct field of enquiry, who sets the scene for the medieval self-portrait, and its emergence as a significant genre. A Greek-speaking native of Egypt, Plotinus studied in Alexandria before moving to Rome, where his circle included the emperor Gallienus (r. 260–8).[3] His mystical reworking of Plato, which has led to him being called the founder of the Neoplatonist school, had a huge influence on the early Christian thinkers Origen (who studied with him in Alexandria) and St Augustine, and on Renaissance philosophy.

Plotinus demurred from Plato's denigration of art for imitating nature, for he believed that nature itself works by imitating the fundamental form or idea, which he called 'the One'. Thus the artist partakes in a universal principle, and is a 'holder of Beauty' who actually improves on nature: 'Phidias produced his Zeus according to nothing visible, but he made him such as Zeus would appear should he wish to reveal himself to our eyes'.[4]

Plotinus still tried to insist that the artefacts produced by the artist are inferior to the universal idea, and that the beauty in the artist's mind cannot be translated fully into brute matter. His editor and biographer, Porphyry, said that Plotinus 'seemed ashamed of being in a body', and he refused to sit for a portrait lest he leave 'an image of an image' to posterity. The story of Narcissus, the boy who fell in love with his reflection in a pool, epitomized for him the dangers of human intoxication with shadowy material beauty.[5]

But more often than not – as in his reference to Phidias – Plotinus still believed that the work of art transcends material reality. An image reflected in water or a mirror, or formed by a shadow, is simply the material body of that object, and

cannot exist apart from it. But this is not so with an image produced by an artist, even if it is a self-portrait. A self-portrait is not simply produced by the artist's material body (whether reflected or seen directly) but by the image dwelling in the artist's soul, which mirrors the divine.

Plotinus expresses the relative autonomy of the self-portrait in relation to nature by saying that the image 'is due to the effective laying on of the colours'.[6] In Egypt, Plotinus must have come across those painted bust-length portraits attached to the front of mummy cases, so they look like faces peering through a window, uncannily alive. Those painted in encaustic often have vibrant visible brushwork and expressive colour contrasts. Little is known about these painters or whether they made their own mummy portraits, or, indeed, about artists in the Roman world. But there is a reference in an epigram of the poetess Nossis of Locri (*c.* 300 BC) to the encaustic self-portrait, dedicated to Aphrodite, of a courtesan named Kallo.[7] This was before mummy portraits, which seem to have appeared around the time of Christ, but votive portraits were displayed in the precincts of sacred shrines, and why wouldn't artists have offered their own self-portraits?

For Plotinus, the self-portrait is produced not by looking out at a mirror, but by withdrawing into the self. Here he uses a sculptural metaphor that would be resuscitated in the Renaissance:

> Withdraw into yourself and look. And if you do not find yourself beautiful yet, act as does the creator of a statue that is to be made beautiful: he cuts away here, he smoothes there, he makes this line lighter, this other purer, until a lovely face has grown upon his work.[8]

This visionary, process-based idea of the self-portrait, in which we sense the artist's ceaseless pursuit of perfection, both for himself and for his internalized artwork, is characteristic of the Middle Ages. A portrait in a herbal of AD 512 of the famous physician, artist and herbalist Krateuas (first century BC) shows him seated at an easel painting a mandrake, a specimen of which is held up for him by a female personification of Contemplation. She is surely a Plotinian presence, encouraging him to look within as well as without.

In the sixth century, a story appears in the Byzantine East in which Christ is posited as a notional self-portraitist.[9] King Abgar of Edessa asked Christ to come and cure him of a disease, but due to pressure of work Christ sent his disciple Thaddeus with a linen cloth against which he had pressed his face, leaving its imprint. Thaddeus held it up before his own face and Abgar was cured.

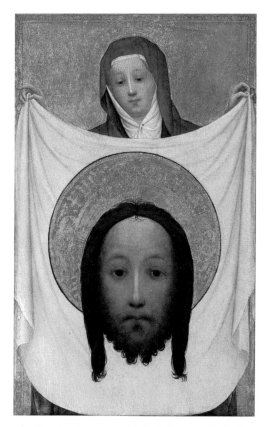

Master of St Veronica, *St Veronica with the Sudarium, c.* 1420, oil on walnut

The piece of linen, which became known as the Holy Mandylion of Edessa (from the Arabic *mandit* meaning 'small cloth'), showed a frontal image of Christ's face and hair. In the tenth century it was moved from Edessa to the palace chapel in Constantinople, but all trace of it was lost after the sack of the city in 1204. The second 'self-portrait', which supplanted the Mandylion in the West, is the Veronica ('true icon'). This was the cloth – or sudarium (from the Latin for handkerchief or towel) – which St Veronica gave Christ to wipe his face on the way to Calvary. Its origins are extremely complex but it is first mentioned in Rome in the eleventh century.[10] Both stories had variants in which a painter initially goes to Christ to paint his portrait, whereupon he makes his own self-portrait on cloth.

The Holy Mandylion, and to a lesser extent the sudarium, was used to justify the use of images against the arguments of iconoclasts, and although Christ usurps

the role of the painter, the legends may have stimulated interest in the idea of self-portraiture. The appearance of the sudarium in Rome has been credited with stimulating a revival of interest in the face as a bearer of particular meanings about the individual, and it also coincides with renewed interest in physiognomic treatises.[11] Nonetheless, no self-portrait in similarly hieratic format is known until Dürer's self-portrait of 1500 – which was itself a one-off – and only in around 1600, with the arrival in Turin of the full-length Turin Shroud, did such images enter the art theoretical literature, with the Holy Shroud being seen as the primordial painting.[12]

Most surviving early medieval self-portraits are found in illuminated books, preserved down the centuries in libraries. Until the thirteenth century, when lay professional artisans with their own workshops in towns start to dominate, these de luxe books were usually created in the scriptorium of a monastery, and they contained a Christian and/or didactic text. They were made by monks, nuns and secular clergy, and tended to be a collaborative enterprise between scribes and painters, with the former – because they were literate and thus had direct access to the Bible – having more status. Scribal signatures are much more common than those of artists, but even here the situation is complicated by the fact that until the late Middle Ages it was common for the scribe and artist to be the same person. With calligraphy playing such a central role in book production, there was no hard and fast division between word and image. Painters probably gained in stature by their intimate involvement with scribes and texts, and were aggrandized by the association: hence, in part, their right to be depicted.

The social status of some medieval artists was extremely high – higher than at any time before or since. Several came from the very highest echelons of society. The English church reformer, statesman, scholar and teacher St Dunstan (909–88) became Abbot of Glastonbury (*c.* 943–57) and Archbishop of Canterbury (959–88), as well as being chief minister to several English kings. Wealthy and blue-blooded, he was the most popular English saint before the canonization of St Thomas à Becket. He is described by his eleventh-century biographer Osbern as a prodigy 'skilled in making a picture and forming letters' from childhood. Dunstan also practised metalwork, and became a patron saint of English goldsmiths. Goldsmiths were the wealthiest craftsmen with the highest status because of their use of expensive lustrous materials, which were greatly admired in the Middle

Ages; but almost all medieval metalwork has been melted down. By any measure, Dunstan is the most high-ranking and politically powerful artist in history. A folk song celebrates the time when Dunstan 'pull'd the devil by the nose / With red-hot tongs, which made him roar, / That he was heard three miles or more'.

At Glastonbury, where Dunstan rebuilt the Abbey and reinstituted monastic life under a strict moral code, he painted a famous and highly influential frontispiece to a Latin grammar. A wiry outline drawing, it is a pioneering example of a technique and style that would become a distinguishing feature of Anglo-Saxon art in this period. Dunstan is prostrate beside a giant standing figure of Christ. A four-line prayer is inscribed over him, the prickly lines pressing down on his flattened back like a bundle of faggots: 'I ask, merciful Christ, that you may protect me, Dunstan, and that you do not let the Taenerian storms drown me'. Taenarum was a storm-lashed coastal mountain at whose foot lay the entrance to the classical underworld.

Dunstan's 'storms' signify the worldly temptations to sin. He is humbly positioned to Christ's left, where the damned are located in the Last Judgment (the Latin for left is *sinister*). By touching Christ's robes, Dunstan is seeking absolution. But Christ looks the other way, to his right (as he does in Crucifixion scenes) and the implication is that it will take many prayers and good works before Christ looks favourably on him, and allows him to pass over to that side. Yet Dunstan's proximity to Christ suggests no lack of belief in his intimacy with the redeemer, and in the likelihood of ultimate success. His submissiveness is that of a courtier, for the profession of humility and even of smallness was a courtly convention. From the time of Emperor Diocletian (r. 284–305) the etiquette of courtly submission and inadequacy was followed by pagans and Christians alike – and went hand in hand with extravagant exaltation of the secular ruler. Writers and orators would frequently apologize for the crudeness and paltriness of what was to follow, and their lack of talent. Self-disparagement formulae included references to 'my littleness, pettiness, smallness'.[13] Conspicuous humility is a standard trope in medieval self-portraiture: the English monk Matthew Paris (d. 1257), who was a celebrated historian, metalworker and painter, prostrates himself beneath the throne of the Virgin and child in the frontispiece to the third volume of his *Historia Anglorum*. But his name is prominently inscribed in large letters above his back.

Mount Taenarum had been thrillingly evoked in the first-century Roman author Statius's epic poem the *Thebaid* (2: 32ff). The summit is a relatively calm place out of reach of the storm clouds and 'the vapours of the lower region', and

St Dunstan, *Self-Portrait Worshipping Christ, c.* 943–57,
ink on parchment

a resting place for 'weary stars'. This is where Dunstan is positioned, on a rocky outcrop, wearied after a long penitential climb. Dunstan's Christ must be rising above those same vapours and clouds, with the wavy line marking their high point. Dunstan is not just covering his face with his hand, he is wiping off the vapours that still cling to it, trying to turn it – as advised by Plotinus – into a 'lovely face', radiant with light.

So why is a medieval churchman not only executing religious pictures, but also a self-portrait of great power and sophistication? A good indication is given by the most important early medieval technical treatise on the visual arts, Theophilus's

An Essay on Diverse Arts (*c.* 1125), perhaps written as a riposte to attacks on art-istic embellishment of churches made by Cistercian abbot Bernard of Clairvaux. Theophilus, the pseudonym of a German goldsmith, claims the 'useful occupation' of the hands avoids sloth and distraction.[14] It is sinful not to exercise a God-given talent for making artefacts that praise the Lord, demonstrate the beauty of the divinely created world, and enable church services to be performed – so long as it is pursued for the love of God rather than for worldly fame or money. Theophilus (he used a pseudonym – lover of God – because he did not want fame) asks his readers to recompense him for his 'labour of instruction' by praying for him every time they make good use of his book.

Dunstan would surely have agreed with all of this (apart from the use of a pseudonym), and his inscribed self-portrait, prominently placed as a frontispiece, is designed to bring himself forcibly to the attention of God and to all future readers of the Latin grammar. But Dunstan is making a further claim on our attention and respect. The heroic Lilliputian figure who has created this giant image of Christ is within touching distance of the divine. Thus his images and words have an unimpeachable authenticity. He is a reliable eyewitness, seeing God through both his inner and outer eye.

~

Explicit assertions of the enormity and endlessness of the artist's task occur in the twelfth century, when illuminators incorporate miniaturized versions of them-selves at work into the picture. We see them holding up or putting the finishing touches to an illuminated initial, or to some other important structural com-ponent, which ingeniously frames them. Some artists depict themselves in the margin, conscientiously pulling up by rope sections of text that the scribe had missed out, as if it were a building block.[15] These wry, self-conscious allusions to the nitty-gritty of the artistic process would not be rivalled until the seventeenth and especially twentieth centuries.

During the twelfth century favourable economic conditions had led to an increased production of artworks, drawing on a wider range of subject matter and showing a greater naturalism, albeit often confined to marginal details such as plant decoration. The emergence of the Cathar heresy, which posited two Gods, the 'good' God of spirit and the 'evil' God of matter, had prompted the church to support study of the natural sciences, including anatomy, and the translation of Aristotle's scientific works. This was seen as an effective way of proving that

God's creation is good in every way. The philosopher Roger Bacon (*c.* 1214–92), in his studies of optics, insisted on the fundamental role of sight in cognition and devotion.

The influential teacher Hugh of St Victor (d. 1141) took a more holistic view of the ideal curriculum. Although he regarded the mechanical arts (painting, sculpture, carpentry, agriculture, fishing, medicine, etc.) as inferior to the speculative arts, he believed they helped mankind overcome physical defects and deprivations experienced after the Fall. They should therefore be studied and admired: 'Want…has devised all that you see most excellent in the occupations of men. From this the infinite varieties of painting, weaving, carving, and founding have arisen, so that we look with wonder not at nature alone but at the artificer as well'.[16] Hugh's explicit interest in and respect for the individual maker is in direct contrast to the prevailing view inherited from antiquity.

Artists' exposure of the mechanics of making, and of themselves as makers, belongs to this same trend – as does the writing down of Theophilus's technical manual, which itself shows awareness of Hugh's treatise. The most vibrant and intense of the self-portraits of the artist at work appears in a Passionale (Lives of the Saints) of *c.* 1170–1200, detailing the sufferings of various saints and martyrs. It was painted by Canon Rufillus of Weissenau in the diocese of Constance (now Switzerland). A tonsured red head with a long gaunt face, he sits on a trestle table placed underneath his own initial letter 'R', finishing off the 'tail' of the letter. This marks the beginning of the 'sufferings' of St Martin.

Rufillus's ambience is carefully delineated. He holds up a pot of paint in his left hand, propping his hand up on a mahlstick, and holds his paintbrush horizontally in his right hand at eye level, as though it were a prosthetic, stalk-like extension of his eyes. The role of eyesight, and of hand-eye coordination, in art-making is emphasized as never before. His signature – FR. RUFILLUS – is inscribed over his head, and runs all the way along his paintbrush. The Latin word for red is '*rufus*' so his name must derive from his red hair, and Rufillus's redness is proudly underscored by the fact that he is currently using red paint (in 1624, Rubens would pun on his own name in a self-portrait by including a red sky and red cheeks: in Latin, *rubens* means 'reddening').

The ant-like 'miniaturization' of the artist suggests the subtlety and control needed to paint all these incredibly intricate patterns and shapes. At the same time, the initial is endowed with architectural scale and form, and can be inhabited by the artist. The task at hand is made comparable to the creation of churches and cathedrals, which were also extensively painted. Yet only in the next century

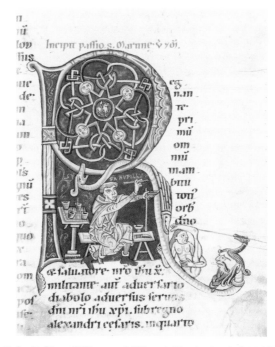

Father Rufillus of Weissenau, *Self-Portrait Illuminating the Initial 'R'*,
c. 1170–1200, ink and colour on parchment

did master masons start to be honoured with tombs and inscriptions in their own cathedrals.[17] Whereas vast teams of workers were required to create such buildings, this artist clearly works alone. There is a powerful sense in this self-portrait initial that the individual artist lives inside his own artwork, and is solely responsible for it. This R-framed image of Rufillus is, by any measure, a self-contained self-portrait.

The letter 'R' is constructed from a fantastic assemblage of disparate decorative elements and mythical beasties. Rufillus is painting the 'tail' of the letter, formed from a writhing serpent, with a different head at each end. At the top end, just behind Rufillus, a snake-like creature with retractable jaws bites the lower portion of the circular section of the 'R'; the other end of the snake terminates in a blue-bearded human head with a serpent's tongue and a dragon crest. Bluebeard stares at a sciapod – a naked one-legged woman with long orange hair – who grabs the body of the snake with her right arm while acrobatically pulling her leg up over her head with the other.

Rufillus is, of course, responsible for having created the monster, but we still admire him for sticking resolutely to his task and not being unduly concerned. St Martin, whose life this is, started out as a Roman soldier, and his name was believed to derive from that of Mars, god of war, and Rufillus claims a kind of martial prowess himself. He has subdued this evil snake and incorporated it into his letter-house. St Bernard of Clairvaux had contrasted the indecent contortions of acrobats and jugglers with the 'decent, grave and admirable' deportment of monks, and the unerring Rufillus counts himself in the latter category. Guidebooks for preachers wanted to revive the classical practice of orators using a mirror to practise their gestures and expressions, and there is a theatrical quality to Rufillus's extended arm and focused eyes. [18]

A different aspect of the working process is explored by the twelfth-century Bohemian lay painter Hildebertus, of whom there are two surviving self-portraits. In both he shows himself at work with his young assistant Everwinus (each has an identifying inscription overhead). In a Sacramentary (a compilation of texts recited for high or solemn mass) of 1136, they appear beneath a busy full-page dedication miniature depicting Gregory the Great surrounded by clerics. The other self-portrait is a celebrated full-page line drawing in the midst of a copy of St Augustine's Christian classic *City of God*, in which the pagan and Christian world views are compared. Hildebertus sits cross-legged before a lectern desk fancifully held up by the front paws of a lion standing on its hind legs. An open book rests on the lectern, but at this moment Hildebertus is not working on it. His right arm is raised and seems to hold a rock, while he holds a quill in his lowered left hand. At first sight, he could be St Jerome, who wrote the standard Latin version of the Bible, healed a lion (which became his symbol), and beat his breast in penance with a rock when assailed by erotic visions.

It turns out that although Hildebertus is no St Jerome, he is assailed by something no less troublesome. He turns to his left and is about to throw a sponge at a mouse scampering across his dinner table. The mouse has knocked a roast chicken over the table's edge, and is heading for what must be a bread roll. They are old adversaries, as we know from a Latin text inscribed in Hildebertus's book: 'Damn you, wretched mouse exasperating me so often!' It is a parody of the Last Judgment, where Christ banishes the damned, 'Depart from Me, you cursed...' (Matthew 25: 41)

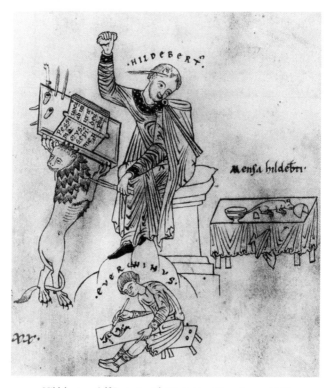

Hildebertus, *Self-Portrait with His Assistant Everwinus, c.* 1150,
ink on parchment

Two points need to be made here. Firstly, Hildebertus is keen to show he is a master of words as well as images. To this end, in both self-portraits he appears to be writing. There are words but no images in the book on the lectern (it almost looks as though he is filling in the bits the scribe missed). Secondly, he wants to show that he has prodigious powers of concentration and stamina. The image was recently called 'A Distracted Illuminator',[19] as if it were an anecdotal genre scene in the Dutch seventeenth-century manner. Yet it has a larger purpose. Hildebertus wants us to believe he is only momentarily distracted, and that his 'distraction' brings enlightenment.

He is actually addressing an issue discussed at length by Augustine in his spiritual autobiography, *The Confessions,* and one which would preoccupy all subsequent preachers and theologians.[20] In Book Ten, Augustine discusses the daily temptations that distract us from our higher calling. They include all manner of

sensory beauty (especially women and works of art); 'greed for food and drink';
and curiosity:

> What of the many times when I am sitting at home and my attention is
> captured by a lizard catching flies or a spider enmeshing them as they fly
> heedlessly into her nets?

And yet, rather than his thought being 'blunted',

> From these sights I press on to praise you, who have wondrously created all
> things and set them in their due place.[21]

Hildebertus is 'distracted' by the mouse, but he would have us believe that, like
Augustine, he profits from the distraction. In his picture he shows complete con-
sciousness of a range of coexistent life forms – the lowest of animal life (a mouse
and a chicken) and the highest (a lion); he shows a masterful man (himself)
and a subservient boy (Everwinus); and he shows words alongside images. He
offers a section of the great chain of being. The completed copy of St Augustine's
extremely long *City of God*, within which this illustration is inserted, demonstrates
that no amount of interruptions or distractions could prevent the fulfilment of the
task. Rather, they spur Hildebertus on, by giving him a better feeling for the big
picture – for the city of man and of God.

Last but not least, it would seem to justify the making of self-portraits – or at
least, it can do so in the twelfth century (Augustine, as hostile to the arts as Plato,
is unlikely to have approved). We can imagine Hildebertus saying:

> What of the many times when I am sitting in my workshop and my atten-
> tion is captured by the beautiful work that *I* am doing?

In this chapter, we have charted the development of a vigorous tradition of
self-portraiture during the Middle Ages, largely within a monastic context, and
culminating in the twelfth century. In the next chapter, we will look at a crucial
catalyst for the efflorescence of self-portraiture from the twelfth century onwards
– the pan-European craze for mirrors and mirror imagery. For both writers
and artists, mastery of mirrors and of mirror lore became a key status symbol,
and a claim to fame.

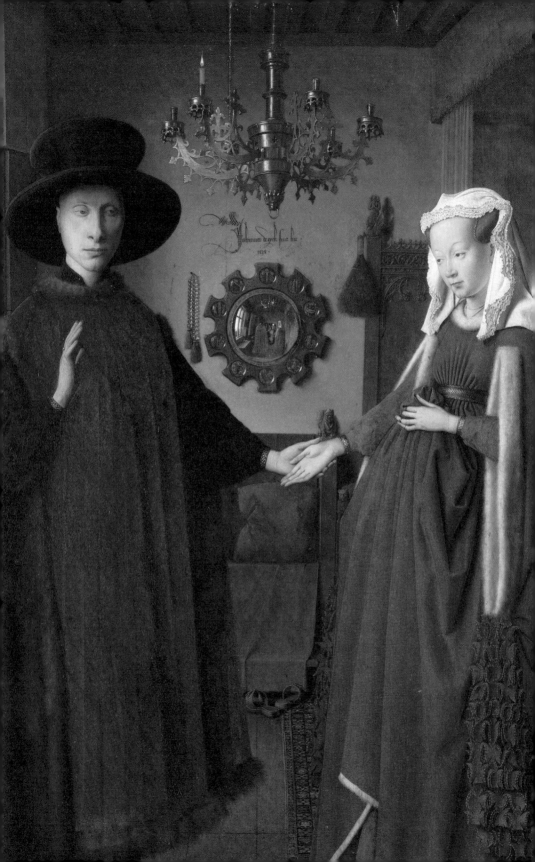

2.

A CRAZE
FOR MIRRORS

~

THE ARTISTIC RENAISSANCE OF the fifteenth century was influenced, especially in Italy, by renewed interest in classical texts and artefacts, and by the Roman cult of individual fame and of magnificence – the perpetuation of one's good name through the commissioning of architecture and art. But the Renaissance has also been assumed to involve a *technological* revolution that far surpassed antiquity. Thus in Bruges in the 1430s, Jan van Eyck 'invents' oil paint, which allows him to depict light, texture and detail as never before; while simultaneously south of the Alps in Florence, Filippo Brunelleschi 'invents' single-point perspective, enabling artists to represent bodies in measurable space. Oil paint had in fact been used for centuries, and serviceable perspectival constructions had been devised by Giotto and his Sienese contemporaries. So the fifteenth century saw a brilliant evolution of existing techniques rather than a revolution.

The history of self-portraiture has been seen even more emphatically in terms of a distinct technological revolution – and it still is. The story goes that self-portraiture took off around 1500 thanks to the invention and proliferation of flat, foil-backed glass mirrors, with the Venetians perfecting the technology and then ruthlessly cornering the market.[1] It is as if suddenly western European artists could see themselves. Self-portraiture certainly flourished during the Renaissance, and mirrors had a role to play, but the link with advances in mirror technology is a dubious one.

Jan van Eyck, *The Arnolfini Portrait*, 1434 (detail), see page 41

For a start, the dates do not coincide, since whereas frontal, naturalistic painted self-portraiture dates from the fifteenth century (a contender for the first being van Eyck's three-quarter view, discussed below), and sculpture from even earlier, it was only in the late seventeenth century that flat, crystal glass mirrors began to dominate, though they remained of modest proportions and fiendishly expensive.[2] Only in the eighteenth century do we hear complaints that mirrors are replacing paintings as fashionable decoration.[3] Most artists seem to have used small glass convex mirrors, with a metal backing – a type dating back to antiquity and developed in the Middle Ages.[4] The glass blower made a ball of glass and cut sections from it before applying a backing made of lead, tin, pewter, silver or mercury – and compounds of these.[5] Clearer crystal glass was developed in Venice in around 1460. The great biographer of Italian artists Giorgio Vasari (1511–74), writing in the mid- to late sixteenth century, alternates between saying that a self-portrait has been painted '*alla sphera*' (with a convex mirror, about the size of a saucer) and '*allo specchio*' (either flat or convex, and more likely to be metal than glass).[6]

The first depiction of an artist in the act of painting a self-portrait appears in a French manuscript dated 1402 containing the Italian author Giovanni Boccaccio's series of biographies *On Famous Women* (1374). Unfortunately the name of the illuminator is unknown. It shows the ancient Roman artist 'Marcia' sitting at a table in her luxuriously appointed workshop gazing at the reflection of her head in a small convex mirror. Boccaccio probably based her on Iaia, one of six women painters mentioned by Pliny: Iaia's self-portrait (discussed in the Prelude) is likely to have been painted using a mirror made of polished metal. The circular image on Marcia's mirror is being scaled up into an over-life-size, flat, rectangular painting that includes her neck and shoulders. The tip of her brush touches her painted red lips, as if to suggest that her second self will speak at any moment.

The *mise-en-scène* insists emphatically that artists are perfectly capable of amplifying and clarifying partial images derived from round and/or convex mirrors, and adapting them to a different format. By the same token, it demonstrates that a finished self-portrait tells us little about the visual 'source' for the likeness. Marcia's self-portrait, which forces the artist to, as it were, see distorted and fragmentary things whole, and to see their own heads from another person's point of view, is exactly contemporary with Cennino Cennini's *A Treatise on Painting*. It perfectly epitomizes Cennini's insistence that painters use their imagination (*fantasia*) to devise their figures – something which allows painting to be 'crowned' with poetry. It could well be that the illuminator was a woman, for many women painters, lay as well as religious, are known from the medieval period.

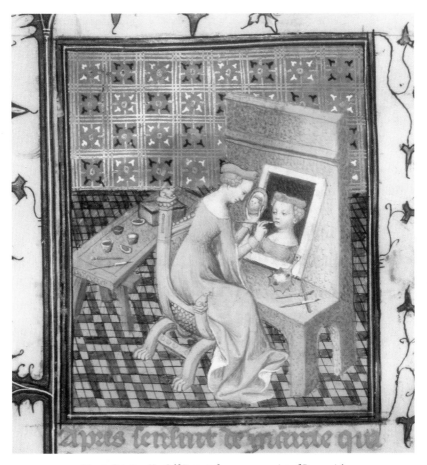

Marcia Painting Her Self-Portrait, from a manuscript of Boccaccio's
On Famous Women, 1402, ink and colour on parchment

This depiction of Marcia comes in the wake of huge interest in the symbolism and science of mirrors. Mirror symbolism had been deployed in antiquity, but it became ubiquitous to the point of cliché from the twelfth century, and has never gone out of fashion since.[7] The medieval craze for mirror imagery must have greatly increased the demand for mirrors, as well as interest in self-portraiture. The clearest manifestation of this mirror craze was the use of the title 'speculum' – Latin for mirror, from *specere* 'to see' – for books of moral and/or factual instruction: a mirror of virginity, mirror of conscience, mirror of alchemy, mirror of magistrates, princes, etc.

St Augustine had first devised the term 'mirror of scripture', meaning that the Bible showed, as in a mirror, both the divine plan and what each individual had to do to reform themselves. Every living thing, from the angels to animals, was a mirror of the creator, reflecting his spirit, but the clarity of each mirror declined as one descended the chain of being. Here on earth, as St Paul had said, we see 'through a glass, darkly' (1 Corinthians 13: 12). However the Virgin Mary, the rise of whose cult coincided with the mirror craze, was believed to be a 'spotless mirror'. In all these meditations on mirrors, it is as though viewers see their moral selves reflected back and can thus mentally do a 'spot-the-difference' competition between themselves and, say, the Virgin. Looking into these mirrors is little different from reading a bespoke moralizing text, and the self-portraits of Dunstan, Rufillus and Hildebertus are indeed located within such texts. It is about recognizing virtues and vices far more than physical attributes. This is somewhat different from the view of antiquity where Seneca insisted (following Socrates) that mirrors were invented so that man might know himself – a knowledge that Seneca rooted in physical awareness. The young would be reminded by their youthful features that youth is a time for learning while the old would be reminded by their grey hair that this is the time for honourable behaviour and thoughts of death. Here physical knowledge leads to moral understanding.

∽

During the Middle Ages and Renaissance, as in antiquity, mirrors continued to be made from metal, which had to be polished before each use: when Vasari refers to self-portraits made '*allo specchio*', he must be referring to mirrors made from steel, tin, bronze and copper more than from glass. Metal mirrors could be made much larger than any existing glass mirrors: the first full-length glass mirrors were only made in France in around 1700, practically costing their weight in gold, liable to break in transit, and composed in sections.[8] Fra Sabba da Castiglione, the Milan-born Knight Hospitaller who wrote a manual of proper conduct for knights in the early sixteenth century, said he would prefer a mirror to any other item in his study, and believed that the study of a 'noble knight' should be furnished not just with books but with armour and a steel mirror – which implies that polished metal was prized both for its reflective qualities and its martial associations.[9] Most metal mirrors in antiquity were concave or convex, and measured between 12 and 20 cm in diameter (some 5 to 8 in.), though Seneca railed against the full-length concave silver mirrors of imperial Rome used for amusement.

Hostius Quadra arranged things so that 'when he was offering himself to a man he might see in a mirror all the movements of his stallion behind him and then take delight in the false size of his partner's member'.[10] Liquids, placed in basins or cups, or found in pools and streams, were and still are another common source of mirror images. (Vasari describes a lost picture of an undressed St George by Giorgione in which the warrior saint is reflected from different angles by a mirror, a pool and his armour.) Polished and oiled stone, especially obsidian, was also popular.

The convex form of many medieval mirrors meant that they showed something of the viewer's surroundings. When the pilgrim lover in the most popular of medieval dream poems, *The Romance of the Rose* (thirteenth century), looks into the well that snared Narcissus, he does not see himself at all, but two submerged crystals – one for each eye – that reflect the surrounding rose garden. As such, the medieval mirror is similar to the mirrors used in scrying, a form of divining by staring into a reflective surface of some kind.[11] At its most banal and lucrative, scrying was used to find out what one's enemies were up to, and to solve or prevent crimes, or to answer questions ('mirror, mirror, on the wall, who is...'). Children, because of their perceived purity and visual acuity, were often used as scryers – or '*specularii*' – with an adult interpreting what they saw. Seeing one's own reflection ruined the effect, and may have aroused archetypal fears relating to liquid reflections (the Greeks believed that a reflection in water could be dragged down or swallowed up, leaving you soulless, and so doomed to die; the Romans had the myth of Narcissus).[12] The theologian John of Salisbury (*c.* 1115–80) was interviewed for a scrying job as a child, but because he could see only the reflection of his own face, was not taken on as an apprentice. Like some churchmen, he suspected the practice was a form of sorcery, and was appalled at how many children lost their sight as a result of long hours spent staring into a reflective surface.

Nonetheless, the practice was still used in church services to communicate with angels, a biblical precedent having been set by Joseph's silver cup, 'in which my lord drinketh, and whereby indeed he divineth' (Genesis 44: 5). This would have been a scrying cup filled with water, wine, oil or blood. Mirrors were also used as miniature 'cameras', rather like camera phones are today. Pilgrims held them aloft before sacred relics in order to capture something of their sacred aura: in 1439 Johannes Gutenberg manufactured polished metal mirrors to profit from a planned display of the sacred relics in Aachen, but the venture failed when the display was postponed. His 'invention' in the 1450s of printing using movable type – with reverse 'mirror images' of the letters – proved more successful.

There is, thus, nothing especially new about Renaissance mirrors. Mirrors are nonetheless crucial to the development of self-portraiture, but it is more the *idea* of the mirror than the precise nature of the mirror image that mattered. This is clear from the first post-classical literary reference to the painting of a self-portrait by an artist using a mirror – or, in this case, *mirrors*. The self-portrait is almost certainly fictitious, but the passage demonstrates how important the possession of mirrors had become to the credibility of the artist. It demonstrates their virtue and intellect, and ensures their fame.

The self-portrait is by Giotto (*c.* 1266–1337) and is mentioned in Filippo Villani's *On the Origin of the City of Florence and on Its Famous Citizens* (1381–2), which includes a pioneering chapter on painters.[13] Villani was a cultural pessimist who believed the present (post-Black Death) age to be decadent, and he hoped to remind his contemporaries of the glories of an earlier era – that of the great Florentine vernacular poet Dante (*c.* 1265 –1321). There are chapters on famous poets, theologians, jurists, physicians, orators, astrologers, musicians, painters, buffoons and soldiers.

Villani tells us that not only did Giotto emulate the ancient artists (Zeuxis, Phidias, Apelles, etc.), he surpassed them in the rendering of nature. Further, he was a prudent man 'anxious for fame not gain', and his skill as a painter was based on wide knowledge, which made him a rival of the great poets. To underscore Giotto's status as both polymathic and literate, Villani says he 'also painted with the help of mirrors himself and his coeval the poet Dante Alighieri on a wall of the Palazzo del Podestà'.[14] Circumstances make the creation of such a double portrait doubtful. Dante had been exiled from Florence in 1301 and condemned to the stake if he ever set foot there without accepting draconian conditions. He never did return and is therefore unlikely to have been depicted from life by Giotto inside Florence's main government building.[15] It is unlikely their paths ever crossed.[16]

The pairing of Dante and Giotto partly came about because Dante makes a celebrated reference to Giotto in *The Divine Comedy*, in relation to the transience of earthly fame: a Bolognese maker of illuminated manuscripts observes that Giotto has eclipsed his master Cimabue, and that Dante has eclipsed the poet Guido Guinizelli. By bringing together these two great cultural heroes, Villani not only shows that *their* fame was not transient, he also posits an intimate connection between poets and painters. It manifests Cennini's aspiration to have painting 'crowned with poetry', and for artists to become named authors.

An early commentator on Dante, Benvenuto da Imola, noted that some people wonder why Dante immortalizes 'men of unknown name and low-class

occupation', but by so doing 'he gives silently to be understood how the love of glory does so indifferently fasten upon men, that even petty artisans are anxious to earn it, just as we see that painters append their names to their works'.[17] In Tuscany some leading artists were putting prominent signature inscriptions on their works, no one more so than the sculptor Giovanni Pisano on the Pistoia pulpit (completed 1301). The inscription runs beneath the narrative reliefs, and although the patron is credited as the 'originator and donor' of the work, Giovanni gets a mini-biography that is both personal and fulsome:

> Giovanni carved it, who performed no empty work. The son of Nicola and blessed with higher skill, Pisa gave him birth, endowed with mastery greater than any seen before.[18]

At around the same time in France, (named) artists in royal employ started to gain titles such as *peintre du roy* and the even more prestigious *valet de chambre*.[19] This may have been because of increased competition for their services from a socially broader-based clientele. Perks could include furred robes, houses and some access to the royal household, though pay was not always forthcoming, and much time could be spent decorating banners, saddles and shields. Giotto was made City Architect of Florence in 1334 – a most prestigious post – in unprecedented recognition of his fame as a painter (no comparable position as City Painter existed). The architectural settings of his pictures imply that he could at the very least design facades: his most famous design is for the cathedral bell tower. He is the first artist since antiquity to generate a considerable amount of comment, starting with Dante's citation.

Recognizable portraits of patrons had begun to be inserted into religious pictures in the fourteenth century, with Giotto's portrait of the kneeling Enrico Scrovegni, patron of the Scrovegni chapel in Padua, being a distinguished example. Pope Boniface VIII (r. 1294–1303) was attacked by the French King Philip IV, among others, for allowing sculpted images of himself to be erected in cathedrals in Italy and France, and even on altars.[20] A market for portraits of famous poets had also developed. Portraits of Petrarch were frequently painted for his patrons and admirers, with their accuracy being an abiding concern.[21] In the mid-fifteenth century the Florentine sculptor Lorenzo Ghiberti wrote that Giotto's pupil Taddeo Gaddi (the father of Cennini's master) painted in Santa Croce a miracle of St Francis resurrecting a child. Gaddi supposedly included portraits of Giotto and Dante, and a self-portrait, all taken from life.[22]

Where the future of self-portraiture is concerned, Dante is not only import-
ant for naming artisans; he is also crucial for the self-referential nature of his texts
– and his example was to be followed by Petrarch. Dante's writings were so autobio-
graphical he felt the need to justify his approach at the beginning of his *Convivio*
(The Banquet), a philosophical commentary on his own quasi-autobiographical
love poems. Orators, he says, 'forbid a man to speak of himself, except when
strictly necessary'. This is because a man will either praise or blame himself, and
no one is a good judge of themselves. But there are two exceptions to this rule.
Firstly, when defending oneself against slander and danger; and secondly, when
one's life story is exemplary in some way and so can give instruction to others –
here Dante mentions Augustine's *Confessions*, 'for by the progress of his life, which
was from bad to good, and from good to better, and from better to best, he gave
example and instruction which could not have been received otherwise on such
sure testimony'.[23] The fact that Augustine spoke from personal experience guar-
antees the authenticity of what he writes. Most painted and sculpted self-portraits
set out to prove the artist to be exemplary in some way (hard-working, humble,
presentable, upstanding, eagle-eyed, socialized, etc.) and thus a 'spotless mirror'.

It is initially perplexing that Villani tells us Giotto painted the double portrait
'with the help of mirrors' – in the plural. It seems unlikely that Giotto would
have needed more than one mirror to paint a self-portrait (like Marcia), and why
would he have needed any mirrors at all to paint Dante's portrait? One possibility
is that Giotto used the mirrors simply to improve the lighting, in the same way
that scholars placed a mirror over their desk. But why would Villani even need to
mention this relatively minor detail?

Something more significant is going on. The only depiction of a mirror
in Giotto's surviving works is in his frescoes in the Scrovegni Chapel in Padua,
where the female allegorical figure of Prudence is shown sitting at a desk with an
open book before her and a quill pen in her right hand. She turns sharply to
her left to gaze into a small convex mirror that she cradles in her left hand like
a medieval iPad. As we have seen, Villani praises Giotto as 'a most prudent man'
and this work may partly have inspired his account of Giotto. But it is still only a
single mirror.

Dante is the key, for he had a vast amount to say about mirrors. Villani had
initially planned to write a book solely about Dante, so he would have known
of the poet's fascination with mirrors. Dante uses mirrors as symbols on thirty
occasions in his writings, with half of these references occurring in the Paradise
section of *The Divine Comedy*. Many involve more than one mirror, and on one

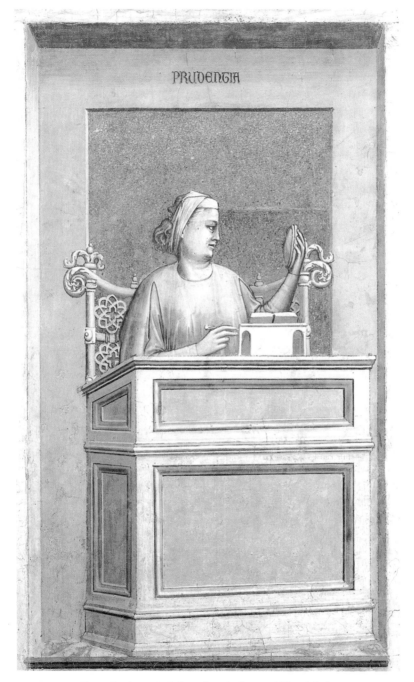

PRUDENTIA

Giotto, *Prudence*, 1306, fresco from the Scrovegni Chapel, Padua

occasion Beatrice tells him to do a scientific experiment involving three mirrors.[24] On three occasions the viewer is encouraged to see their physical selves reflected in the mirror, and these are important for the subsequent history of self-portraiture – or at least, they help explain why Villani thinks it worth crediting Giotto with mirror ownership, and with the creation of a double-mirror-assisted self-portrait.

Two of these passages occur in close proximity towards the end of the Purgatory section, and the second of these is especially relevant to artists.[25] When night falls, Dante lies down to rest and he has a dream in which he sees a beautiful young woman, who gathers flowers and looks into a mirror. She is Leah from the Book of Genesis, the eldest daughter of Laban and the first wife of Jacob.[26] She addresses Dante and tells him about her younger sister Rachel, who became Jacob's second wife, marrying him a week after her sister. In the Middle Ages, because Leah was fecund and Rachel sterile, they came to represent the active and contemplative life. Dante innovates by furnishing them with mirrors, and has them sit all day long in front of them, Leah weaving a garland of flowers, Rachel doing nothing but look: '[Rachel's] joy / In contemplation, as in labour mine' (27: 100–8).

Dante's respect for Leah and Rachel came about because he believed the human soul has a double purpose, to be both active (*pratico*) and contemplative (*speculativo*).[27] The active life works on behalf of the human race with prudence, honesty and justice; the contemplative life considers the works of God and nature. We can see how Leah, busy working on her garland, might be an apposite model for an artist. Giotto's Prudence has aspects of both Leah and Rachel. She holds her quill pen, poised to write or draw, at the same time as she quietly looks in the mirror. That Giotto, in Villani's account, has mirrors while in the presence of Dante suggests that he too is both Leah and Rachel, active and contemplative, and that his self-portrait is painted as part of a process of self-knowledge and self-love. So too Marcia, staring at herself in her gorgeously appointed studio. It is a virtuous circle: the self-portrait proves you are a mirror-owner, and know how to use them. The mirror-assisted self-portrait perpetuates your fame and – by its perfection – proves that your fame is merited.

Many of these ideas inform the most famous mirror in art – the circular convex mirror hanging on the middle of the rear wall in Jan van Eyck's portrait of Giovanni Arnolfini and his wife (1434). It is probably the earliest surviving portrait on panel of two people who were not rulers, and it is the earliest known portrait where the subjects are seen in a domestic setting. Van Eyck was the highly

paid court painter to Philip the Good, Duke of Burgundy, with his own coat of arms and the title of *valet de chambre*, and he sometimes even performed secret missions for the Duke. Arnolfini supplied textiles and luxury goods to the court.

The frame of the mirror is decorated with ten roundels, each showing a scene of Christ's Passion, with the Crucifixion at the top. The backs of the Arnolfinis, the room they are in, and two men standing in a doorway opposite the Arnolfinis, are reflected in the mirror in miniature with impossibly crystalline clarity (crystal glass was not yet invented). On the wall above the mirror is inscribed in a calligraphic flourish: 'Jan van Eyck was here / 1434'. It is widely assumed that the painter may indeed be here – as one of the men in the doorway, being greeted by Arnolfini. Few painters have been as fascinated by reflective and transparent surfaces as van Eyck: in an altarpiece dated 1436 he seems to be reflected in miniature in the curved edge of the convex/concave shield of St George, perhaps exploiting the similarity between the Flemish for shield (*schild*) and painter (*schilder*).

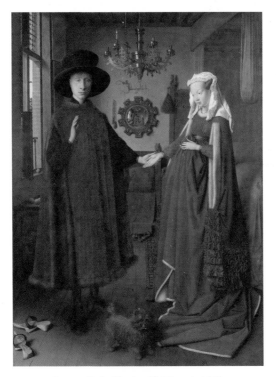

Jan van Eyck, *The Arnolfini Portrait*, 1434,
oil on panel

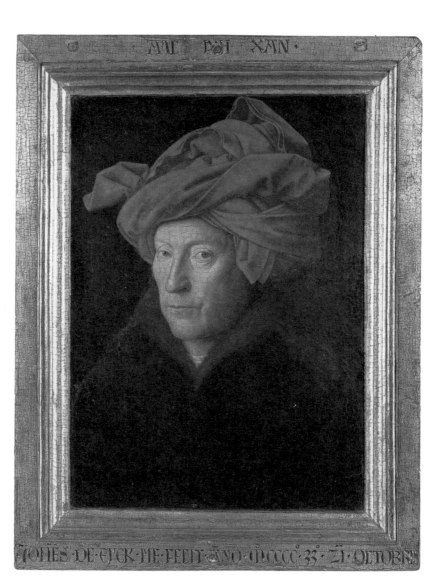

Jan van Eyck, *Portrait of a Man (Self-Portrait?)*, 1433,
oil on oak

The Arnolfini mirror embodies many of the key aspects of the mirror craze that we have been discussing. It is first and foremost a mirror of God, insofar as it is a permanent 'mirror' of Christ's Passion and it reflects light; it is secondly a mirror of creation, insofar as it shows the Arnolfinis and the contents of their room; and it is finally a mirror of the individual, insofar as it shows the Arnolfinis and their visitors. The mirror, with its Christological frame, reminds anyone who looks in it (and especially this mortal married couple) that they should each aspire to be a worthy 'bride' of Christ. Its circularity gives it a cosmic dimension. A similar mirror, adorned with the seven virtues, would be made a century later by the father of Benvenuto Cellini.

Van Eyck not only depicted himself miniaturized, however ('my littleness, pettiness, smallness'). He may also have painted the first surviving independent self-portrait, a third-life-size hypnotic head and shoulders of a man wearing a turban-like red chaperon. His lined and stubble-peppered skin glows brightly against the dark background. Though traditionally considered a portrait, it is now usually assumed to be a self-portrait because the sitter looks out at us, and because of the unusual prominence of the painter's motto. The motto is inscribed at the top of the gilded frame, which is signed and dated along the bottom: 'As I can [*Als ich can*] / Jan van Eyck made me on 21 October 1433'. Van Eyck obviously enjoyed the pun on *ich*/Eyck, and he leaves it open whether the authorial 'I' is boastful ('As only I can') or modest ('As best I can'). The meticulousness of the paintwork shows it took far longer than a day to complete, but van Eyck may want to imply he did not spend too long self-absorbed. Indeed, his shoulders and head are shown in three-quarter view, and he turns his slightly bloodshot eyes sharply in our direction. White highlights turn these eyes into scintillating mirrors. A moment later, and his piercing gaze will be gone – perhaps following the light that streams in from his right. He is a man who sees things – himself included – in close-up, but without losing track of the bigger picture.

We do not know why he painted this work. It has been suggested that it may have been painted to mark his marriage to his second wife, Margaret, but van Eyck's surviving portrait of her was only painted in 1439 and is larger. Another proposal is that he kept it in his workshop to demonstrate his skill to potential clients. Yet he scarcely needed to prove his skill as a portraitist to clients at this stage in his career. To portray himself at all, and in fine clothes (perhaps supplied by Arnolfini), demonstrates pride in his social status and his mastery of art. It is more likely he painted it as a dynastic image, to be passed down as model and memorial to his own descendants. Like most Renaissance self-portraits there is no

indication of the source of his wealth – the tools of his trade – or even his hands. The absence of hands and of painter's equipment might almost suggest it is a miraculous image, painted without human agency.

There is a clear religious allusion. The work was painted in 1433, and '33' is written in arabic rather than roman numerals (MCD33). This was believed to be the 'perfect' age at which Christ died, and the age that people would be when resurrected – though we do not know when van Eyck was born and he may have been older than thirty-three when he painted it. He painted Margaret when she was thirty-three, and her age is inscribed on the frame. This age-consciousness recalls Seneca's view that mirrors were invented so that man might know himself – by noting his own age. Dante seems to refer to a similar kind of mirror-gazing when he attacks looking into a mirror for the purposes of beautification, and harks back to a golden age when women 'came away from the mirror...without a painted face' (Paradise 15:113–4). Both Margaret and Jan van Eyck wear fine clothes, but Margaret does not seem to be wearing make-up while Jan's face is seemingly unidealized. In this period, private meditation manuals and spiritual conduct books such as Thomas à Kempis's *Imitation of Christ* (1418) were encouraging solitary scrutiny and prayer. Here van Eyck is the mirror of painters, spotless because of his 'honesty' about his age, crow's feet and stubble.

At around the time van Eyck was painting the Arnolfini's mirror and his self-portrait, Leon Battista Alberti (1404–72) was establishing the pool-gazer Narcissus as a model for the artist. Both in charismatic person (he was the illegitimate son of an exiled but still wealthy Florentine banker) and in his treatises on painting, sculpture and architecture, Alberti did more than anyone before or since to establish the visual arts as a 'speculative' rather than a mechanical art. For him the ideal artist was learned in all the liberal arts, especially mathematics. Using anecdotes about ancient artists extracted from Pliny and other Roman authors, he insisted that the visual arts and artists had been held in the highest esteem in antiquity, and that emperors and philosophers had practised painting and taken a close interest in architecture. Alberti's adoption of Narcissus as the 'first' artist in his treatise *On Painting* (the Italian version dedicated to the architect Filippo Brunelleschi) has been seen as ushering in the modern age of art, with everything centring on and originating with the artist. But Alberti's Narcissus can equally be seen as a culmination of the medieval mirror craze.

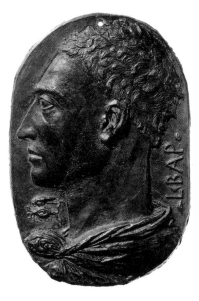

Leon Battista Alberti, *Self-Portrait, c.* 1435, bronze plaquette

Alberti was fascinated by self-portraiture, both in theory and in practice. His signed bronze self-portrait plaquette (a single-sided medal with relief decoration) may well be the first independent self-portrait by a Renaissance artist. Generally dated to the mid-1430s, it influenced the production of antique-style medallic portraits by Pisanello and Matteo de' Pasti in the 1440s and 50s. So authoritative was Alberti's example that the only independent self-portraits that survive from the fifteenth century in Italy are medals – two by the Venetian painter Giovanni Boldù; and one each by Pisanello, Filarete and Lysippus the Younger.[28]

Alberti also writes about making self-portraits in his autobiography, and Vasari reports seeing in Palazzo Rucellai, Florence, the most famous of Alberti's secular buildings, a now lost painted self-portrait made with the aid of a mirror. An autograph manuscript of Alberti's essay *On Tranquillity of Mind* features a possible self-portrait drawing that shows him standing in a field or garden filled with flowers.[29] For this reason, Alberti must be considered one of the key figures in the history of the genre.

In a brief autobiography, written in the third person in around 1438,[30] Alberti gives a vivid account of his activities as a maker of portraits and self-portraits. He paints and models portraits of friends, both from life and from memory, even friends he had not seen for a year. Further:

He strove to render his own features and characteristic appearance, so that, by the painted or modelled image, he might be already known to strangers who summoned him.[31]

Portraiture is here a manifestation of that selfless love that Alberti advocated in his treatise *On the Family*, and which he based on classical notions of ideal friendship.[32] The idea that the artist should not appear interested in money is an essential part of their claim for social status (more than, as in the Middle Ages, proof of spirituality and humility), and the attraction of independent self-portraits is partly due to the fact that they would seem to be the least obviously commercial of artefacts – almost art for art's sake. Even today, self-portraits are still often regarded as the most autonomous of art forms, spontaneous uncommissioned expressions of the artist 'at free play'. That said, they were probably sent out as loss-leader 'gifts' to prospective employers, and as evidence of Alberti's own Petrarch-like status and fame.[33]

Love, rather than friendship, plays a central role in Alberti's famous discussion of portraiture and self-portraiture at the start of the second part of his treatise *On Painting*. Having given a formidably detailed account of perspective and geometry in the first part of the treatise, he opens the second part with an assertion of the high status and universal significance of painting. It 'possesses a truly divine power in that not only does it make the absent present (as they say of friendship)'.[34] Painters 'see their works admired and feel themselves to be almost like the Creator. Is it not true that painting is the mistress of all the arts or their principal ornament?'[35] Here he alludes to the ancient idea that God had 'painted' the world into existence.[36] Alberti's argument takes an even more astonishing and original turn with his identification of the first human painter:

Consequently I used to tell my friends that the inventor of painting, according to the poets, was Narcissus, who was turned into a flower; for as painting is the flower of all the arts, so the tale of Narcissus fits our purpose perfectly. What is painting but the act of embracing by means of art the surface of the pool?

In Ovid's canonical version of the Narcissus story, recounted in his *Metamorphoses*, Narcissus is a beautiful youth loved by the nymph Echo, but who refuses to love her in return. As a punishment for rejecting Echo, the goddess Nemesis makes him fall in love with his own reflection in a pool. He pines away and at his death

is turned into the eponymous flower. All authors before Alberti had regarded Narcissus in a bad light, embodying vices such as pride, vanity, self-delusion and (because the narcissus flower bears no seeds) sterility. He hardly seems like an appropriate model for the socially adept, convivial, intellectually curious and productive artist that is Alberti's ideal. The successful artist requires 'good manners and amiability', he writes, and should 'ask and listen to everyone's opinion' since it helps 'to acquire favour'.[37]

Alberti must have taken the idea very seriously for he says he repeatedly discussed Narcissus, and claims not to be the first to call him the first painter. Yet no modern scholar has discovered such a reference in the earlier literature. Narcissus's reflected image was sometimes referred to as a painting, 'painted' by the pool, but Narcissus is never said to be the author of the painting.[38] Alberti's claim could, however, be based on a passage in *The Romance of the Rose*. A 'pilgrim lover' goes in search of an allegorical 'rosebud', experiencing lots of adventures and temptations along the way. Looking into wells is central to the poem's symbolism, and Narcissus is referred to on several occasions (there is also a long passage about experiments you can do with different kinds of mirror). In one scene, the mythical sculptor Pygmalion, who successfully prayed to Venus that his own female statue could come alive, compares his love favourably to that of Narcissus, who was never able even to touch his beloved. From this negative comparison, Alberti may have imagined Narcissus as a painter counterpart to Pygmalion.

Alberti must also have been influenced by the medieval mirror craze, for he believed, in a very traditional way, that mirrors could educate the viewer, and show them the way to self-perfection. In his treatise *On Painting*, there is a fascinating passage in which he advises the painter to use a mirror to test out the quality of his pictures:

> I do not know how it is that paintings without fault look beautiful in a mirror; and it is remarkable how every defect in a picture appears more unsightly in a mirror. So the things that are taken from Nature should be emended with the advice of the mirror.[39]

It is not often that the rationalist polymath Alberti says, 'I do not know'. But by doing so he avoids having to admit that he too believes in the magical, oracle-like properties of mirrors.

It seems perfectly justified to regard Alberti's advocacy of the 'Narcissus-painter' as *the* seminal celebration of self-portraiture, and a key catalyst for its

placement at the heart of artistic practice. The idealization of the 'narcissistic' painter, looking at and admiring himself alone, chimes perfectly with certain modern notions of individualism, and of the emergence of the cult of solitary genius (the term 'narcissism' was first coined by a German psychiatrist in 1899).[40] However, there is a crucial difference between early conceptions of Narcissus and modern interpretations. Indeed, Alberti's interest in Narcissus is more complex than many modern commentators would have us believe.[41] This is because in most versions of the myth Narcissus does not even realize that the image reflected in the pool is his own.[42]

As Ovid tells it in what became the most influential version of the myth: '*Unwittingly*, he desires himself'. It is only when it is too late that Ovid's Narcissus finally recognizes himself. In most subsequent accounts, however, the recognition scene never occurs, so Narcissus never knows what we know – that he is a narcissist. In *The Romance of the Rose*, Pygmalion says Narcissus thinks he is staring at a beautiful girl, a device that prevents us seeing him as homosexual. In a much later variation, Jean-Jacques Rousseau has him falling in love with a female portrait that turns out to be a portrait of Narcissus in drag.

Alberti must have known his designation of Narcissus as 'first human painter', bolstering his claim with a non-existent lineage in poetry, was a potentially dangerous idea. But his silence about what his Narcissus-painter *sees* gives the idea some elbow-room. It allows Narcissus not to be excessively narcissistic: he can see his surroundings and 'another' person, and last of all – himself. Alberti's Narcissus is a figure in a landscape, just as Alberti was in his self-portrait drawing in a field of flowers, and van Eyck in the Arnolfini's convex mirror.

This interpretation is corroborated by Alberti's self-portrait medal.[43] From Alberti's exaltation of the Narcissus-painter, we might expect a full frontal face, looking out in an intent manner. But the plaquette is very different. Its aggression, obliquity and idiosyncratic busyness come as something of a surprise. Alberti depicts himself in craggy, unerring bust-length profile, staring horizontally. The format evokes the stern profile images of Roman emperors on coins and gems that had fascinated Florentine and northern Italian intellectuals since the fourteenth century. He is even clothed in a toga, tied with a big knot, which projects forcefully from his chest like the pommel of a sword.

Hovering between the knot and Alberti's chin is his 'winged-eye' emblem. The eye faces towards us, though its attached wings would launch it horizontally, like a projectile, in the same direction in which Alberti's own eyes are looking. The winged eye trembles and flickers because vermicular tendrils flare off it,

almost as though it has just been plucked out of a head and is still quiveringly alive. Three more winged eyes provide punctuation stops for Alberti's abbreviated signature, piled up vertically behind a ramrod straight neck.

Alberti believed there is 'nothing more powerful, swift, or worthy than the eye…it is the foremost of the body's members, a sort of king or god'.[44] The winged eye appears again on the reverse of a profile portrait medal of Alberti, made by Matteo de' Pasti in *c.* 1446–50, this time accompanied by a Latin inscription 'QUID TUM'? – 'what next?', or 'what then?' This motto suggests Alberti's restless curiosity and Argus-eyed omniscience. Even the knot of his toga is shaped like an eye. But it also implies an element of cynicism about worldly affairs. In his treatise *On the Family*, a speaker says: 'Everything in the world is profoundly unsure. One has to be far-seeing in the face of frauds, traps and betrayals'.[45]

The combination of Alberti's severely static profile and the 'flying-eye' motifs suggests he is a visionary, rather than a science boffin making complicated arrangements of mirrors to see himself in profile. Like God, this particular artist can see everything. His 'flying eyes' get everywhere, and that is why he has been able to depict himself from the side, including areas like the back of his head and neck that are normally invisible to him. The Greek physician Hippocrates believed that during sleep the soul (which was commonly envisaged as a winged figure) wandered about and observed the body.[46] In shamanism, each person has three souls, one of which can travel outside the body and stay there for some time.[47] Alberti's winged eyes have a comparable ever-awake function. One is reminded, too, of Plato's comparison of the painter with a revolving mirror that captures everything in heaven and earth, including the painter.

At the end of his treatise, Alberti asks all those who have profited from it to include his portrait in their paintings 'as a reward for my labours'.[48] Narcissistic, yes – but with his sleepless eyes cropping up everywhere, and claiming co-authorship.

We have seen how interest in mirror-assisted self-portraiture long pre-dates the appearance of large, flat crystal glass mirrors, and that the key catalyst is the late medieval fascination with the science and symbolism of mirrors. Being able to demonstrate a mastery of mirrors was a crucial indicator of virtue and intellect, and made the artist worthy of enduring fame. In the next chapter we will explore how artists used self-portraiture to assert their position in society at large, establishing ties and making themselves a mirror in which society sees itself.

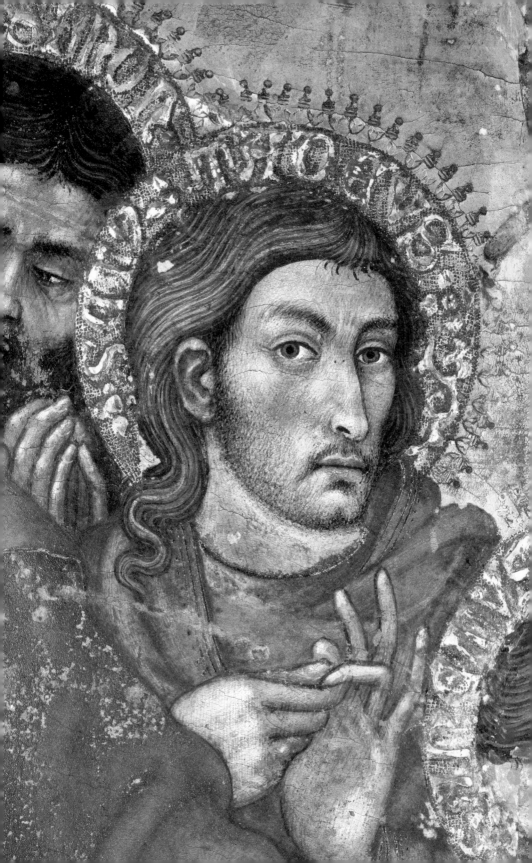

3.

THE
ARTIST
IN SOCIETY

⌒

DURING THE FOURTEENTH AND FIFTEENTH centuries, new kinds of self-portrait develop in which the social and spiritual relations of the artist are put on a more formal and less fleeting basis. They take on a dynastic character, in which the self-portrait of the artist is juxtaposed with other portraits. These group scenes encompass a greater variety than ever before, asserting ties of friendship, kinship, love and devotion. They range from feudal courts to the court of heaven; from family members to workshop assistants.

However idealized and mythical these group self-portraits might be, they do at the very least reflect a new intimacy with the great and the good that could be enjoyed by an artist while making a portrait from life. This notional intimacy implies the existence and demands the cultivation of certain social skills from the artist. The first surviving independent portrait from life is often claimed to be a profile portrait of the French King Jean II (1319–64), and his court painter Girard d'Orleans remained with him even when he was in captivity for four years in England with a select few retainers after losing the Battle of Poitiers.[1] Alberti's insistence that the portrait, whether painted from life or from memory, is the product of friendship implies that even if the sitter is not a friend before it is painted, they will be a friend after.

The controversial apogee of this trend is the catchphrase 'every painter paints himself', which gains currency during the fifteenth century in Italy, and is most

Taddeo di Bartolo, detail of self-portrait from *The Assumption and Coronation of the Virgin*, 1401, see page 54

51

closely associated with the consummate courtier Leonardo da Vinci. It implies that whoever the artist is depicting will bear a 'family resemblance' to the artist himself, in the same way that retainers might wear the colours of their feudal overlord. He recreates elite society in his own image.

The best starting point for a study of these kinds of social self-portrait is the 1380s. During this decade, we not only have two fictional literary accounts of social self-portraits (including Villani's of Giotto/Dante, see Chapter 1) but also a group portrait by Peter Parler that includes the first naturalistic self-portrait.

\sim

At exactly the same time that Villani was setting up Giotto on a blind date with Dante, the French author Jean Froissart was making self-portraits central to a courtship ritual. Froissart is best known for his *Chronicles* of the Hundred Years War, but he was also a very successful poet. One of the stories in his lengthy yet still incomplete 31,000-line verse romance *Méliador* (1383–8) stars Sir Agamanor, a fearless knight who happens to be a painter and poet. He was inspired as a nine-year-old by seeing painters decorating his home with scenes from the Trojan wars. They lent him their tools and gave him lessons, and after three years he was as good at painting 'in all colours' as they were.[2]

While fighting anonymously as the Red Knight in a tournament, Sir Agamanor falls in love with the daughter of the castle owner. Back at his lodgings, he obtains brushes, 'coloured paints of oil and gum', and a linen cloth a metre and a half (some 5 ft) wide, and sets about immortalizing the tournament and party in a beautiful multi-scene narrative painting that contains several self-portraits, and portraits of his beloved.[3] Sir Agamanor's self-portrait is a potent new weapon in a courtship ritual. At just this time, King Charles VI of France was commissioning portraits of potential brides and in 1385 chose Isabelle of Bavaria on the basis of her image. Previously, verbal descriptions had been used to select brides.[4] So portraits were now playing an important role in the marriage game.

Froissart realizes full well that a knight who paints and writes is socially dubious – at one point Sir Agamanor berates himself for ever having picked up a paintbrush: 'Her heart is of too high an estate / To be given to an entertainer'. But it is clear that Sir Agamanor's talent for portraiture and self-portraiture in particular gives him a competitive advantage: it proves him to be articulate, heart-felt – and someone prepared to risk derision in the service of love. His love and self-knowledge is demonstrated by his ability to memorize and immortalize his

beloved's face, and to create his own likeness. It was standard practice to refer to the 'colours' of rhetoric when discussing eloquence, and Sir Agamanor's eloquence is visual as well as verbal.

The French poet Guillaume de Machaut (d. 1377) imagined Memory working with a brush, painting the past in front of his mind's eye.[5] Froissart clearly knows about painting, and he delights in the details of Sir Agamanor's training, tools and media. The lover-artist is an exotic kind of magus – and he eventually (after painting another self-portrait and fighting two knights) gets the girl.

The knight-as-painter also reflects the fact that all medieval knights were painted living artworks by virtue of the 'colours' they wore – both those of their heraldic blazons, and those of their lady, which they fixed onto their armour. The first troubadour poet whose work survives, William IX, Duke of Aquitaine (1071–1126), painted a picture of his married mistress, the Viscountess Dangereuse, onto his shield because 'it was his will to bear her in battle, as she had borne him in bed'.[6] In the fourteenth and fifteenth centuries, knightly adornment became increasingly elaborate and particularized, with all manner of inscriptions and devices – the most famous being the garter of the English Order of the Garter (founded *c*. 1348). Sir Agamanor's practice of painting 'in all colours' on linen could easily carry the same message, and it certainly singles him out.

Froissart's Sir Agamanor would soon have a real-life counterpart in King René of Anjou (1409–80), a poet and presumed painter, as well as the author of a book of rules for tournaments, lavishly illustrated by his Flemish *valet de chambre*, Barthélemy d'Eyck. According to a letter written to the Venetian connoisseur Marcantonio Michiel in 1524, René taught Flemish-style painting to an Italian artist during his short reign in Naples, and the essayist Michel de Montaigne later saw a supposed self-portrait by René being given to the French King François II.[7]

In the story of Sir Agamanor, we have an instance of a painter trying to convince a peerless virgin of high rank that he is both a noble knight and worthy of her. A comparable scenario occurs in a painting by the Sienese artist Taddeo di Bartolo, but in this case, the virgin to whom the painter is devoted is the mother of God. The self-portrait is inserted into Taddeo's *Assumption and Coronation of the Virgin* (1401), a gold-ground altarpiece that was the largest yet made in Italy. It was painted in Siena for the high altar of Montepulciano's cathedral, and paid for by the Aragazzi, the dominant family in that city. Taddeo was then one of the leading painters in Siena, and is now best known for his frescoes of Roman civic virtue in Siena's Palazzo Pubblico – the first such cycle in a city republic.

Taddeo di Bartolo, *The Assumption and Coronation of the Virgin*, 1401,
tempera on panel, altarpiece of the cathedral of Montepulciano

In the presumed self-portrait, Taddeo depicts himself as St Thaddeus, his name saint, one of the apostles crowding round the Virgin's empty tomb. Thaddeus was famed as a preacher and debater, and he went to visit King Abgar and cured him of leprosy. While there, Thaddeus would have seen the Holy Mandylion, the 'self-portrait' specially made for Abgar by Christ by pressing his face into a linen cloth (this story is inserted in the 'Life of St Thaddeus' in *The Golden Legend*, Jacobus de Voragine's book of saints, first compiled in around 1260, which gained great popularity in the medieval period).[8] We know it is Thaddeus because each of the major protagonists in the altarpiece is identified by an inscribed halo. It is a self-portrait of Taddeo not simply because of the name, but also because he is the only apostle who looks out directly at the viewer, and his facial features are more subtly and naturalistically drawn, especially his facial hair.

Thaddeus is using his elegantly raised hands, with their impossibly long fingers, to convey a special message to us. His gesture is usually taken to mean he is counting or making debating points, but this was typically done by using the

index finger of the right hand to touch the fingertips of the left hand.[9] Here he touches the ring finger of his left hand with his thumb and index finger, an action that mimics the putting on of a wedding ring. Ancient folk belief had it that this finger was directly connected to the heart by a nerve, and this was why it became the wedding ring finger.[10] Thaddeus's finger is here *visually* attached to his heart because his left hand is placed directly over the left side of his chest. In *The Golden Legend*, Thaddeus is someone who takes care of his heart, and is called 'heart for his greatheartedness, little heart for his purity....'[11] His *warm*heartedness is suggested by his unusually rosy cheeks and lips.

The Florentine artist Orcagna had depicted himself at the side of a carved tabernacle of the *Dormition and Assumption of the Virgin* (1359), but he is a static observer in contemporary dress, not an intimately involved participant.[12] Taddeo/Thaddeus is showing that he wants to enter into a mystic marriage with the Virgin, such is his devotion to her. A giant seated image of her floats directly overhead as she ascends to heaven (he is aligned with her heart). She holds her hands up in prayer, with her ring and middle fingers heavily laden with rings, presumably gifts from her earthly acolytes (rings would have been offered by devotees). Right at the pinnacle of the altarpiece we see the coronation of the Virgin by Christ, another quasi-marriage ceremony in which she becomes the 'Bride of Christ'.[13]

The idea of mystic marriages principally derived from the medieval cult of the Song of Songs, or Song of Solomon, the only erotic book in the Bible. This had had a huge influence on mysticism and love poetry since the eleventh century. It consists of a series of rhapsodic and intensely physical exchanges between a man and a woman in which they praise each others' beauty and body parts (cheeks, eyes, neck, hair, breasts, navel, jewels, perfumes). The speakers were assumed to be a bridegroom and a bride, with the former often interpreted allegorically as Christ, and the latter as the Church, the Virgin Mary or the human soul, both male and female. The bridegroom's place was often taken by the male worshipper, and the bride to whom his rapturous prayers were addressed was the Virgin.

This substitution became more prevalent as the cult of the Virgin gained in popularity and she came to be regarded as the most approachable and amenable saint, who would intercede directly with God on behalf of mankind. The French Benedictine Prior and troubadour poet Gautier de Coincy (d. 1236) collected accounts of the Virgin's intercessory miracles and wrote songs addressed to her, punning on '*marier*/Marie': 'let us marry the Virgin Mary', he implores, 'no one can make a bad marriage with her'.[14] The Virgin was the patron saint of Siena. So the gesture also alludes to the artist's place of origin, and his special claim on

the Virgin. We do not know whether Taddeo was married or not (Vasari only mentions a nephew) but he is claiming, through this blushingly impassioned self-portrait, an unrivalled intimacy with the Virgin.

Taddeo's claimed intimacy with the Virgin gained further sanction by painters' identification with St Luke the Evangelist, the disciple who had been on closest terms with her. St Luke had become patron saint of painters in the mid-fourteenth century because he was reputed to have painted a portrait from life of the Virgin and Child. From this time, St Luke became the model for the learned, literate painter who has unparalleled access to the great and good (as such, he is the precursor to the Albertian painter). The identification became complete with images in which the painter gives St Luke his own features.

No one knows quite how or why St Luke, a doctor by training, metamorphosed into a painter, but it was a useful myth to justify the church's use of images: the church needed a prestigious 'first Christian painter', particularly during the iconoclastic controversies of the eighth and ninth centuries. From the sixth century onwards, more and more pictures of the Virgin and Child were claimed to have been painted by him. Pope Gregory the Great (r. 590–604) was said to have eliminated plague in Rome by carrying around Luke's painting of the Virgin housed in Santa Maria Maggiore. It is only during the fourteenth century that St Luke's activities as a painter, rather than his products, became of interest. The earliest surviving depiction of the evangelist making a picture, by the Bohemian illuminator John of Troppau, is dated 1368. (Troppau's own painters' guild in Prague had installed a now lost altarpiece to St Luke in 1348.)[15] He is shown alone in his studio painting a small panel of Christ on the cross, flanked by the Virgin and St John – the only subject apart from the Virgin and Child he was said to have painted. St Luke looks upwards for inspiration, presumably in the form of a vision. The temporal difficulty of how an adult St Luke, who had first met Christ in adulthood, came to paint the infant Christ is likewise sometimes sidestepped by showing him having a vision in which the Virgin and Child float into view.

In *The Golden Legend*, there is no mention in the 'Life of St Luke' of his being a painter, but his special intimacy with the Virgin is insisted on. St Luke's gospel says more about the childhood of Jesus than any other, and he is the only one to describe the angel's annunciation of the birth of Christ. The typical *mise-en-scène* of St Luke painting is often identical to that of scenes of the annunciation, with the painter playing the part of a recording as well as an annunciatory angel.[16] Luke records and announces, in a sensational world exclusive, what the Virgin and her baby, and their chamber, *actually* looked like. The chamber is often richly carved

and decorated, but there are no paintings, which may imply that St Luke – a Christian – is the true inventor of that art form.

The finest of these paintings, and the earliest surviving panel painting of this subject from northern Europe, was made by Rogier van der Weyden (1399/1400–1464) soon after he was appointed salaried Town Painter of Brussels in 1436, with the right to wear the cloak of a town official. Together with his contemporary Jan van Eyck, Rogier was the most celebrated painter in Europe for the latter part of the fifteenth century, and even more influential. *St Luke Drawing the Virgin and Child* (*c.* 1435–40) was probably painted – like most such images – as an altarpiece, in this case probably intended for the chapel of the Brussels painters' guild. The setting of the scene within a luxurious portico with a panoramic landscape view is inspired by van Eyck's *Madonna of Chancellor Rolin* (*c.* 1435), which Rogier may have seen in the artist's studio. His treatment, however, is broader,

Rogier van der Weyden, *St Luke Drawing the Virgin and Child*, *c.* 1435–40,
oil and tempera on panel

softer, and more monumental and expansive: he does not share van Eyck's taste for scintillating miniaturist detail and reflective surfaces.

The work is often understood as a self-portrait, albeit idealized, with St Luke taking on Rogier's features, and a pretty good case can be made for this. A later copy of a lost self-portrait is a good match; and so too is a contemporary copy of a lost self-portrait included in a history painting (see below). Luke also tends to be shown as old and bearded; Rogier's Luke is beardless and in early middle age.

This work, one of the earliest depictions to show the Virgin seated before St Luke as if for a portrait, is the first to show him drawing – using the difficult technique of silverpoint – rather than painting.[17] With less equipment, the intimacy increases. St Luke is shown half kneeling, half hovering. His hands float up before him, holding their tools with the same delicacy that an angel might hold a lily or sceptre. Luke's other role as a writer of the gospels is alluded to by the open gospel book in the room behind him. He is drawing the Virgin's face, seen from the front, as if for a simple portrait likeness. He is almost hypnotized by it (just as well, as her breast is bared), but has had to interrupt his sketching. She has turned her head to breastfeed, and he can now only observe the left side of her bowed head. Like St Luke, the Christ child only has eyes for his mother's face. Or rather: she has turned her head so that a second painter, St Luke's modern alterego, Rogier van der Weyden, can get a better view. In this respect, Rogier is even more privileged than his alterego St Luke. And are we not meant to think that the modern way of painting things – with lovely landscape backgrounds and architectural settings – is so much better? We moderns get the small, 'baby' truth of the portrait (Rogier himself also painted small-scale devotional panels) together with the larger truth of the figures in the splendid room and landscape. Luke's silverpoint is, as it were, the seedpod to Rogier's blossoming plant. Rogier's picture is an annunciation of the whole world by an artist at ease in it.

∿

The painters' embrace of St Luke enabled them – by proxy – to achieve a partial parity with mason-sculptors, for the most prominent self-portraits in this period were sculptures placed on the fabric of churches. Around seventy sculpted self-portraits have been identified on churches from the twelfth century until the sixteenth century, mostly in German-speaking countries, but also in Italy, France and Spain.[18] Most of the early ones tend to be sited on the building in a slightly ad hoc way, but this changes with the self-portrait by the German architect and

sculptor Peter Parler (*c.* 1333–99) in St Vitus Cathedral, Prague. It is a bust, truncated horizontally just below the shoulders, and the gaunt intensity and tilt of the head that lends it animation is very striking. Not only has it been called 'in all probability the first real [i.e. naturalistic] self-portrait of an artist known to us'[19] (half a century before Alberti and van Eyck), it also takes its place alongside nineteen other busts of the ruling family and their inner circle.

Peter's father Heinrich (d. 1371) was an innovative and successful master mason, and more than a dozen family members are recorded in the building trade. The Parlers had a major influence on architecture in southern Germany. In 1356, the Holy Roman Emperor Charles IV summoned Peter to Prague to be Master of Works of St Vitus Cathedral, and to work on several other important projects including the Charles Bridge. The cathedral had been begun in 1344 by Matthias of Arras (d. 1352).

Parler's self-portrait, which has been dated *c.* 1379–86, is sited in a niche set high on the triforium (the gallery above the arches of the choir), together with portrait busts of eleven members of the royal family, three archbishops and four rectors, and his predecessor Matthias – a total of twenty in all.[20] They are arrayed at the same height beneath a projecting cornice and distributed around three sides of the triforium, with the royal family at the semi-circular eastern end, nearest

Peter Parler, *Self-Portrait, c.* 1379–86,
sandstone, St Vitus Cathedral, Prague

the high altar. Many of the busts are aligned with their subject's tomb below. Each individual seems to look across and along the upper reaches of the building, rather than down into the choir. Peter and Matthias occupy a position furthest away from the royal family on the north side, and their tomb slabs were placed on the floor nearby, just outside the choir. Full-length statues of the aristocratic founders of Naumburg's cathedral had been sited in the choir in around 1260, but there is no precedent for the social inclusiveness of the Prague scheme. Other master masons who had included their self-portraits on their buildings were never such a permanent fixture in an aristocratic dynasty.

The remarkable cultural politics of Emperor Charles IV (1314–78) provide a partial explanation. Charles was descended from the powerful Counts of Luxembourg, who had secured vast territories in Italy, Germany and Bohemia. His grandfather Henry VII had forced the Pope to crown him Holy Roman Emperor in 1312, and his father John, King of Bohemia, had died at Crécy in 1346, fighting for the French even though he was by then blind. Charles spent much of his reign travelling through his domains. He was extremely cultured, wrote Latin works including an autobiography, and had close contacts with Italian humanists, including the poet Petrarch. He founded universities in Prague, Arezzo, Pavia, Lucca, Orange and Geneva.

Prague, as the capital of the empire, was the focal point of Charles's vast building projects and cultural schemes, with Karlštejn Castle and the cathedral being the most important. In his autobiography, he said he had found it a 'wilderness' on returning as a young man. When Petrarch later visited Prague on a diplomatic mission, he rebuked a Bohemian cleric who had apologized for the backwardness of his native land. Petrarch said he had never seen anything less barbarous than the Emperor and his entourage: they seemed to be authentic Athenians.[21] The Emperor's mason/sculptor would then be a new Phidias.

Charles was concerned above all else with claiming that his rule had divine blessing, and that he was invested with sacred powers. He built churches and monasteries, collected relics and commissioned gold and jewel-studded reliquaries to house them. He was given two thorns from Christ's Crown of Thorns by the French king, and three of Charlemagne's teeth came from Aachen. He also secured the tablecloth from the Last Supper and Christ's loincloth. Hieratic bust reliquaries were made for St Wenceslas and St Sigismund, and the triforium bust portraits were evidently meant to evoke this kind of reliquary.

That the reliquary-style busts are so far from the ground suggests their aloofness from ordinary mortals: they are made more for divine than human consumption.

Other Christian emperors – Constantine, Charlemagne and Henry II – were traditionally depicted holding models of churches or cities they had built, and the presence of rectors (who managed the cathedral on a daily basis) and architects can be seen as the 'human resources' equivalent. Charles is, of course, in a perfect position to survey the church he has had built, and to examine at close quarters some of its most distinctive structural features.

Yet the presence of Peter Parler adds to Charles's sacred allure, too. For art, as well as rulership, had recently been established as a quasi-sacred, visionary calling. The court painter Master Theodoric was elected the first master of the newly founded Prague Brotherhood of Painters in 1348, and it may have been he who painted the now lost altarpiece to St Luke that was installed that same year in the Guild Chapel. In 1367 he was referred to in the course of an imperial grant as 'beloved master...our painter and our *familiaris*' – a rank comparable to *valet de chambre*.[22] The earliest surviving depiction of the evangelist making a picture by the Prague illuminator John of Troppau is dated 1368 – a few years before Peter Parler's self-portrait. When visiting Lucca, whose university he founded in 1369, Charles must have seen the *Volto Santo*, the Holy Face of Christ, a wooden crucifix supposedly carved by Nicodemus, who had helped take Christ down from the cross and carry him to his tomb. Or rather, Nicodemus had carved the body, and an obliging angel had carved the face. The realism of Parler's own self-portrait and of many of the portraits (others, more generalized, were made by members of the workshop) bears witness to their existence as real historical figures. Peter Parler is not just present as Charles's builder, but as someone who can carve the faces of God's elect on earth, and fly high like an angel.

Peter Parler's vivid presence in the entourage of the Holy Roman Emperor may seem surprising, but it makes good sense when we consider the paramount importance to Charles of building projects. It is far harder to explain the purpose of another self-portrait by Rogier van der Weyden which makes big dynastic claims inserted into one of his four *Scenes of Justice* for Brussels Town Hall, but its conspicuousness demonstrates the prestige of the artist. Rogier stands in the middle of the entourage of the legendary Pope Gregory the Great (r. 590–604), yet depicted in such an idiosyncratic way that it became the first authentic self-portrait to inspire comment from his contemporaries, and probably the most famous of the fifteenth century.[23]

The *Scenes of Justice* was the largest and most important commission of Rogier's career. Each of the four panels was about 4.3 metres (some 14 ft) square, and illustrated two episodes from scenes of 'impartial' justice, one Roman and one

Christian, with long explanatory inscriptions along the bottom. They were placed in the Golden Chamber of Brussels Town Hall, where capital cases were tried, and soon became a tourist attraction (though surely not as much of an attraction as the executions performed outside). A group of nobles is known to have come to the town hall specially to see the series in 1441. Destroyed in 1695 during the bombardment of Brussels by French troops, the panels are known today from early tapestry copies and contemporary accounts.

The first panel, signed and dated 1439, showed the Emperor Trajan delaying his march to war so that one of his soldiers, who had murdered the only son of a widow, could be executed. The second panel showed Pope Gregory the Great, four centuries later, praying to God to be merciful to Trajan because, despite being a pagan, he had been just. God listened, and Gregory miraculously found Trajan's tongue still alive in his skull. Gregory is shown being offered his dark green and black skull on a jewelled platter, with the tip of a pink tongue poking through the teeth. Rogier mingles with the papal court, his head in half profile poking above the Pope's crown. He is the only one to look out of the picture, and scrutinizes us from beneath a big black and blue hat.[24]

The theologian Cardinal Nicholas of Cusa (1401–64) mentioned visiting the town hall in his treatise *On the Vision of God* (1453). For Cusa, images in which the eyes stare out at the viewer, and seem to follow them round the room, are analogous to the way in which God relates to the individual. He tells the monks he is addressing to carry out an experiment – gather in a room and look at an icon of Christ. Each monk will feel that the icon is looking at them alone, only to discover later that everyone in the room felt the same sensation. So too with God's love: God's attention to us is 'so strong that the one who is being looked upon cannot even imagine that the icon is concerned for another', yet God's love is actually spread around equally. Love of God springs from self-love that is stimulated by this feeling of specialness. Cusa includes in his list of 'omnivoyant' images a face 'by the pre-eminent painter Rogier in his priceless painting in the city hall at Brussels'. [25]

It is an interesting image for Cusa to choose, as Rogier's self-portrait – the only face to look out of the picture – is not obviously icon-like. Since he looks at us over his right shoulder, only his right eye is fully visible. The painter's forthright yet cyclopic gaze is not his only distinguishing feature. The swarthy, weather-beaten colour of his skin – a combination of browns, pinks and reds – and his black and blue hat also single him out. Those around him have almost uniformly pale skins. The darkness of Rogier's face makes the whites of his eyes seem more

Self-portrait detail from the Trajan tapestry, copy after Rogier van der Weyden's *Scenes of Justice*
painted for the Brussels Town Hall *c.* 1435–40 (destroyed in 1695)

staring. Indeed, his skin colour is closest to that of Trajan's exhumed skull, and an African or Middle Eastern soldier in the first panel. The skin colour is unlikely to have been an innovation or mistake by the tapestry weavers to distinguish him from the historical figures, as it is technically complex, and unflattering. Yet it is the dark colour of Rogier's skin, as well as his gaze, that makes Nicholas conflate him with an icon, for most viewers of the veil of Veronica in Rome were struck by the dark colour of Christ's skin, explaining it as the side effect of his suffering.[26]

But it seems unlikely that Rogier's sunburnt skin colour and posture is just meant to evoke the famous portrait of Christ in Rome. The artist was surely inspired by one of the most celebrated and discussed passages in the Song of Songs. Very early on the bride announces:

> I am black, but beautiful, O ye daughters of Jerusalem....Look not upon
> me because I am black, because the sun hath looked upon me (1: 5–6)

Commentators debated whether this simply meant that she was apologizing for being Ethiopian or Saracen, or simply for being sunburnt; confessing her sins or welcoming persecution and suffering.[27] The best all-round explanation for Rogier's strange appearance and awkward position (he nearly has his back to the proceedings, and twists his head sharply round) comes from the influential early Christian Father Origen. For Origen, the bridegroom is God, the 'Sun of Justice', a cosmological term that was frequently used. Having seen that the bride was 'crooked' and 'not standing straight', he 'looked askance' at her, and so she was cast into dark shadow. To be delivered from sin, she will be 'crooked in nothing', and not 'turn aside'.[28] Rogier would depict Christ as the 'Sun of Justice' in the *Braque Triptych* (*c.* 1450), with his head placed before the rising sun so that its rays create a halo. Here Rogier, in his very own scene of justice, is straightening himself out, turning himself round, hoping – rather like Trajan – to be looked on forgivingly by the 'Sun of Justice'. But by donning a mask of humility he makes himself far more conspicuous – and alive – than any other member of the papal court.

~

It is often said that Renaissance self-portraiture is primarily a product of competitive aristocratic court cultures, with the artist using self-portraiture to claim the status of courtier. Yet the most high-profile fifteenth-century self-portraits were

not made by court artists (who anyway rarely worked for a single patron). Rogier van der Weyden was Town Painter of Brussels, and although it was part of the Duchy of Burgundy and Philip the Bold and his court were frequent visitors, he was an independent master rather than a court painter. The most conspicuous kinship self-portraits (made by the sculptor Lorenzo Ghiberti and his pupil Filarete) emanate from the republic of Florence and the papacy in Rome. Great artists added lustre to a wide range of political entities.

Lorenzo Ghiberti (1378–1455) is celebrated above all for making two sets of bronze doors for the Baptistery of Florence's cathedral after triumphing over his rivals in open competition; he incorporated his self-portrait in both, putting himself in the most exalted of company. Ghiberti, who trained as a goldsmith, seems to envisage himself as a great prophet at the court of heaven rather than a mere courtier or craftsman. Supremely confident, Ghiberti was the most successful artist of his day, despite failing to keep any deadline. While working on the doors his earnings were the equivalent of a branch manager of the Medici bank, and he died a rich man.[29] Ghiberti was one of four Florentine artists referred to in Alberti's dedication of the Italian version of his treatise *On Painting* – the only one to produce a self-portrait and to have written a theoretical treatise. His narrative reliefs set a new standard for clarity, verve and elegant naturalism, and his second set of doors features sophisticated perspectival effects that help create mood, and deft borrowings from antique sculpture.

In both sets of doors a self-portrait bust is inserted into the decorative foliate borders. The self-portraits are part of a series of projecting bust-length heads of prophets and (in the first door) sibyls. Below each self-portrait, Ghiberti included a signature inscription. On the second door, the artist is flanked on his left by an image of his sculptor son and heir, Vittorio, again in the same format, instantly creating a dynasty. Although analogous to the bust series of Peter Parler, they are more conspicuous by virtue of being at eye level, and projecting further forward like chunky door knobs.

Both of Ghiberti's self-portrait heads look down, but from on high, as it were, penetratingly rather than humbly. The other prophets twist and turn their heads in a more transitory way. We would normally say they were alert, animated, even inspired. But the presence of Ghiberti's bust makes them seem fidgety, surprised and perplexed. He seems more magisterial.

The self-portrait bust for the second door, made in around 1447–8 when Ghiberti was seventy, emerges from a circular aperture. This type of framing device is antique in origin, and was used for images of gods and emperors. He looks

older than in the first self-portrait, but he is wiser and more powerful. He has a bald pate, but his skull is perfectly domed and sleek, both architectural and light-catching. His ears, partly covered by a large astrolabe-like turban in the first self-portrait, are now exposed, to listen to the music of the spheres, and the praise of passers-by. A wonderfully observed flower – perhaps a wild rose – blooms directly below him. Ghiberti's autobiography shows he was proud of his skill at depicting flora and fauna; and Florence was, after all, the city of 'flora'. Alberti, in his passage on Narcissus, said painting was the flower of the arts. Ghiberti is here the flower of artists, leaning over to survey his own creations. In both self-portraits Ghiberti has a cool unerring gaze that is keyed in to the geometry of the doors. In the second self-portrait the diagonal lines formed by the sides of the mountains in the reliefs below converge on Ghiberti and his son Vittorio.

Ghiberti's doughty studiousness is absolutely in keeping with an artist who was, with the exception of Alberti, the greatest artist-intellectual of his day. He was the first artist to write an autobiography, and the first person since antiquity to write a history of art – or rather *two* histories of art. These appear in the three books that comprise his *Commentaries* (begun *c.* 1447). The first book lists the skills and knowledge required by the artist followed by a short history of ancient Greek art; the second is a short history of modern art since Giotto, followed by Ghiberti's own autobiography; and the third book is a sophisticated digest of

Lorenzo Ghiberti, *Self-Portrait with Turban, c.* 1420, gilded bronze, north doors (detail), Baptistery, Florence

Lorenzo Ghiberti, *Self-Portrait* and *Portrait of His Son Vittorio, c.* 1447–8, gilded bronze, eastern doors (detail), Baptistery, Florence

medieval theories of vision and optics. Becoming a Ghibertian artist is not for the faint-hearted: they must have a 'working knowledge' of grammar, geometry, philosophy, medicine, astrology, perspective, history, anatomy, the theory of drawing and arithmetic. And they must study at night, and not oversleep.

Ghiberti's text is associated with the Florentine tradition of the *Zibaldone*, collections of moralizing commonplaces meant to inspire future generations of the family. But it is more systematic than a commonplace book. Vasari consulted the *Commentaries* when researching his *Lives of the Artists*. He rebuked Ghiberti for his self-absorption and use of the first person in the autobiographical section: "'I made", "I said", "I was making", "I was saying"'.[30] He clearly recognized that this unapologetic authorial 'I' was a milestone in artistic self-portrayal. Alberti and Vasari both still used the third person when they wrote their autobiographies.

The inscription on the first set of doors merely says 'the work of Lorenzo of Florence'. That on the second set leaves us in no doubt that we stand in a privileged place: 'Lorenzo di Cione Ghiberti Made with Marvellous Skill'.

Ghiberti's artistic and literary ambitions clearly rubbed off on the Florentine sculptor, architect and theorist Antonio di Pietro Averlino (*c.* 1400–*c.* 1469), the self-styled Filarete (Greek for 'lover of virtue'). He is the most prolific of early Renaissance self-portraitists – and the only one to depict himself with his studio assistants, or 'disciples', as he calls them. With them, he holds his own exuberant court.

After training in Ghiberti's studio, Filarete is recorded in Rome in 1433, where he made bronze doors for the porch of St Peter's, before moving on to Milan in 1451 and working as an architect and architectural theorist, writing his *Treatise on Architecture*. Four self-portraits survive, with his face invariably appearing in *all'antica* – or *all-Alberti* – profile. In Milan he created one of the earliest double-sided self-portrait medals, with a remarkably naturalistic profile self-portrait on the recto, and on the verso an allegorical image of himself tapping the trunk of a tree for honey. But it is the two earlier self-portraits on the doors for St Peter's that are most intriguing.

In comparison to Ghiberti's Baptistery doors, Filarete's are an antiquarian mish-mash of early Christian and classical elements. The best parts are the exuberant fillers and framing elements featuring ancient and modern profile portraits, mythological scenes, animals and plants. Filarete's own self-portrait profile roundel is located here, held up by a pair of centaurs. On the rear of the doors, which are otherwise undecorated, he has included his self-portrait with 'disciples'. This is a long rectangular relief with Filarete leading a line of six assistants in an energetic line dance, similar to a medieval carole, with all of the figures moving to their left.[31] They hover over the ground, each managing the considerable feat of holding hands and a tool of their trade. Their names are inscribed below their feet, and there is no doubt who is in charge. Filarete's own inscription is in much larger letters and explains that these are his '*discipuli*'. He also holds up a compass, traditional tool of *deus artifex* – God as creator. A circle is inscribed in the empty space behind it, as if conjured up magically out of thin air. In contrast Agniolus, who brings up the rear, holds a claw hammer. Unlike the 'disciples', Filarete does not wear a leather apron, and his dance step is more restrained than theirs. The dance troupe is flanked by a man on an ass who holds a pitcher and a second man on a camel playing pipes. An explanatory inscription stretches just above the heads of the dancers, grandly disclaiming: 'For others the fame and the money, for me joy'.

The Latin word for joy – *hilaritas* – is almost graffitied into the bronze, and curves down as though it were made from the hot alcoholic breath issuing from Filarete's mouth. *Hilaritas* was a prime Christian virtue – St Hilary felt joy even when suffering excruciating torture. The panel is precisely dated – 31 July 1445 – and must represent their unalloyed delight at finishing the doors after a decade of torturous toil. The ass and camel are exotic biblical references that tie their celebrations in to various biblical feasts. Drunkenness was often interpreted by Christian as well as pagan writers as akin to mystical rapture.[32]

Over the door in the porch was Giotto's mosaic showing Christ walking on water, and Filarete's relief is a joyful, airborne response to it. Giotto's lost mosaic is the only modern work of art described in Alberti's treatise on painting: 'Each [disciple] expresses with his face and gesture a clear indication of a disturbed soul in such a way that there are different movements and positions in each one'.[33] Filarete's 'disciples' contort themselves into different positions, but are fearless and full of belief.

The relief is a celebration of teamwork, and *hilaritas* was a sign of civilized societies. Aristotle believed smiling and laughter distinguished man from the animals: there is a pig and a dog at Filarete's feet, as well as the ass and camel, but not even the dog shares the joy. The Florentine humanist and biblical scholar Giannozzo Manetti, writing in 1438 in a moving dialogue on the death of his son, said that 'man by his nature is a social and civic animal, capable of smiling, born for doing good and acting, even to be a certain type of mortal god'. Manetti later wrote a treatise *On the Dignity and Excellence of Man* (*c.* 1452) in response to a medieval pope's treatise *On the Misery of the Human Condition*.[34] The compass-wielding Filarete seems to see himself as 'a certain type of mortal god' *and* a social animal.

～

Until around 1490, the social construction of the artist excluded wives – except for the ultimate bride, the Virgin Mary. Van Eyck is a partial exception, but his portrait of his wife was still painted much later than his own self-portrait. Portraits of bourgeois married couples became quite common in the second half of the fifteenth century, but it is not until around 1490 that an artist would depict

Filarete, *Self-Portrait with His Workshop*, *c.* 1445, bronze,
relief on interior of doors for the porch of St Peter's, Rome

himself in a double portrait with his wife. The German goldsmith and printmaker Israhel van Meckenem (active 1465; d. 1503) depicted himself with his wife Ida in a single print, and it is the earliest example of a formal self-portrait in a print. In Froissart's poem, Sir Agamanor expresses his love with a self-portrait presented privately to his lady. Van Meckenem's celebration of his love was much more public.

The print is not only pioneering in genre terms, it is also one of the most delightful and intense double portraits ever made. The couple are shown in close-up, their heads and upper shoulders filling the entire pictorial field. They turn towards each other, smiling, eyelids drooping in a swoon, his cap and her bonnet practically touching, his nose tumescently bulbous, the tops of her breasts pushed up by her low-cut gown. Israhel's sloping left shoulder overlaps Ida's right, and we imagine their lower bodies practically merging. Were they not fully clothed, they could easily be lying in bed.

They are clearly not poor. The background is a framed patterned 'cloth of honour', often placed behind people of importance, such as the Virgin Mary, and Ida wears a fur-trimmed gown. Israhel may have a lined, unshaven, rugged face, but it becomes a showcase for his considerable shading skills, and a swarthy contrast to Ida's pellucidity.

Ida is situated to her husband's left (our right) in traditional fashion. But any subservience this might imply is moderated not just by their close proximity, but by the heart shape formed by Ida's bonnet and veil. She is not just standing on Israhel's 'heart side', she *is* his heart. Here Ida has opened her heart and Israhel has reciprocated. The print is signed along a strip at the bottom: 'The Portrait of Israhel and Ida his wife'. His signature – I V M – is placed further along, right over her heart. Israhel would subsequently make an innovative series of twelve engravings of courting couples, including *Couple Seated on a Bed*, and the germ of the idea is here.

If the body language is intimate, the impersonal inscription (*the* portrait; *his* wife) is in keeping with its creation for public as well as for personal consumption. Israhel was a famous artist, and in 1505 he was ranked alongside Dürer and Schongauer as a pioneer of printmaking. But he was very different from them, and far more prolific; only ten per cent of the over six hundred prints connected with him were original. Most were copies and reworked versions of the work of other printmakers, including Dürer and Schongauer, repackaged and reissued in big editions with his own monogram. He has been called 'the most voracious pirate in Renaissance printmaking'.[35]

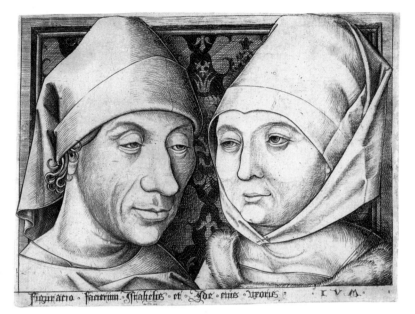

Israhel van Meckenem, *Self-Portrait with His Wife Ida,* c. 1490, engraving

Married-couple self-portraiture would have to wait until Peter Paul Rubens's *Self-Portrait with Isabella Brant* (c. 1610), set in a honeysuckle bower, for anything as erotic. Rubens's work gave rise to a Netherlandish genre of 'fertility self-portraits' showing the artist with his wife and children, and exemplifying the aphorism 'Art is born of Love' – a genre which van Meckenem, the great pirate of printmaking, invented.[36]

~

The claims of kinship made by all these works are modest in comparison to the most radical form of Renaissance self-portraiture – the 'unwitting' or 'disguised' self-portrait, whereby every figure made by a particular artist shares his features and mannerisms. The recognition of this new form of surrogate self-portrait coincides with Alberti's choice of Narcissus as a model for the modern painter, but it is more solipsistic and all-encompassing than anything envisaged by Alberti.

This form of self-portrait was suggested in a popular catchphrase coined in the fifteenth century that would remain in vogue until the eighteenth, and which has been revisited by modern psychology: 'every painter paints himself'. The basic

idea was that when painting any figure it would be, at some level, an unwitting self-portrait – whether in terms of the physiognomy, gesture and character, or general pictorial style. This catchphrase was inspired by the classical notion that a man's works and deeds, whether good or bad, will reflect his essential character and personality – in short, his soul. It was even applied to architecture, possibly because of the presence of Alberti's self-portrait in Palazzo Rucellai.[37]

In a Florentine collection of witty anecdotes compiled in the 1470s, Cosimo de' Medici (1389–1464) is quoted using the catchphrase 'every painter paints himself' to illustrate the instinctive (bad) habits and compulsions in man.[38] A sonnet attributed to Filippo Brunelleschi, and possibly addressed to an artist whose work displeased him, includes the lines: 'a crazy nature produces crazy results, because they have to resemble their cause'.[39] That this catchphrase became popular in fifteenth-century Florence must be due to an increasing awareness of personal styles in art.

The catchphrase is used in the late 1490s to criticize a particular painter and a particular artwork. Here the beauty of the painter is insisted on, as if to suggest he is a new Narcissus – in love with himself, and reproducing himself in his art. When he wishes to paint someone else

> He often paints not the subject but himself.
> And not only his face, which is beautifully fair
> According to himself; but also in his supreme art
> He forms with his brush his own manners and his customs...[40]

The sonnet was written by Gaspare Visconti, a poet at the Milanese court, and is part of a series of poems written for Bianca Maria Sforza, the illegitimate daughter of the Duke of Milan. The target of the poem must be Leonardo da Vinci, who had until recently been painting the *Last Supper* in the refectory of the convent of Santa Maria delle Grazie in Milan. All Leonardo's figures and portraits, Gaspare claims, are imbued with his own ideal beauty, deportment, gesture and manners: his art is a private hall of mirrors.

Leonardo, with his Albertian range of interests and skills, would have been horrified at the idea that he always painted himself. He might even have regarded Visconti's sonnet as a joke, for in the *Last Supper* he had striven to devise a wide range of gesture, expression and physical type (Visconti may have seen its sheer flamboyance as typically Leonardo). Leonardo repeatedly railed against those painters who 'painted themselves' – the first diatribe dates from 1492; the last

from after 1510. He regarded it as the 'greatest defect of painters':

> If the master is quick of speech and movement his figures are similar in
> their quickness, and if the master is devout his figures are the same with
> their necks bent, and if the master is a good-for-nothing his figures seem
> laziness itself portrayed from the life...any part that may be good or poor
> in yourself...will be partly shown in your figures.[41]

If figures 'often resemble their masters', this is because judgment, 'one of the
powers of the soul', is at fault:

> Having to reproduce with the hands a human body, [judgment] naturally
> reproduces that body which it first invented. From this it follows that he
> who falls in love naturally loves things similar to himself.[42]

Thus Israhel van Meckenem makes his wife a virtual mirror image of himself.

For Leonardo, it was important that the painter was aware both of his own
shortcomings and of the 'praiseworthy proportions' for 'a body in nature'. He
advises artists to have themselves measured up to see where they fall short of the
ideal.[43] This doctrine does not, of course, address the question of what the painter
should do if he is a perfect specimen – like the famously beautiful and refined
Leonardo.

Leading artists were now putting themselves more in the picture, physically,
socially and stylistically – so much so that they were accused of only ever painting
self-portraits. These developments coincide, in the years around 1500, with artists
depicting themselves in heroic and splendid isolation.

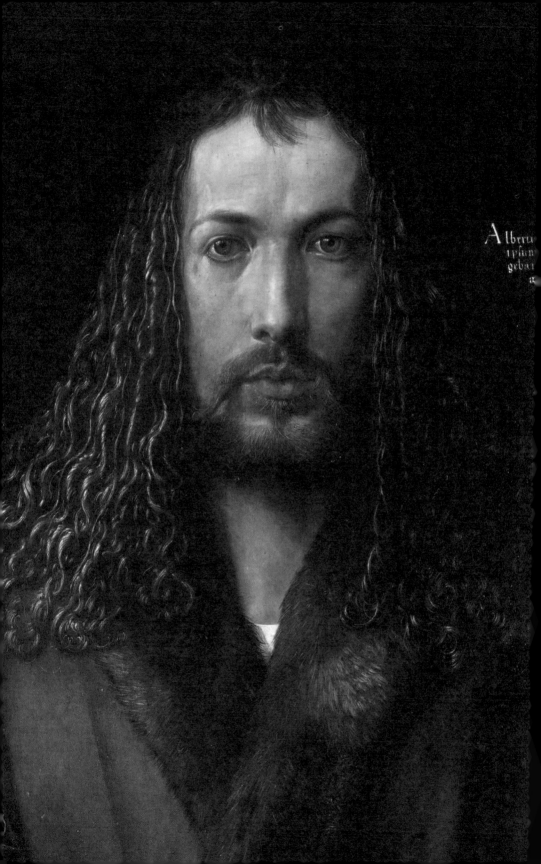

4.

THE RENAISSANCE ARTIST AS HERO

∾

UNTIL THE 1490S, THE FIFTEENTH-CENTURY record of achievement in self-portraiture is still relatively modest and spasmodic. Independent self-portraits are generally small-scale, and those insinuated into religious narratives tend to be discrete and marginal, or they are 'disguised' as St Luke. The most conspicuous – by van der Weyden, Ghiberti and Filarete – all belong to the second quarter of the century.

This changes in the 1490s, in central Italy, Mantua and Nuremberg, when for the first time several self-portraits are made that match the fictional self-portraits of Villani and Froissart for heroism and panache. The idea of the artist as cultural hero would also merge with the myth of the child prodigy, with artists aggrandizing their youthful achievements.

The dazzling decade of the 1490s started with the resurrection of an artist who had been dead for over 150 years. In Florence in 1490 a wall monument to Giotto was unveiled in the cathedral where he had been Master of Works.[1] One of the first commemorative monuments to an artist, it features a specially commissioned 'portrait' bust by Benedetto da Maiano, possibly based on a presumed self-portrait.

The Giotto monument was almost certainly financed by Lorenzo de' Medici as part of a policy to promote the arts in general, and Florentine artists in particular. He was partly inspired by the classical concept of virtue, which considered conspicuous expenditure on architecture and art, secular as well as sacred, to be a

Albrecht Dürer, *Self-Portrait*, 1500 (detail), see page 84

personal and civic duty, rather than mere vainglory or penitential reparations for being a money-lending banker. Lorenzo was called 'the Magnificent', because magnificence – as Aristotle wrote in the *Ethics* – becomes the wealthy and redounds to their greatness and prestige: they should embellish their city and their own house, which is also 'a public ornament'.[2] A central part of magnificence is patronizing the best artists, though partly because of his own money troubles, Lorenzo frequently acted as an artistic consultant, recommending Florentine artists (such as Leonardo, Filippino Lippi and Verrocchio) to foreign patrons. He was particularly interested in architecture, regularly reading Alberti's treatise on the subject, and even submitting a design for the facade of the cathedral in 1491. Growing appreciation of individual artists would be manifested in the inventory of the contents of the Medici Palace made in 1492 after the death of Lorenzo de' Medici. This is one of the first to mention the name of the artist, as opposed to just describing the subject matter or (in the case of portraits) giving the name of the sitter. As yet, though, no self-portraits are listed.

A series of monuments to famous men had been planned during the second half of the fourteenth century for the cathedral and the seat of government, the Palazzo Vecchio, but although poets were included in the cathedral scheme, artists were not. However, a wall monument was erected in the cathedral to Filippo Brunelleschi, architect of its famous dome, after his death in 1446. This monument consists of a half-length marble portrait bust, carved by Andrea Cavalcanti, set inside a decorated roundel. The face is based on Brunelleschi's death mask, presented to the cathedral by his heirs. Beneath the roundel is a long laudatory inscription. The dead man stands before us looking very much alive.

The Giotto monument is in almost exactly the same format as the Brunelleschi memorial, and shows Giotto making an image of Christ out of mosaic, an art form that Lorenzo de' Medici hoped to revive. Below is a long Latin inscription by the poet and philologist Angelo Poliziano, in which Giotto boasts of his achievements in the first person:

I AM HE THROUGH WHOM PAINTING, DEAD, RETURNED TO LIFE

AND WHOSE HAND WAS AS SURE AS IT WAS ADEPT

WHAT MY ART LACKED WAS LACKING IN NATURE HERSELF.

TO NO ONE WAS IT GIVEN TO PAINT BETTER OR MORE.

DO YOU ADMIRE THE GREAT BELL TOWER RESOUNDING

WITH SACRED BRONZE?

THIS TOO ON THE BASIS OF MY MODEL HAS GROWN TO THE STARS.

AFTER ALL, I AM GIOTTO. WHAT NEED WAS THERE TO RELATE
THESE THINGS?
THIS NAME HAS STOOD AS THE EQUAL TO ANY LONG POEM.

DECEASED 1336. ERECTED BY THE CITIZENS 1490.[3]

The claim that Giotto is the 'equal to any long poem' is a clear reference to Dante's *Divine Comedy*, of which the first printed edition had appeared to great fanfare in 1481, financed by Lorenzo de' Medici. A large 'portrait' fresco of the author had been painted on a wall of the north aisle of the cathedral in 1465. Dante is shown holding up his book, a colossus who towers over Hell and Purgatory to his right, and over present-day Florence (with the bell tower that Giotto designed and Brunelleschi's dome) to his left. The Giotto monument establishes him too as a fully-fledged cultural hero and shaper of present-day Florence.

The Giotto of Poliziano's inscription has no truck with Dante's meditation on the transience of all art and fame in the Purgatory section of *The Divine Comedy*. The inscription is a revival of a Roman genre, whereby an epigram attached to an image on a tomb or monument buttonholes the passer-by and tells them about their claim to fame. Classical authors also sometimes prefaced their work with 'I am he who…'. Poliziano's Giotto claims to be an omnipotent, autonomous miracle-worker. No credit is given to God, guilds or private patrons. Although Poliziano says that Giotto has brought painting back to life, he is careful not to say that he has revived a previous, antique type of painting. This is in keeping with a riposte made by Poliziano when the style of his own Latin had been criticized: 'Someone says to me, "You don't express yourself as if you were Cicero". What of it? I am not Cicero. Yet I do express myself, I think'.[4] This quip is justifiably seen as a key marker in the development of Renaissance individualism. So too is the even more emphatic declaration 'I am Giotto'.

At the time of the creation of the Giotto memorial, the most famous and wealthy artist in Europe was probably Andrea Mantegna (1431–1506), court artist to three generations of Gonzagas, the *condottieri* rulers of Mantua. He was in the vanguard of classicizing artists, collecting and studying antiquities and filling his pictures with classical architecture and inscriptions. His frescoes of Gonzaga court life and his vast series the *Triumphs of Caesar* seemed to many to usher in a new age. He was made a knight by Federico Gonzaga.

Three Mantegna self-portraits inserted into religious narratives have been identified.[5] A self-portrait also appears in the Gonzaga frescoes, as part of a triple

self-referencing. Mantegna wove his own facial features symmetrically into the plant decoration of a painted pilaster, suggesting both that he is the 'flower' of painters and endlessly fertile. To his right, winged putti hold up an inscribed tablet dedicating 'this humble work' to Ludovico Gonzaga and his wife by 'their Andrea Mantegna of Padua'. To the left, Cardinal Francesco Gonzaga, in the so-called 'Meeting Scene', holds a folded note on which is written 'ANDREA ME PINXIT' (Andrea painted me).[6] Andrea – rather than the pope or God – has made this cardinal.

From 1476–94 Mantegna built his own house in Mantua, in the style of a Roman town house, cubic in shape with a circular central courtyard. A bronze self-portrait bust in high relief, inspired by antique busts, and perhaps by those of Brunelleschi and Giotto, has been dated to the early 1490s, and it may have been intended to adorn his new home. It is assumed that Mantegna designed and modelled his bust, even if he did not actually cast it.[7]

In 1504 Mantegna purchased the rights to a funerary chapel in Mantua's main church, the decoration of which was completed in 1514. The bronze self-portrait bust ended up here, placed against a marble roundel with a central disk made from Roman imperial porphyry, one of the hardest of stones. A Latin inscription below buttonholed the visitor: 'You who see the bronze likeness of Aeneas Mantegna, know that he is equal, if not superior, to Apelles'.

As Virgil tells it in the *Aeneid*, Aeneas, the son of the Trojan Anchises and the goddess Aphrodite, had heroically led the surviving Trojans out of their burning city and ultimately to the shores of Italy. His descendants had founded Rome. Mantegna is thus one of the great pioneers and founding fathers – a new Giotto. Apelles, the most famous painter of antiquity, had worked for Alexander the Great (who had given him his mistress Campaspe). In the inscription, Mantegna is cast as both man of action and artist. His Gonzaga patrons are flattered by being associated with Alexander the Great.

In its visceral machismo, the bust out-Romans the Romans. Mantegna looks out horizontally, his head turned to his right. His tumescent bulldog face scowls. This is perfectly in keeping with what we know about Mantegna's fiery character. Shoulder-length matted hair, bare chest and shoulders, add to the heroic allure. His only adornment is a wreath of laurel leaves that crowns his head. In antiquity laurel was used to honour great leaders and poets, and Petrarch claimed to have been crowned in Rome. Boldù used it in his medallic profile self-portrait of 1458, in which the 'painter of Venice' sports naked shoulders and upper chest.[8] However, that work's mood is much more reflective. Boldù's features are smooth and exquisitely disembodied; on the reverse of the medal is a seated boy with his

Andrea Mantegna, *Self-Portrait*, *c.* early 1490s, bronze bust mounted on marble
and porphyry roundel, Mantegna Chapel, Sant'Andrea, Mantua

head in his hands confronted by a skull and a winged boy symbolizing the spirit of
Death. Mantegna looks away from the altar, primed for irresistible action in this
world. He flaunts his nudity, and wears it heroically like a suit of armour.

But even Mantegna's bare-chested heroism pales beside the life-sized self-
portrait sculpture made by Adam Kraft (*c.* 1440–1507) in the free Imperial City
of Nuremberg in *c.* 1493–6. It was the largest, most conspicuous and impressive
self-portrait that had ever been made.[9] Kraft is a kind of Atlas figure: he supports
an entire building on his shoulders, but not as penance – in the medieval style –
because he does it effortlessly and joyously. His self-image emerges from the long
Germanic tradition of architectural self-portraits already referred to in relation to
Peter Parler, but it is virtually a freestanding statue. Kraft was a stone sculptor who
also advised on architectural projects, and his self-portrait is placed at the base of a
twenty-metre-high sacrament house that he designed for the church of St Lorenz
(the consecrated host was locked up inside). Commissioned by one of the richest
men in the city, Hans Imhoff, in 1493, it would have redounded to the patron's

Adam Kraft, *Self-Portrait, c.* 1493–6,
sandstone with partial painting, St Lorenz Church, Nuremberg

credit to have employed the leading sculptor in the city – a man who could not only design and build a tower (like Giotto), but also lift it. The contract stipulated that the sacrament house be 'beautifully made'.

This towering sandstone structure, surmounted by a crucifix, was located in the church's choir, to the left of the high altar. It was originally brightly painted, but now only a few traces of paint remain. Kraft's full-length bearded figure is placed at the front, on the western side, facing the main entrance of the church. He crouches down on one knee, holding his mallet and chisel, and bears the entire structure on his broad shoulders. Kraft means strength, so he lives up to his name. He looks up, his face held up and open like a sunflower, with a wonderfully rapt expression, and seems about to stand – or sprint. Two workshop assistants bear the south and north sides of the structure. Astonishingly, Kraft and his colleagues are larger than any of the religious figures represented on the tower. The arms of Imhoff and his family (two wives, ten children) are displayed on the tabernacle shrine above, but are far less conspicuous and would have been even when they were painted. How did Adam Kraft get away with it? It is almost as though Imhoff is conspicuously expressing his own humility (and distracting us from the vast size

of his monument) by allowing himself to be upstaged by this giant armed with mallet and chisel.

Alberti, in his dedication to Filippo Brunelleschi of the Italian version of *On Painting* (1436), said that until now he had always believed nature was no longer producing great intellects – 'or giants which in her youthful and more glorious days she had produced so marvellously and abundantly'.[10] It was commonly believed, because of the occasional discovery of large bones and fossils, that in the past humankind was of greater stature. Kraft is just such a giant, and his Christian name is that of the first man, Adam (he took this so seriously he tried to get his wife to change her name to Eve).

Nuremberg had grown rich on international trade, and the city council was run by merchants.[11] Unlike most other cities, there were no trade guilds, and crafts vital for the city's economic and military wellbeing were directly controlled by the council. Painting and sculpture were called the 'free arts' because there were no guild regulations determining training and conduct, or licensing artists to practise. Until 1509, foreign masters could set up shop in Nuremberg, and the more open environment does seem to have encouraged innovation and fruitful competition between artists and between patrons. Artists were not 'free' politically, however, as they had no say in the running of the government, and there was no safety net if they fell on hard times.

No Nuremberg artist was more commercially innovative or cosmopolitan than the printmaker and painter Albrecht Dürer (1471–1528), the son of a distinguished goldsmith. He is the first non-Italian artist to become famous for his conduct and appearance – especially his hair and hands – as well as his art. Leonardo was known for his beauty, wit and elegance; Dürer used self-portraiture to immortalize himself as the northern 'artist-as-beauty'.[12]

Dürer is the most celebrated, prolific and inventive creator of self-portraits during the Renaissance. Altogether he made some sixteen self-images – including independent drawn and painted self-portraits, and painted images of himself as a bystander in three major altarpieces. He also made studies of his hands and legs. In around 1510, he sent his own self-portrait to Raphael, and Raphael reciprocated with some drawings of his own (though not a self-portrait). He believed that 'many painters paint figures resembling themselves', and that great artists had 'a creating power like God's. For a good painter is inwardly full of figures'.[13]

Paradoxically Dürer is not the most public of self-portraitists, for he did not make (like van Meckenem) a print self-portrait. He may have felt his 'AD' monogram sufficed, and several print portraits of him were made by other artists in

his lifetime. Cold commercial considerations may have played a part too: a print of the Virgin would make more money than a self-portrait. Three independent painted self-portraits of 1493, 1498 and 1500 appear to be personal milestones for they are all signed, dated and elaborately inscribed. All three show him dressed opulently, and make a feature of his hair, the drawing of which is invariably a masterpiece of the calligrapher's art.

The most opulent is the self-portrait of 1498, a half-length image, in which we see him from his right side in half profile (a Flemish convention), standing before a window with a view of a verdant landscape. It was painted in Nuremberg while Dürer was working on a series of fifteen woodcuts of the Apocalypse, or 'The Revelation of John the Divine'. This was the first book to be both published and illustrated by an artist, though some images were sold individually as loose sheets. These dramatic full-page images, timed to fuel and exploit the religious fervour connected with the imminent half-millennium, and the supposed second coming of Christ, made Dürer famous throughout Europe. Yet he presents himself in the self-portrait as someone who has never felt fear, let alone apocalyptic fear. He must have been aware of the irony. He could easily be one of the sumptuously dressed male clients in his own *Apocalypse* print of *The Whore of Babylon*. The only pain this man might have experienced is the pressure of being a living work of art.

Dürer initially trained to be a goldsmith, and this goldsmith manqué is pure gold. Golden hair with coiffured corkscrew curls, all painted with the finest of brushes, tumbles down golden skin. He sports an elegant moustache and beard. The faces in Dürer's painted portraits rarely look animated, and this one is no exception. Just below the window ledge we find inscribed in calligraphic letters: 'In 1498 I painted this from my own form. I was twenty-six years old. Albrecht Dürer'.

It is usually assumed that Dürer is presenting himself here as an Italian-style *gentiluomo* (gentleman), and his letters home from Venice during his second stay there in 1505–7 are often used as virtual speech bubbles for the picture. The letters were sent to his friend the Nuremberg humanist (and sybarite) Willibald Pirckheimer, on whose behalf Dürer acquired luxury textiles, jewelry, feathers, etc. Dürer wrote: 'What do you mean by setting me to such dirty work [buying rings]? I have become a gentleman at Venice'; 'My French mantle, my doublet, and my brown coat send you a hearty greeting'; 'How I shall freeze after this [Venetian] sun. Here I am a gentleman, at home only a parasite'.[14] Dürer's expensive tastes meant he was frequently in debt, and Pirckheimer had loaned him the money to undertake the second Venetian trip.

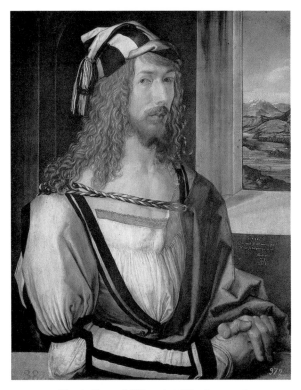

Albrecht Dürer, *Self-Portrait*, 1498, oil on panel

But he also complains about Venetian artists who steal his ideas and copy his works; and he says he is so thronged by friendly Italian artists 'that at times I have to shut myself up'.[15] There is already a sense in this self-portrait of him being protectively yet constrictingly shut away, like a reliquary in a cathedral treasury. Through the window we glimpse an alpine landscape with a distant snow-capped mountain, which picks up the white stripes on his tasselled cap: the visual echo emphasizes his indomitable remoteness. His gaze is sly, suspicious. Petrarch called his own autobiography 'My Secret' because he claimed to want to keep its contents private and there is something grandly secretive about Dürer's self-portrait.

The intensely hieratic and sombre self-portrait of 1500 is more the kind of thing we might imagine being made by the creator of the *Apocalypse* series. It is a half-length, full-frontal image, placed against a black background with darker brown hair and skin to match Dürer's brown coat. The principal break in the painting's symmetry is the artist's portentously raised right hand, the fingertips placed

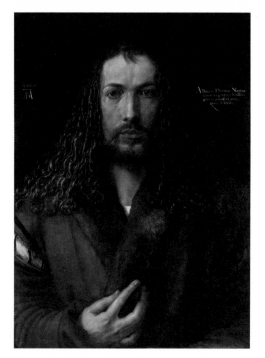

Albrecht Dürer, *Self-Portrait*, 1500, oil on panel

in front of his breastbone. Since the mid-nineteenth century, this format has frequently been compared to images of Christ, especially the Mandylion and Veronica.[16] Veronica's veil was the most important relic kept in St Peter's, Rome. By making the visual analogy (and the darkness alludes to it too), Dürer implies he is a Christ-like figure, with divine powers of creation. In his later treatise on proportion, Dürer would claim that God 'grants great power unto artistic men'.[17]

That said, Dürer is much too well turned out to be an exact counterpart to Christ. His permed hair, plucked eyebrows, waxed handlebar moustache and trimmed beard are a tour de force of the barber's art. Indeed, hair has surely never been so intricately and painstakingly painted, with many individual strands picked out. If we compare the self-portrait with Dürer's engraving of 1513 showing Veronica's veil held by two angels, the artist's cascading curly hair is much closer to that of the angels than of Christ, which is understandably rather dishevelled. Indeed, no image of Christ by Dürer has such finely wrought hair. The closest comparisons are with the hair of Dürer's women and the fur of his animals.

Dürer's hair was famous among his contemporaries, and after his death in 1528 his admirers exhumed his body to take casts of his face and hands, and cut lockets of hair. In 1507 the canon Lorenz Beheim joked to Pirckheimer about their mutual friend, while hinting at an emotional entanglement: 'The obstacle is his pointed beard, which doubtless has to be waved and curled every single day. But his boy [assistant], I know, loathes his beard; thus he had better be careful to shave'.[18] In 1509–10 Dürer published some poems and when the secretary to Nuremberg city council derided them, he countered by calling himself the 'hairy, bearded painter'.[19] In the self-portrait of 1500, individual strands are depicted with filigree fineness and the colours range from precious gold and silver to brown and black. At the central parting, a long lock of hair has been looped and tied in a circle. His clothes are luxury items lovingly delineated.

Because of his richly ornamented, proffered beauty, Dürer's self-image recalls aspects of the bride and bridegroom in the Song of Songs. Here we find several rapturous celebrations of hair, by both the bride and the bridegroom: 'Your tresses are like flocks of gazelles' (4: 1); 'You have wounded my heart, sister, with one of your eyes and with one hair of your neck' (4: 9); 'His head is like the finest gold; his locks are like the shoots of palm-trees / fir-trees, and black as a raven' (5: 11).[20] Biblical commentators, in interpretations that would surely have appealed to Dürer, claimed that the hair signified thoughts. Gregory the Great believed that hair was the external manifestation of the flux of spiritual thoughts; for the Venerable Bede curls are 'thoughts that do not dissipate but stay governed by rules'.[21] So this is not the self-portrait of the artist as proto-hippy, but as supremely fertile and versatile thinker, who even sports an 'O'-shaped locket. At precisely this time, Dürer had become more interested in art theory, especially human proportions.

When he painted this self-portrait, he may even have had a specific passage from the Song of Songs in mind. The bride explains how the bridegroom came to her house during the night to tell her he has to depart:

I sleep, but my heart waketh: it is the voice of my beloved that knocketh, saying, open to me, my sister, my love, my dove, my undefiled: for my head is filled with dew, and my locks with the drops of the night. I have put off my coat; how shall I put it on? (5: 2–3).

We have the dark background, the shiny dark hair, the fiddling with a coat, the reverential stare...

This self-portrait is meant to be the last word in the artist as beauty. And that beauty is meant to live forever. The inscriptions on the painting, placed either side of the artist's eyes, emphasize this. The more laconic one on Dürer's right – the date 1500, above Dürer's AD logo, here making a pun on Anno Domini – prompts thoughts about eschatological time, and the second coming of Christ; the chattier, more localized inscription to Dürer's left – 'I, Albrecht Dürer of Nuremberg painted myself thus, with undying colour, at the age of twenty-eight years' – suggests the picture will never fade.

Initially the painting's reception seems to have been enthusiastic. Conrad Celtis, the German poet laureate, had written an epigram about it by the end of 1500.[22] At an unknown date it was put on display in Nuremberg's town hall, alongside sculpted and painted portraits of the great and good, which had populated the building ever since its construction in 1332–4.[23] Visitors record its presence there later in the century, with particular praise given to the hair by the Dutch art historian Karel van Mander. Dürer painted some of the town hall in 1520/1, and in 1526 he donated his two panels of the *Apostles* to the city fathers. A portrait of his elderly mother Barbara would later be installed, too. It is probably the first portable self-portrait to be publicly displayed.

Nonetheless, it had no significant artistic progeny until the nineteenth century. Whereas his other painted self-portraits in half profile from two altarpieces were reproduced in the seventeenth century, it was not until 1811 that a reproductive print seems to have appeared. The writer Goethe later described the face of Christ in a fifteenth-century German painting of St Veronica as 'frightening, Medusa-like',[24] and Dürer's self-portrait may have inspired similar feelings. Its static, hieratic format may have looked crude and its austere opulence almost medieval in the era of Titian and van Dyck.

Even if Dürer's self-portrait had been displayed in Nuremberg's Great Hall shortly after it was made, it would not, strictly speaking, be the first independent self-portrait to receive such an accolade. Indeed, the idea may have come from a bust-length self-portrait by the Umbrian artist Perugino displayed in the council room of the banker's guild in Perugia, the Collegio del Cambio. The self-portrait is part of an elaborate allegorical fresco cycle started in around 1496 and completed in 1500. Depicted on the walls and ceiling are classical gods and heroes; the planetary deities; the four Christian virtues; prophets and sibyls; and, on a wall of their own, the Nativity and Transfiguration of Christ. The iconography and the Latin inscriptions were devised by a Perugian humanist, Francesco Maturanzio, but Perugino is definitely the star of the show (there is, as far as we know, no

Perugino, *Self-Portrait between Famous Men of Antiquity*, 1496–1500, fresco,
Collegio del Cambio, Perugia

portrait or verbal acknowledgment of Maturanzio). Perugino's self-portrait is
painted in fresco like a framed easel painting that hangs on a cord strung with
marble beads fixed to a central painted pilaster. It appears as though the members
of the Collegio have acquired or commissioned a self-portrait of Perugino, and
have given it pride of place in their council chamber.

Beneath the self-portrait is a framed Latin inscription extolling the artist:

PIETRO PERUGINO OUTSTANDING

PAINTER.

IF THE ART OF PAINTING WERE LOST

HE WOULD BRING IT BACK.

IF NO ONE HAD INVENTED IT

HE WOULD DO SO.

Another framed inscription on a pilaster on the opposite wall gives the date 1500,
the likely completion date of the whole fresco cycle.

When he worked on the Collegio del Cambio, Perugino was one of the leading
artists not just of Italy, but of Europe, sought after by powerful patrons and very
highly paid. He had included himself as a bystander in religious scenes painted for
a church in Perugia, and on the wall of the Sistine Chapel, Rome (1481–2), whose
decoration he probably masterminded, and which made his name. From 1500–5,

Isabella d'Este tried desperately to secure an allegorical painting from him for which she had drawn up a detailed plan. This transaction produced an extensive three-way correspondence between the fiercely independent-minded artist, the micro-managing Isabella and her agents. Isabella is informed that Perugino is incorrigible, and behaves as if he were Giotto – presumably the Giotto of Lorenzo de' Medici's monument.

Perugino's confidence and originality had been brilliantly shown in a half-length depiction of the martyrdom of St Sebastian (*c.* 1493–4). The naked saint is transfixed by a single arrow, which projects from the left side of his neck, producing a trickle of blood. However, it is far from a conventional arrow, for it is formed from a thin line of letters: PETRAUS PERUGINUS PINXIT. Perugino implicates himself as a sinner – albeit an immensely powerful one – by virtue of having restaged the martyrdom in his art. This is one of a number of dramatized, interactive signatures that appear in Italian and German art in the years around 1500, where the signature becomes a major protagonist, rather than being confined to the border, or being 'inert'.[25]

In the Collegio self-portrait, Perugino looks straight out unerringly, across to the tribunal's bench and the allegorical sculpture of Justice, as if waiting to hear their considered opinion of his work. It is far from being an idealized portrait – his face is plump with a double chin and ruddy complexion – but he is supremely attentive and focused. His vigilant expression, with lowered eyelids and downturned mouth, is determined to the point of truculence, while his wavy shoulder-length hair is dashingly unkempt. The blue monochrome background, his bright red cap and simple black robe give the image a heraldic clarity and austerity.

Perugino places himself at the central, pivotal point of a diptych comprising two frescoes with arched tops (a lunette). Two Virtues are placed in the lunette, with six antique heroes below. Above and to his right, where his head turns, female allegories of Prudence and Justice sit on a fluffy cloud-bank hovering over a panoramic, soft-focus pastoral landscape that continues into the neighbouring lunette.

Prudence holds an astonishing sceptre, topped by a bulbous circle of convex mirrors, towards which she points. She explains in the accompanying inscription that she undertakes the search for truth and for hidden causes, and that if her example is followed, nothing will be done incorrectly. Her head is angled in the general direction of Socrates – who theorized that mirrors were invented so man might know himself – as if to imply they have a particular affinity. Prudence's sceptre is the most elaborate mirror artefact yet seen in painting. It suggests she

has panoramic, 360-degree vision, and this same compound-eye vision is being claimed by Perugino, both through the encyclopaedic range of figures included in the fresco cycle, and in the evanescent panoramic landscape that stretches out far behind him to right and left. His intent frontal gaze in the self-portrait has the Albertian effect of saying: 'I may be looking hard at you but I have eyes in the back of my head, and that's how I saw and painted the whole landscape'. This is the first self-portrait in which a landscape background underscores the painter's own depth and breadth of vision. Vasari recognized the revolutionary quality of Perugino's landscapes, and so too did the Victorian critic John Ruskin: 'he carried the glory of his luminous distance far beyond all his predecessors'.[26] But it is also the notional portability of Perugino's 'framed' self-portrait that underscores his ocular ubiquity. Rather than being fixed into the wall, the painting is merely hung, so it can be moved and set up in different environments – just like St Luke's miraculous icon of the Virgin.

Another key aspect of the artist's heroization in the years around 1500 is the appearance of self-portraits depicting the artist as a boy or young man. The myth of the male child prodigy, who either outstrips his teachers or else has no teachers apart from nature, would become an abiding theme of artistic biographies and autobiographies during the Renaissance, when the idealization of boys and boyhood became very fashionable.[27] As we have seen, Sir Agamanor, hero of Jean Froissart's fourteenth-century verse romance *Méliador*, was nine years old when he started to paint, and only three years later, at the ripe old age of twelve, surpassed his teachers who were professional painters (according to Cennini, the ideal apprentice spent thirteen years in his master's workshop, from the age of ten to twenty-three).

Stories told about Giotto hold out the possibility of dramatic social mobility for the talented. In Lorenzo Ghiberti's *Commentaries*, Giotto's childhood marks the dawn of painting:

The art of painting began to arise in Etruria in a village called Vespignano, near the city of Florence. There was born a boy of wonderful talent, who was drawing a sheep from life [when] the painter Cimabue, passing by on the road to Bologna, saw the lad seated on the ground, drawing on a slab of rock.

Cimabue is impressed, and 'perceiving his skill came from nature', visits Giotto's father and asks if he can take the talented child with him. The rest is history, as Giotto superseded his master and reinvented painting.[28] All the basics of the standard child prodigy myth are here, from the chance discovery of the child, to the innate talent and the ultimate superseding of the teacher.

Chance discoveries of youthful genius had been common mythological staples, as are stories of youthful precociousness (for example, Hercules strangling the snakes in his cradle). The Romans had believed there was sometimes a sacred aspect to the simplicity of childhood, and that the gestures and words of children could be coded prophecies.[29] Isidore of Seville, in his great compendium of etymologies (*c.* 615–30), believed that the Latin for 'boy', *puer*, derived from *purus*, meaning 'pure', and that *pueritia* (boyhood) lasted from the age of seven to fourteen.[30] Miraculous precociousness is almost compulsory in saints' lives, and would become ever more so in the life of Christ. St Luke, who specialized in Christ's childhood, has him, at the age of twelve:

> in the temple, sitting in the midst of the doctors [of divinity], both hearing
> them and asking them questions. And all that heard him were astonished
> at his understanding and answers. (2: 46–7)

In the fifteenth century, when there was an upsurge of interest in the education and wellbeing of boys, Christ's childhood was fleshed out even further, and his exploits became even more miraculous. In numerous artworks, the Virgin is shown either teaching her baby how to read, or else he is reading unaided. These ideas were not only applied to Christ and the saints. In 1459, the ten-year-old Lorenzo de' Medici was described as a 'manly little boy, a wise head on young shoulders' after his leading role in assuring the triumph of Cupid in a masque held in honour of the son of the Duke of Milan.[31] The addition of visual artists to the elite tribe of the precocious would attest to their improved status – or, at the very least, their increasing boastfulness.

Dürer's first three surviving self-portraits, dated 1484, 1491–2 and 1493, seek to establish his precocious power in different ways. They insist that for this youthful maker of images, work is not toil – punishment for original sin – or the slow accumulation of expertise. Precocious art is always, as it were, created out of thin air, with a quasi-divine effortlessness.[32]

Self-Portrait at the Age of Thirteen (1484) is a meticulous silverpoint study in which we see the fresh-faced boy half-length and side-on. His right arm is raised,

Albrecht Dürer, *Self-Portrait at the Age of Thirteen*, 1484,
silverpoint on paper

and he points horizontally out of the side of the picture at some 'off stage' entity
with the elegantly elongated forefinger of his right hand. As Dürer was born on 21
May 1471 – that is, nearly five months, or half way through the year – it would
be perfectly possible to call it *Self-Portrait at the Age of Twelve* (for some unknown
reason art historians have settled on thirteen). This title would make much more
sense of the picture's portentousness. 'Twelve' gives it a grandiose symbolic res-
onance – just as '1500 AD' does on the Munich self-portrait.

Dürer inscribed it at an unknown later date: 'This I drew myself from a
mirror in the year 1484, when I was still a child. Albrecht Dürer'. It is the first
document in what would become an ambitious project of self-commemora-
tion. In 1524, aged fifty-three, and only four years before his death, he wrote
a family history using notes and documents preserved by his father, and this
self-portrait must have been one of those lovingly preserved documents. The pose
is closely modelled on a self-portrait by the father, in which the goldsmith is

seen side-on proffering a statuette with his right hand, while the left hand is hidden from view. The self-portrait was surely a task set for the son by the proud father, and destined to take its place in the family archive. His talented son, still at this stage training to be a goldsmith, already depicts himself as an instructor rather than a fabricator.

The Dürer family project is remarkably similar to that of Ghiberti, who also trained as a goldsmith. Ghiberti's *Commentaries* featured autobiography, a history of art and theoretical treatises. Dürer the younger would also write treatises on proportion and perspective. Ghiberti emphasized the father-son relationship, placing his own self-portrait and a similar one of his son, whom he trained, next to each other on the Baptistery doors (see Chapter 3).

The fact that we know Dürer's birthday, and that he flaunts precise dates in his self-portraits, is of great importance. During the fifteenth century, merchants, especially in Nuremberg and Florence, increasingly wrote family histories, and were noting down birthdays, whereas in previous centuries only the date of death was accurately recorded – the Paduan humanist Albertino Mussato (1261–1321) is the first European since antiquity known to have celebrated his own birthday: in 1317 he wrote a poem 'Whether His Birthday Ought To Be Celebrated or Not'.[33] Alberti, in his book *On the Family*, recommended that every father note with care the exact day, month, year, hour and place of birth of each child.[34] This had a bureaucratic and legal purpose insofar as it made it easier to ascertain when children had come of age, and could therefore occupy public posts and pay taxes; but it also fostered a greater self-consciousness about an individual's personal history and development. Accurate astrological predictions could be made about the individual's present and future.

With the young Dürer's slightly wide-eyed, visionary stare, and his mysterious pointing gesture, he has something about him of the scryer's assistant, the *puer purus* who looks in the mirror with his clear eyes for revelations, and then points to the person he has seen within. However, the prime motivation of Dürer – and of his father – must have been to make the pose echo that of the twelve-year-old Christ debating with the doctors.[35] Even at the age of twelve the artist seems to measure himself against Christ – and does not find himself wanting.

A more militant ideal of boyhood flourished in Florence in the 1490s, and may have inspired two artists in their twenties, Michelangelo and Giorgione, to identify with the boy David in his battle with Goliath. A mobilization of boy vigilantes occurred in Florence in the late 1490s when the Dominican Prior of San Marco, Girolamo Savonarola, was the dominant figure in Florentine politics

and society. Religious companies for boys had been established in Florence at the beginning of the fifteenth century, reflecting a new interest in their education, but from around 1496 until his burning at the stake in 1498 Savonarola turned these groups into a unified moral police force. They were God's elect, guardian angels entrusted with upbraiding and reforming their weak and debauched 'fathers'. Their policing activities could and did turn violent. Michelangelo compared himself to David in a poetic couplet inscribed on a drawn study for marble and bronze statues of the biblical hero that he made in 1501–4. Just as David overcame insuperable odds to defeat Goliath with his sling, so would Michelangelo in making his statues with his bow (drill). The outstretched arm of David in the sketch is analogous to Michelangelo's own arm, as he draws and writes.

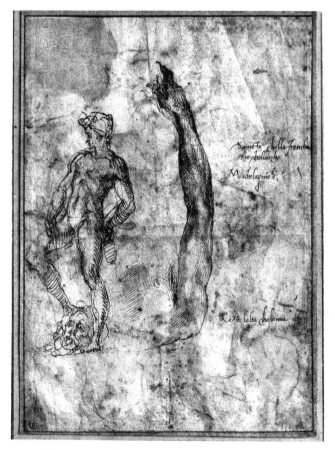

Michelangelo, *Study for a Bronze David*, c. 1501–4, pen and brown ink

A new phase in self-portraiture begins with *Self-Portrait as David with the Head of Goliath* (*c.* 1505–10) by the short-lived Venetian painter Giorgione da Castelfranco (1477/8–1510). Previous painters had almost exclusively produced religious works, with the most successful receiving large-scale public commissions for church or state. But Giorgione worked primarily for sophisticated private patrons, producing intimate cabinet pictures with secular subject matter that is deliberately esoteric. He made landscape, weather and lighting key protagonists of several pictures, using them to create the prevailing mood. His pictures seem expressly designed to provoke discussion and reverie.

His self-portrait survives as a cut down canvas that shows only the head and shoulders of David. The appearance of the original work is known from a later engraving (in reverse, without the chiaroscuro, and with a light background) by Wenzel Hollar that is inscribed: 'True portrait of Giorgione da Castelfranco made by himself and praised in Vasari's book'. Here, the courageous shepherd boy David appears to be wearing the armour he was given by Jonathan after defeating

Giorgione, *Self-Portrait as David*, *c.* 1505–10, oil on canvas

Goliath. He rests his left hand on the severed head of Goliath, which he has deposited on a parapet. His fingers grip Goliath's thick wavy hair.

Giorgione probably identified with David not only because of his precocious bravery, but also because he was a musician and a lover of women. At any rate, this is how Vasari describes the artist: '[He] took unceasing delight in the joys of love; and the sound of the lute gave him marvellous pleasure'.[36] David was famous for his musical talents – he played the harp (a viol is sometimes shown in sixteenth-century art) and was infamous for his adulterous affair with Bathsheba.

Giorgione's David turns his head sharply towards us. Some have seen this as a defiant gesture. Yet the mood is sultrily sensuous and melancholy, almost as if, at the moment of his first triumph, he were already conscious of the snares that lay in wait. The dark background of the portrait contributes to the brooding atmosphere. St Augustine saw David as marking the transition from adolescence to manhood of God's people,[37] but in Giorgione's painting, it is as though a boyish clarity of vision is becoming clouded by experience. David's face is sharply divided by the light that falls from his right, casting the left side into darkness, and his polished armour is divided into light and dark segments, a mirror of his mixed state. In Venice, it was fashionable for youths who were not soldiers to go around in armour. So now we have a wholly new type of hero – the soulful soldier, the giant killer who is also a reflective mirror-man.

The brilliant play of contrasts may have inspired a pictorial analogy made by Baldassare Castiglione in his great conduct book, *The Courtier* (1528), which was begun in around 1508. Just as a good painter juxtaposes light and dark, and puts contrasting colours and figures together, and by so doing makes each component stand out with greater intensity and beauty, so a courtier who is a brilliant fighter and soldier should be mild-mannered and unboastful. By this 'honest dissembling', his various virtues will appear all the greater.

Michelangelo and Giorgione's identification with the boy David suggests a new, more iconoclastic conception of art, where the young overthrow the old, and where genius is innate rather than learned. Nothing is known about Giorgione's conception of himself as an artist, but his self-portrait is first noted in a collection famous for its antiquities. It may be that the head of Goliath, displayed on a shelf-like ledge, is a surrogate antique fragment, and Giorgione is saying, 'I have slain and surpassed antiquity'. Michelangelo in his later years derided his teacher Ghirlandaio, claiming he taught him nothing, and he frequently used martial metaphors to describe the art-making process – guilt-free equivalents of Perugino's identification with an arrow.[38]

Yet a more reverential ideal of boyhood, in which a boy felt 'platonic' love for an older man, had also come to the fore in late fifteenth-century Florence. The most influential and elevated account came in the philosopher Marsilio Ficino's *Commentary on Plato's Symposium on Love* (1474), which had been written for Lorenzo de' Medici and was the first of many Renaissance treatises on love.[39] It was Ficino who coined the term 'platonic love'.[40] While the 'beloved youth' offered beauty, the man offered wisdom. The same sort of transaction could occur in art education, between pupil and master, and would be mutually inspiring. The famously beautiful Raphael made a self-portrait drawing and a painting as a 'beloved youth' with doe-like uplifted eyes, radically reducing his age in the process. But the most astonishing 'beloved youth' image is *Self-Portrait in a Convex Mirror* (*c.* 1524) by Parmigianino (1503–40). The twenty-one-year-old artist

Raphael, *Self-Portrait,* *c.* 1506, oil on poplar

Parmigianino, *Self-Portrait in a Convex Mirror*, c. 1524,
oil on panel

brought the painting with him to Rome in 1524 as a gift and calling card for the newly elected Medici pope, Clement VII, then forty-six. It is a middle-aged platonic lover's dream.

A tour de force of technical and conceptual ingenuity, it is the most famous of all Italian self-portraits, and was described in unusual detail by Vasari. The wooden support for the self-portrait is gently convex: 24.1 cm (nearly 9½ in.) wide, it is 1.8 cm (nearly three-quarters of an inch) deep at the centre. The room in which the artist sits has the voided austerity of a monk's cell. The optical distortion turns the single window on the left into a roof light, suggesting an attic designed for thoughts of higher things. But this artist is no monk. Rather he belongs to the physical and intellectual aristocracy, an ideal of the cultivated and elegantly dressed painter put forward by Leonardo and – in relation to courtiers – by Castiglione. He is a priceless work of art, with his flawlessly pale skin, flowing chestnut hair, chestnut eyes and cushion lips fractionally parted. His oval face is miraculously immune to optical distortion.

The work is usually dated to 1524, which would make the artist twenty-one. But in the self-portrait (as in two other self-portrait drawings of this period),[41] he has given himself the face of a child who has not begun to shave. As such, it may have been passed off as the self-portrait of a child prodigy painted many years before.[42] Raphael had died four years earlier in Rome – because of a fever

brought on by excessive love-making, according to Vasari – and Parmigianino's self-portrait proposes himself as a new 'platonic' Raphael.

The self-portrait's pièce de résistance is the depiction of the artist's massively magnified (left) hand. This lies on a parapet-style table in the foreground, languid and etiolated as a Venetian reclining nude. The fact that this is his left hand (Parmigianino was right-handed) is important because in the courtly love tradition the left hand is pre-eminent. Rings given by lovers were supposed to be placed on the little finger of the left hand because (for right-handers) the left hand is 'unused' and therefore unsullied. For the Pope's poetry-writing father Lorenzo de' Medici, the ultimate privilege was to be offered his lady's left hand, and he even urged everyone to strive to become left-handed.[43] In relation to a Medici pope, and to other prospective patrons, Parmigianino's proffered left hand is the pure 'platonic' hand of love and service.

Vasari's glowing description of this tour de force is longer than that of any other portrait – excepting the *Mona Lisa*. So too is his account of the portrait's owners. He had first seen the painting in his youth in Arezzo, when it was in the collection of the writer Pietro Aretino, a gift from the Pope. From Aretino it passed into the collection of the medallist Valerio Belli, then based in Vicenza. It was clearly a desirable commodity but (to the Pope and Aretino at any rate) perhaps also a novelty whose appeal, like the youthfulness it depicted, did not last.

During the 1550s, the production of child prodigy self-portraits would be turned into a cottage industry by Amilcare Anguissola, a nobleman from the small northern Italian city of Cremona, then under Spanish control. In 1566 Vasari paid him a visit. The celebrated artist and art historian was researching the second edition of the *Lives*, published two years later, and was there to see paintings by Amilcare's six daughters, who had been fast-tracked by their father into this overwhelmingly male profession, and were to varying degrees regarded as prodigies. They mythologized their family life by painting edifying portraits of each other.

The eldest sister, Sofonisba (*c.* 1532–1625), was already one of the most famous artists of her day. She had been invited in 1559 to the court of Philip II of Spain, to paint portraits and give art lessons to his fourteen-year-old bride.[44] Sofonisba's fame was cemented by her numerous self-portraits, which were sent by her father as calling cards to potential patrons, and painted on commission. In several, she looks even younger than Raphael and Parmigianino, and much more cultivated. She was the most prolific maker of self-portraits before Rembrandt: at least twelve survive; perhaps another seven are lost.[45] Most were made in Cremona during her teens and twenties. Vasari was impressed by one he

saw in the nearby city of Piacenza, in the house of the archdeacon, whose portrait she had painted. Vasari does not say if both of Sofonisba's paintings were displayed side by side, but if they were – as seems highly likely – it would be one of the first recorded instances of a self-portrait being displayed next to a portrait by the same artist.

The circumstances of the Anguissola sisters were unprecedented. Few women practised as painters and those that did were almost invariably the daughters of painters. But Amilcare encouraged all his daughters to paint, and Sofonisba and Lucia were apprenticed to local portrait painters. Because women were not allowed to study anatomy, perspective or do life drawing, they tended to specialize in minor genres such as portraiture. Castiglione had recommended drawing and painting as a suitable pastime to noble women. And there does then seem to have been an upsurge of women painters in the middle years of the century, just as there was with women poets. Vasari mentioned only one female artist in the first, 1550, edition of the *Lives* (the sculptress Properzia de' Rossi), but thirteen are mentioned in the expanded 1568 edition, with a specially warm mention for the Anguissola sisters. Increasing demand for portraits must also have improved the prospects for women painters. When the Milanese painter and art theorist Giovanni Paolo Lomazzo wrote the first extended discussions of portraiture in his *Trattato dell'arte della pittura* (1584), he complained that so many people now wanted to be immortalized that 'any crude dauber [could] set up as a portraitist'.[46]

Amilcare created such demand for Sofonisba's self-portraits that he effectively became the world's first dealer in self-portraits. The family was not well off, and he could scarcely have afforded dowries for six daughters, so the potential profits from painting must have been an incentive for him – and for any future husband. He was evidently a wheeler-dealer. On 23 December 1558 Annibale Caro, a distinguished poet and translator of Virgil's *Aeneid*, wrote to thank Amilcare for letting him visit the family home and experience the 'virtues' of his 'honoured' daughters, especially Sofonisba. He gladly accepts the offer of a self-portrait (a Christmas present?), an honour which even princes are unlikely to receive. He then states, for the first time in print, what has become a truism about self-portraiture:

> Nothing do I desire more than the effigy of Sofonisba herself, so that I can simultaneously show two marvels together, the work, and the artist.[47]

Unfortunately, Amilcare took it back after only seven months, probably because Caro had offered only honeyed words rather than hard cash.

Sofonisba's early self-portraits emphasize her status as a virginal yet bookish child. A painting of 1554 is probably the earliest signed and dated independent self-portrait in Italian art, and features the first book to be included in a self-portrait – a tribute to the high literacy levels of women, especially in the vernacular.[48] She gives herself the large cat-like eyes and oval face of a beautiful child. She looks even younger in an oval miniature from the same period, which rivals Parmigianino's in its intellectual ambition and wit – and its shape. It is usually entitled *Self-Portrait Holding a Medallion* (c. 1556), but the circular artefact is far too big to be a medallion, and it covers her entire torso 'like a large shield'.[49] It is inscribed in gold with large letters interlaced into a mysterious monogram, surrounded by bunches of grapes. The best explanation is that they make up the letters of her father's name, AMILCARE. Her own longer Latin inscription circumnavigates the border, but in smaller letters: 'Painted from a mirror with her own hand by the Cremonese virgin Sofonisba Anguissola'.[50]

The 'medallion' may be a large steel convex mirror, and what we see is its inscribed and decorated back. Putting her father's name to the mirror would imply that he is its rightful owner, controlling access to it, and that he is her rightful owner (which legally he was). What this simultaneously asserts is her childlike innocence and dependence, and her precociousness. Her father's ownership of the mirror, and her willingness to advertise his ownership, would prove she is no vain Venus (or Parmigianino), staring at her own mirror image all day. Perhaps her large output of self-portraits had brought criticism. Here the mirror conceals her body as much as it reveals it, by blocking our view of her torso.

Portrait miniatures were often exchanged by lovers and, protected by covers, they were worn next to the heart. In Shakespeare's *Merchant of Venice*, Bassanio finds a miniature of his beloved Portia, and is jealous of the painter's intimacy with the sitter:

Fair Portia's Countefeit. What demi-god
hath come so near creation? Here, in her hairs
The painter plays the spider, and hath woven
A golden mesh to entrap the hearts of men

Sofonisba has refused to 'play the spider' with her own hair, *à la* Dürer, for it is tied back leaving no stray or loose hairs. The only place where she has played the spider is with the letters of her father's name, which together create a golden tangled mesh that seems to entrap her own heart. This willing state of entrapment

Sofonisba Anguissola, *Self-Portrait Holding a Medallion*, c. 1556,
varnished watercolour on parchment

may be symbolized by the grapes, which suggest she is almost mystically intoxicated by her father.

She renounced the role of precocious daddy's girl in around 1559, shortly before leaving for Spain. In an ingenious double portrait she depicts her former teacher Bernardino Campi painting her portrait. She acknowledges his role in 'creating' her and in shaping her career, but the half-length portrait he is painting is much larger than life-size. She is on a much bigger scale than he, and her head is higher. She is also positioned in the centre of the composition, with Campi at the margins. She is a giantess among painters, an enthroned personification of painting.

We have traced the 'heroization' of the artist in self-portraiture from the 1490s; in the next chapter we see how this heroization licensed its polar opposite – the mock-heroic self-portrait – often made by the very same artists who had made heroic self-portraits.

5.

MOCK-HEROIC SELF-PORTRAITS

∿

THE SELF-PORTRAITS DISCUSSED so far tend to show the artists at their best, and even if the artists are prostrate (St Dunstan), overburdened (Rufillus and Kraft) or over-stimulated (Alberti), they are well turned out.

During the course of the sixteenth century, a sub-genre emerges in which self-abnegation and self-mockery reach unprecedented extremes. A de-idealization process takes place, for both comic and tragic effect. We can no longer be sure the artist will be saved from damnation – or just plain ridicule. By the artist's own account he may not be competent; he may be over the hill.

A major catalyst for this is the heroization of the artist that occurs in the years around 1500. The status and wealth of the very best artists – at least in Italy – did markedly improve, and Michelangelo, Raphael and Titian died bedecked with honours and extremely rich, on a par with the minor nobility. The visual arts were discussed in Castiglione's *The Courtier*, and the traditional claim that they were mechanical refuted; stories from Pliny about the prestige of the arts in antiquity are related, especially that of Apelles's intimate relationship with Alexander the Great, and Pliny's claim that in antiquity drawing was classified as a 'free art' which no slave could practise. Castiglione's ideal courtier has to learn how to draw, and to have a good understanding of the 'rare' art of painting, which can represent every aspect of nature. Castiglione was a close friend of Raphael, who twice painted his portrait.

Caravaggio, *Self-Portrait as Sick Bacchus*, 1594 (detail), see page 127

The mutual respect that might exist between painter and patron prompted an epistolary tour de force in 1543, when the poet Claudio Tolomei wrote to Sebastiano del Piombo (*c.* 1485–1547), who had succeeded Raphael as the leading portrait painter for Rome's elite:

> I don't know whether I've been prompted by ambition, vanity, or a mixture of both. You know how many times you yourself have said you wanted to paint my portrait. When, as I hope, this is accomplished, then I will seem to have gained a mirror, which I will always call a divine mirror, because in it I will see you and me together. You, because I will perceive in my image your singular ability and your marvellous skill; me, because I will see my image expressed vividly in your art, which will constantly stimulate me to purge my soul of its many defects…it will fire my soul with a fine desire for honour and glory.[1]

The portrait is, in effect, a double portrait – a mirror of the artist and a mirror of Tolomei.

Aggrandizement of the artist could license its polar opposite – debasement and a vision of the world turned upside down. Self-mockery and self-laceration is a perk afforded to the supremely confident. Only emperors, kings and nobles have fools, and the powerful prove their wisdom, urbanity and invulnerability by tolerating laughter. Castiglione's ideal courtier also needs to be witty, and he devotes a long section to jokes. Alberti's flying eyes are witty; and so too Mantegna's stony features woven into the grotesque plant decoration. Sebastiano del Piombo, in a characteristically droll letter to Michelangelo, suggests he recycles a depiction of Ganymede as St John of the Apocalypse. The ready wit of Renaissance artists distinguishes them from their classical forebears: there are few jokes in Pliny. The historian and great portrait collector Paolo Giovio (1483–1552) ranked artists with wits.[2]

The mock-heroic occurs with far more intensity and intimacy in self-portraiture than in portraiture. Sitters for portraits understandably enough wanted to look their best – *fare figura*. The impossibility of painting a non-idealized portrait is the subject of a 'portrait' by Michelangelo Cerquozzi (1602–60), famous for his pictures of battles and Roman street life. As we know from the inscription, the portrait shows a much-loved, Tolomei-style connoisseur ('*virtuoso amato*'). He is a dapper youth holding out a piece of paper with a flourish. Turn the picture round, and on the reverse Cerquozzi has painted the same scene from behind the

sitter, and now, looking out at us, we see a grotesque self-portrait of the craven money-grabbing painter grinning and wearing the crown of Midas.[3]

Michelangelo, who created both heroic and anti-heroic self-portraits, was, along with his many other accomplishments, a distinguished poet who alternated between an elevated Petrarchan style of love poetry, and a low buffooning burlesque. His first patron, Lorenzo de' Medici, had done the same in his own poetry. These styles are usually kept apart, rather than mixed in the same poem, although the vocabulary and sound effects of Michelangelo's 'high' style are harsher than those of his contemporaries, and make him the most congenial of Italian Renaissance poets to modern tastes. Michelangelo's most famous burlesque poem was written while he was painting the second half of the Sistine ceiling (1508–12). It was addressed to an unknown 'Giovanni', and is accompanied by a caricatural self-portrait.

In the sonnet, Michelangelo complains of the physical contortions he has to make while standing on the scaffolding. He's grown a goitre, his chin 'points to heaven', and 'I feel the nape of my neck on my hump'. The paint drips onto his face making it 'a richly decorated floor...I cannot see where to put my feet'. His skin is stretched and wrinkled, and he is no longer master of a bow, but the slave: 'I bend myself like a [semi-circular] Syrian bow'. Inevitably, he paints badly:

> the thoughts that arise in my mind are false and strange, for one shoots badly through a crooked barrel. Defend my dead painting, from now on, Giovanni, and my honour, for I am not well placed, nor indeed a painter.[4]

We are a long way from Leonardo's idealized image of the painter, sitting before the easel in his finest clothes, listening to music. This is more like Leonardo's caricature of the sculptor, his face 'plastered and powdered all over with marble dust which makes him look like a baker'.[5] According to his biographer Ascanio Condivi, Michelangelo's eyesight was temporarily damaged by the four-year ordeal, and for a while he had to hold letters above his head in order to read them. Even in the summer of 1509 he had complained to his father of unhappiness and illness because of overwork. His father informed him that a rumour had spread in Florence that he was dead. In the poem, his painting is 'dead', too.

This is quite a contrast to the confidence of the poetic couplet written next to a sketch for his statues of David (see Chapter 4). He does seem to have reveled in choreographing these melodramatic mood-changes, passing from militant certainty to savage self-pity.

Michelangelo, *Sonnet with Self-Portrait Caricature*, 1508–12,
pen and brown ink

In the full-length self-portrait sketch accompanying his poetic lament on painting the ceiling he shows himself in disfigured action. His bottom, stomach and neck are distended, his facial features summarily indicated. He is elongated, and looks as though he has been suspended from the ceiling by his painting hand.[6] Having said that, Michelangelo does not mention or depict his famously squashed nose, broken in a fight with a fellow artist. Indeed, he doesn't look quite as bad as we imagined he would from the poem.

What Michelangelo is painting overhead is even more caricatural – a naked crouching figure with four strands of electroshock sticky-up hair, and a goofy round-eyed, open-mouthed face. Michelangelo surely intends this diabolical gargoyle to be his alter ego, and he was certainly interested in the idea that 'every painter paints himself'. He uses the trope in two poems, threatening to make an ugly portrait of a cruel mistress if she continues to make him ugly through grief.[7] Vasari quotes him as saying that Gentile da Fabriano's paintings lived up to his name (i.e. '*gentile*' – refined); and, on being asked why a certain painter 'had made

the ox more lifelike than the rest', Michelangelo quipped: 'Any painter can make a good portrait of himself'.

A wonderfully perceptive illustration of Michelangelo's anecdote was later made by the Florence-based English caricaturist and landscape painter Thomas Patch (1725–82). Patch gave his own face to the body of an ox lying down in a field with a bell around its neck and with a view of Florence in the background. A biblical inscription – 'he that humbleth himself shall be exalted' (Luke 14: 11) – is a riposte to those who deride practitioners of 'low' genres. But it can stand as a motto for all those who allow themselves to be laughed at. Indeed, Christ himself was the supreme 'Holy Fool', the God who became man in order to endure mockery and suffering.

By being sardonically self-deprecating, and by presenting himself as filthy and deformed, Michelangelo makes himself the inheritor of Giotto's mantle. Giotto was the archetype of the witty yet modest artist, never at a loss for the *mot juste* and the clever put down.[8] In Boccaccio's story collection the *Decameron* (*c.* 1350), which featured recognizable contemporaries, he is physically ugly, and mud-spattered after being caught in a torrential downpour but still firing off quips.[9] The ostensible purpose is to show that nature 'has frequently planted astonishing genius in men of monstrously ugly appearance'. We are meant to respond in similar fashion to Michelangelo's verbal and visual self-portrait. It panders to the Renaissance taste for paradox and polarities.

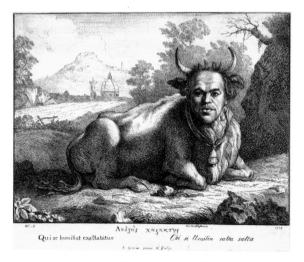

Thomas Patch, *Self-Portrait as an Ox*, 1768–9, etching

Vasari tells a marvellous anecdote about the cultivation of stylistic ineptness by the young Michelangelo and his Florentine contemporaries:

> In his youth, being once with his painter friends, they played for a supper for him who should make a figure most completely wanting in design and clumsy, after the likeness of the puppet figures which those make who know nothing, scrawling upon walls; and in this he availed himself of his memory, for he remembered having seen one of those absurdities on a wall, and drew it exactly as if he had had it before him, and thus surpassed all those painters – a thing difficult for a man so steeped in design.[10]

Even this stylistic slumming brings credit.

A similar sensibility informs a badly drawn figure by Giovanni Francesco Caroto (*c.* 1480–1555), who spent most of his life in Verona, with an extended stay in Milan from around 1510–15. In around 1515, Caroto painted a small half-length portrait of a young boy with shoulder-length red hair who turns towards us grinning. He holds up a piece of paper with a drawing of a full-length figure, in expectation of our approbation. The joke is that he is no child prodigy in the Dürer or Raphael mould, for this is no more than a stiff stick figure. A slightly more sophisticated profile image of an eye has been drawn at the side, as if an adult has been trying to help him.

The drawing must be the child's first self-portrait. Caroto is very similar to the Italian for carrot (*carota*), so it may be that the family name derived from their orange hair (as with Rufillus), or that Caroto is using orange hair as a comic trademark.[11] Vasari says that Caroto had a son, but a mocking portrait of his young son would hardly be witty. It is more likely to be an imaginary or fake self-portrait of himself as a would-be child prodigy: 'This is me as an eight-year-old – and already a genius!'

Caricature seems to have been invented by Leonardo while working in Milan at the ducal court. It was a courtly entertainment which demonstrated the artist's refined awareness of cultural, social and stylistic difference. And, of course, his powers of observation and mastery of nature. It is not known whether any of his grotesque heads represented particular people or were just physiognomic types.

Giovanni Caroto, *Portrait of a Red-Headed Youth Holding a Drawing, c.* 1515,
oil on panel

However, Leonardo's critical account of the motto 'every painter paints himself'
– a lazy painter will paint lazy figures; a devout painter figures with bowed
heads – suggests he believed artists made 'true' self-portrait caricatures every time
they painted, and that these were instantly recognizable. The germ of the idea
for caricature must have come from this motto, and this must be why the first
caricatures of known contemporaries are self-portraits.

Leonardo famously juxtaposed profile drawings of idealized youths and grot-
esque old men. The contrast encapsulated his society's suspicion and fear of the
old, and of old age – even if dying young was much more likely than living to
a ripe old age. Until the second half of the sixteenth century, artists preferred to
portray themselves in vigorous youth and maturity. When Dürer at forty-two
draws himself ailing in *The Sick Dürer* (1513), pointing helpfully to the spot
where it hurts, he remains a fine athletic figure of a man. Lorenzo Ghiberti is
perhaps the only fifteenth-century artist to have depicted himself after the age
of fifty, yet the seventy-year-old's skin is unlined and he looks far younger. This
youth cult corresponds to the pattern for male portraiture, where many were
commissioned when the sitter was around thirty-three, the 'ideal' age.

This pattern changes with Michelangelo, and especially with Titian, who
depict themselves as old, ugly, and no longer in total control. Age and ageing are

among their favourite topics of discussion, with their decrepitude being bran-
dished and perversely relished at strategic moments. Even at fifty, at the height
of his powers in the mid-1520s, Michelangelo writes in an exaggerated fashion to
an impatient patron: 'I have many obligations, and I am old and ill disposed, so
if I work one day, I need to rest for four'.[12] Titian regularly mentions his age to
patrons, and the imminence of death.

The Italian Counter-Reformation must have something to do with the
appearance of 'extreme old age' self-portraits, for one of its heroes was Nicodemus,
the Pharisee who came secretly by night to receive teaching from Christ, and
who assisted at his burial (John 3). On being told that a man could only see the
Kingdom of God if he is born again spiritually, Nicodemus asked how a man
can be born again when he is already old. Christ replied he must be born again
through baptism, implying that it is never too late to be reborn. Nicodemus's
interchange with Christ was cited in a decree on Original Sin, promulgated by
the Pope in June 1546.[13] Crucially, Nicodemus was believed to be a sculptor who
carved a portrait of Christ (the *Volto Santo* in Lucca), so he was an appropriate role
model for the penitent artist.

Michelangelo seems to have felt an acute need for visual self-mockery when
working heroically high up in the Sistine Chapel, for in his mid-sixties he gave
his own unrefined facial features to the crumpled flayed skin held up by St
Bartholomew in the *Last Judgment* (1536–41). He is understandably even more
stretched out than in his self-portrait caricature sketch. Bartholomew was mar-
tyred by being flayed alive, so the skin should logically be his own, yet there
is a striking mismatch between Bartholomew's own features and those on the
flayed skin. It was only claimed as a self-portrait in 1925, but it has been widely
accepted, and the 'flayed' head is a close match with a contemporary craggy por-
trait of Michelangelo.[14]

This 'flayed' self-portrait is the grisly apogee of the penitential self-portrait. St
Bartholomew, holding up the butcher's knife which was his traditional attribute,
turns to Christ as if to appeal on Michelangelo's behalf for pity and for admit-
tance to the realm of the blessed (the flayed skin hangs perilously over the zone
of the damned, and the face 'looks' down). Bartholomew was known in his own
right as someone who weeds out 'harmful thorns' and 'cuts down the forests of
impiety',[15] and the implication here is that it is he who did the purgative cutting
– at Michelangelo's request.

At just this time, Michelangelo's poetry is full of metaphors relating to the
shedding of skin. In a sonnet probably written for his beloved boy Tommaso da'

Cavalieri, he praises the selflessness of the silkworm that 'with pain and suffering' sheds its own covering, and 'clothes another's hand.' He wishes with morbid wit that his own dead skin could clothe Tommaso's living skin by being made into a gown and slippers.[16] Later, the sculptural process itself becomes a form of flaying: just as the sculptor removes the rough outer 'skin' of the marble block to reveal the figure within, 'so the excess that is one's own flesh, with its coarse, rough, hard bark, hides some good works in the soul which trembles under this burden'.[17] Ultimately, this self-cleansing is an 'imitation' of Christ's Passion, for it was believed that the scourging caused his own skin to come away.[18]

Vasari claimed, in a letter of 1565, that the figure of Nicodemus in Michelangelo's *Pietà* of *c.* 1547–55 is a self-portrait. This colossal sculptural group was designed to be placed over an altar in Michelangelo's funerary chapel. Christ's crumpled body is barely supported by the Virgin Mary and Mary Magdalene,

Michelangelo, *Last Judgment* (detail), 1536–41,
fresco, Sistine Chapel

who are being helped out by the giant, hooded figure of Nicodemus. He looms large over Christ and the two Marys, his craggy bearded face poking out from the pointed vulva-shaped opening in the hood, 'reborn' at the pinnacle of a pyramidal composition. But Michelangelo had problems with the carving, and in frustration and anger set about it with a hammer. His assistant partially restored it, but Michelangelo-Nicodemus still has to stand among the self-inflicted ruins. The artist-as-hero has become the sculptor-as-failure.[19]

When the great Venetian painter Titian (*c.* 1490–1576) paints himself in old age his decrepitude is there for all to see.[20] Titian's first self-portraits were made strikingly late; three made for important patrons no longer survive (an inaccessible 'copy' in a private collection may be the original), but the appearance of two is known, and Titian, while clearly elderly, appears dignified and senatorial. Two self-portraits that do survive, both probably kept in Titian's home or studio, but publicized through copies, are very different. They could be called 'extreme old age' self-portraits. These, and several self-portraits inserted into other late pictures, demonstrate an acute interest in the ageing process.[21] The results are not altogether flattering, and commentators have detected an element of caricature. Titian no longer has strong and steady painter's hands, and looks both unable and unwilling to work. These self-portraits in turn became the basis for caricatures of the artist produced after his death, making him probably the first artist to be caricatured.

Titian's contemporaries assumed he was much older than we do now, and it must have been the artist who misinformed them. His death certificate said he was 103, which would give a date of birth of 1473. The current consensus is that he was born around 1490. His desire to be older may have been influenced by Venice being a gerontocracy, with an elderly ruling class and the average age of the doges being around seventy (like popes). It also marked him out as Venetian, for Venice was famed for its large number of healthy old people; in Venice old age legally started between fifty and sixty.[22] Titian exaggerated his age more by design than by accident. He may initially have liked the idea of being, as it were, a 'second-childhood prodigy'. Already in 1542 his writer friend Pietro Aretino, in relation to a gorgeous child portrait of Clarissa Strozzi, praises the artistic miracles kept for the 'ripeness of your old age'.[23] Aretino marvels that Titian can still produce beautiful children in his old age – something that would become the subject of the most famous posthumous caricature of the artist, the now lost *Titian and His Mistress,* a faked-up pastiche possibly by Jacopo Bassano in which the doddering artist touches the pregnant belly of his young mistress, and which for two centuries was believed to be an authentic self-portrait. There were commercial reasons,

too, for exaggerating his age. Most of Titian's letters after 1559 mention his age, often when appealing for money from patrons (a habit that gave him a reputation for greed). By hinting he was in his 'ultimate old age', he encouraged patrons to act promptly if they wanted any more pictures.

But Titian's two late self-portraits – despite the artist wearing fine clothes and the gold chain given to him by his principal patron the Habsburg Emperor Charles V of Spain, who ruled over much of Europe – tell a more compelling story. The self-portrait that has been variously dated from the mid-1540s to the early 1550s shows him seated in an empty room behind a small table covered with a white cloth. His impossibly broad torso faces us, but he averts his gaze by turning his head to his left, from where the light comes, as if he has seen or heard something. His right hand rests on the table top, and his left hand is lower down, presumably on his left thigh. The basic twisting pose, and the scale of the torso, recalls Michelangelo's heroic seated statues of Giuliano de' Medici and Moses.

But there is a sluggishness and absent-mindedness about Titian. The eyes look a little watery, the mouth a bit slack, the hands weak. Some of the brushwork is

Titian, *Self-Portrait*, *c.* 1546–7, oil on canvas

correspondingly summary. Whereas Michelangelo's giants look as if they might rise at any moment, Titian seems immobilized by his large torso, and is hemmed in by the table, beneath which his right leg must be placed. The pose has been called 'awkward, under-occupied'.[24] It would be all too easy to turn this into a genre scene in a tavern, in which an absent-minded gourmand impatiently awaits his dinner. Here Titian made himself look older and frailer than in the other self-portraits from this period, and perhaps older than he really was – closer to the age he claimed to be. A very similar figure, seated at a table, appears in Jacopo Bassano's *Purification of the Temple* (*c.* 1580). He is a moneychanger, and has been interpreted as a satire on Titian's greed.[25] Titian may have been uneasy about his wealth, for in his great *Flaying of Marsyas* (1570–6), the watching elderly figure of Midas looks like a caricatural self-portrait.

The second self-portrait, painted in the 1560s when Titian was probably in his seventies (nineties to his contemporaries), is a visual last rites, and was not sold during the artist's lifetime. It is painted in profile – an archaic format scarcely seen in painting since the fifteenth century – and it has been said that this 'accentuates the sitter's gaunt and hawkish features to an extent almost verging on caricature'.[26] He resembles one of Leonardo's ugly old men in profile. His right hand is tucked down at the bottom of the picture, holding a brush. The hand, barely brushed in, seems inactive and withdrawn, as if he has just renounced his calling. He still wears his gold chain, but it has shrunk radically in length and thickness: worldly success now hangs by a thin gold thread. The face and beard are thinly painted, and the weave of the canvas shows through, giving the face a crumbly texture. At just this time, Titian's contemporaries doubted his desire as well as his capacity to paint.

Titian was evidently satisfied with the picture, and recycled it in several other works. It became his 'official' image. By turning/looking to his right, he faces the side traditionally associated with all things spiritual. By contrast, in the earlier self-portrait, with its more worldly genre-scene feel, he turns sharply to his left. Titian's 'extreme old age' self-portraits certainly helped increase his fame. But their novelty – their frankness to the point of grotesqueness – suggests punitive piety played an important part. The ability to caricature one's appearance, or to refrain from idealization, establishes a critical distance between body and soul. Titian's gaunt, bony features belong to a man who is shedding his flesh.

Titian, *Self-Portrait*, 1560s, oil on canvas

In 1576 the Milanese physician Girolamo Cardano wrote the first warts-and-all autobiography, describing virtues and vices, successes and failures, and even his physical appearance, wallowing in his deformities, infirmities and impotence. The Bolognese painter Annibale Carracci (1560–1609) painted two great mock-heroic self-portraits that are comparably confessional.[27] They are lugubrious, but there is no hint of a spiritual pay-off for the artist: Annibale imagines painting and painters as dead or dying things, actors in a black comedy. The second one is of particular interest because a preparatory drawing survives, and this is for a *heroic* self-portrait.

Annibale started out sharing a studio with his elder brother Agostino and cousin Ludovico. Annibale and his brother pioneered a return to life drawing

after the 'mannered' excesses of much late sixteenth-century art characterized by convoluted (Michelangelesque) body language and lurid colours. The brothers depicted street life and made caricatures,[28] as well as being leading religious and mythological painters. After moving to Rome in 1596 to decorate Palazzo Farnese with mythological scenes, Annibale became the most sought after artist of his age. But in 1605, on completion of the work at Palazzo Farnese, he was paid what he considered to be a derisory amount by Cardinal Odoardo Farnese. This slight, together with exhaustion from overwork and depression at having to play the part of a courtier, seems to have caused a breakdown from which he never fully recovered before his death in 1609. His Bolognese biographer, Carlo Cesare Malvasia, described him as follows: 'Neither clean nor well-dressed, with his collar askew, his hat jammed on any old way and his unkempt beard, Annibale Carracci seemed to be like an ancient philosopher, absent-minded and alone'.[29] This is pretty much what we see in a self-portrait drawing from the early 1580s, where a sallow, dishevelled figure leans forward through an oval window embrasure decorated with skeletal sea-monsters and dolphins – perhaps this is the loneliness of a sea-sick Narcissus.

Self-Portrait with Other Male Figures (*c.* 1585) is ostensibly a kinship self-portrait located in a bare studio. It shows Annibale standing before his easel,

Annibale Carracci, *Self-Portrait*, early 1580s, pen and brown ink

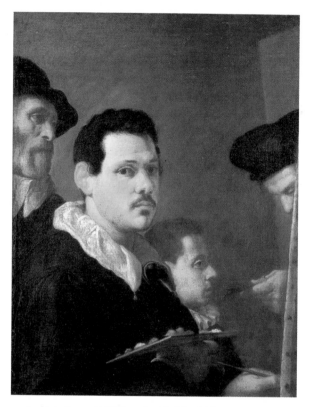

Annibale Carracci, *Self-Portrait with Other Male Figures,* c. 1585,
oil on canvas

brush and loaded palette in hand, with only the nailed edge of his canvas visible. A frieze-like group of three standing male figures is arrayed behind him. We know it is a self-portrait because the painter looks out towards us, rather than to his companions, and he shows himself painting with his left hand (he was right-handed). Thus the painting is what Annibale sees when he looks in a mirror placed at right angles to his canvas.

The men are probably family members, from different generations, representing the three ages of man. A boy in the centre is being offered a spatula loaded with black paint by the stooping man in his thirties on the right. The man's body is cut off by the edge of Annibale's canvas, and his hand and head almost appear to be emerging out of it. He is probably Annibale's painter brother Agostino, and the boy a symbol of future generations of Carracci artists. This private ceremony

wittily parodies the offering of a communion wafer – the spatula hovers before the boy's mouth and nose. Agostino is, as it were, a High Priest of Art transmitting the painting potion. The caviar-like black paint evokes black bile, one of the four ancient humours, the Greek word for which is melancholia. Black is indeed the dominant colour in the picture, used for doublets, hats, Annibale's hair and eyes – its blackness all the deeper for being contrasted with white neck ruffs. It was Aristotle who first claimed a connection between the melancholic humour and exceptional talent in the arts and sciences, and this idea was revived in the Renaissance by Florentine philosopher Marsilio Ficino who said that melancholy, the brooding temperament of those born under the planet Saturn, was a divine gift comparable to Plato's poetic frenzy.[30] Yet this dynastic scene is lugubrious rather than triumphant. Faces are joyless, impassive, mask-like. Despite his proximity, Annibale seems blankly disengaged, alone in the crowd.

Self-Portrait on an Easel in the Studio (*c*. 1604) is one of the most celebrated and mysterious of Italian self-portraits. Two versions exist, in St Petersburg and Florence, both likely to be autograph. A bust-length self-portrait has been left on an easel in a dark studio that is undecorated and unfurnished. The man who stares impassively out of his picture, lit from his left by a cold lunar light, is the Annibale of the description – neither clean nor well-dressed. The legs of the easel frame the image like the foreshortened outline of a coffin. A small dog and a cat guard the base of each leg. Relieving the gloom is a squarish, shimmering patch of off-white paint, made by a coarse brush dragged horizontally. This is set in the background near the top left corner. It could be a roughly primed canvas, but is more likely to be a window for a figure stands before it. In the St Petersburg version, one arm seems to hang by the figure's side with the other resting on the window sill. In the Florentine version, the figure's arms seem to be truncated, and it leans slightly forward out of the window. This is no ordinary figure. It is tall, attenuated, spectral.

Because the figure's bottom half seems to taper in, it has been said that this is a herm, an armless male bust attached to a tall pedestal; the most famous herm was Terminus, the Roman god of boundaries, and here it would represent the boundary between life and death, flesh and spirit.[31] This interpretation seems broadly correct. The elevated zone of light, with its hazy glow, must represent a trembling spirit world of some kind, in contrast with the lower, hard-edged 'bestial' zone inhabited by the painter, his pooch and pussy. Yet the figure is too asymmetrical, slight and feminine to be a herm. It is more likely to have been inspired by the story of Echo. When Narcissus spurned her, Echo withered away until nothing was left but her voice. During the sixteenth century, she was given a prominent

role in interpretations of the Narcissus myth, and for Neoplatonists she became a spiritual, feminine foil to Narcissus's brute materialism. In Alessandro Farra's treatise *Settenario* (The Seven Days; 1571), Echo signifies the divine spirit that descends to enlighten our souls; it blows hither and thither like the wind and emits a luminous splendour. By contrast, Narcissus, 'sunk in the senses', is 'entirely earthly, weak and sickly'.[32]

The self-portrait, with its back turned to the dissolving 'woman in the window', depicts an 'earthly, weak and sickly' man, 'sunk in the senses'. The canvas also happens to be placed very low down on the easel. The divine wind may be evoked by the shimmering brushstrokes used for the white 'view' through the window. Annibale was in his forties when he painted this picture, but he makes himself

Annibale Carracci, *Self-Portrait on an Easel in the Studio*, c. 1604, oil on panel

look younger here, of an age more befitting Narcissus. Both he and his pets are a mordant memorial to his younger sensuous self, the pioneering genre painter who made vibrant, earthy images of labourers gulping down bean soup, drinking boys and butchers.

The image is a kind of recantation, for the 'preparatory' drawing is an unqualified celebration of worldly success. Here the easel is set up in a well-lit studio with a beamed roof. The sitter for the portrait is in a more dignified Roman pose, perhaps wrapped in a toga and evoking a famous print portrait of Raphael in which he is wrapped in a cloak. A group of greyhounds looks up at it as in the ancient anecdote about dogs mistaking a portrait for their master – in this case a wealthy one who goes hunting. In the background we seem to see a painting or bust with a similar pose, but in reverse. This reduplication, perhaps in a more costly medium, emphasizes that there is a demand for such images, and that the sitter must be rich and famous. In Annibale's painted self-portrait, the lap dog may not even recognize his master.

Three Milanese artists made a significant contribution to the mock-heroic self-portrait in the second half of the sixteenth century. By then, Leonardo had become a legendary figure, and his physiognomic and anatomical drawings were well known in the city. The mordant verbal and visual wit involved in emblems, which Leonardo had also devised and which were popularized by the Milanese jurist Andrea Alciato (1492–1550), also played a part. Alciato's *Emblemata* (1531) was eventually published in nearly two hundred editions.

The Milanese master of emblematic visual assemblages Giuseppe Arcimboldo (1527–93) perfected the self-portrait made for tragi-comic effect.[33] He is best known for works like his jolly portrait of Emperor Rudolf II as Vertumnus (1591), Roman protector of gardens and orchards, fabricating him from fruit and vegetables. (Rudolf not only invites us to laugh at him, but also to eat him.) Arcimboldo also made a portrait of a bespectacled librarian precariously constructed from books; and of a notorious syphilitic jurist fashioned from fish. For his own bust-length self-portrait, a drawing on paper, *Self-Portrait as a Man of Papers* (1581), Arcimboldo fashioned himself from curling pieces of paper, like a human house of cards. He thereby insisted that great art is rooted in drawing, or *disegno*, while at the same time demonstrating its fragility: a gust of wind will scatter him; a shower of rain, pulp him; a spark, incinerate him.

Giuseppe Arcimboldo, *Self-Portrait as a Man of Papers*, 1581,
pen and ink, wash and coloured ink on paper

The assemblages all seem to have been painted after his summons in 1562 to Vienna and Prague to work for the Habsburgs as a portrait painter. The few that have been identified are routine affairs. The Habsburgs were sometimes portrayed in 'straight' portraits with their dwarves, and were great collectors of natural and man-made marvels that were displayed in cabinets of curiosities. Arcimboldo's assemblages were marvels of just this kind. They are in the burlesque mode exemplified by a Michelangelo poem where he compares his beloved's beautiful teeth to parsnips, her breasts to watermelons, her mouth to a bag full of beans.

Yet the composite appearance of Arcimboldo's fantastic heads is something very new. It must have owed a great deal to Leonardo and his contemporaries' interest in anatomical dissection.[34] By the mid-sixteenth century, this had brought about a revolution in the visualization of the human body thanks to publication of highly illustrated anatomical treatises. For the first time, large numbers of Europeans could become familiar with the 'marvels' of the inside of the human body.

Arcimboldo's *Self-Portrait as a Man of Papers* has an elegantly 'flayed' appearance, or at least the feeling that the skin, hair and clothes could be peeled and torn away. It invokes 'flap' anatomies, where a paper flap could be lifted up to reveal the organs and skeleton below. No wonder the expression of this man in his mid-fifties is so solemn. He is turned to his right, and before long could look even the worse for wear than Michelangelo or Titian. This papery self-portrait was surely also inspired by the fragile legacy of Leonardo, which largely consisted of works on paper: the inheritor of Leonardo's drawings and notebooks, the Milanese nobleman Francesco Melzi (1491/3–*c.* 1570), had chosen the young Arcimboldo to make organ shutters for Milan's cathedral. Here Arcimboldo is comically offering his body up as an object of anatomical study. As such, his self-portrait pokes fun at the academic pretensions of artists in the mould of Alberti, Leonardo, Dürer – and especially Vasari.

In 1563 the first modern art academy with a set of regulations and extensive curriculum, as well as a 'royal' patron, had opened in Florence, with Vasari one of the main movers. The Accademia del Disegno followed in the footsteps of literary academies, and was dedicated to raising the status and ambitions of art. Vasari intended the Accademia to form a collection of artists' portraits and self-portraits, and although this never happened, the second expanded edition of his *Lives of the*

Giorgio Vasari, *Self-Portrait, c.* 1561–9, fresco above the mantelpiece, with Gyges on the left, northwest wall of the Sala Grande, Casa Vasari, Florence

Artists (1568) credited artists with far more self-portraits than in the first edition (Giotto went from none to three),[35] and was illustrated with 144 woodcut portraits of the artists, based on drawings that Vasari and his pupils made of supposed portraits and especially self-portraits. These were placed at the beginning of each life, a magisterial frontispiece.[36] Most were based on bystander portraits, taken from altarpieces and frescoes, deemed 'self-portraits' simply because the figure looks out towards the viewer, or seems more individualized. Vasari had a keen interest in self-portraiture, and in the preface to the *Lives* he claimed that according to Pliny, the inventor of art was 'Gyges the Lydian, who, being by the fire and gazing at his own shadow, suddenly, with some charcoal in his hand, drew his own outline on the wall'.[37] This is a double mistake on Vasari's part, for Pliny actually credits Gyges, a king of Lydia, with the invention of ball games; and while Pliny does say that art began with the drawing of a man's shadow, he says nothing about it being a self-portrait.[38] Gyges's importance to Vasari is twofold. He corroborates Vasari's belief that *disegno* – drawing and design – was the foundation stone of all the arts; and he puts self-portraiture at the heart of artistic endeavour. Vasari pushes Alberti's Narcissus aside and crowns someone more respectable – and considerably more athletic. He painted a dignified elderly Gyges tracing his shadow alongside other famous scenes from Pliny as part of the decoration of his house in Arezzo (1540s); and he did the same again, but giving Gyges a youthful muscular body, in his Florentine residence in the 1560s, adding his own self-portrait bust above the mantlepiece.[39]

A self-portrait painted *c.* 1568 by the Milanese painter and art theorist Giovanni Paolo Lomazzo challenges the Vasarian ideal of the artist. Lomazzo belonged to the Accademia della Val di Blenio, founded in Milan in 1560. This was a literary and artistic society dedicated to promoting a fabricated dialect that was claimed to be the ancient language of Swiss wine porters working in Lombardy. (Porters were a stock figure of fun, as in Shakespeare's *Macbeth*.) The 160 members wrote burlesque literature in the dialect, and wined and dined each other. Artists belonged to it too, and many made caricatures and 'child art', in the spirit of the youthful Michelangelo. In 1568 Lomazzo was appointed 'Abbot' – or 'Nabad' – of the Accademia, and in the following year published some of his own dialect writings. Lomazzo celebrated his appointment by painting *Self-Portrait as the Abbot of the Accademia della Val di Blenio*. It is one of the slyest and sleaziest self-portraits.

The thirty-year-old Lomazzo depicts himself as a dissolute shepherd-cum-devotee of the wine-god Bacchus. His pose is closely based on the louche *Shepherd with a Flute*, from Giorgione's circle. An earlier profile self-portrait, with a white

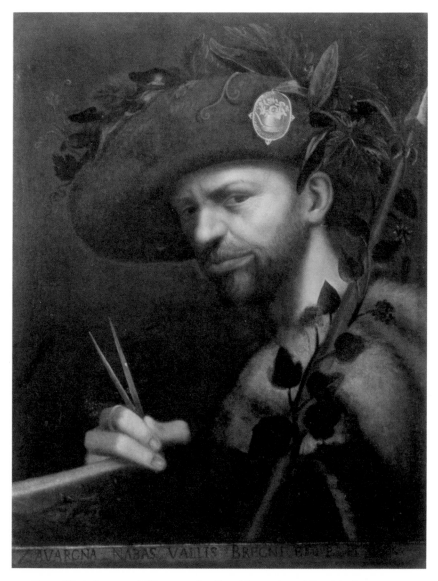

Giovanni Paolo Lomazzo, *Self-Portrait as the Abbot of the Accademia della Val di Blenio, c.* 1568,
oil on canvas

tunic slipping off Lomazzo's left shoulder (a traditional attribute of Cynic philo-sophers), suggests a long-standing love of subversion. It was probably painted in his late teens, but he makes himself look sultrily prepubertal – a knowing child prodigy. In the bust-length self-portrait, largely a symphony of devilish blacks and greys, he leers at us over his left shoulder. Like a one-man band, he is absurdly overloaded with literary, artistic and sybaritic symbols. He could be a frontispiece for a pirate edition of Alciato's emblems.

Lomazzo's hat is covered in laurel and vine leaves. A gold seal is pinned to it, adorned with a vine-covered ship. An ivy-clad thyrsus – the spear of Bacchus – rests on his left shoulder. Anyone pricked by its point goes mad. He holds a pair of steel compasses, symbol of God as Creator and of the geometry-obsessed Renaissance artist. Here, however, he holds them up menacingly, more weapon than tool. You would not want to argue. He seems to parody the compass-wielding allegory of Architecture on the reverse of the pompous *all'antica* portrait medal of Bramante (*c.* 1505), *the* great Milanese architect.[40] In his later theoretical treatises, written after he had gone blind in the 1570s, Lomazzo repudiated the scientific and empirical emphases of early Renaissance art.

Lomazzo's Bacchus could almost have stepped out of the pages of *In Praise of Folly* (1511) by Erasmus, the great Dutch scholar and satirist who also produced some pioneering self-portrait caricatures, profile images with a giant nose, that are found in a manuscript of around 1515 concerning the letters of St Jerome. The noses function as reference marks 'pointing' to the text. Erasmus wrote in praise of noses, and the various uses to which they can be put.[41]

'Folly', in Erasmus's book, gives a first-person account of his own life and opin-ions, and Bacchus looms very large. Folly was nourished at the breast of Bacchus's offspring drunkenness, which washes away the cares of the soul. Drunkenness also induces a kind of pleasant madness, and is responsible for what Plato called the 'frenzy of poets and seers'.[42] The members of the Accademia della Val di Blenio may have appreciated the association between drunkenness, folly and genius. Aurelio Luini, a co-founder of the Accademia, owned a sketchbook containing around fifty caricatures of old men and women by Leonardo, which inspired the caricatures made by the society's members.[43] Could it be that they drew caricatures while drunk?

In 1573, the Venetian painter Paolo Veronese was asked by the Inquisition, an institution created by the Catholic church to supress heresy, to explain the presence of German soldiers, a buffoon with a parrot and a servant with a bleed-ing nose in a painting that might have been a *Last Supper* or a *Feast at the House*

of Simon (no one seemed to know). He gave a reply that might also serve as the credo of Lomazzo's self-portrait: 'We painters take the same license as the poets and the jesters take'.[44]

Michelangelo Merisi da Caravaggio (1571–1610), who was born near Milan and trained there, was an ardent devotee of Bacchus. No Old Master has been more blamed – or praised – for 'painting himself'. Few commentators have strayed far from the verdict of Giovanni Pietro Bellori, in the first detailed biography (1672):

> Caravaggio's style corresponded to his physiognomy and appearance; he had a dark complexion and dark eyes, and his eyebrows and hair were black; this colouring was naturally reflected in his paintings…the dark style…is connected to his disturbed and contentious temperament.[45]

Although Caravaggio never seems to have painted an independent self-portrait, his own features recur in his mythological and religious paintings. More than for any other Old Master, self-portrayal was an occasion for self-incrimination, and an assertion of his own unheroic status. Confirmation that Caravaggio used himself as a model comes from another early biographer, Giovanni Baglione, who says that when he first came to Rome in 1592, Caravaggio 'painted some portraits of himself with a mirror. The first was Bacchus with different bunches of grapes….'[46]

In order to intensify the drama and naturalism of their work, artists were increasingly using themselves as models when they needed to do a face exhibiting extreme or fleeting expressions. Dante had claimed that you could only paint (*pinge*) a figure properly if you first became that figure:[47] he doesn't mention looking in a mirror when trying to 'inhabit' a character, but it is probable he meant this. Bernini is said to have made faces in front of a mirror while planning his *St Lawrence* and *David*. Rembrandt's pupil Samuel van Hoogstraten believed the artist must

> reform oneself totally into an actor…at best in front of a mirror, where you are simultaneously the performer and the beholder. But here a poetic spirit is necessary in order to imagine oneself in another's place.[48]

Caravaggio's 'Bacchus' mentioned by Baglione is probably the half-length picture now usually referred to as *The Sick Bacchus*. Here the wine-god is far from being footloose and fancy free. He sits behind a grey stone table, wanly smiling. His complexion is both livid and marmoreal. He also has very dirty fingernails. His white toga, draped over his left shoulder, leaves his right, nearest side, provocatively naked. We are positioned above him, as if we have just strolled over to his table. In its boyish semi-nudity and twisting pose, it evokes – and parodies – the Sistine ceiling *ignudi*, painted by Caravaggio's great namesake Michelangelo:[49] but whereas the elevated *ignudi* grasp bunches of acorns (papal symbols), Caravaggio's debased low-lifer clutches grapes. This smallish, hunched up sybarite is quite clearly our social and even physical inferior. The table lowers and confines him.

As a self-portrait, it reveals little directly about Caravaggio, even if some art historians claim he painted it after a serious illness. It certainly alludes to his night-owl, drinking-den existence. But knowing what we do about the artist's almost psychotic touchiness and ferocious pride, there ought to be some knives, plates, pitchers or glasses on the table ready to be shoved into faces or smashed over heads. In this respect, Lomazzo's Bacchus would be a much truer model for the *enfant terrible*, for it intimates imminent gratuitous violence.

Caravaggio, *Self-Portrait as Sick Bacchus*, 1594, oil on canvas

An inventory of Caravaggio's possessions made in 1605 includes a convex mirror and a large mirror – which may or may not have been flat. The large convex mirror of polished steel that appears propped up on a table in his *Conversion of the Magdalen* is probably his own. Judging by his paintings, a flat mirror would have been of little use, except for directing light. Caravaggio was far more interested in the distorted, sensuously rounded images offered by convex and concave mirrors, as well as by their symbolism; and in later works by curved polished armour.[50] Visual rhymes are often made in his pictures with other shiny spheres, whether fruits or eyes. His fascination with unnatural roundness is even manifested in his use of his own features for the severed heads of Medusa and Goliath, with the former being painted on a circular convex parade shield. In both works, the artist is gruesomely spherical. Spherical glass carafes furnish enchanting reflections in five early works of the 1590s. His own reflection, first discovered by a restorer in the 1920s and recently revealed by reflectography, appears in a glass carafe in a large picture of *Bacchus* (*c.* 1596–7). Caravaggio would surely have agreed with the philosopher Francis Bacon's later assertion that human understanding 'is like a false mirror, which, receiving rays irregularly, distorts and discolours the nature of things by mingling its own nature with it' (*Novum Organum*, 1620). The painting marks the culmination of Caravaggio's love affair with glass.

When Caravaggio includes his self-portrait in his great religious paintings, he struggles both to see and escape the horrifying action. In *The Martyrdom of St Matthew*, we glimpse him in the background running away half dressed, glancing back fleetingly over his shoulder. In *The Taking of Christ*, he is at the side, peering over a crowd of soldiers, holding up a lantern. Where once the artist was a heroic witness or helpful assistant, here he is a grubby rubbernecker, merely glimpsing and ogling.

David with the Head of Goliath was probably painted in penance for his crimes (he had been involved in several brawls, killing a man in Rome in 1606), and was sent as such to Cardinal Scipione Borghese in Rome to help secure a pardon. The severed self-portrait head of Goliath looks gruesomely alive: his eyes remain wide open, albeit blearily.

The pose is loosely modelled on the St Bartholomew scene in Michelangelo's *Last Judgment* – in each painting a mutilated bit of body is held up in the left hand, and the implement of mutilation in the right. Here, despite the almost magnanimous tilt of David's head towards his vanquished enemy, and the glowing nakedness of his 'heart' side, he may soon drop it into the pit of hell. But the disparity in size, age and position of the two heads, with the giant adult head

Caravaggio, *David with the Head of Goliath*, 1609–10, oil on canvas

situated lower down, apes what was by now a standard format for court por-
traiture. Boy princes and young princesses were frequently shown next to their
dwarf, with the contrast in looks and height redounding to the children's credit.
So, for example, in Giacomo Vighi's *Charles I of Savoy as a Child, Accompanied by
a Dwarf* (early 1570s) the young prince, armed with a sword, stands next to his
large-headed adult male dwarf, towering over him, with his hand resting on his
head.[51] This 'dwarfing' is Caravaggio's last word in self-mockery.

In this chapter we have argued that the ability of artists to indulge in con-
spicuous self-mockery is made possible by the heroization of the artist that
occurred after around 1490. In the next chapter we will see how this heroization
of the artist is manifested in spectacular self-portraits depicting the artist at work
in the studio, which had itself become a destination for wealthy art collectors
and tourists.

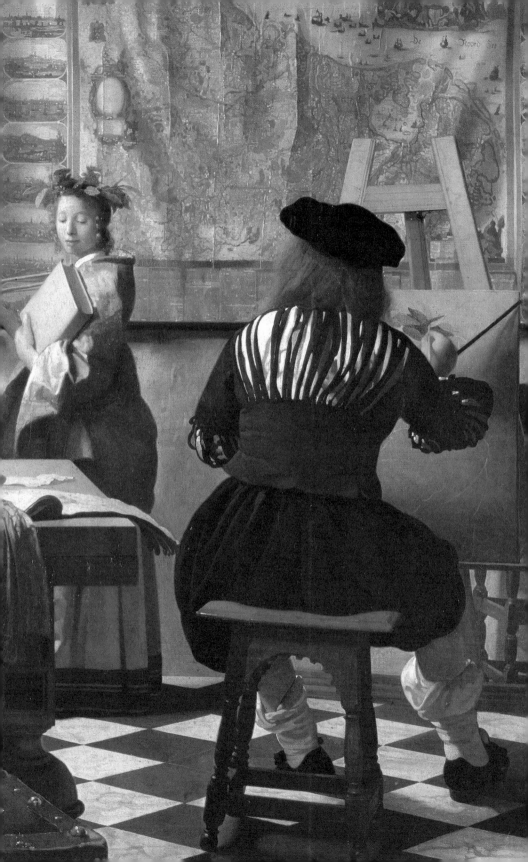

6.
THE ARTIST'S STUDIO

∽

THIS BOOK HAS BECOME increasingly dominated by images in 'flat' media – prints, drawings and especially paintings. That is not solely due to the obvious fact that more 'flat' self-portraits can be produced due to the relative speed and cheapness of their execution, for we have previously observed the extraordinary richness, variety and prominence of sculpted self-portraits in the late Middle Ages and Renaissance. One reason for the decline is changing attitudes towards architectural sculpture. Renaissance and Baroque churches do not, by and large, have so much sculptural decoration.[1]

More important than any loss of outlet, however, is the assumption that painting is the more expressive and universal art form, and the supreme vehicle for self-portrayal. The supremacy of painting had in fact already been preached by fifteenth-century theorists who practised sculpture, such as Alberti, Filarete and Leonardo. Gradually the catchphrase 'every painter paints himself' came to exclude rather than include the idea that 'every sculptor sculpts himself'.[2] This chapter investigates how painting came to dominate self-portraiture and art in general. It then analyses the mythology of the painter's studio, and the ideas behind great self-portraits showing painters at work. It ends with a survey of the incomparable self-portraits of Rembrandt, and the first collection dedicated to the genre.

The supremacy of painting, and the higher social status of most painters, was reinforced by the belief, deriving from antiquity, that painting and poetry

Jan Vermeer, *The Art of Painting, c.* 1666–8 (detail), see page 143

are 'sister' arts. As early as the fifth century BC the Greek lyric poet Simonides called painting mute poetry (at this time poems were read out loud, or sung) and poetry a speaking picture. This sort of thinking made painting the 'natural' medium for writers to turn to for a metaphor of their art. The essayist Michel de Montaigne (1533–92) is typical. His self-reflexivity is couched in terms that are by now extremely familiar. In the preface to the *Essays*, he tells us that he is 'painting' himself, with the implicit understanding that every painter *does* paint himself: 'Here I want to be seen in my simple, natural, everyday fashion without striving or artifice: for it is my own self that I am painting'.[3]

In the essay *On Presumption*, Montaigne excuses his autobiographical tendencies by citing the inspirational example of the painter King René of Anjou (1409–80):

> I saw one day in Bar-Le-Duc King Francis II being presented with a self-portrait by King René as a souvenir of him. Why is it not equally permissible to portray yourself with your pen as he did with his brush?[4]

Montaigne feels envy for the unique freedom supposedly granted to painters. His own skills as a self-painter are gradually improving: 'I have portrayed my own self within me in clearer colours than I possessed at first'.[5] In 1590 the Milanese artist and theorist Lomazzo would even claim that Christ's Holy Shroud – the full-length version that had recently been taken to Turin and the 'face' in Rome – was a 'painted' self-portrait, which proved the divine origin of painting.[6]

The philosopher René Descartes (1596–1650), who frequently refers to painting in his writings, would see the painter's studio as a model for the mind.[7] In his unfinished dialogue *The Search after Truth by the Light of Nature* (1640s), some friends discuss the best way of acquiring knowledge. One of them says that the imagination of children is said to be a *tabula rasa*, or rather a blank canvas. 'The senses, the inclinations, our masters and our intelligence' are various painters who paint pictures on it, which are usually imperfect. Intelligence comes along, but since it takes a while to learn how to paint, it takes a while before the painting can be rectified. However, intelligence can only partially improve it, because from the beginning it has been 'badly conceived, the figures badly placed, and the proportions badly observed'.[8] Descartes demonstrates how a painter's studio might be seen to furnish a complete autobiography of our own faltering development.

This kind of pictorial metaphor, in which personal development is a succession of false starts, followed by only partially successful corrections, belongs to the

age of the visible brushstroke, and the pentimento (derived from the Italian word meaning 'to repent'). The collecting of drawings, which had taken off in the mid-sixteenth century, also directed attention to the processes of art-making – and so too did learning how to draw. A pioneering collector – both of drawings and self-portraits – is the Venetian soap manufacturer Gabriel Vendramin (1484–1552), a close friend of Titian.[9] Vendramin not only owned several artists' portraits and self-portraits (Raphael, Dürer, Valerio Belli, Vittore Belliniano), he also seems to have sought out self-portraits by artists whose paintings and drawings he collected.[10] Most innovative of all was his 'Titian room',[11] located in a big bedroom in his palatial house on the Grand Canal. This contained a pair of Titian female portraits and two circular pictures, an *Ecce Homo* (probably), and a half-length self-portrait of the artist drawing. Vendramin was not the first collector to group works by a single artist together (Lorenzo de' Medici kept five large paintings by Paolo Uccello in his chamber, and three Donatello reliefs in an antechamber). But he is the first on record to arrange a room in this artist-focused way, and thereby transform it into a kind of artist's studio, with the artist at work next to his pictures.

This approach was taken even further by the Nuremberg merchant Willibald Imhoff (1519–80), grandson of Dürer's closest friend. In 1560 he bought the artist's remaining papers and drawings from the widow of Dürer's brother. Imhoff was buying up everything by the artist that he could find, and eventually owned about twenty of Dürer's paintings, including the self-portraits of 1493 and 1497, and family portraits. Imhoff not only had what was probably Dürer's earliest surviving work; he also had what was then believed to be his last, the unfinished painting *Salvator Mundi* (1505). So his collection gave a cradle-to-grave account of the artist's creative life, in the manner of Dürer's own family history. Inventories of Imhoff's large collection grouped works by individual artists, and this may have been unprecedented.

THE ARTIST AT WORK

By the seventeenth century, studio visits were fashionable for anyone who considered themselves a gentleman. Descartes may well have made studio visits while living in Holland from 1628–49. In England, the popularity of studio visits led to a new genre of 'advice-to-a-painter' poems in which the poet instructs a painter by standing, as it were, at their shoulder. The first of these dates from 1633.[12]

No wonder, then, if some of the greatest of seventeenth-century self-portraits depict the artist at work.[13] Strictly speaking, this represents a revival of medieval

conventions, but whereas in most medieval depictions the artist is at work 'on site' or, in the case of St Luke, going to the Virgin's palace to do her portrait, in the seventeenth century the artist's studio itself is the 'destination', an exotic site of pilgrimage and entertainment. Much of the interest of these self-portraits stems from the ways in which the artists negotiate the spatial and conceptual limitations of the studio: the banality of the workshop situation, and even its intimacy and domesticity, has to be balanced by a sense of sacredness, and the artist's contemplative aloofness.

One of the finest 'artist-at-work' pictures was painted by Artemisia Gentileschi (1593–after 1653). Like her Italian precursors Sofonisba Anguissola and Lavinia Fontana, she made several self-portraits but few of these have survived or been convincingly identified (they are cited in letters and inventories). Artemisia specialized in female heroines and the female nude, and there has been a tendency to assume that at some level she always 'painted herself', even if the physiognomies of her heroines are differentiated. Because she was raped by a collaborator of her painter father, who was subsequently tried and convicted, her many depictions of Judith, killer of Holofernes, have been interpreted as self-portraits.

A purely biographical interpretation is probably anachronistic, however. Her idiom is resolutely heroic and non-domestic, her scale monumental. Judith was a popular subject, painted on several occasions by her father Orazio, who taught her how to paint, and it is debatable if her Judiths refer to her feelings about the rape (Holofernes never touches Judith).[14] The 1630s would see the emergence of a cult of the strong woman, promoted by Queen Marie de' Medici of France and her daughter-in-law Anne of Austria.[15] Artemisia depicted herself as an Amazon in a lost painting for Cosimo II de' Medici, and in 1649 promised a patron: 'You will find the spirit of Caesar in this soul of a woman'.[16] She was famous in her own lifetime and this generated demand for self-portraits and portraits.

Self-Portrait as the Allegory of Painting (c. 1638–9) was probably painted for Charles I when Artemisia was visiting her father in London. Orazio was court painter to Henrietta, Queen of England. In the catalogue of Charles I's collection, compiled after his execution in 1649, it is listed with another self-portrait which has been lost.[17]

Guessing the hand and style of different artists was a popular pastime at the Stuart court,[18] and the King had a particular and well-known interest in self-portraits. He commissioned self-portraits of his court painters, Daniel Mytens, Rubens and van Dyck, which were hung in the intimacy of the King's breakfast chamber. His love of Italian painting was reflected in self-portraits by Titian,

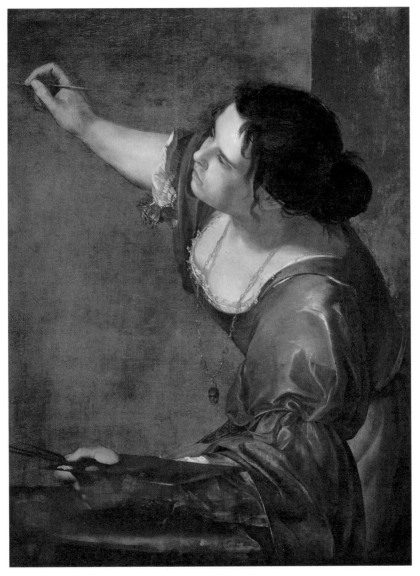

Artemisia Gentileschi, *Self-Portrait as the Allegory of Painting*, c. 1638–9,
oil on canvas

Pordenone, Bronzino and Giulio Romano, hung in the Long Gallery at Whitehall. He was given a Rembrandt self-portrait (1630–1) by the Earl of Ancram; Dürer's self-portrait (1498) and the so-called *Portrait of Dürer's Father* were a gift from the city council of Nuremberg.[19] The sheer chutzpah of Artemisia's picture – she is both sexy and awesome, near and far – would in part be due to the fact that it had to compete with so many rival self-portraits by famous male artists.

Artemisia's picture is generally, though not universally, accepted as a self-portrait, but it has the air of Artemisia, and how could it not have been an important mission statement? It is the most forceful affirmation of artistic genius that had yet been painted. It is based in part on the description of Pittura (Painting) in Cesare Ripa's iconographic handbook *Iconologia* (first edition 1593), which became a bible to many seventeenth-century painters. It was designed to increase the intellectual content and legibility of art. Ripa describes Pittura as: 'A beautiful woman, with full black hair, dishevelled, and twisted in various ways, with arched eyebrows that show imaginative thought…with a chain of gold at her throat from which hangs a mask, and has written in front "imitation". She holds in her hand a brush, and in the other the palette, with clothes of evanescently coloured drapery….'[20] Ripa envisages Pittura as a full-length figure, her robes extending to her feet, where painter's tools and instruments are scattered on the ground, but the lower body of Artemisia's Pittura is elided and there is no sense that she is even fixed to the ground.

Artemisia's eyebrows are not arched – but her arms and back are. No one since the Middle Ages had shown painting to be such an intensely physical activity – except for Michelangelo in his tiny caricature, bent like a Syrian bow. Her outstretched right hand is blotchy and looks as though it is dusted with charcoal; she sensibly wears a brown apron over her green dress. She actually leans her left forearm, which bears the palette and spare brushes, on a small table (its corner marked with A. G. F. – 'F' for *fecit* (made it). But we scarcely notice that she is supported at all. Her body below the waist merges with the dark background, and her heroically scaled and foreshortened upper body seems to be floating towards the light, which powerfully strikes her forehead and pneumatic breast. The background – a mass of scumbled browns and blacks – seems almost inchoate and immaterial. It has been variously interpreted as a blank canvas and as a wall. Whatever it is, it is surely the kind of surface Leonardo had in mind when he said the painter could get inspiration from stains on walls.[21]

So where are we and what is going on? The cult of Michelangelo, as much as Ripa, is the key to our understanding of the London self-portrait. In 1612,

Artemisia had married a Florentine and moved to his home city. Orazio had recommended her as 'without equal' to the Grand Duchess Cristina, and from then on she enjoyed Medici patronage and protection. In 1616 Artemisia became the first woman artist to join the Accademia del Disegno in Florence, and in 1615–17 she contributed an *Allegory of Natural Talent* to the decorations glorifying Michelangelo in Casa Buonarroti. Commissioned by his great nephew and namesake, Michelangelo the Younger, it consisted of a scantily clad woman holding a compass – the iconography, once again, taken from Ripa.

No compass will help us map the later self-portrait, for Artemisia is creating something out of nothing. Her open-armed pose and monumental scale and her floating foreshortened torso are modelled on the creating God of the Sistine ceiling – especially God separating light and darkness. It is a breathtakingly bold double appropriation of Michelangelo and of the 'God-as-painter' idea. To this end, the brown background is not clearly identified as a blank canvas, and it is parallel to the picture plane: it would have to be angled into the room for her to feasibly paint it. She seems to be reaching across and beyond it, towards the powerful light, and this is where her unsquinting eyes are looking. Artemisia is posited as an artist who works directly with light, and for whom the sky is the limit. A grotesque mask hangs on a chain around her neck – as recommended by Ripa – but it is not inscribed 'imitation', for she is a creator *ex nihilo* – out of nothing.

Artemisia may have assisted her father with oil-on-canvas ceiling paintings for the Queen's House in Greenwich (1638–9), which included an *Allegory of the Arts under the English Crown*. Her self-portrait could easily be displayed on a ceiling: it could be rotated and shown any way up.[22] It is a gravity-defying self-portrait, and it also articulates a frustration with the limitations of small-scale easel painting: it challenges the cult of the studio as much as it contributes to it. As Artemisia was a woman, she was never able to get commissions for frescoes and large-scale decorative schemes, like the Greenwich ceiling. So the self-portrait – a 'mere' 96.5 by 73.7 cm (*c.* 38 by 29 in.) – gestures towards something much larger, and is full of yearning. Yet her gender is not the only reason for her confinement to easel painting. The Carracci were already regarded as the last of the universal painters, who could work on a variety of scales, media and subjects. This was increasingly the age of the subject specialist, and the gallery picture. There is nostalgia for a more heroic age not just in Artemisia's specialism in ancient heroines, but in her emulation of Michelangelo.

When Artemisia was working in Florence for Michelangelo the Younger, he was preparing the first edition of his great ancestor's poetry. One hundred poems

were eventually published in 1623 – with the language smoothed out and the gender of the addressee changed, where necessary, from male to female. One can only wonder if he showed her the madrigal written for Vittoria Colonna which begins: 'A man in a woman, indeed a god speaks through her mouth....'[23]

The Rome-based French artist Nicolas Poussin (1594–1665) contributed more than anyone in the seventeenth century to the cult of the easel painter. He never painted a fresco, and executed only one major altarpiece, early in his career. He was only too aware that he was a 'mere' easel painter, and his anxieties over his limitations are transmitted in the two very different self-portraits painted in succession in 1649–50, the first time we know of an artist doing such a thing. They were painted for two of his most important Parisian patrons, the banker Jean Pointel and Paul Fréart de Chantelou, the king's steward. Poussin specialized in religious, mythological and ancient Roman subjects, which were often esoteric. He researched his subjects with great attention to historical accuracy, and painted in a sonorously rhythmical, classicizing style. He offered intellectual depth to compensate for his pictures' lack of size.

The commission for a self-portrait came about because Chantelou had asked Poussin to arrange for a portrait to be made in Rome – presumably because Poussin was not a portrait painter himself. Having looked around for a suitable artist, and being dissatisfied with the available talent, Poussin decided to execute the portrait himself, despite, as he warned Chantelou in a letter of March 1650, not having painted a portrait for twenty-eight years. The only earlier portrait that is known is a brooding melancholic self-portrait drawing of around 1630, supposedly made when Poussin was recovering from an illness, though some scholars contest the attribution.[24] He may also have been reluctant to stare at himself in the mirror: in his paintings, the only people to do so are a recumbent Narcissus (*c.* 1630) and a transvestite Achilles, seduced by the daughters of Lycomedes (1656). His 1630 self-portrait is indeed rather camp.

Poussin claimed to be dissatisfied with his first effort for Chantelou, so he immediately painted another. He then sent the first self-portrait to Pointel, and the second to Chantelou, assuring him it was 'the better painting and the better likeness' and so he had no need to be jealous of Pointel. They are fascinating works for many reasons, but here we will focus on their differences, especially the intimacy of the first and the expansive grandiloquence of the second. Taken together,

they exemplify different yet equally vital aspects of Poussin's art. As such they are the first contrasting 'pair' of self-portraits.

In the first self-portrait (1649), which has been cut down on all four sides, especially the top and the bottom, Poussin turns wistfully towards us in a fidgety side-on pose that is very similar to that of Giorgione's *Self-Portrait as David* (see Chapter 3), of which he may have known copies.[25] The sombreness of his black toga is only partially belied by his tilted head, tousled hair, pale pink cheeks and pensive smile. Behind him is a ghostly sculpted relief with an inscribed tablet flanked by two putti trailing a garland. The Latin inscription gives his name, title (First Painter to Louis of France), age (fifty-five), and the date of the picture. The relief is similar to funerary monuments made by his sculptor friend François Duquesnoy, with whom he had shared a house and who had died young in 1643.

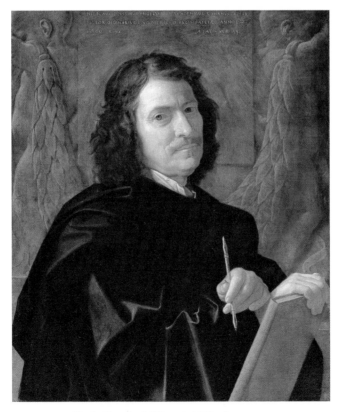

Nicolas Poussin, *Self-Portrait*, 1649, oil on canvas

The 'crossed' position of Poussin's wrists is very striking. His right arm stretches across his body so that he can grasp the top edge of a book, propped at an angle on an invisible ledge or table. The book once had 'On Light and Colour' inscribed on its spine, as if to reinforce the picture's Venetian qualities. Meanwhile, his left hand, elegantly holding a chalk-holder, is pushed towards the viewer. It is supported at the wrist by the right arm, which functions like the painter's mahlstick. Poussin, despite being a right-hander, holds the chalk as if he means to use it. He may be alluding to the greatest of Venetian artists, Titian, who in a 'reversed' print of Gabriel Vendramin's self-portrait that shows him drawing, holds a pencil in his left hand, and a tablet in his right.[26] But it is also an expression of love and loyalty to his patron. In folklore, love spells were best written using the fingers of the left hand, which was closest to the heart.[27] Poussin's chalk-holder is a kind of artist's Cupid's arrow, with which he snares his patron.

The commission occurred in a climate of jealousy among Poussin's patrons,

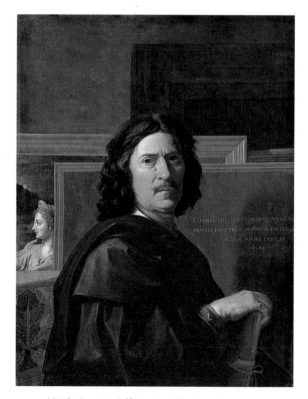

Nicolas Poussin, *Self-Portrait*, 1649–50, oil on canvas

and protestations of love and loyalty from the artist. In a letter of 24 November 1647, Poussin reassures Chantelou, who considered a painting recently sent to him, *Ordination* from the great series *Seven Sacraments*, to be too austere, and inferior to a more charming work sent to Pointel:

> I am not a fickle person, given to switching my affections, when once I have committed myself. If the picture of *Moses Discovered in the Waters of the Nile* in Monsieur Pointel's collection generates feelings of love in you, is that proof that I painted it with more love than I did the pictures I painted for you?[28]

Having gone to great lengths to justify the austerity of the *Ordination*, Poussin must have realized he could hardly send Chantelou a self-portrait that was so intimate and charming. So he immediately painted another more formal and manly self-portrait (1649–50) that would complement the *Seven Sacraments*. He stands in a similar position, in the same black toga, but he is hieratic, his head stiffly upright with a stern gaze, his hair less 'fly-away' on top. His face is fuller and he makes himself look much older. The right hand holds a folio volume, presumably containing drawings, and a diamond ring adorns his little finger, the stone cut into a pyramid shape – a Stoic symbol of constancy and indomitability. The dainty proffered left hand of the first picture is edited out entirely.

The background consists of framed pictures, stacked on top of each other in front of a door (which looks like a framed picture), at roughly the same height as Poussin's eyes but extending to left and right beyond the vertical edge of the self-portrait. The picture in front, extending to Poussin's left, is blank except for a similar inscription to the first self-portrait, though now we are informed that the year, 1650, is a papal Jubilee, and that Poussin is fifty-six. It overlaps a picture that extends the other way, to Poussin's right. In this picture, we can see a woman with a rosy complexion in left profile, being embraced by a pair of hands that come from 'offstage'. According to the art historian Gian Pietro Bellori, writing in 1672, this symbolizes Painting being embraced by the arms of Friendship.

This is a new kind of self-portrait that tries to counteract the claustrophobic intimacy of so much independent self-portraiture – and of Poussin's first self-portrait. Poussin certainly looks us in the eye, with a cold Medusa-stare that would turn us to stone. But its real purpose is to outstare us and to make us look aside. The framed pictures in the background suggest a visual world of potentially limitless lateral expansion – sliding doors opening up new vistas, portable paintings

entering and charting new worlds. It evokes an ambitious series such as the *Seven Sacraments*, rather than a 'one-off' easel painting. The allegorical figure of Painting looks away from us, beyond the borders of the self-portrait, and is embraced by someone *outside* (we only see Friendship's forearms and hands). In the Jubilee year, thousands of European pilgrims went to and from Rome, centre of the 'universal' Catholic church. Poussin's easel pictures claim a comparable reach and scope. But he remained acutely size conscious. After sending *The Gathering of Manna* (c. 1637–9) to Chantelou, he wrote to a painter friend in Paris asking them to bear in mind 'that in such small spaces it is impossible to do and to observe [all] that one knows, and that in the end this can only be an idea of a grander thing'.[29]

The conundrum tackled by Poussin in separate pictures achieves a splendidly preposterous synthesis in Jan Vermeer's *The Art of Painting* (c. 1666–8). Never has a painter's studio been more sumptuously idealized. It puts the 'ease' into easel, and has become the classic image of the painter working from beautiful life. But central to the idealization process is to present us simultaneously with two types of artist – an erudite painter of history, and an impassioned painter of love.

A foppishly dressed artist paints a young woman standing in a window who is dressed, Ripa-style, as Clio, the Muse of History. She holds a big history book and a trumpet (which stands for fame), and is crowned by a laurel wreath (representing honour and glory).[30] On the table next to her lies another big book, propped up at an angle (a treatise on perspective?); a colossal plaster cast of a face; and an open folio manuscript. These all allude to artistic education, and aspiration: the plaster cast is face upwards, 'looking' towards the window, bathed beatifically in light.

On the wall behind Clio is a printed map of the Netherlands, flanked by views of the principal towns. As well as alluding to the painter's place in the world, Vermeer's map was surely also inspired by Marco Boschini's 681-page poem, *La carta del navegar pitoresco* (1660), a patriotic defence in Venetian dialect of Venetian painting. The title and subtitle would have sufficed for Vermeer: 'The map of pictorial navigation. Dialogue between a Venetian senator and dilettante, and a professor of painting.... Divided into eight winds which lead the Venetian boat across the high seas of painting as the dominant sea power to the confusion of him who does not understand compasses'.[31] For Venice, Vermeer substitutes the Netherlands, the great northern sea – and painting – power. Already in 1572,

inspired by Paolo Giovio and Vasari, Hieronymus Cock had published a series of twenty-three portrait prints of famous Netherlandish artists, with eulogizing epigrams. Dirck van Bleyswijck's *Description of the City of Delft* (1667) celebrated the many famous artists the city had produced, and mentioned Vermeer.[32]

The set-up is clearly not realistic. Studios were workshops and did not look like this. Vermeer's was on the top floor of his house – not nearly so grand. A model would not pose holding a heavy book and trumpet – she would probably

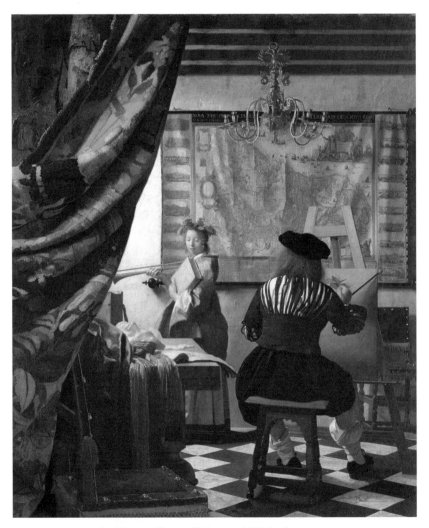

Jan Vermeer, *The Art of Painting*, c. 1666–8, oil on canvas

just be required for the painting of her face. Painters did not paint in fine clothes on unprotected marble floors. The *mise-en-scène* represents a Leonardo and St Luke-style idealized vision of the painter's existence. This studio is set up for visits by connoisseurs: the big chair in the foreground awaits us. A French diplomat visited Vermeer on 11 August 1663, but unfortunately he had nothing to show. *The Art of Painting* was never sold by Vermeer, and was probably painted so he had a sample of his work in house.

Taking our cue from the new genre of 'advice-to-a-painter' poems, what advice would we give this painter? We could begin by asking him how he will fit the trumpet into his small picture. There is altogether something odd about what Vermeer's alter ego paints. It is strikingly different in conception to the scene we see. For the painter is working on a close-up, half-length image of the woman, and at the scale he is working on, the trumpet will be reduced to a meaningless fragment, as indeed will the map (if included). The painter has so far only painted the laurel leaf wreath that crowns Clio's head (he has chalked the outline of her upper body). In the 1660s Vermeer produced several luscious close-ups of jewel-like pretty girls, the most famous being *Girl with a Pearl Earring* (*c.* 1665). It seems that this painter is ruthlessly editing Clio down into one of these lovely keepsakes, adorned with laurel leaves like those adorning Giorgione's *Laura*. His tunnel vision rejects the wider world of maps, oceans and loud trumpets.

He is clearly a bit of a fop. Slashed doublets had come back into fashion after being popular in the early sixteenth century, and then again in the 1620s and 30s.[33] The drunken lecher on the left of Vermeer's *Procuress* wears one: he is often said to be a self-portrait. Artistically, slashed and striped doublets were associated with the lover artist Giorgione, in part because of the mistaken attribution of Titian's *Bravo* to him.[34] Vermeer seems to be expressing the exotic and louchely bohemian side of artists, known for their flamboyant clothes. But the slashed doublet also expresses something about his approach to art-making. 'Slashing' is precisely what the painter is doing to the total *mise-en-scène*, insofar as he has ruthlessly cut his small fragment of a picture out of a larger visual whole.

In *The Art of Painting*, Vermeer shows himself to be two artists – the macrocosmic painter of Clio and declamatory trumpets, and the whispering microcosmic painter of Laura. In the Clio camp we can situate three pictures from this time – *The Geographer* and *The Astronomer* (both from around 1668), and *The Allegory of Faith* (early 1670s); in the Laura camp, most of the rest of his work. To a degree, he is recreating the tension that exists in paintings of St Luke, where there is an implied rivalry with, and critique of, the first Christian painter: whereas Luke

offers a close-up of the Virgin and Child, the 'modern' painter offers a panoramic view of the entire interior. Vermeer was head of the Delft Guild of St Luke in 1662–3 and again in 1670–1, so the subject would have been in his mind when embarking on this picture. Clio looks at the book she is holding with the same rapture that might be shown by the Virgin towards the Christ child. Vermeer does not want to renounce his Laura side, but as in Poussin's second self-portrait, he wants to show that his domestic art of modest scale can give 'an idea of a grander thing'.

~

Several Dutch seventeenth-century paintings of the artist's studio show the artist being visited by potential patrons, but these generally mediocre and modest pictures are completely upstaged by Diego Velázquez's *Las Meninas* (1656), the most ambitious statement about the status of easel painting that had been made. Earlier painters to the Spanish court, such as Titian and Anthonis Mor, had made self-portraits that were exhibited alongside their portraits of the royal family.[35] Here the Spanish royal family occupy the centre of this large canvas (318 cm high and 276 cm wide; *c.* 10½ by 9 ft), while Velázquez stands to the side and in partial shadow. But the picture is so dominated and determined by the canvas at which he works, and by perspectival and illusionistic trickery, that it was rightly described by a near contemporary as 'the theology of painting' – with Velázquez as the Christ and St Luke of painting.

Our main source of information about *Las Meninas* is a description by Antonio Palomino in his *El museo pictórico y escala óptica* (The pictorial museum and optical scale, 1724). Palomino had talked to four of the nine people depicted in the work, and to others who had known and worked with Velázquez. As a result we know the names of eight of the protagonists. We also know that the scene is located in a fairly accurate depiction of Velázquez's studio in the former apartments of the deceased Crown Prince Baltasar Carlos in the royal palace, the Alcázar. The completed picture was displayed in the King's private office.

At centre stage stands the key dynastic pawn, the five-year-old Infanta Margarita María, daughter of Philip IV of Spain and his second wife Mariana of Austria, whose images are vaporously reflected in the mirror behind (van Eyck's *Arnolfini Portrait* was in the Royal Collection). She is flanked by two ladies in waiting, *las meninas*, the curtseying Isabel de Velasco, and the kneeling María Agustina Sarmiento, who offers her a clay pitcher of water, red and a bit heart-

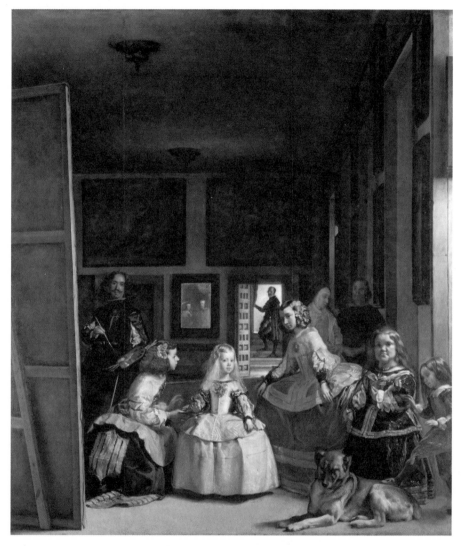

Diego Velázquez, *Las Meninas*, 1656, oil on canvas

shaped. This must symbolize her purity, loyalty and clarity of vision – she is the most brightly lit, and gazes the most intently: only her eyes are not in shadow.

In the foreground, stage left, are a female and male dwarf: Maribárbola and Nicolás Pertusato, an Italian fool who puts his tiny foot on a large slumbering dog, which belonged to the King. Behind them the chaperone Marcela de Ulloa, dressed in widow's robes, turns towards a bodyguard. At the back, silhouetted in the doorway, is José de Nieto, Chamberlain of the Queen's Quarters. The foreground, stage right, is dominated by a huge canvas planted squarely on the floor, like a stage flat. The court painter Velázquez stands away from it, partially in shadow.

So far, so relatively simple. But why are they gathered here and what is going on – these are among the most intriguing and irresolvable questions in art history. The dramatic lighting effects, with a gloomy mid-ground sandwiched between a light foreground strip and the illuminated open doorway in the background, contribute to the mystery of the scene. The room is lined with pictures (copies of paintings by Rubens, the epitome of the successful court artist), but none is well lit.

One of Chamberlain José de Nieto's main responsibilities was to open doors for the royal couple, so it seems likely that the King and Queen are standing in the viewer's position. Their presence here is recorded in the mirror, as well as in the outward gazes of so many of the protagonists. They are present in sublime, hazy miniature – near and yet far. The swag of red curtain above the King's head in the mirror image suggests a studio prop, so Velázquez could be painting their portraits. Yet this is no ordinary mirror, for despite being unusually large, it reflects none of the figures in the studio.[36]

By this stage in his career, Velázquez was Chamberlain of the Palace, with little time for actual painting. He has his key of office hanging from his waist. He was probably already expecting to be knighted by the King, and his candidature was indeed put forward in 1658, but was rejected because it could not be proved he had noble ancestry. This monumental painting, with its extraordinary array of suggestive flecked and dabbed brushwork, must have been part of his candidature.

It has been said that Velázquez posits his relationship with the King as a modern equivalent of that of Apelles and Alexander the Great: Alexander visited Apelles's studio and gave him the exclusive right to paint his portrait.[37] Palomino says that while the picture was being painted, the royal family and court made frequent visits. They 'came down often, considering this a delightful treat and entertainment'. Alberti said the ideal history painting should include no more

than eight or nine figures, varied in age, gender, dress and attitude – so this is a group portrait in an Albertian mould.

And yet the painter leaves the question of his status tantalizingly, amusingly and, above all, courteously, open. This painting could easily have been the grand rousing finale of the chapter on mock-heroic self-portraits. Paolo Giovio put painters with wits, and Veronese compared painters with jesters – and Velázquez seems to accept and even relish this designation. He is here in the entourage of the five-year-old Infanta, along with her dwarves and fools whom he paints with unique sympathy, both here and in a famous series of individual portraits. He has used a canvas of a size appropriate for a history painting – it is taller and nearly as wide as his much-praised *Surrender of Breda* – for a portrait of mostly tiny creatures, confined to the bottom half of the picture. Although Velázquez 'rises' highest, he will still not be able to reach the highest section of the canvas he is painting.

The job of the dwarf was, in part, to put the perfection of the royal child in relief. In Velázquez's early portrait of Baltasar Carlos with his dwarf, the latter holds a rattle and an apple to contrast with orb and sceptre held by the Crown Prince. But dwarves, and fools, also show the world turned upside down. In 1638, on Shrove Tuesday, Velázquez had appeared in a burlesque play as the Countess of Santiesteban, required to speak a single line, with the King's first minister appearing as a porter.[38] Here, he shows a painting turned back to front in a 'behind-the-scenes' view of a painter's studio. The visual and conceptual conundrums in the painting belong to the most exalted of courtly games, with Velázquez as master of ceremonies. The most daring reversal is the mirror image of the royals, for not only are they miniaturized, the Queen now stands to the *right* of the King, in the honorific position.

Velázquez aligns himself most closely of all with José de Nieto, transforming Nieto into a surrogate painter, for his right hand, raised to push aside a curtain, could be that of a painter, about to apply paint to canvas, while his left hand holds a palette-like hat. The coffered design of the door by which he stands is analogous to the back of Velázquez's canvas – which, placed on the floor, functions for us as a kind of giant door (it has also been called a 'vast cage').[39]

Velázquez had a large library, which contained Dürer's treatises on proportion and measurement, and many other books on perspective and optics. He also owned many measuring instruments and a grand total of ten mirrors.[40] Dürer's 1498 self-portrait was in the King's collection, a gift from Charles I of England – which raises the question as to whether *Las Meninas* has a link with Dürer. Dürer's coat of arms was an open door, using a partial pun on his name ('*tur*' is German

for 'door'). An open door is visible at the summit of a triumphal arch in an astonishing print produced by Lucas Kilian of Augsburg to mark the centenary of Dürer's death in 1628. 'Twin' Dürers, derived from two full-length self-portraits included in altarpieces, stand in front of the arch, either side of a table where they perform geometrical and perspectival demonstrations.[41] This is the grandest prior evocation of an artist's studio, and perhaps the closest precursor to *Las Meninas*. *Las Meninas* is a tour de force of perspectival and optical effects, and Velázquez

Lucas Kilian, *Double Portrait of Albrecht Dürer*, 1628,
engraving

envisages the ideal painter as a magician who can encompass all of human life: the studio as secular cathedral.

The painting prompted Palomino to write what may well be the earliest attempt at a history of self-portraiture, albeit of a particular kind:

> I consider this portrait of Velázquez to be no lesser work of artifice than that of Phidias, the renowned sculptor and painter, who placed his portrait on the shield of the statue he made of the goddess Minerva, executing it with such artifice that if it were removed the statue itself would be completely ruined. Titian made his name no less eternal by portraying himself holding in his hands another portrait with the image of King Philip II. Thus just as the name of Phidias was never effaced so long as his statue of Minerva remained whole, and Titian's as long as that of Philip II survived, so too the name of Velázquez will live from century to century, as long as that of the most excellent and beautiful Margarita, in whose shadow his image is immortalized.[42]

It is a jumble of thoughts and protocols – Phidias's name has obviously survived the destruction of his statue; Titian's self-portrait had been burnt in 1602, and his fame is scarcely dependent on that of Philip II; Velázquez's fame is no longer dependent on that of the Infanta Margarita who, having become Habsburg Empress, died in Vienna aged twenty-one. As early as 1696 Felix da Costa had already concluded, in a treatise on painting: 'The picture seems more like a portrait of Velázquez than of the Empress'.[43] In 1724, the same year in which Palomino's treatise was published, the Alcázar was destroyed by fire, and the rescued masterpiece was taken from the King's private office to the new royal palace. In inventories it was the painting with the highest valuation, and in 1778 Goya made the first reproductive print. Its modern fame, however, derives from when it was displayed in a new public museum, the Prado, in 1819.

~

With Rembrandt van Rijn (1606–69), the production of self-portraits is taken to a new level, both in terms of quantity, quality, variety and duration. The self-portraits created his fame as much as they reflected it, and more than ever before, they allude constantly to the history of self-portraiture, inserting the artist into the roll call of great artists. Although he is the first artist whose features were widely

recognized throughout his working life, he estranges the viewer with his changing costumes and expressions, and his proximity. His studio, as mediated through the self-portraits, is not exactly hospitable or even accessible. The intimacy and interiority of these self-portraits is qualified.

Over a forty-year period Rembrandt painted himself over forty times, etched himself thirty-one times and drew himself half a dozen times. Studio copies were made, and passed off as originals. Self-portraits comprise nearly twenty per cent of his total production. Even here, though, the bulk of his output came in the early part of his career, and there is a trough in the 1640s. The peak period came when he was first establishing himself in Leiden from 1628 to 1631: he made around thirty self-portraits, more than half of which are etchings. By the time he was thirty, in the mid-1630s, he had painted more than half his eventual output of self-portraits.[44] From around 1640 to 1652, he produced few self-portraits, and these are – for Rembrandt – routine affairs. No such doubts surround the best of the twenty or so late self-portraits: their force, originality and size (most are life-size) never cease to amaze.

There are problems of definition, however. It has recently been argued that most of these early pictures are not really self-portraits, but *tronies,* the Dutch term for a picture of a head or face, often of an emblematic or symbolic sort – a virtue or vice, or a study of a particular expression. He used his own likeness for convenience, and for its generic qualities.[45] There is some truth in this, and there was to be no sustained discussion of the self-portraits as a series until the nineteenth century.[46] But many of his early self-portraits do mark themselves out as images of a particular 'inspired' artist. Moreover, his physiognomy in these self-portraits is distinctively imperfect rather than generic (wide nose, perpetual frown, etc.), which suggests he wanted the sitter as well as the author of the self-portraits to be recognized. Even his adoption of a beret, partly inspired by depictions of sixteenth-century artists, became a trademark.

The large number of etched likenesses meant he was among the most recognizable artists in the world, and his likeness was prized from early on – even in foreign lands. In the 1639 inventory of the collection of King Charles I, a Rembrandt self-portrait was described, displayed above the office door of Lord Ancram, who had brought it back from Holland as a gift for the King in the early 1630s: 'the picture done by Rembrant. Being his owne picture & done by himself in a Black capp and furrd habit with a little goulden chaine upon both his Shouldrs'.[47] The term self-portrait was coined only in the nineteenth century (1831 is the first recorded use in English), and the repetition of 'done by Rembrant' / 'done by

himself' suggests the genre of self-portraiture was still quite novel. The compiler of the inventory is making sure that future readers understand exactly what type of picture he is talking about.

We see Rembrandt feeding off earlier self-portraits, and establishing self-portraiture as an autonomous genre with its own history.[48] Self-employed rather than a salaried court painter, it may be that he felt he needed to keep reminding distant patrons, actual and potential, of his continuing presence and present fame. No self-portrait is recorded in the inventory of his possessions made at the time of his bankruptcy in 1656, and the assumption must be that all had been sold. Only three self-portraits are cited in documents in his lifetime, but two had entered royal collections rich in self-portraits, and a third was owned by a major dealer. All the owners knew the identity of the sitter.

Rembrandt was apprenticed to a painter in his home town of Leiden in 1622, and in around 1626 set up in business on his own, sharing a studio with Jan Lievens. He used his own features for the protagonists in several of his earliest religious paintings, but there is a flurry of independent self-portraits in 1628/9. They were a self-reinforcing prophecy: it is as though he wanted to make himself seem famous before he really was famous.

The painted Leiden self-portraits established Rembrandt as a 'child prodigy' – perhaps in competition with van Dyck (1599–1641), the great child prodigy of the day who had painted his first major self-portrait aged fourteen or fifteen (it may have been painted later and made to look younger).[49] Rembrandt looks tiny and childlike in *The Painter in his Studio* (*c.* 1629), standing at the back of a spartan studio to contemplate a large canvas from a distance. He is swallowed up in his voluminous working clothes and wide-brimmed hat, and dwarfed by the giant wooden easel with its elephantine legs in the foreground. It is a David versus Goliath scenario – armed with brush and pigment, rather than sling and shot – and there can be only one victor. The largest, most hieratic and glamorous of the early works, *Self-Portrait with Plumed Beret* (1629), is a tour de force of seductive *sfumato*. Now he wears expensive clothes and a gold chain despite having the flaw-less ivory skin and fluffy stubble of a teenager.

The famous head-and-shoulders self-portrait etchings are usually considered studies in expression performed before a mirror – similar in kind to the ones that the Italians Caravaggio and Bernini made. They are now given titles such as *Self-Portrait Open-Mouthed* and *Self Portrait with Angry Expression*. But the comparisons that are made between these studies and the facial expressions found in Rembrandt's other works are rarely compelling, and the most expressive feature of all – Rembrandt's

fantastical hair – is found only in the etchings, for example *Self-Portrait with Curly Hair and White Collar* (*c.* 1630). Indeed, the idiosyncratic depiction of hair proves the etchings were more than mere *tronies*: they were depictions of an inspired artistic temperament. In many cases it is the hair, rather than the face – often hidden by deep shadow – that is the most striking and expressive feature.

Never before had etchings been made with such a sketchy technique, but the sketchiness is at its most extreme in the hair, which leads a comically dishevelled life of its own. A nineteenth-century cataloguer called it 'frizzley hair'. This was a golden age for male hair, with no style more distinctive – or controversial – than the lovelock, in which a long lock of hair hung down the 'heart' side, either tied with a love token or 'shaggy'. Lovelocks were especially popular in England, and de rigueur at the court of King Charles I – as we can see from van Dyck's portraits. The Puritan polemicist William Prynne, in his infamous diatribe *The Unlovelinesse of Love-Locks* (1628), considered their only useful function to be 'to give the Divell holdfast, to draw us by them into hell: a fitting place for such vaine, Effeminate, Ruffianly, Lascivious, Proud, Singular and Fanatique persons'.[50]

Lovelocks were rarely found in sober republican Holland, but Rembrandt advertises his devil-may-care exoticism by sporting the shaggiest of lovelocks in

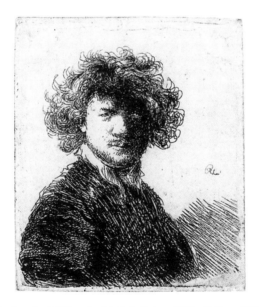

Rembrandt, *Self-Portrait with Curly Hair and White Collar, c.* 1630, etching

eight early self-portraits, and Prynne's adjectives could be variously applied to all of them.[51] His wild, ever-changing hair is a virility and fertility symbol. Even his signature became unkempt, as the art historian Filippo Baldinucci pointed out later in the century: 'He used to sign his prints with badly composed, deformed and botched letters'.[52]

The wildness of his hair evokes the dishevelled hair of Ripa's *Pittura* – 'thick, scattered and twisted in diverse manners, with arched eyebrows, the manifestation of fantastical thoughts'. Its curly luxuriance equally attests to Rembrandt's fascination with Dürer, his most important precursor as a painter and printmaker, and as a serial self-portraitist. His early work is full of allusions to Dürer's art and his eruption into hairy self-portraiture pretty much coincides with the centenary – in 1628 – of Dürer's death. From around 1570 to 1630 there had been a so-called 'Dürer Renaissance' in German-speaking lands, and in Antwerp (which Dürer had visited).[53] Rembrandt eventually formed a large collection of Dürer prints.

Dürer's hair is highlighted by the Dutch art historian Karel van Mander in his *Schilder-boeck* (1603–4), a biographical history of Netherlandish and German painters that became a standard work, and which Rembrandt, an educated man, would have read. Of particular relevance to Rembrandt would be his claim that Dürer was very friendly with the most eminent artist from his home city, Lucas van Leyden. Van Mander made a pilgrimage to Nuremberg in 1577 and his eyewitness description of the panel painting in Nuremberg's town hall, where it was displayed with a portrait of the artist's mother, focuses on the depiction of hair:

> There is a small self-portrait, in which he painted his face with long hair on it, hanging down. Some of the hair intertwines, and some is traced in gold very effectively. I can remember this well: I had the painting in my hands when I was in Nuremberg in the year 1577.[54]

Gold filigree strands of calligraphically curly hair are a trademark of some of Rembrandt's earliest painted self-portraits, and he achieves this effect by scratching a sharp implement across the still-wet brown paint to expose the lighter ground layer beneath. This 'etching' trick is seen in a self-portrait in the background of a historical scene of 1626. It is also used for the hair of two other background figures, and – discretely – for the emperor's beard. But the trick culminates in the two versions of *Self Portrait as a Young Man* (1628/9). Here a shadow occludes the face like a carnival mask, while the hair glows in exuberant gilded autonomy.

Rembrandt moved to Amsterdam in 1631, enjoying considerable success, and the 1630s are the high point for painted self-portraits in opulent dress and gold chains. The darkness of the clothes, sombre smokiness of the monochrome backgrounds, and almost permanently frowning brow, lend these pictures a certain intensity, yet this is still his least original and most repetitive phase of independent self-portraits. In the 1640s, Rembrandt painted only four relatively routine self-portraits, and made a single self-portrait etching. This has been put down to personal difficulties, such as the death of his wife Saskia in 1642, financial problems due to vast expenditure on a house and on collecting art, and the fashion for more highly finished and classicizing art. But it is just as likely that he had – momentarily – lost interest in the genre.

In the 1640s and early 1650s, Rembrandt made his great sequence of landscape paintings, drawings and etchings, and his almost exclusive focus on peasant culture – dilapidated cottages and back-breaking work – seems to have been the catalyst for a new kind of self-portrait that emphasized labour. In his paintings, now built up from thick impastos, his face emerges into the light like a potato from peaty soil.

In 1652, Rembrandt painted his first self-portrait in about seven years, and the existence of a rare preparatory drawing suggests he took some trouble over it.[55] It is his largest and most imposing independent self-portrait so far. He stands before us in three-quarter length, hands on hips, thumbs through his sash belt, jutting elbows penetrating and putting pressure on the vertical edges of the canvas. He wears a coarse brown short-sleeved robe, tied at the waist with a brown sash. Underneath is a black doublet, its colour complementing the browny-black background, and matching that of his beret, which provides a dark halo for his rugged but brilliantly lit face. A pair of black eyes stares at us unblinkingly. His hands look as though they are made from the same rough, dark material as his clothes. It is painted freely and even brutally.

The uncompromising pose in the painting, and in the drawing, which shows him full length with legs apart, is remarkably similar to that of Holbein's militant full-length mural portrait of Henry VIII in London's Whitehall Palace (1530s), of which many copies were made: four large painted copies were even made in the aftermath of Shakespeare's *Henry VIII* (1613).[56] Rembrandt owned Holbein prints, and he must have read van Mander's life of Holbein; van Mander says that everyone who approached Holbein's portrait of Henry VIII was 'stricken with fear', and Holbein is just as terrifying. An 'almost perfect exemplum of the Northern artist', comparable with Dürer, his genius came from nowhere – the 'rocky, desolate' wasteland of Switzerland. He was always his own man. An English lord once

Rembrandt, *Self-Portrait*, 1652, oil on canvas

tried to make a studio visit, but Holbein refused to open his door because he was 'painting something from life or doing something private'. When the aristocrat persisted, Holbein threw him down the stairs. The story has an equally appealing if fanciful coda, for when the courtier complained to King Henry, he was reprimanded: out of seven peasants he could fashion seven lords, but not one Holbein out of seven lords.[57] A similar anecdote is told about Rembrandt by Baldinucci in his biography of the artist: 'When he worked he would not give an audience to the most powerful monarch in the world, who would have had to go away and come back repeatedly, until he had finished that work'.

The artist's insistence on privacy recounted in these tales recalls Montaigne's famous assertion in his essay 'On Solitude' (1580) that we should 'set aside a room, just for ourselves, at the back of the shop, keeping it entirely free and establishing there our true liberty, our principal solitude and asylum'. In the 1652 self-portrait, Rembrandt certainly does look as though he might throw us down the stairs in order to preserve his privacy. He must maintain his solitude and thus his liberty. Montaigne's essay continues in a way that seems pertinent to what we see:

> there we should talk and laugh as though we had no wife, no children, no possessions, no followers, no menservants, so that when the occasion arises that we must lose them it should not be a new experience to do without them. We have a soul able to turn in on herself; she can keep herself company; she has the wherewithal to attack, to defend, to receive and to give. Let us not fear that in such solitude as that we shall be crouching in painful idleness.[58]

Whether Rembrandt in his busy successful years worked in the solitude that the painting suggests is doubtful. There are more drawings by Rembrandt and his many pupils recording life in the artist's studio than by any other European painter of this period. And it is a crowded, bustling place, and a tourist attraction for eminent art lovers.

In the 1652 self-portrait Rembrandt may have resurrected a defiant pose used by Holbein, and a defiant aspect of his character, but he equally defiantly rejects his style. At just this time in the Netherlands, Holbein was lionized for his hyperreal, meticulously painted illusionism. He was seen as the 'father' of the hugely fashionable 'fine painters', such as Rembrandt's former pupil Gerrit Dou (1613–75) and Dou's pupil Frans van Mieris the Elder (1635–81). Dou and van Mieris specialized in meticulously detailed (so-called 'washed') genre paintings, and were prolific self-portraitists, depicting themselves wearing expensive clothes in opulent settings, rich with symbolic meaning. Rembrandt had partially catered to this taste in his early paintings, but his increasingly 'unwashed' style led to him becoming less fashionable.

Rembrandt was not the first artist to draw attention provocatively to the harsher, more ascetic and less courtly aspects of their working lives. Dürer (again according to van Mander) would sometimes wander round Nuremberg in his working clothes, and Michelangelo in his later years slept in his working clothes and boots.[59] In 1656, the sculptor Bernini made a point of wearing

rough working clothes when the former Queen Cristina of Sweden visited his Rome studio:

> Since it was what he wore for his art, he considered it to be the most worthy possible garment in which to receive that great lady. This beautiful subtlety was quickly perceived by the Queen's sublime genius. His action not only increased her concept of his spirit, but even led her, as a sign of her esteem for his art, to wish to touch the garment with her own hand.[60]

There is a clear Christian aspect to this dressing down: Christ was the son of a carpenter, and his disciples included fishermen. Once again, though, it is the prior heroization of the artist that makes these sartorial choices possible.

It is not until Rembrandt's very late self-portraits that he takes a close-up and in-depth view of his own working practice. The sequence starts with *Self-Portrait at the Window, Drawing on an Etching Plate* (1648), continues in the lost *Self-Portrait with Pen, Inkpot and Sketchbook* (1657?), and culminates with three paintings of the 1660s where he is painting. Rembrandt had been declared bankrupt, and his house and extensive art collection sold off in 1657, and it is hard not to feel that the elderly artist was taking stock and laying claim to his own artistic territory at a time when his commercial star was on the wane.[61]

Two of these late self-portraits make ambitious statements about the nature of art, but could not be more different, and embody polarities in Rembrandt's art and self-image. In *Self-Portrait as Zeuxis* (c. 1662), Rembrandt recreates the mischievous exuberance of his early etchings. He appears in the guise of the great Greek painter Zeuxis as he paints the portrait of an old lady.[62] Although Zeuxis was famed for his portrait of the supremely beautiful Helen of Troy, he had reputedly died by suffocating with laughter while making a portrait of a wrinkled, droll old lady. The painting technique is astonishingly coarse, and Zeuxis has rugged, bark-like skin as he grimaces at us conspiratorially over his shoulder. This is the only self-portrait by Rembrandt to suggest his studio might have been busy and noisy.

The self-portrait of *c.* 1665 at Kenwood is the most grandiose and heroic that Rembrandt ever made. Lit from his right, he wears his painter's tabard and cap, and stands before a canvas mysteriously inscribed with two circles. His right hand is placed on his hip, and his left hand merges with a palette, brushes and mahlstick, to make a prosthetic painting arm. Various explanations have been given for the circles, none of which has gained universal assent. Are they the circles of

Rembrandt, *Self-Portrait, c.* 1665, oil on canvas

a world map? Do they allude to the circle that Giotto was reputed to have drawn freehand to demonstrate his prowess? Another interpretation suggests itself when we notice that if the arc of the 'circle' behind Rembrandt's head were continued downwards, it would pass through the painter's right eye, which is illuminated. It would then be a visualization of a credo attributed to Michelangelo, and cited by van Mander in his life of the artist, which stressed that it was necessary 'to have compasses in the eyes and not in the hand'.[63] Michelangelo was attacking the

academic notion that it was sufficient for the artist to follow proscribed rules of proportion and geometry; while these 'rules' had to be absorbed, it was the eye that made the final judgment in making the figure appear to breathe, move and feel. Here Rembrandt takes his stand against classicizing and 'washed' art. The vision of this easel painter is visionary: his paintings offer profound truths. And doesn't his famously sweaty and oily face, with its shiny bulbous nose, confront us like a new, artist-centred sudarium?

Rembrandt's fame was still such that when the future Grand Duke Cosimo III de' Medici (1642–1723) toured Europe in the 1660s, twice visiting Amsterdam, he saw 'the famous painter Rembrandt' on both occasions. During his 1669 visit he acquired, a few months before the painter's death, a recent self-portrait.[64] He was acquiring self-portraits by other artists after studio visits for his uncle Cardinal Leopoldo de' Medici (1617–75), who had begun the first dedicated collection of painted self-portraits in 1664. A great collector of drawings and scientific instruments, he is seen as a pioneer of modern museological methods. At his death in 1675, he owned seventy-nine self-portraits, half of which came from family collections and the rest from acquisitions and gifts.

Leopoldo's collection was left to his nephew and displayed *in toto* in the Uffizi in 1681. It is now hung in the Vasari Corridor, and numbers over 1,600 works. For the first 225 years the collection featured only paintings. For sculptors to gain admittance, they had to have *painted* their self-portrait.[65] Many painters would donate their self-portrait, seeing it as a way of securing their reputations. Especially during the eighteenth and early nineteenth centuries, inclusion was a key indicator of a painter's worldly success; it placed them in a line of painters reaching back to Raphael, whose youthful self-portrait (see Chapter 4) was the most prestigious exhibit.[66] The collection represents a culmination of the Medici cult of the artist, which had begun with Lorenzo de' Medici's monument to Giotto, and which had continued with Duke Cosimo I de' Medici's support for the Accademia del Disegno. Indeed, in the late sixteenth century, some self-portraits in the family collection were already gathered together in a room.[67]

In 1681, the collection's curator, the brilliant art historian Filippo Baldinucci (1625–97), had many of the self-portraits cut down to a standard size and given a standard frame. The self-portraits, mostly small-scale and close-up, were displayed cheek-by-jowl, covering every inch of the walls, from floor to ceiling. Baldinucci

displayed the self-portraits chronologically by regional school – though it is hard to see how this could have manifested itself visually with any clarity when the display was so tightly packed and regimented. The uniformity of the packed display must always have been peculiarly dispiriting, like a catacomb or prison for painters. It is unclear whether such a collection is really a celebration of individual artistic genius or of conformity to an academic type. The chronology was determined not by the artist's date of death, as at the Accademia di San Luca in Rome (saints' days were determined by the date of death), or by date of birth, or by the date when they reached the golden age of thirty-three, but according to the decade of their creative flowering.[68]

The last Medici duke died in 1737, and his collections were given to the city of Florence in perpetuity. The first catalogue of the self-portrait collection, the de luxe four-volume folio-sized *Serie di ritratti degli eccellenti pittori...*, was published 1752–62 with the support of the Florentine collector of self-portraits Francesco Gabburni.[69] Each volume contained a reproductive engraving and brief biography of fifty-five artists by Francesco Moücke. Even though Rembrandt, van Dyck, Annibale Carracci – among others – had several self-portraits in the Medici collection, Rubens is the only artist to have two, albeit quite similar, self-portraits reproduced, probably because he worked for the Habsburgs, who now ruled Tuscany. The single 'definitive' self-portrait was the ideal. Moücke's biographies focus on the lives of the artists but say almost nothing about the self-portraits themselves as works of art. Rembrandt died 'tormented by regrets for past follies'.[70] This retrospective nostalgia was, of course, shared by anyone looking at the Medici collections, for their golden age, and that of Florence, were also in the distant past.

In this chapter we have been tracing the way in which the processes of painting, drawing and printmaking, and the painter's studio, became mythologized in seventeenth-century art and literature; we also briefly explored the formation of the first extensive collections of self-portraits. In the next chapter we look at how eighteenth-century artists depicted themselves at an existential crossroads, buffeted by contrary and fleeting passions, with an agitated body language to match.

7.

AT THE CROSSROADS

IN 1761, JOSHUA REYNOLDS (1723–92) painted an allegorical portrait of the most famous actor of the day, David Garrick. *Garrick between Comedy and Tragedy* shows the actor standing in verdant woodland having his arms pulled by female allegories of Comedy and Tragedy, the former smiling and scantily clad, and practically ripping his clothes, the latter severe and veiled, and pointing upward to higher things. Garrick's body language is what we would now call 'conflicted', so while his head turns towards Tragedy and his arched eyebrows vault up his forehead, he is smiling even more broadly than Comedy, and his torso turns towards her. Perhaps his head says 'Tragedy', and his heart says 'Comedy'.

The picture is a witty and necessarily inconclusive variation on the theme of 'Hercules at the Crossroads', or 'The Choice of Hercules', in which the Greek hero is shown caught between female allegories of Virtue and Vice, still unsure whether to stride off and perform heroic labours (which he does), or to remain a pampered fornicating sybarite. This subject had been depicted many times since the Renaissance, and Federico Zuccaro painted 'The Choice of Hercules' on the ceiling of his own house in Rome, with a stirring inscription telling the viewer to take the arduous path of Virtue. But Reynolds's picture is the first version to put a particular artist in the place of Hercules.

James Barry, *Self-Portrait with Dominique Lefèvre and James Paine the Younger, c.* 1767 (detail), see page 171

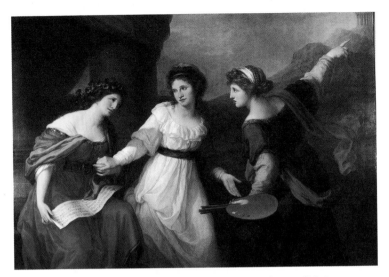

Angelica Kauffman, *Self-Portrait Hesitating between the Arts of Music and Painting*, early 1790s, oil on canvas

The first self-portraits to explicitly put a painter at the crossroads were made in the early 1790s. Angelica Kauffman's sumptuously sentimental *Self-Portrait Hesitating between the Arts of Music and Painting* (early 1790s) is in the same urbane vein, for the choice of female allegories it offers might almost be one between red wine and spring water. The Swiss-born Kauffman (1741–1807) had come to England in 1765, and was a co-founder of the Royal Academy (and the last female to be a member until 1922). In 1781 she married an Italian artist and moved to Rome. This is probably the last, and certainly the largest, of her many self-portraits. In her youth Kauffman had apparently consulted a priest as to whether she should become a musician or painter, and he recommended painting as less likely to interfere with her devotions.[1] The work depicts her teenage self making her career choice. Kauffman, clad in a white vestal dress, stands between the female allegories. She looks wistfully and squeezes the hand of the submissively feminine Music, while gesturing towards the upstanding and more masculine Painting, who is energetically pointing upwards. There is an implicit stylistic choice going on, too, for Music is voluptuous Venetian, while Painting is Raphaelesque Roman.

Far more traumatic and complex psychodramas, with the artist caught at an existential crossroads, profoundly unsure which way to turn, would inspire some of the finest self-portraits of the eighteenth century. Reynolds – a prolific

self-portraitist – is the pioneer here, too, for his greatest self-portrait dramatizes a major turning point in his own life.

～

Reynolds was the most successful artist of the eighteenth century, and probably the most prolific portrait painter of all time. A founder member and first President of the Royal Academy, he was knighted by King George III in 1769. He worked seven-day weeks for nine months of the year, not even finding the time to attend church (much to the dismay of his sister).[2] In one year he had over 150 different sitters, and in total painted over 2,000 portraits. He painted nearly thirty self-portraits, with three-quarters made after 1766, when the honours started to roll in. Many were publicized in reproductive prints, making him the earliest serial self-portraitist whose works could be laid out on a library table and studied virtually from beginning to end.

Most are standard-sized half-lengths with the artist side on, looking penetratingly over his shoulder. This is the basic format of his first self-portrait, painted in 1746; and of that painted at the request of the director of the Uffizi in 1775. In the latter he wears doctoral robes to receive an honorary degree from Oxford University, and clutches – rather too firmly for conservation purposes – a sheaf of rolled-up Michelangelo drawings. A Latin inscription painted on the back lists his many honours.

Compared with Reynolds's overall output, thirty self-portraits is a mere drop in the portrait ocean. And on the whole they did not detain him for long. When he was elected (absentee) Mayor of Plympton, his home town, in 1773, he sent a self-portrait in doctoral gown conceived and executed in a single day. The varnish was still wet when he sent it, and it hung in the Guildhall with 'dust & other foul matter' sticking to it.[3] He took more time over the self-portrait for the Uffizi, rejecting his first effort, but that was unusual.

An early self-portrait is exceptionally innovative, however. Here he is heroic, but in a nuanced way that is very moving. The image dramatizes distance and absence, the difference between ambition and actuality. He stands before a blank canvas, boldly brandishing in his right hand a mahlstick, brushes and palette. He turns sharply to his left to look far away, his left hand shielding his eyes from the light streaming in.

Because his eyes are in shadow, it is usually seen as an essay in Rembrandtian self-portraiture (Reynolds was a great admirer and collector), but the gestures,

shadowed face and relative formal clarity are closer to the startled figures in Raphael's great nocturnal altarpiece *The Transfiguration*. It was in Rome but widely known through copies and prints.[4] Here, a semi-recumbent disciple on a hillock below the levitating Christ uses one hand to shield his eyes from the divine light, while stretching the other arm out laterally. Reynolds is also experiencing a blinding revelation he can barely see or comprehend. He is usually assumed to have painted it just before he left for Italy and his Grand Tour, in 1747–8, but it would not be surprising if he painted it shortly after his arrival in 1749. The Grand Tour, de rigueur for artists and fashionable aristocrats, was the culmination of a young man's education.

This is one of Reynolds's rare portraits with prominent hand gestures.[5] It is also the only one to show him painting, and the only one in 'landscape' format (Reynolds probably turned a standard half-length 'portrait' canvas – like the one on his easel – on its side). It surely shows him straining to see in the blazing Mediterranean light, scanning vast new cultural horizons.

Sir Joshua Reynolds, *Self-Portrait*, 1775, oil on canvas

Sir Joshua Reynolds, *Self-Portrait*, 1747–9, oil on canvas

Is this the earliest consciously sublime self-portrait? The first translation of Longinus's Greek treatise *On the Sublime* (AD third century) had appeared in French in 1674, and the English critic and portrait painter Jonathan Richardson concluded the second edition of his *Essay on the Theory of Painting* (1725) with a chapter on the sublime – nature or art that inspired fear and awe by its measureless grandeur. This treatise was one of the inspirations for Reynolds to become an artist. Richardson regarded a portrait as 'an Abstract of one's life'. In the 1730s, while in retirement, Richardson drew daily self-portraits that are strikingly candid (the practice recalls the daily letters in an epistolary novel), and painted a self-portrait juxtaposed with his own son and the 'sublime' poet John Milton. Richardson had invented a new genre – what we might call the 'tracker' self-portrait.

For Richardson, the sublime painter 'must be perpetually Advancing'. The sublime 'Ravishes, it Transports', and 'like a Tempest drives all before it'. When it appears it is as 'the Sun traversing the Vast Desert of the Sky'. It 'disdains to be Tramell'd, it knows no Bounds'. It is like going 'on a great Expedition'.[6]

Jonathan Richardson, *Self-Portrait Wearing a Cloth Hat, c.* 1730–5,
black chalk heightened with white chalk on blue paper

This self-portrait certainly evokes sensations of boundlessness and immensity.
Reynolds is turning away from puny half-length (self-)portraiture, yearning to
produce something truly epic. A pained awareness of the limitations of easel
painting – and of what Hogarth derisively termed 'face-painting' – is implied.
Yet portraiture – aggrandized by classical references and by heroic scale – would
always remain Reynolds's bread and butter.

To understand how Hercules became *the* model for the heroically conflicted
artist we need to turn to the influential and famously pedantic essay by the
English political philosopher and aesthetician Anthony Ashley Cooper, Third Earl
of Shaftesbury. *A Notion of the Historical Draught or Tablature of the Judgment of
Hercules* (1713) was written in the form of incredibly detailed instructions for the
Neapolitan painter Paolo de Matteis, from whom Shaftesbury had commissioned
a large picture of *Hercules at the Crossroads between Virtue and Vice*, of which three
versions, and a print, are known.[7]

For Shaftesbury, it was essential for the painter to depict a single 'pregnant moment' that both recalled the past and prophesied the future. Shaftesbury identifies four 'moments' in the story that could be depicted, but he opts for the third because it represents the peak of psychological drama, when Hercules 'is wrought, agitated, and torn by contrary Passions.... He agonizes, and with all his strength of Reason endeavours to overcome himself'. Shaftesbury goes on to describe in forensic detail what Hercules does during this key transitional moment. His body moves much slower than his mind, with the exception of 'the Eyes and Muscles about the Mouth and Forehead'.

With his minutely nuanced proscriptions, Shaftesbury established the depiction of the 'pregnant moment', and the subtle play of mixed emotions, as a central goal for great art. [8] Shaftesbury claims that the flicker of emotions and sensations will be 'easily comprehended', and thus subject to reason, but his proto-novelistic addiction to piling physiognomic and psychological nuance on nuance makes this all but impossible. He even believed that those with self-knowledge acquire 'a peculiar speculative habit, so as virtually to carry about with them a sort of pocket mirror, always ready and in use'. [9] No doubt Shaftesbury's interest in closely observing the ebb and flow of consciousness influenced Jonathan Richardson's diet of daily self-portraits. But we are not that far from David Hume's *Treatise on Human Nature* (1739), where the self is defined as 'nothing but a bundle or collection of different perceptions, which succeed each other with an inconceivable rapidity, and are in a perpetual flux and movement'. [10]

The Irish-born painter James Barry (1741–1806) was the great exponent of the embattled self-portrait, and has become the Romantic-era symbol of thwarted and misunderstood genius, a would-be giant in an age of pygmy painters. He insisted that only a hero should be permitted 'to commemorate a hero', [11] and accused the British government of neglecting history painting because of a preference among patrons and the public for portraits, which had corrupted artists. The 'real artist' had to stand firm against 'fraud and wrong'. Whether 'we [artists] are martyrs or conquerors, can be no part of our concern'. [12] Barry had become Professor of Painting at the Royal Academy in 1782, but was expelled in 1799 because of the stridency of his lectures and public criticism of artists, patrons and the public. The rest of his life was spent in poverty and increasingly paranoid isolation: he believed Royal Academicians were plotting to kill him.

Paradoxically this reputation as a doomed artist has been cemented not by his epic history paintings, which then as now had a lukewarm reception, but by five 'passion-beaten' self-portraits (to use the adjective coined by an Irish

contemporary to describe his character).[13] In four of these self-portraits he places himself in direct relation to Hercules, so situating himself at an existential cross-roads, both agonized and ecstatic.

His earliest surviving self-portrait, painted in Rome in *c.* 1767, is as impressive a calling card as Reynolds's youthful self-portrait shielding his eyes. Barry depicts himself with his back towards us painting a double portrait of two artist friends, Dominique Lefèvre and James Paine the Younger. The heads of the three artists are loosely aligned and form a wave that dips then rises up to the obscure object of their desire. They are shown admiring the greatest of antique fragments, the *Belvedere Torso*, whose modern fame and unrestored state owed much to the admiration of Michelangelo. A frontal glimpse of the *Torso* is shown hovering overhead in the top corner of the picture. It was displayed at the time in a small room in the Vatican surrounded by railings, and there was a cast in the French Academy in Rome, but here it has been elevated for overwhelming dramatic effect. Paine is in the foreground making a painting of it, while Lefèvre (a member of the French Academy) gazes up enraptured, clutching a portfolio of drawings. Barry's picture-within-a-picture appears unfinished, almost painted in grisaille, which makes everything appear disembodied.

The *Torso* was believed to be a depiction of Hercules, and the German antiquarian Johann Joachim Winckelmann in his *History of Ancient Art* (1764) had given a characteristically evocative and fanciful account. Despite being 'abused and mutilated', it appears 'in a blaze of its former glory':

> the artist has figured a high ideal of a body raised above nature, and a nature of virile maturity elevated to a state of divine contentment. Hercules appears here as if he has purified himself by fire of the slag of humanity and attained immortality among the gods.[14]

Barry, too, gives us an elevated and dematerialized Hercules, and the spectral quality of the picture suggests the sculpture purifies any human that comes into its orbit. The back and side views of the *Torso* were as admired as the front, and by showing himself from the back, Barry strives to become a living embodiment of the *Torso*.

Yet Barry turns his head sharply, down and towards us, in a surprising and arresting gesture as though he has been distracted. It is not clear what he is looking at. If he were looking at his artist friends, so he can paint them, why would he position them behind him? And if he were looking at himself in a mirror, would

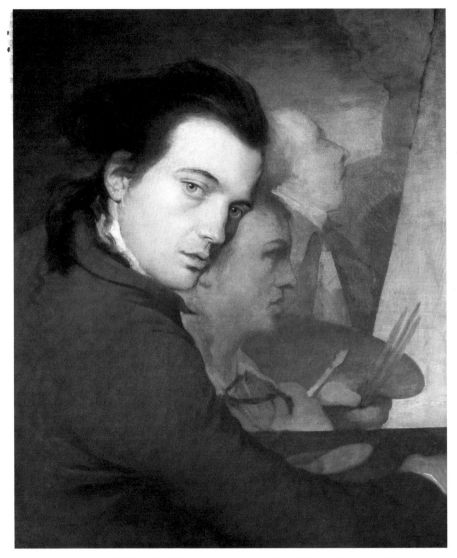

James Barry, *Self-Portrait with Dominique Lefevre and James Paine the Younger*, *c.* 1767,
oil on canvas

this mean he has already finished the spectral group portrait on his easel? Or have *we* interrupted him?

The last two proposals seem the more credible, for Barry belongs more to the material world than the spectral world of the *Torso*. He has spent more time painting himself than his picture-within-a-picture. A stooping figure, he is marvellously incarnated in his delicately flushed face, piercing yet sad eyes, tremulously parted lips, back-swept flowing black hair, with a rippling lock pouring into the gap between his jacket and white shirt collar. Overall, Barry's head is one of the most tautly sensuous pieces of painting in all British art.

Barry's first patron was his compatriot Edmund Burke, whose *A Philosophical Inquiry into Our Ideas of the Sublime and Beautiful* (1757) had influenced his decision to become a history painter. Barry is clearly drawing a contrast between the 'sublime' background scene, and the 'beautiful' foreground self-portrait. He is hesitating at the crossroads, unsure whether he can commit himself wholly to the high abstract ideal of history painting, and turn away from the 'low' sensuous immediacy of art made using the 'mirror of nature'. Winckelmann had criticized the poor standard of modern studies of the *Torso*: they are 'but weak reflections of the original' because its contours 'that rise and fall like waves' defeat accurate depiction.[15] Is not Paine, with his blank canvas, suffering from painter's block, paralysed by its greatness? Barry is dramatizing a similar dilemma that confronted Reynolds. It is a choice between being a myopic portrait painter or an epic Michelangelo.

Barry's fellow Royal Academician the Anglicized German artist Johan Zoffany (1733–1810) was equally torn by contrary passions, but sexual torment plays a far more important part.[16] In 1778–9 he produced a trio of extraordinary self-portraits while working in Florence and Parma that are thematically connected. This outpouring was prompted in part by spending a great deal of time in the Uffizi, for in 1772 he had moved to Florence to paint for the English Queen Charlotte his radiantly detailed *Tribuna of the Uffizi* (1771–8), showing groups of connoisseurs and members of the nobility admiring works of art in the Uffizi's foremost gallery, depicting himself among the art lovers. At this time, foreign artists and patrons showed great interest in the self-portrait collection. The Florence-based English patron Lord Cowper commissioned Giuseppe Macpherson to make 223 miniature copies, which Cowper presented to George III.

Zoffany, a Catholic, had come to England with his wife in 1760, and made his name with his portraits and theatrical pieces commissioned by David Garrick. Portraits of the royal family led to King George III nominating him for the newly

founded Royal Academy, and the Florentine commission from the Queen. Zoffany's wife had returned home soon after his arrival in London, probably because of his womanizing, but they were never divorced. His pregnant teenage mistress went with him to Italy, and he passed her off as his wife. He spent several years in Florence and Parma, receiving many prestigious commissions and honours.

Zoffany had urged the Grand Duke of Tuscany to ask Reynolds for a self-portrait in 1773, which was promptly supplied. When it arrived, Zoffany apparently ran to embrace it. But it was later claimed he encouraged local artists to find fault with it. Recent commentators have cast doubt on the story, though the

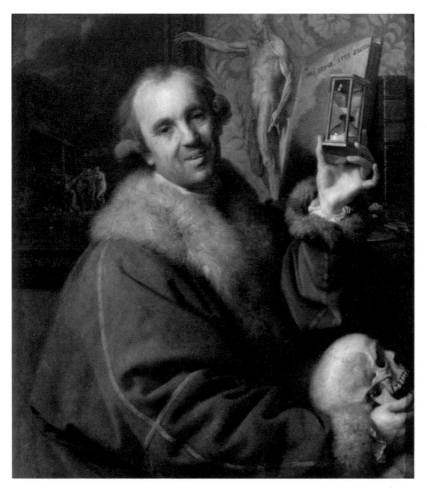

Johan Zoffany, *Self-Portrait with Hourglass*, 1778, oil on canvas

self-portrait submitted by Zoffany to the Medici collection in 1778 could almost be a parody of Reynolds's portentous offering. Artists queued up to copy Zoffany's picture as soon as it had been delivered, and a colour engraving was included in Carlo Lasinio's illustrated catalogue of the collection in 1789.

The silver-haired artist sits enveloped in a voluminous fur-lined painting robe. There is a Venetian opulence and insouciance about the pose and costume. But he is hemmed on all sides and overhead by a cacophony of allegorical props, relating to art, death, religion and sex. Zoffany's right arm cuts right across the foreground, the seams on the sleeve of his coat making a large cross pattern – an indication of the criss-crossing we have to perform to read the picture, as well as a 'cross he has to bear'. His hand cradles a grinning skull. Behind the hourglass on a table is a folio sketch book inscribed 'ARS LONGA VITA BREVIS' (Art is long but life is short), and next to it a volume of Pliny's *Natural History*, probably a modern edition containing the sections on ancient art.[17] Standing by is another symbol of mortality, a version of Jean-Antoine Houdon's flayed *écorché* figure of John the Baptist (Johan's name saint), first made in 1767 and a standard prop in artists' studios. The Baptist reaches out his right arm as if to bless/baptize the painter, and also to point to the large landscape painting on the wall behind. This depicts a kneeling monk in a wild, Salvator Rosa-style landscape. He is being tempted by three naked beauties.

Zoffany has an unforgettable mobile expression on his face, which has been called a rictus. He throws his head back and to the side, his mouth ajar to reveal an uneven top row of white teeth. This recalls the heads of celebrated antique pathos figures such as the *Laocoön* displayed in the Vatican, and the *Dying Alexander*, which was acquired by the Medici. But there is a wistful twinkle in Zoffany's eye, and a faint smile on his lips, which makes his expression disconcertingly enigmatic. Is he laughing, like Democritus, at human folly? Or is he nervously smiling at his own inability to turn his back on temptation in the form of women, fur trim and pagan antiquity?[18] The French art theorist Roger de Piles (1635–1709), who wrote the first detailed discussion of portrait painting, had criticized 'unnatural' faces assembled from disparate parts where 'the mouth is smiling, and the eyes are sad'. The treatise in which this passage appears was translated into English in 1743.[19] But Zoffany's self-portrait turns the tragi-comic facial assemblage into high art.

⁓

Not even Zoffany's 'rictus' can quite prepare us for the self-portrait busts of the Austrian sculptor Franz Xaver Messerschmidt (1736–83). More than any previous

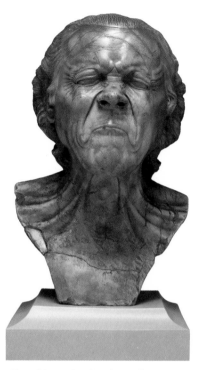

Franz Xaver Messerschmidt, *The Vexed Man*, 1771–83,
alabaster

artist, he believed that self-portraiture had a vital therapeutic and empowering function. The presence of his self-portraits proved he had battled heroically with his demons and, if only momentarily, vanquished them.

On the sculptor's death, sixty-nine busts were found in his studio. His brother subsequently sold forty-nine to an entrepreneurial chef who organized an exhibition in 1793. This was the first-ever solo show of self-portraits, and one of the largest ever held. The exhibition was, however, staged in Vienna's old Municipal Hospital, as a kind of freak show (full-sized automata were also exhibited there).[20] They were displayed as a group on several occasions subsequently until being dispersed at auction in 1889, and they were later feted as precursors of Expressionism.[21] The heads were identified in the Hospital handlist as *Charakterköpfe* (character heads), with exciting genre-scene titles such as *Childish Weeping, The Vexed Man, The Sinister Looking Man, The Enraged and Vengeful Gypsy, The Incapable Bassoonist* and *Grief Locked Up Inside*. We do not know who

gave them these melodramatic titles, which are still used today, but it is unlikely to have been the artist.

The traveller Friedrich Nicolai visited Messerschmidt in 1781, and his detailed account, published in 1785, was the first discussion of a group of self-portraits to appear in print. He said they were 'grimaces' made by the artist after pinching himself in front of a mirror – the term 'grimace-heads' would give a better sense of their involuntary, visceral qualities. Then as now anyone seeing the heads en masse would have found them both perplexing, intriguing and repellent – none more so than *A Man Vomiting* and the *Beak Heads*, where the lips of a raised head are transformed into a cantilevered proboscis, possibly inspired by the protective 'beaked' masks worn by plague doctors. The artist is referred to in the title only once: *The Artist as He Imagined Himself Laughing*. This title was surely an attempt to suggest it was all a big joke at our expense, and that Messerschmidt was a caricaturist. But he was in deadly earnest, a holy fool rather than a wit.

Despite the extreme expressions and sensations depicted, often with shocking levels of naturalism, they manifest a high degree of 'self-control'. Each head is perfectly frontal and symmetrical, with the small variations in crow's feet and wrinkles probably being accidental. The French painter and designer Charles Le Brun had made an influential illustrated treatise on expressions in the late seventeenth century, in which the faces are symmetrical, but the drawings are schematic outlines, and thus somewhat disembodied. Messerschmidt's 'grimace-heads' are fully embodied. The symmetry, polished finish, usually a drab alloy of tin and lead, and stylization of details such as hair and eyebrows, make them resemble masks, gargoyles, decorated parade helmets and grotesque finials.

Messerschmidt had established himself as an independent sculptor in Vienna in the 1760s, making portrait busts and religious works in the prevailing Baroque style. In 1765 he spent several months in Rome (dressed as a labourer he had strode up to the *Farnese Hercules*, and then carved a 'splendid' version out of 'misshapen' limewood). On his return to Vienna he added a severe Neoclassical bust in Roman style to his repertoire. His portrait head of the art critic Franz von Scheyb – symmetrical, pupilless and truncated at the neck – was the first work of its type to be made in Vienna.

The five years following Messerschmidt's return from Rome marked the zenith of his fortunes. He received several prestigious commissions from the court, and in 1769 he became a member of the Vienna Akademie. A year later he bought a large house, but by the following year commissions had dried up and he was plunged into financial difficulties. In 1774 he had to sell his house and was refused

a professorship at the Akademie because of his 'deranged behaviour'. He moved to Bratislava to be with his brother in 1777, and made portrait busts and reliefs. Despite being regarded as very eccentric, and the subject of all sorts of rumours, he continued to receive some commissions – and visits from curious sightseers. His 'straight' work shows no signs of mental or physical deterioration. Messerschmidt is thought to have begun the 'grimace-heads' in around 1771, when in his mid-thirties, and at about the time when he started having hallucinations. But the vast majority were probably made in the last six years of his life.

In Vienna, Messerschmidt had frequented spiritualist circles, which were the height of fashion. The English traveller Sir Nathaniel Wraxall visited Vienna in 1779 and was told there were three thousand practising alchemists and found widespread interest in freemasonry: 'Princes, ministers and general officers of distinguished reputation' were not ashamed to be initiated and attend 'nocturnal meetings for the purpose of invoking and raising apparitions'.[22] The German physicist and writer Georg Christoph Lichtenberg saw Garrick perform *Hamlet* three times on a visit to England in the early 1770s, rating the ghost scene 'one of the greatest and most terrible which will ever be played on any stage'.[23] Even sculpture was being 'spectralized' by the European fashion for nocturnal visits to sculptors' studios and galleries to experience works by lamp and torchlight.[24]

Messerschmidt's spiritualist circle in Vienna was interested in all things Egyptian. They believed that the ancient Egyptians possessed secret knowledge, and that Egyptian sculptors, by making a statue in perfect proportion, animated it with a divine spirit.[25] The sculptor began to think, in quasi-astrological terms, that everything in nature and in art was governed by a secret system of proportions and correspondences. If he felt a pain in his lower body while working on a particular area of a bust, it was because the nose, ear, etc. 'corresponded' to the place where he felt the pain. His interest in Egyptian sculpture may have been prompted by the printmaker, designer and polemicist Giovanni Battista Piranesi, whom he could have met in Rome. Piranesi praised the eclecticism of Roman art and architecture, and above all its appropriation of Egyptian motifs. Messerschmidt would certainly have seen Piranesi's pioneering Egyptian-style wall decoration for the Caffè degli Inglesi, with Egyptian statues placed in fictive windows.[26] He hung a drawing inspired by Egyptian statues in his studio window, and claimed its proportions were the model for those of the human body. Sunlight and moonlight shining through the drawing would have animated it.

But Messerschmidt believed the Spirit of Proportion had become jealous of his discoveries, and had started to cause him pain. The only solution was to

pre-empt and master the pain by pinching himself every thirty seconds 'especially on his right side amid the ribs'. The right side is traditionally the virtuous and strong side, and pinching himself there caused him to grimace but always with the requisite 'Egyptian proportion' (we can assume the Spirit of Proportion pinched him on the weaker left side). He stood in front of the mirror and recorded for posterity the expressions he made. He discovered a total of sixty-four (2^6 or 8×8) grimaces with 'Egyptian proportions'.

Such grimaces may have had a sexual component, and the 'pinching fights' code for masochistic masturbatory practices. The self-portrait busts would then be a record of his Herculean attempts to control his 'vicious' libido. Goethe's *Sorrows of the Young Werther* (1774) showed the disastrous suicidal consequences of a cult of total amorous spontaneity that does not have a creative outlet – 'if only you could express all this…creating there a mirror of your soul'. Messerschmidt's busts are, as it were, mirrors that channel his emotions. Nicolai describes the sculptor as a 'melancholy Pietist' who 'places his entire faith in an imagined rebirth'.

Silence is a crucial component of that striving for self-control. In several works, the mouth is clamped shut, either through the lips being sucked in or pushed out, or through a mysterious horizontal band of material being 'taped' across the mouth. For Winckelmann, silence was a condition of supernatural beauty and perfection, and a characteristic of Greek sculpture.[27] More generally, silence was an inherent property of the visual arts, and in antiquity they were called 'silent poetry' (because poetry was read aloud or sung). Cesare Ripa's allegorical figure of Painting has her mouth gagged. So in these works Messerschmidt strives to maintain stoical silence and symmetry against all the odds. Even in the open-mouthed works, he may have envisaged silent screams.[28]

Messerschmidt's ability and desire to maintain control over the most extreme facial expressions, with each expression held only for a few seconds, recalls a famous account of an acting exercise performed by David Garrick, probably in silence. The French writer Diderot described it in the *Paradox of Acting* (1769):

What I am going to tell you is something I witnessed myself. Garrick put his head through the gap between two leaves of a door, and in the space of four or five seconds his face passed successively from wild joy to moderate joy, from joy to composure, from composure to surprise, from surprise to astonishment, from astonishment to sadness, from sadness to gloom, from gloom to fright, from fright to horror, from horror to despair, and then back again from this final stage up to the one from which he started.

So far, so David Hume. But Diderot believed Garrick was entirely master of these emotions, and so separate from them:

> Was his soul capable of feeling all those sensations and of collaborating with his face in playing of that scale, as it were? I don't believe it for a moment, and neither do you.[29]

Is Messerschmidt an actor trying to stage-manage the facial scales, thereby triumphing over sensation?

The violent switchbacks of emotion and sympathy that were so fashionable in this period are also exemplified by the struggles Francisco Goya (1746–1828; see also Chapter 8) went through to produce a frontispiece self-portrait in 1799. In that year the Spanish painter and engraver published the *Caprichos* (Caprices), a series of eighty prints exposing human folly. He wanted to set himself up as a force for moral good, but like Hercules in Shaftesbury's 'third phase', he is forever adjusting his position to strike the right balance between fascination, indifference and contempt.

Goya announced his new project in a Madrid newspaper, writing grandly in the third person:

> Since the artist is convinced that the censure of human errors and vices (though they may seem to be the province of Eloquence and Poetry) may also be the object of Painting, he has chosen as subjects adequate for his work...those that he has thought most suitable matter for ridicule as well as for exercising the artificer's fancy.[30]

Goya initially planned to have as a frontispiece a version of what became *The Sleep of Reason Produces Monsters*. This print went through several metamorphoses, visual and conceptual, and had initially been planned as the frontispiece to a series of prints about dreams. The first version had 'Goya' asleep in his studio, slumped over his box of painting materials. To his left are giant fluttering bats and a prowling cat. The basic *mise-en-scène* derives from Dürer's print *Temptation of the Idler*, in which a scholar sleeps next to his stove, while a dragon-winged devil pumps bellows into his left ear, and a naked Venus holds out her hand to him. However,

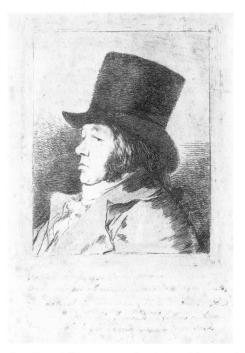

Francisco Goya, *Self-Portrait*, 1799, frontispiece of the *Caprichos*,
etching and aquatint

directly above the head of Goya's dreamer is a screaming face, and above that, regally presiding over the proceedings, is a spectral self-portrait of Goya: he looks over towards the bats, smiling wryly. This watchful spectre reflects Hippocrates's shamanistic notion that during sleep the soul wanders around and 'has cognizance of all things'.[31]

But in the revised version of the print, Goya got rid of the spectral self-portrait, and it is easy to see why. He looks too interested in the bats – they have taken the 'artificer's fancy'. He then added a caption – 'The author dreaming...'[32] – but this too called into question his own virtue (why is he dreaming this?). He finally opted to turn the dreamer into an anonymous symbol of unreason: *The Sleep of Reason Produces Monsters*. But the print that had caused him so much conceptual to-ing and fro-ing was relegated to the back of the book.

A new frontispiece self-portrait was provided, yet the artist remains at a moral and conceptual crossroads. We see him in surly left profile, encased in the heavy sartorial armour of big overcoat and helmet top hat. He glances surreptitiously

in our direction out of the tiniest corner of his left eye. This is a new kind of self-portrait in which an artist pretends not to be looking. He is having a joke at his own expense. His 'enigmatic' facial expression demands the forensic skills of a Shaftesbury. Preparatory drawings show Goya struggling with the downturn of the mouth, and eventually closing the left eye until it looks like a so-called 'lazy eye'.[33] But none of this can quite mask Goya's glee in the obscene.

The dilemma for Goya is that his desire to be a moralist does not always coincide with his 'artificer's fancy'. This was given its most famous formulation by William Blake in *The Marriage of Heaven and Hell* (1793), when he commented on Milton's *Paradise Lost*: 'The reason Milton wrote in fetters when he wrote of Angels and God, and at liberty when of Devils and Hell, is because he was a true Poet and of the Devil's party without knowing it'. Even Milton is now a Hercules at the Crossroads.

~

The St Vitus dance of self-portraiture climaxes in the print self-portraits of Baron Dominique-Vivant Denon (1747–1825). The French engraver, diplomat, author and museum director was that rare thing – a serial self-portraitist with a sense of humour. His large lithograph of 1818 trumps all previous serial self-portraitists by depicting Denon from cradle to near-grave. Whereas Jonathan Richardson made a daily self-portrait in retirement, Denon appears to have done so from birth.

Denon was made Baron as a reward for being Napoleon's roving cultural commissar and in 1802 the Director of the Louvre – which he immediately renamed the Musée Napoléon – with responsibility for artworks looted from foreign as well as from French collections. Denon had a sharp eye, and a finger on the cultural pulse. His admiration for Rembrandt's prints, which he collected and engraved, and his naked ambition, inspired him to make some of the most inventive self-portraits of his period, many of which were included in catalogues of his own engravings. In *c.* 1795, he made a *trompe-l'œil* composition showing six prints casually strewn on a flat surface, with his own dapper self-portrait in plumed hat overlaid by three Rembrandt prints, including a self-portrait whose edge cuts across his heart. In 1794, he published what was marketed as forty-five engraved self-portraits from the Uffizi, though many were not even in that collection, some were not self-portraits, and few were faithful to their painted models.[34] The saucy showman side of his personality appears in a circular self-portrait in nightgown and nightcap, in which he finger-wags the viewer/voyeur with a smirk on his

face.[35] He may have been aping some of the more grotesque and dissolute aspects of Rembrandt's character that were traditionally highlighted by critics, and reiterated in the Musée Napoleon catalogue – his ugliness, pompousness, sordidness and greed.[36] The confrontational self-portraits of Joseph Ducreux (1735–1802), yawning and pointing, are also crucial precursors.

The culmination of Denon's printmaking was a large lithograph entitled *Memories of Vivant Denon Evoked by Father Time*. Father Time flies across a winter landscape with a white sheet draped over his sickle. Two putti try to slow Father Time down, one snatching at his hourglass, the other pulling his arm. The sheet sports sixteen self-portrait heads jostling together in higgledy-piggledy Hogarthian profusion, like different faces in a crowd. This sheet is a new Holy Shroud, with Father Time as St Verónica. It shows the sixteen 'stations' of Denon from breastfeeding babyhood through to blind decrepitude. The Raphaelesque baby sports the unmistakable wry Denon smile. He implies he *was* the ultimate child prodigy, and *is* a second childhood prodigy (a blind engraver).

Dominique-Vivant Denon, *Memories of Vivant Denon Evoked by Father Time*, 1818, lithograph

It is a parody of a series of twelve engravings by the German Riepenhausen brothers charting the life of Raphael, published in 1816: the series starts with Raphael as a newborn baby being presented by an angel to a Muse (?), and ends with his tragic death, surrounded by distraught friends and pupils. Like the restless and pluralist curator he was, Denon starts off in angelic Raphaelesque mode, and passes on through the more diabolical Rembrandt, Hogarth, etc. It is a stylistic 'Rake's Progress'.

~

Denon did not only make self-portraiture central to his own art. During his Directorship at the Musée Napoléon (1802–15), single self-portraits by ten paint-ers – five of whom were French – were hung in the Grande Galerie, and four by Rembrandt (a family portrait was mistakenly identified a portrait of Rembrandt's own family).[37] The emphasis on self-portraiture is strikingly different to that of the Paris Salon, founded in 1737 and suppressed in 1793 after the Revolution, which rarely included more than a single self-portrait, and often none at all.[38] The most prolific self-portraitist had been the genre painter Jean-Baptiste-Siméon Chardin, who exhibited three self-portraits entitled *Tête d'étude* in 1771, 1775 and 1777.[39] However, there had been a rise in 1791 (eight self-portraits) and 1793 (six self-portraits). The Royal Academy Summer Exhibition in London was little different, though there were some self-portraits in its members' rooms. Only one (unidentified) Reynolds self-portrait was ever exhibited, in 1790.[40]

The displays at the Musée Napoléon prompted a group of wealthy collectors and connoisseurs in London to organize a series of spectacular exhibitions, and these would include self-portraiture in an even more emphatic way. In 1805 they founded the British Institution for Promoting the Fine Arts in the United Kingdom. Funded by subscribers, it took a long lease on premises in London's Pall Mall, and held regular summer exhibitions of 'sublime' pictures by Old Masters and winter exhibitions of contemporary British art. Until this time Old Master exhibitions had been ramshackle affairs, generally thrown together in a rather ad hoc way and lacking in coherence.[41] When some contemporary artists complained there was too much emphasis on foreign Old Masters, a Reynolds exhibition com-prising 142 pictures was held in the summer of 1813, with two self-portraits from the 1780s along the west side of the middle room, placing the artist at the heart of his own exhibition. In the catalogue preface Reynolds was praised as a British Giotto who raised the nation's art from a 'state of degradation'.[42]

This was the first full retrospective exhibition given to a single artist. The most significant precursor was the survey exhibition of sixty-four works organized by portrait painter and miniaturist Nathaniel Hone (1718–84) in a rented room in 1775. Hone organized this after his painting *The Conjuror*, a satire on excessive veneration of the Old Masters (especially by Reynolds), was excluded from the Royal Academy Summer Exhibition.[43] Hone painted several self-portraits, and one or more would have been included in this pioneering exhibition – seemingly the first one-man show.[44] But it was probably not much more systematic than the displays put on in artists' showrooms.

The Reynolds exhibition coincided with the publication of a substantial biography written by the portrait painter James Northcote, who had been his assistant. Northcote was himself a prolific self-portraitist, usually depicting himself wearing a 'Titian cap'.[45] There is barely a mention of the self-portraits in the text of *Memoirs of Sir Joshua Reynolds* (1813), except for a passing reference to the Uffizi self-portrait. But there is a frontispiece engraving (in reverse) of the great early self-portrait of the late 1740s, and a momentous reference to the self-portraits in the 'alphabetical list' of the most important portraits:

Of Sir Joshua Reynolds himself
The portraits have been so numerous, as to bid defiance of enumeration.
These are all from his own pencil, with the exception of one by C G Stuart,
an American, one by Zoffanii, and one by Mr Breda, a Swedish painter.

For the first time, an artist is credited with having a veritable mania for self-portrayal that cannot be quantified; or else, credited with satisfying an insatiable demand for his self-portraits. There were many more busts and painted portraits than the three cited here.[46] Northcote then recommends the 'best engravings': most of the self-portraits had been engraved during his lifetime.

In the summer of 1814 and 1817, the British Institution held two exhibitions of historic British art, with numerous self-portraits, including two by Hogarth 'with the pug dog' (no. 94), and 'painting the figure of Comedy' (no. 97). Then in 1823, another retrospective of Reynolds was held, with sixty-three works, accompanied by a selection of works by European Old Masters. This included three self-portraits, two of which were identified in the handlist as follows:

42 Sir Joshua Reynolds; the first Portrait painted of himself
43 Sir Joshua Reynolds; the last portrait painted of himself

For the first time, an artist's career is, as it were, bookended by self-portraits. He starts, and ends, with himself.

In the European Old Master exhibitions held regularly at the British Institution, a few self-portraits were included, but despite there being many supposed Rembrandt self-portraits in British collections, only one was shown.[47] Rembrandt's self-portrait prints had been treated as a distinct category in the first (unillustrated) catalogues of his prints, published in 1751 and 1797, but the authors were embarrassed by their burlesque qualities, bizarre hairstyles and general grossness.[48] The first serious, though still guarded, discussion of the self-portraits as a group appeared only in 1876.[49]

Van Dyck was the only Old Master of whom two self-portraits were shown, albeit in separate exhibitions, but he was treated as an honorary Englishman: one of the self-portraits, from the Royal Collection, was included in the exhibition 'Portraits of Eminent British Men'.[50] Thus the British Institution established self-portraiture as well as portraiture as a peculiarly modern and British genre, and Reynolds as the world's first lifelong 'tracker' self-portraitist.[51]

We have explored the emergence during the eighteenth century of self-portraiture in which the artist is 'torn by contrary passions', from the high seriousness of Reynolds and Barry, to the demonic comedy of Zoffany, Messerschmidt, Goya and Denon. We concluded with public displays of multiple self-portraits in exhibitions in Paris and London.

By positing self-portraiture as something quintessentially British, the exhibitions at the British Institution touch on the theme of the next chapter: the self-portrait that speaks of rootedness and even nationality rather than of transience and travel.

8.

COMING HOME: INTO THE NINETEENTH CENTURY

DURING THE LATE EIGHTEENTH and nineteenth centuries many scathing yet nostalgic attacks were made on the current state of art and patronage. The critics practised or promoted a wide variety of different artistic styles, and they differed on the precise identity of the lost golden age that was aesthetically and morally superior, but they all cast doubt on the authenticity of modern art, artists and patrons.

Concern with authenticity is partly a consequence of changes in the art world during the seventeenth and eighteenth centuries. The rise of selling exhibitions open to the public, auction houses and dealers, and the proliferation of 'minor' genres such as portraiture, landscape and genre scenes, increased the dominance of portable artworks that were not site-specific and were often made on spec. The 'commercialization' of the art world brought new freedoms as well: artists could be less dependent on a single patron, whether aristocratic, ecclesiastical or – after the French Revolution – the State. But new kinds of self-portrait and new modes of display that emphasized integrity and rootedness would be devised to reclaim that lost authenticity.

In 1778 an aristocratic Englishwoman Anne Seymour Damer (1748–1828) carved a marble self-portrait bust that marks a turning point in the history of art, both because of its novelty and its unlikely destination. The stillness and

Gustave Courbet, *The Painter's Studio, A Real Allegory Defining Seven Years of My Artistic and Moral Life*, c. 1854–5 (detail), see page 198

Anne Seymour Damer, *Self-Portrait*, 1778,
marble

symmetry of Damer's bust is in marked contrast to the fidgetiness of most earlier eighteenth-century self-portraits. It exudes a firm sense of self. Yet it has scarcely been discussed in the modern literature either on self-portraiture, sculpture or women's art.

Damer was the daughter of a favourite cousin of the author and connoisseur Horace Walpole, and it was he who encouraged her to take up sculpture after the suicide in 1776 of her husband John Damer, Lord Milton, who had run up huge gambling debts. She had begun modelling in wax in her early teens.[1] Damer was a notable eccentric, known to stomp around the fields near her home with a hooking stick, dressed in a man's coat, hat and shoes. Her special forte was animal sculptures, which Walpole regarded as the equal of Bernini, but she also gave busts of the politician Charles James Fox (whose Whig politics she famously supported) and of Lord Nelson to Napoleon. When Sir George Beaumont bought Michelangelo's unfinished *Taddei Tondo*, she unceremoniously offered to finish it.

Even at a time when there were ever-increasing numbers of successful women painters, in both Britain and France, all producing numerous, generally glamorous self-portraits, Damer represented the height of novelty. There seems to have been something of a vogue for women trying their hand at modelling in clay,

for the actress Mrs Siddons apparently executed busts of herself and her brother. But carving was something else. James Dalloway wrote more about Damer than any other sculptor in his *Anecdotes of the Arts in England* (1800), noting that in antiquity no female sculptor 'had attained to excellence sufficient to be recorded'.[2]

Damer may have made sculptures of kittens and lap dogs, but there is nothing fluffy about her over life-size self-portrait bust (with a height of some 60 cm; 23⅝ inches). It is severely symmetrical and frontal, the short hair split into neatly regimented flame-like clumps, the face impassive and streamlined, eyelids lowered meditatively rather than meekly, lips fractionally parted with the hint of a very superior smile. She wears a round-necked linen *peplos* (the garment of ancient Greek women), and the base of the bust is cut into a clean 'U' shape that excludes her breasts. She wants her viewers to be unsure of her gender, and she looks boyish. A Greek inscription on the trapezoid pedestal (written by Damer, who studied classics) identifies her as the maker (and the heir to Greek sculptors), as does another brief inscription behind the head. It seems to be the first frontal and symmetrical marble portrait bust since late antiquity, when Roman portraits busts took on some of the hieratic qualities of Egyptian art, and one of the first of many such Neoclassical busts.

Narcissus – traditionally regarded as a deluded loser – had recently become a model for rooted self-knowledge and contemplation. In the preface of 1757 to Jean-Jacques Rousseau's comedy *Narcisse, ou l'amant de lui-même* (Narcissus, or the lover of himself), egoism is compared unfavourably to self-knowledge – the preserve of Narcissus. By self-knowledge Rousseau did not mean understanding the nature of mankind in general – the traditional meaning – but of one's own individual self. Equally pertinent to Damer's bust is a passage in Edward Young's *The Complaint, or Night-Thoughts on Life, Death and Immortality* (1745), where Narcissus and Cain are exemplars of Virtue and Vice. While Cain is on the move and hopelessly impressionable – always, as it were, at Shaftesbury's crossroads – Narcissus is quietly steadfast and self-contained, like Dante's Rachel:

Man's greatest strength is shown in standing still...
The true is fix'd, and solid as a rock...
[Virtue], like the fabled self-enamoured boy,
Home-contemplation her supreme delight;
She dreads an interruption from without,
Smit with her own condition; and the more
Intense she gazes, still it charms the more.[3]

Damer's bust is a perfect illustration of Young's Virtue, and makes a stark contrast to other more Cain-like contemporary self-portraits, including those by successful women portrait painters. Angelica Kauffman, Elisabeth Vigée-Lebrun and Adélaïde Labille-Guiard dressed up fashionably, apparently happy to be the object of the admiring gaze. Damer is unaware of admirers for she only performs 'home-contemplation'.

Equally remarkable is the fact that her bust was made for the Uffizi collection, when Damer stayed in Florence in 1778–9.[4] It was to be the only sculpture in the self-portrait collection until the twentieth century. One can only imagine the irritation of male sculptors when an aristocratic part-timer was admitted, but her novelty value as a woman sculptor must have prevailed. No doubt some might have complained it was far easier to carve a symmetrical bust, but post-Damer full-frontal, symmetrical, 'solid-as-a-rock' self-portraits, often with transfixed 'eyes-front' gaze, became common. John Flaxman made two such reliefs (with lanky locks) in 1779; there are hieratic drawings by Jakob Carstens (1784) and Goya (1790s); Bertel Thorvaldsen made a bare-shouldered marble bust in 1810. Portraits were also made in this format – notably Chaudet's and Houdon's bare-shouldered busts of *Napoleon* (1804 and 1806). This vogue created the climate in which Dürer's hieratic self-portrait of 1500 could be rehabilitated, becoming the iconic image of the artist. In 1811 the first reproductive print appeared, but with the right forearm lowered to make the image completely symmetrical.

Traditionally, symmetry had been the preserve of architecture rather than of sculpture or painting, and it was Goethe who made architecture central to his vision of a harmonious and stable society. In his hugely influential essay 'On German Architecture' (1772), he visits Strasbourg's medieval cathedral in search of the gravestone of its first architect, 'noble Erwin'. But no one can tell him where it is. Goethe wants to erect a memorial to this forgotten hero, but then realizes Erwin already has 'the most magnificent' memorial – the cathedral itself, which rises from German soil like a 'wide-spreading tree of God'.[5] Goethe sensed an organic relationship between the medieval architect, his building and the place, which had been lost in modern times.

The finest German self-portrait to respond to Goethe's clarion call is by the messianic landscape painter Philipp Otto Runge (1777–1810). He is best known for an uncompleted four-part cycle, *The Times of the Day*, with complex

allegories and hallucinatory detail that he hoped would be a 'total work of art', stimulating all the senses. But he was also a penetrating portrait painter of family and friends, and a prolific self-portraitist. About seventeen self-portraits survive, mostly close-up, bust-length drawings, with the artist's head sharply turned to look hypnotically over his shoulder at the viewer. Runge was in close contact with Goethe until his early death in 1810, corresponding with him about his art and particularly his ideas about colour, and in 1806 sent him a haunting self-portrait drawing with some silhouettes depicting the growth of plants.[6] Goethe himself had made several self-portrait drawings.

We Three (1805) is one of a number of remarkable family portraits painted after Runge returned to Hamburg (his childhood was spent along the coast). The picture, created as a gift for the artist's father, was destroyed by fire in 1931, but is known from colour photographs. It is in landscape format, with the three family members depicted in half-length. Runge shows himself standing in a shady

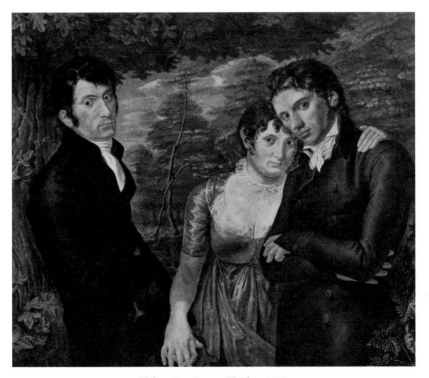

Philipp Otto Runge, *We Three*, 1805,
oil on canvas (destroyed 1931)

nook in woodland beneath the 'wide-spreading' branches of an oak tree, his body brushed by leaves, with 'naturally' tousled hair. His head rests on that of his wife Pauline, who hugs him. On the other side, his brother Daniel leans his back against the gnarled bark of the oak tree, holding hands with Pauline. Its structure evokes Hercules at the Crossroads, with Pauline as Hercules. But although she has chosen Philipp, she maintains unbreakable intimate contact with Daniel. They all look out at us unsmilingly, rather than towards each other, and it is hard for us to know who is the artist.[7] Their rootedness, and the intensity of their bond with each other and with nature are expressed silently, solely through rough, smooth, and even clammy forms of touch.

We Three exemplifies Runge's belief that art is a secret 'family language', incomprehensible outside the family circle.[8] Whereas earlier self-portraits with family members by, say, Rubens, and by many late eighteenth-century artists, had emphasized the worldly success and ease of the artist, during the nineteenth century family and friends can take on the characteristics of an incestuous sect.

Where Runge insists on being lovingly embedded in family and nature, Francisco Goya (1746–1828) insists on being embedded in his art. He is the first artist to be obsessed – almost *ad absurdum* – with demonstrating the intimacy of his relationship to his art. In some of his early self-portraits in which he shows himself either in the process of painting, or with a canvas on a stretcher, he lays claim to them as physical objects. The intensity with which Goya wanted to stamp his imprint on his own work must in part have been due to the machine-age speed with which he worked, and the generally small scale. Over six decades, he produced around 700 paintings, 900 drawings and 300 prints.

From 1774–92, Goya was employed at the Royal Tapestry Factory in Madrid producing cartoons (sixty-three in all). By the 1780s he had also begun to establish himself as a portrait painter, and between 1780 and 1783, in his mid-thirties, Goya inserted himself into four important pictures: he appears as a bystander in an altarpiece, beneath a crucifix held out by St Bernardino of Siena; as a smirking bullfighter in a tapestry cartoon; and as a painter in major portraits of the Secretary of State, the *Conde de Floridablanca* (1783), and of *The Family of the Infante Don Luis* (1783), the King's brother. He also painted an independent self-portrait.

In both portraits, and in the independent self-portrait, he shows himself with a canvas, so that no one can doubt he is the painter. The influence of Velázquez's

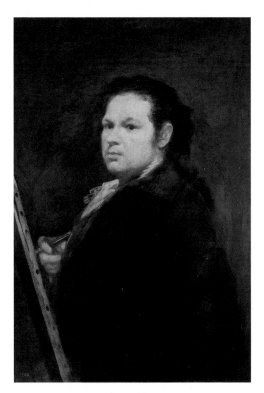

Francisco Goya, *Self-Portrait*, 1783,
oil on canvas

Las Meninas must have played a part. Goya had made the first-ever reproduct-
ive print of it in 1778, extremely hazy in style as if trying to evoke its age.[9] But
whereas Velázquez stands well back from his picture-within-a-picture, and leans
away from it, Goya engages bodily with his own canvases – carrying them, touch-
ing them, casting his shadow over them like Vasari's Gyges.

In his half-length *Self-Portrait* (1783) we see him in left profile, his brightly
lit face half looking towards us. He is a portly figure, and his distended stomach
presses up against an inclined canvas, whose nailed edge is visible. His right hand,
holding a porte-crayon, is jammed between his chest and the canvas, as if about to
pin it or cut a hole through it. Although the canvas 'rises' directly from his groin
area, it is not phallic. Goya is deadpan rather than aroused. He might be putting
on a sandwich board or corset. Where Titian, Rembrandt and Velázquez used
their fingers to paint, Goya uses his whole body. Philosophers in the eighteenth

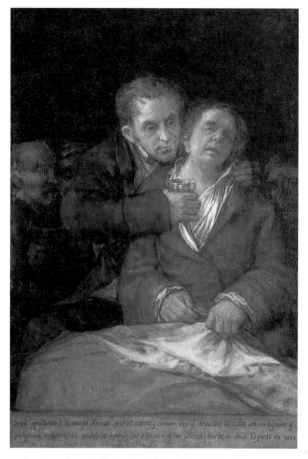

Francisco Goya, *Self-Portrait with Dr Arrieta*, 1820, oil on canvas

century had idealized the sense of touch, considering it the most truthful sense and the one most used by children. Goya exemplifies this, making the canvas a prosthetic architectural exoskeleton.

In *Self-Portrait in the Studio* (1790s) he stands with his back towards a large light-shot, multi-paned window, a darkly sublime apparition beadily scrutinizing us. Armed with palette and brush, he seems to take a big step towards a large canvas on our left. This is not a realistic studio set-up because the light from the window is dazzling, and would make Goya's own shadow fall darkly and fully over the picture he is painting – surely the viewer's portrait. But nothing can stop him haunting and inhabiting his own picture.

Typically, when he portrays an aristocratic painter in her studio, the Marquise of Villafranca, he distances her from her artwork. She sits holding her painting implements in a throne-like armchair, but with her back to the canvas. Only Goya can be on intimate terms with art, and he gets closer to his own canvases than his patrons will ever be. It has been said that the self-portrait is 'the one form of easel painting that resists being owned' because 'it is not about [the owner]' and it 'denies in its every detail that a mere owner has any right to it'; Goya makes this thought possible and extends it to all art.[10]

In his final self-portrait, *Self-Portrait with Dr Arrieta* (1820), painted as a gift for the doctor who saved his life, Goya's guardian angel puts his arm around him, tugs his white shirt, and tries to give him a glass of water. His feverish, sweaty patient sits up in bed tugging the white sheet. Goya's hair brushes the doctor's cheek. In the pitch-dark background a line of diabolical cadaverous heads wait in vain to receive Goya into their company. A long inscription along the bottom thanks 'his friend Arrieta' for saving his life when he was seventy-three years old. Here a self-portrait becomes a quasi-legal document that bears witness both to a friendship and a miracle of touch. The composition is clearly modelled on a *pièta*. This picture is Goya's Holy Shroud, the imprint of his Passion. And now he does not grasp a canvas; he tugs at a white sheet.

~

In Goethe's novel *Elective Affinities* (1808), an architect who is restoring a Gothic chapel in the grounds of a country estate asks the beautiful young girl Ottilie to help him repaint the interior. Ottilie, who has been orphaned, keeps a journal, and notes the architect's observations on the 'orphaned' status of modern art. The works of a sculptor 'desert him as the bird deserts the nest in which it was hatched' while the architect 'employs his whole mind and his whole love in the production of rooms from which he himself must be excluded'. Is it surprising that the artist becomes gradually alienated

since his work, like a child that has been provided for and left home, can no longer have any effect on its father? And how beneficial it must have been for art when it was intended to be concerned almost exclusively with what was public property, and belonged to everybody and therefore also to the artist![11]

It was just these kinds of complaint that gave rise to the one-artist museum in the artist's birthplace or adopted home – a fashion that continues to flourish. Many were dedicated to famous Old Masters. The headquarters of the Albrecht Dürer Association, founded in Nuremberg in 1817, were in Dürer's own timber-framed house, which had been bought in 1826 for the city by Dürer enthusiast Friedrich Campe, and passed on to the Association. This became the first one-artist museum, and the first major exhibition was mounted for the 1828 tercentenary of Dürer's death, celebrated in ten German cities.[12] The emphasis was much more on Dürer's supposedly impeccable life than his art. A bronze commemorative statue, with the head based on the 1500 self-portrait, was erected in the renamed Albrecht Dürer Platz in 1840. This was the first free-standing statue erected to an artist.

The most ambitious and influential memorial to a modern artist was the mausoleum and museum built for the leading artist of his time, the Rome-based Italian sculptor Antonio Canova (1757–1822). He had hoped to be buried in the Pantheon in Rome (near Raphael)[13], but when this plan was rejected in 1820, he designed his own Pantheon-style memorial in Possagno, the small rural backwater in the Veneto where he was born. Built on the site of a church dominating the town, the Tempio della Trinità was conceived as a 'total work of art', with Canova responsible for architecture, sculpture and paintings. The interior is presided over by a grandiose tomb and colossal self-portrait bust that looks across at one of his own altarpieces.[14]

Work carried on after Canova's death in 1822, energetically supervised by his stepbrother and heir, Bishop Giovanni Battista Sartori (1775–58). The Tempio was finished in 1830 and consecrated in 1832. Canova's body was interred in his tomb, minus the heart, which was buried in a spectacular tomb in Venice (one he had designed, but never executed, for Titian), and his right hand, which was preserved by the Venice Academy of Art.

In the Tempio, brotherly love was celebrated. The colossal marble self-portrait bust flanks the tomb he shares with his stepbrother, and a matching bust of Sartori by Canova's pupil Cincinatto Baruzzi balances it. Canova turns to his left, towards his large altarpiece, with raised enraptured eyes and lips slightly parted to draw breath. He is forever transfixed. Sartori looks horizontally to his right, towards the doorway, emphasizing his guardian role. No clothes compromise the severe Roman nakedness of their powerful necks and upper torsos. Canova's self-portrait bust had been made in 1812, probably in response to a similar-sized herm bust self-portrait made in 1810 by his Rome-based rival Bertel Thorvaldsen, who would establish a mausoleum-museum in his native Denmark (1839–48).[15]

Antonio Canova, *Self-Portrait*, bust (on right), 1812, marble, in the Tempio della Trinità, Possagno, in the tomb that he shares with his stepbrother Giovanni Battista Sartori, completed 1830

A vast museum, the Gipsoteca, was built to display Canova's full-sized plaster models, terracotta sketch models and sculptures from his Roman studio, as well a painted self-portrait. Completed in 1836, it was located next to the house where Canova was born. Canova's tools, sketch models, paintings, prints, and some of the many portraits made of the artist, were displayed in the family home, with the most important room being the one where he was born. The 'prodigal sculptor', together with his art and money, and most of his body, had come home.

The idea of the pantheon, devoted to a single artist of transcendent genius, would be given its greatest yet flimsiest expression by the French painter Gustave Courbet (1819–77). A serial self-portraitist, his self-exaltation would culminate in the most ambitious and evocative self-portrait ever made: *The Painter's Studio,*

A Real Allegory Defining Seven Years of My Artistic and Moral Life (*c.* 1854–5) At 3.6 metres high and nearly 6 metres wide (some 12 ft high and 20 ft wide), and with around thirty near-life-size figures, some famous, some anonymous, it dwarfed any previous depiction of an artist's studio (as did its title). The people encapsulate the seven years since 1848, the year of the revolution that led to France's short-lived Second Republic, after which Louis Napoleon gained power, becoming Emperor in 1852. Whereas previous depictions of a visit to the artist's studio, from Velázquez onwards, are relatively convivial affairs, Courbet seems oblivious of his visitors. He is busy painting a picture of a river valley in his rural home region – and this is where they must all go to save their souls.

Courbet's leadership of the Realist school was established by monumental, unflinching pictures of the rural poor such as *The Stonebreakers* (1849) and *A Burial at Ornans* (1849–50), but self-portraiture was the nerve and mood centre of his art. He is the first artist to write about his self-portraits. In 1854, he informed his patron Alfred Bruyas: 'I have done a good many self-portraits in my life, as my attitude gradually changed. One could say that I have written my autobiography'.[16] More studio photographs and caricatures were made of Courbet than any other nineteenth-century artist, and he probably painted more self-portraits.[17]

In the same letter, Courbet discusses the different moods manifest in four self-portraits, one of which – 'of a fanatic, an ascetic' – is being bought by Bruyas for

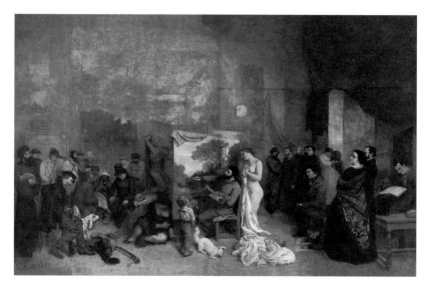

Gustave Courbet, *The Painter's Studio, A Real Allegory Defining Seven Years of My Artistic and Moral Life, c.* 1854–5, oil on canvas

two thousand francs. The self-portraits are a special category, direct proof of his desire to 'realize a unique miracle' and live a principled life 'without having made a painting even the size of a hand to please anyone or to be sold'. He is delighted his 'dear friend' Bruyas is buying his *Self-Portrait with a Pipe* (1849), which he claims he refused to sell 'in a period of utter poverty' to Emperor Napoleon III, and later, 'in spite of pressure from the dealers', to a Russian ambassador: 'It has finally escaped the barbarians'.

Courbet's first surviving self-portrait dates from 1840, and altogether he painted and drew about twenty-five, the vast majority by 1855, when he was thirty-six. Age-wise, they follow the traditional pattern, and he had no interest in tracking his physical decline, hastened by alcoholism. *Self-Portrait at Sainte-Pélagie* (1872–3) was painted while Courbet was imprisoned for participating in the Paris Commune (an insurrection to prevent the restoration of the monarchy). He depicts himself as a youthful pipe-smoking dandy, though contemporary reports describe him as grey-haired, haggard, barely recognizable.[18]

Courbet's father was a wealthy landowner in the rural region of Franche-Comté, on the border with Switzerland, and Courbet was brought up in Ornans, a small town about sixteen kilometres (ten miles) from the regional capital Besançon, where he trained before moving to Paris in 1839. Asserting his rural regional roots would be a central feature of his metropolitan art, but he insisted above all on his independence. His outsider/insider status owed much to a new invention: the steam train.

From 1843 to 1851 he included one or two self-portraits in every submission to the Salon, an annual exhibition of new art selected by a jury. Despite the great variety of activities being performed in the self-portraits – smoking, dying from sword wounds, committing suicide, dancing and sleeping al fresco with a beautiful woman, playing the cello – they are unified by the intensity of the sensory experiences. The tactile emphases we observed in Goya and Runge are taken to a new pitch. He makes us aware of the weight, shape and feel of his body – its relationship to the ground and solid matter more than its relationship to air and sky. He is frequently a victim of gravity – falling, flopping, lying, sleeping, usually ending up in positions no physiotherapist would recommend. He is perpetually rehearsing his dying fall and burial, dreaming of his body's merging with the soil (he would add sand to his paint) and his skeleton's discovery by a future Goethe and the development of a cult (in one self-portrait, he is an expiring medieval sculptor who has just been carving into natural rock). His staging of his own death has similarities with the first staged self-portrait photograph, Hippolyte Bayard's *Self-Portrait as a Drowned Man* (1840), made in protest against the government's

failure to support his new photographic process: 'no one has recognized or claimed the body'.[19] Many of Courbet's self-portraits are very dark, but not just to make them look Old Masterly. This is a nocturnal world, full of semi-conscious musings and strange groping hand movements. Courbet evidently liked the way looking into a mirror makes the right hand into a left hand: in one self-portrait he plays a cello (an instrument he did not play) left-handed. The untrained hand makes more authentic mood music.

Courbet's hands often touch his own body, but they seem to belong to someone else, checking he is still there and not just a figment or fragment. In five self-portraits (some perhaps made with a convex mirror), he touches his head or face, but the hand seems alien. In *The Desperate Man* (1844–5), a head and shoulders close-up in landscape format, both hands seem to travel without a map over his pop-eyed head. Is this me? Is this connected to a body? Or is it severed like the heads of Medusa, Goliath and Robespierre? The motif of the hand-clutched head is inspired by a head-grabbing, tormented, flayed figure that was then attributed to Michelangelo, a copy of which appears in two other self-portraits.

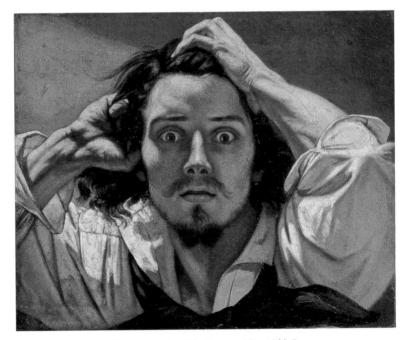

Gustave Courbet, *The Desperate Man*, 1844–5,
oil on canvas

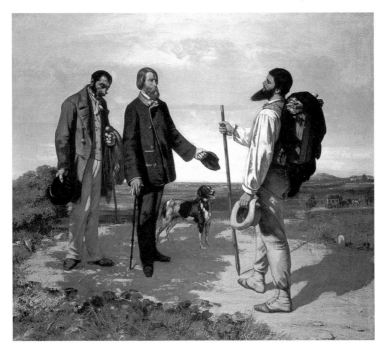

Gustave Courbet, *The Meeting*, 1854,
oil on canvas

Courbet's self-portraits could almost illustrate the definition of Romantic painting furnished by the philosopher Hegel in his *Lectures on Aesthetics* (1835). Hegel argued that the Romantic arts of painting and music could not only express ' the particular spirit of nations, provinces, epochs, and individuals', but also the subjective life of the soul – 'Grief, agony, both spiritual and mental, torture and penance, death and resurrection, spiritual and subjective personality, deep feeling, fear, love, and emotion'.[20]

Yet Courbet could also touch the ground commandingly and without bathos. When he wrote to Bruyas about his penchant for self-portraiture, his patron had just taken delivery of *The Meeting* (1854), in which Bruyas and his servant meet the great man out hiking on a country road. Bruyas was a banker's son from Montpellier who wrote about and collected contemporary art, and he believed Courbet represented the future. He commissioned his own portrait and a self-portrait from the artists he favoured. Courbet takes on the role of a bohemian nomad doomed to roam the earth, but free. Yet his feet are planted firmly on the

ground, and his incarnatedness is demonstrated by the fact that he, like Dante in hell, is the only entity to cast a shadow. Dante was idolized by the Romantics, and the painter Eugène Delacroix had attended a ball in 1830 dressed as the poet. Bruyas doffs his cap, a deferential Virgil. With his swagger, his cantilevered 'Assyrian' beard, and spilt shadow, Courbet is every inch the messianic artist whom Bruyas believed would lead the struggle for an 'elevated and serious' art.[21] His body language says '*noli me tangere*' – do not touch me, for I only touch the earth.

The Universal Exhibition of 1855 was the French answer to the Great Exhibition of 1851 in London, and propaganda for the rule of Emperor Napoleon III, who had taken power in a coup in 1851. Painting had been excluded from the London Exhibition, and so here at least the French could prove their supremacy, and the State's commitment to commissioning vast history paintings (they lagged far behind industrially). A survey of modern French art was planned, including retrospective solo shows for four grand old men of French painting – Jean-Auguste-Dominique Ingres, Delacroix, the battle painter Horace Vernet and the orientalist genre painter Alexandre-Gabriel Decamps. They had all been born in the last century, except for Decamps, who escaped by a whisker (b. 1803).

Courbet was invited to paint a large new commission for the show, but he turned the offer down when instructed to send in a sketch for prior approval. He still submitted a number of works, but after *The Painter's Studio* and the *Burial at Ornans* had been rejected (eleven others were accepted), he decided to go it alone. He had a tent erected on a piece of land opposite the Palais des Beaux-Arts, which he called the Pavilion of Realism. This one-man show is a milestone in the history of self-portraiture – and of self-publicity.[22] Never before had so many and varied self-portraits by a single painter been exhibited. The centrepiece of the group of thirty-nine canvases and two drawings was *The Painter's Studio*. The critic Maxime Du Camp was dismayed by what he saw: 'Courbet waving, Courbet walking…Courbet everywhere, Courbet forever'.

Visitors paid an entrance fee and received a booklet prefaced by a brief signed statement. The artist insisted: 'all I have tried to do is to derive, from a complete knowledge of tradition, a reasoned sense of my own independence and individuality'. Courbet hoped to make a profit from sales of tickets and paintings. But few came, and there was scant interest, even from the caricaturists – and even after Courbet reduced the entrance charge.

Courbet must have been mortified by the lukewarm reception accorded to *The Painter's Studio* – bafflement seems to have been the prevailing view.[23] To make matters worse, it explored a supremely fashionable subject. Fanciful paintings of

great Old Masters in their studios – with visiting lovers and royals – were very popular, and throughout 1854 the leading art journal *L'Artiste* published many detailed accounts of '*les ateliers de Paris*' (the studios of Paris).[24] Courbet's great contribution to the genre was rolled up after the exhibition, and put in storage until being sold at auction by his sister in 1881. It was used as a backdrop in an amateur theatre for twenty years before being bought by the Louvre in 1920.

It has a triptych format, with the artist at work painting a landscape in the centre. He explained the structure in a letter of 1864 to the art critic and realist novelist Champfleury.[25] On the right are 'the shareholders, that is, friends, workers and devotees of the art world…the people who serve me, support me in my ideas, and take part in my actions'. They included Bruyas (with whom he surely planned the work when he had visited him in Montpellier),[26] the poet Baudelaire, and various socialists. Those on the left represented 'the other world of trivial life, the people, misery, poverty, wealth, the exploited and the exploiters, the people who live off death'. They included a Jew, priest, clown, game hunter and other workers. Despite going into some detail about the cast, he confessed: 'it is fairly mysterious, it will keep people guessing'.

Courbet himself sits parallel to the picture he is painting, and so we see him in profile, his right arm raised to put the finishing touch to a straw hut in an untamed Franche-Comté landscape. He is observed from behind by a nude female model, whose clothes lie on the floor, and from the front by a little orphan boy

Gustave Courbet, *The Painter's Studio, c.* 1854–5
(details, left and right of the artist)

in clogs. Sitting on the ground to the left of the canvas is an Irish beggar woman with a swaddled baby, and behind her is an academic mannequin figure, hung in a martyrdom pose.

Delacroix visited the exhibition, and was so impressed he stayed for an hour, but although he considered the rejected picture a masterpiece, he wrote in his *Journal* that the landscape painting 'creates an ambiguity: it has the character of a *real sky* in the middle of the painting'. If Delacroix had visited Besançon's cathedral, he would have had a better idea of what Courbet was up to. For there, right in the middle of Fra Bartolommeo's *Carondelet Altarpiece* (*c.* 1511), the most famous artwork in Franche-Comté, is an Arcadian landscape seen through a doorway – though at first sight, it looks like a picture-within-a-picture.[27] The doorway is flanked by saints and the donor, Ferry Carondelet, Bishop of Besançon. He kneels in profile to the right, and gestures towards the Virgin and Child who are being wafted in through the top half of the doorway on a dark cloud, supported by putti. The landscape is populated by four small nude figures. The basic premise seems to be that with the arrival of Christianity, untamed nature will be civilized and pagans baptized and clothed. To the left of the doorway kneels John the Baptist in his hermit's rags, and standing behind him is an arrow-encrusted St Sebastian.

In *The Painter's Studio* Courbet takes the place of Carondelet as master of ceremonies, gesturing towards the landscape in the act of creating it. The Irish beggar woman substitutes for John the Baptist, and the mannequin for St Sebastian. But with *his* landscape, Courbet reverses the flow. Now, in its untamed state, the landscape is the redeeming object of desire. It must be entered, not exited – and to this end Courbet presses his body up against the canvas so that his right leg seems almost to step into it.[28] Imaginatively 'entering' landscape paintings had been a favourite fantasy for critics and viewers since the mid-eighteenth century – the most famous being Denis Diderot's forty-page travelogue, accompanied by an abbot, through the landscapes of Joseph Vernet exhibited at the Salon of 1765.[29]

The central trio of Courbet, model and child (and a white cat), inhabit the most brightly lit zone of the picture. Almost everything outside is more thinly painted and gloomily lit. The groups of figures either side of Courbet – the 'shareholders' and the 'trivia' – have a lugubrious spectral quality, and have been compared to sleepwalkers in a waiting room. They are like sinners in limbo or purgatory, waiting for their summons from Courbet (or, more prosaically, for their train to Besançon). Some of the figures on the left may have the facial features of political figures: the bearded hunter seated in the front with his

dogs resembles Napoleon III, the 'poacher' of the Republic. So politics, economics and culture are going to be reborn, with Courbet as the redeemer: in his letter to Champfleury, he said that here 'it is the world that comes to me to be painted'. In 1855, Baudelaire jotted down in his notebook: 'Courbet saving the world'.[30] But he is not saving his earlier pictures, big or small. Stacked and hanging in the background, they have faded irredeemably, drained of all vitality in the face of this landscape's effulgence.

∿

Few artists went to greater lengths to root themselves in primordial soil than the Dutch artist Vincent van Gogh (1853–90). From very early on, he aspired to be a peasant painter, living and recording the life of a peasant with religious fervour. He even collected the clothes of peasants and labourers. In a very early letter, about the early life of Oliver Cromwell in flat rural East Anglia, he observed that:

> The souls of places seem to enter the souls of men; often from a barren, dreary region there emerges a lively, ardent and profound faith.[31]

He identified with the more sentimental and heroizing peasant painter Jean-François Millet, rather than with Courbet. In 1885, he went to live in the rural village of Nuenen, and while there he wrote: 'I've never seen the house where Millet lived – but I imagine these 4 little human nests [pictures of cottages] are of the same kind'.[32] He praised the intense look of a Millet self-portrait in charcoal wearing 'a kind of shepherd's cap on top'[33] and agreed with a critic's remark that Millet's *Sower* seems 'painted with the soil he sows'.[34] Even from the asylum in Saint-Rémy, he would write to his mother – in reference to his thick impastos – 'I plough on my canvases as they do in their fields'.[35]

Van Gogh's first major bout of self-portraiture occurred when he lived in Paris from 1886–8. He painted himself over twenty times, gradually adopting the high-keyed palette and dabbed brushstrokes of the style that was called Neo-Impressionism. He was determined to use portraiture as a vehicle for self-expression – which he believed to be totally lacking in his *bête noire*, portrait photography: 'painted portraits have a life of their own that comes from deep in the soul of the painter and where the machine can't go'.[36]

Painting himself saved money – he did not have to pay the model[37] – but it also helped anchor him in an unfamiliar environment. He was now in a fast-moving

cosmopolitan world of artists and art galleries. He touched base, as it were, with his first darkly brooding self-portrait, for it was inspired by Rembrandt's *Self-Portrait with Easel* (1660) in the Louvre. Rembrandt had become *the* great exemplar of the down-to-earth, home-loving Old Master. He had apparently never travelled abroad, and was reputed to have preferred fraternizing with beggars rather than princes. In an extraordinary coloured print made at the time of the Dürer tercentenary, a Rembrandt self-portrait literally rises up from the ground next to a rickety house that was mistakenly believed to be his home. A plaque on the building shows a gardener digging.[38]

Rembrandt bookended van Gogh's Paris stay, for his last and most impressive self-portrait, *Self-Portrait at the Easel,* was inspired by the same Louvre self-portrait.[39] But now the painter stares blindly at the canvas with black-green eyes, a frozen zombified version of a hieratic Neoclassical bust. He looks literally petrified amid the splintery craquelure of brushstrokes, and the icy-white shimmer of the background. In Carel Vosmaer's *Rembrandt: Sa vie et ses œuvres* (1877), the first major biography, geniuses are said to be as 'isolated, colossal, and sometimes also

Rembrandt's Woning, 1828,
etching and aquatint

as bizarre and enigmatic' as sphinxes in the desert, or Celtic menhirs.[40] Van Gogh strives for this sort of menhir-like immovability.

On a more down-to-earth level, the picture was painted in January 1888, and he could not afford much heating. So it is also the first *frozen* self-portrait. On arriving in Arles in February, van Gogh said his blood was 'more or less starting to circulate again'.[41] In June, he told his sister that she may well consider this self-portrait the face of death.[42] But he is petrified less by his own circumstances than by his own genius – by the Medusa-stare of his own sensational picture. He also told his sister that it was much more profound than any portrait photograph.

Van Gogh went to the southern rural backwater of Arles to realize his dream of becoming a peasant painter, and with the hope of enticing like-minded artists to form an artists' colony. Having rented the four-room Yellow House, and set up a studio there, he invited Paul Gauguin to join him. They had met in Paris, but Gauguin was then in Pont-Aven, a favoured haunt of artists on the Brittany coast. Gauguin agreed, and van Gogh set about making what he called a 'Studio of the South', decorating it with pictures of 'connected and complementary subjects'. This was now the age of the 'house beautiful', where each object was carefully chosen to create harmony and to advertise the unique sensibility of the owner. Van Gogh's Yellow House is a budget version of William Morris's Red House, built for him by Philip Webb in 1859–60.

Van Gogh hung Japanese prints (the height of avant-garde fashion), and decided to put his sunflower paintings in Gauguin's room. Sunflowers were the favourite decorative motif of aesthetes: a *Punch* cartoon of 1881 depicted Oscar Wilde as a sunflower, with the caption: 'O, I feel just as happy as a bright Sunflower!'[43] Van Gogh bought twelve traditional rush-bottomed chairs in the mistaken belief that there were twelve members of the Pre-Raphaelite brotherhood. He bought two beds, and planned to paint his own with a naked woman and a baby in a cradle,[44] and over it hung two portraits of male friends, a poet and a soldier, to represent his artistic and sexual side. He also painted pictures of the Yellow House, inside and out, and of the neighbourhood, including the café and a nearby garden.

He envisaged it as a quasi-monastic retreat, a church for the religion of the future, with Gauguin as abbot. It was also to be a museum filled with self-portraits, and with portraits of artists, friends and local people. He was sending his pictures to his art-dealer brother Theo in Paris, but if he particularly liked a work, he made a copy to keep. He wanted to track his own development, and not send his favourite offspring away and become alienated from his art. He approved of the increasing tendency for dealers to mount solo shows, or group shows of

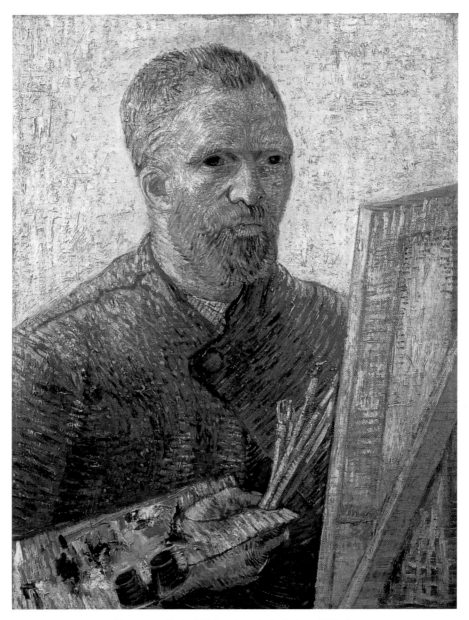

Vincent van Gogh, *Self-Portrait at the Easel*, winter 1887–8,
oil on canvas

like-minded artists.[45] Édouard Manet had started the trend when he exhibited fourteen works at a Parisian dealer in 1863,[46] and there were eight Impressionist group exhibitions from 1874–86.

As a youth, van Gogh had copied out texts by German Romantics into albums to be given as gifts to friends, and he was full of their idealism. It was the German Nazarenes in Rome in 1808 who pioneered the idea of an artists' brotherhood, based on a sentimental belief in medieval piety and solidarity, and they in turn influenced the English Pre-Raphaelites. Their inspiration was Wilhelm Wackenroder's *Confessions from the Heart of an Art-Loving Friar* (1796), published anonymously when he was a lawyer of twenty-three. The fictional friar preaches universal harmony in which temporal, physical and individual 'antipodes' are brought together into a variegated and pleasing whole. The centrepiece is a paean to Dürer, in which the friar visits Nuremberg – 'with what childlike love I gazed at your antiquated houses and churches, upon which the permanent trace of our early native art is imprinted!' – and sees the neglected cemetery, made beautiful by tall sunflowers that 'spring up in multitudes', and Dürer's 'forgotten bones'.

Two great 'antipodes' – Dürer and Raphael – are brought together in a dream. The friar dreams he visits a gallery of Old Masters after midnight, and finds it 'illuminated by a strange light' and all the artists standing in front of their own pictures. He is told they descend from heaven every night to look at 'the still beloved pictures [painted] by their own hands'. Apart from the others, he sees Dürer and Raphael standing hand in hand 'silently gazing in friendly tranquillity at their paintings, hanging side by side'. He was just about to greet 'my Albrecht and pour out my love', when he awoke. Only after the dream did he read in Vasari that Dürer and Raphael had been friends 'through their works' – a reference to their exchange of drawings.[47] The art-loving monk is really an artist-loving monk, for he describes artists rather than artworks. The artist *is* their art, and always stands in front of it. Van Gogh clearly had a similar meeting of 'antipodes' in mind with 'abbot' Gauguin. It resulted in what may be the first multiple exchange of self-portraits.

When Gauguin delayed his arrival, ostensibly due to lack of money for the train fare, van Gogh suggested he and his painter friend in Pont-Aven, Émile Bernard, send portraits of each other. In the end, they sent painted self-portraits, with portrait drawings of the other artist shown pinned to the background wall. Gauguin's output of self-portraits had been meagre before his association with van Gogh; but it now rocketed. A further exchange of self-portraits was made with Gauguin's painter friend Charles Laval, whose gift van Gogh considered 'very assured'.[48] He also hoped to do an exchange with the

leading Neo-Impressionist, the short-lived Georges Seurat,[49] but hoped in vain (Seurat obliterated his one attempt at a self-portrait, inserted into a portrait of his mistress). In a letter to Bernard, van Gogh even proposed an exchange with an artist whose name he could not remember – 'the other one'.[50]

Gauguin arrived in October 1888, and in November van Gogh painted a novel kind of paired self-portrait and portrait, depicting his own rush-bottom chair and Gauguin's armchair in two pictures. He plays with traditional gender associations. The set-up, with the chairs angled inwards, apes Renaissance paired portraits of husbands and wives, where they are turned in on each other. But while van Gogh situates his own chair on the male 'dexter' side (our left) in bright daylight, he gives himself the armless 'lady's' chair. Gauguin gets the 'gentleman's' armchair, albeit a very curvaceous one, in a room lit by lamp and candlelight. This gender-bending was a key component of their relationship. Van Gogh had wanted Gauguin's room to be 'as nice as possible, like a woman's boudoir, really artistic',[51] and Gauguin had depicted himself against a 'girlish' background of flowery wall-paper – a symbol of purity.

The inspiration for a 'chair' portrait has been linked to Luke Fildes's *The Empty Chair* (1870), a lithographic tribute to Charles Dickens, published in *The Graphic*

Vincent van Gogh, *Van Gogh's Chair*, 1888,
oil on canvas

Vincent van Gogh, *Gauguin's Chair*, 1888,
oil on canvas

after his death. Van Gogh had a copy of the print, and he idealized the magazine's illustrators as a brotherhood.[52] The position and type of chair in Fildes's image is very close to Gauguin's chair, and van Gogh has even placed a lighted candle on the seat, as if in memory of his friend. Already, there were strains in their relationship, and the image is full of foreboding and fear for his friend (a novel is precariously balanced on the seat edge).

By contrast, van Gogh's chair self-portrait seems full of optimism, brightly sunlit and with two sprouting onions poking up healthily out of a crate in the background that is inscribed 'Vincent'. The sprouting shoots resemble cuckold's horns, as though van Gogh is making a jaunty joke about Gauguin's lack of faithfulness. It is his most enchanting self-portrait. German Romanticism again offers a framework for interpretation. In Goethe's essay 'The Collector and His Circle' (1799) a doctor sketches the history of his family art collection, founded by his grandfather. He had started out commissioning watercolours of local wildlife and plants, and then moved on to life-size painted portraits of his nearest and dearest, depicted 'with the objects [the sitter] usually had about him'. Eventually, they had portraits of 'all the furniture as well'. Later generations added to the collection. The doctor's brother-in-law, on the death of his sister, painted still lifes of her

effects, singly and in composed groups, but only 'objects in everyday use'. These 'silent images did not lack for either unity or expressiveness'. The last still-life arrangement he painted 'hinted at transitoriness and separation, and at perman- ence and reunion'.[53] These are precisely the themes explored by van Gogh in his very own 'still-life' self-portrait and portrait. Van Gogh chose chairs because they are designed to be touched with impunity by the whole body, and they are stabil- izing entities firmly placed on the ground. They make a house a home.

The day before Gauguin was due to leave Arles in December 1888, van Gogh had a breakdown during which he first threatened Gauguin with a razor, and later that same night he cut off part of his left ear, giving the severed portion to a prostitute. This harrowing incident was memorialized yet transcended in two self-portraits with bandaged ear of January 1889. The bandages are held in place by a fur hat that 'normalizes' them, transforming them into ear flaps, protecting him from the winter cold. Van Gogh was admitted to the Saint-Paul Asylum in Saint-Rémy in May 1889, and in September wrote to Theo:

> People say…that it's difficult to know oneself – but it's not easy to paint oneself either. Thus I'm working on two portraits of myself at the moment – for want of another model….One I began the first day I got up, I was thin, pale as a devil. It's dark violet blue and the head whiteish with yellow hair….But since then I've started another one, three-quarter length on a light background.[54]

Whereas Poussin pioneered the painting of consecutive self-portraits, van Gogh pioneered the painting of simultaneous self-portraits. But it is not a celebration of the luxuriant superabundance of an artist's feelings and moods – in the por- tentous manner of the young Courbet. It is now an index of estrangement, of a catastrophic loss of control.

~

Gauguin responded to the idea of the furniture self-portrait, sculpting a stone- ware jug self-portrait in Paris in early February 1889.[55] The jug is formed from Gauguin's severed head, with streams of red glaze simulating blood. Every time the jug is lifted, it will appear as if the bearer is presenting the head of an executed criminal, enemy or martyr. At a stroke, Gauguin qualifies the domestic idealism rooted in everyday objects that underpinned van Gogh's Studio of the South.

The design revolution inaugurated by the Arts and Crafts Movement had stimulated demand for handmade pottery in 'folk' styles. Gauguin first made hand-built ceramics in Paris in 1886, collaborating with the ceramicist Ernest Chaplet, using motifs inspired by Breton folk art and Pre-Columbian ceramics. He saw it as a money-making sideline, but they failed to sell. He was excited by the potential of stoneware, however, and after returning from Martinique in 1887 made a series of vases and jugs in the shape of human heads informed by Peruvian portrait jars, and by Toby jugs. Whereas the imagery of the earlier ceramics had generally been utopian, the self-portrait jug is apocalyptic. It was made after Gauguin had witnessed the guillotining of a glamorous multiple murderer called Prado, who claimed – among many other things – to be the illegitimate son of Emperor Napoleon III.[56]

Gauguin depicts himself as martyr, genie and Medusa. His eyes are closed but we suspect he may be sleeping. Are we about to witness his rebirth? The browny-orange glaze flows over his undulating face as if coaxing it into life, and encouraging us to caress it. Where each ear should be, an undulating 'throat' rises up to the lip of the jug. Van Gogh's injury is both alluded to and denied. There is only a trace of blood around these 'ear-throats': redemptive water, wine, blood or milk will overflow the lips of the jug, like a volcanic eruption. No meal could ever be the same again. Gauguin's demonic persona would re-emerge a

Paul Gauguin, *Self-Portrait Jug*, 1889,
glazed stoneware

few years later in Tahiti in a life-size hieratic head sprouting two pairs of diabolical horns.

Van Gogh's communal idyll is not Gauguin's only target. The writer brothers Edmond and Jules de Goncourt excoriated contemporary culture, and instead idealized the pre-revolutionary age of Madame de Pompadour, when artists were also artisans, making decorative objects and doing interior design. The holistic nature of the art world was reflected in the organicism of the art: 'all harsh and rebellious matter was subordinated to the supple caress of the artisan'.[57] The brothers were confirmed bachelors who shared a house on the outskirts of Paris, which they filled with rococo and Far Eastern artefacts, creating a *'harmonie artiste'* (aesthetic harmony). Their passion for objets d'art filled the erotic gap created by their disdain for modern woman. Edmond, in his guidebook to his own house, *Maison d'un artiste* (House of an artist) of 1881, describes drinking from Sèvres porcelain cups moulded from the breasts of Marie Antoinette, and returning from a shopping exhibition exhausted 'as if from a night of sexual debauchery'.[58]

Gauguin loathed 'coy, insipid' Sèvres porcelain, and the object fetishism it gave rise to. In July 1889, he claimed it had 'killed' ceramics: 'Everybody knows

Paul Gauguin, *Head with Horns*, 1895–7,
wood with traces of polychromy

Paul Gauguin, *Self-Portrait Jar*, 1889,
enamelled ceramic

this, but it's inviolable: it's the glory of France'. Porcelain was fired only briefly, but for Gauguin, the fire in the kiln was 'hell', and the longer the pot remained inside the 'graver, more serious' it became. Authentic pottery was the primordial art form: 'In the remotest times, among the American Indians, the art of pottery making was always popular. God made man out of a little clay'.[59]

Having depicted himself at death's door, Gauguin went right back to the beginning and depicted himself at birth, as a foetal baby. But this is a world away from Vivant Denon's Raphaelesque self-image as a baby. *Self-Portrait Jar* (1889) is a crumpled primordial foetus, sucking its thumb, daubed in a weather-beaten white-brown glaze. Formally, it was inspired by a terracotta mask from Asia Minor that had been illustrated in a book on illness in art as an ancient depiction of mental illness.[60] But it equally harks back to Courbet's sultrily insolent close-up *Self-Portrait with a Pipe*. The jar was to contain tobacco, which van Gogh believed stoked the 'furnace of creation', and, of course, the pipe was the adult's thumb substitute.[61] Like van Gogh's chairs, the two self-portrait pots are a complementary pair, and just as paradoxical: the infant is much taller than the adult (28 as opposed to 19.5 cm high; or 11 to some 7½ in.). Pablo Picasso, who made ceramic sculptures after seeing a Gauguin retrospective in 1906, may have been thinking of these works when he said his own sculptures were vials filled with his own blood.[62]

In this chapter, we have explored the various ways in which self-portraiture was at the centre of attempts to re-root 'homeless' artists. In the next, we will explore the complex role of sexuality and sexual relations in the artist's domestic and studio life.

9.

SEX
AND
GENIUS

∾

THE OBSESSION WITH 'LOCATING' the modern artist, explored in the last chapter, inevitably stimulated interest in their private life and domestic arrangements. The role of women – and sex – in a male artist's life became a live and controversial issue in the nineteenth century, and generated some extraordinary self-portraits. The beginnings of female emancipation – with more middle-class women working and studying art – gave a disconcerting new twist to the relationship between male artists and female models.

The Goncourt brothers were key contributors to the debate. For the male artist, did women, whether wives or mistresses, foster genius, or impair it? Such questions owed much to social anxieties brought about by the Industrial Revolution, and by the massive shifting populations drawn to cities. Chilling attempts were made to identify social types, all the better to control them, and the artist was one of the most interesting categories, both because of their supposed originality, and their exposure to female models. The debate centred on the relationship between art, genius and sex. The ideal was not necessarily the mythical pious monogamy practised by Raphael and his mistress La Fornarina, which was how the nineteenth century tried to rescue him from Vasari's slur of promiscuity, or the probable monogamy practised by Ingres and his 'excellent' wife Madeleine – 'our household is, I venture to say, held up as an example'.[1] The issue was whether aspiring geniuses should be having sex at all.

Lovis Corinth, *Self-Portrait with His Wife*, 1903 (detail), see page 223

Vasari had already claimed that Raphael had died young as a result of his debaucheries, and that his art had declined as a result; and that Andrea del Sarto's excessive love for his wife, whose features he used for all the women in his paintings, had been to the detriment of his career. His predicament became the subject of Robert Browning's 1855 poem 'Andrea del Sarto': 'Why do I need you? What wife had Rafael, or has Agnolo?' The notion that genius was incompatible with sexual excess was given a pseudoscientific grounding by the influential Italian criminologist Cesare Lombroso in *Genius and Madness* (1863). Lombroso, who believed genius was a form of epilepsy (something that was later credited to van Gogh), said that 'many great men have remained bachelors; others, although married, have had no children'; some great women, such as Florence Nightingale, had been celibate.[2] The bachelor Goncourt brothers gave their repudiation of woman a precise historical basis. Since the French Revolution, society had become so fragmented that modern man could no longer relate to modern woman: 'For our generation, art collecting is only the index of how women no longer possess the male imagination'.[3] They are referring here to what would become known as the *femme nouvelle* (new woman), who had often left the family home to enter the world of work, relocating to metropolises like Paris. They were stereotyped as frock-coated, trousered, bicycle-riding, cigarette-smoking, predatory or lesbian *hommesses*.[4] Women's right to divorce was established in France in 1884. The alienated male artist and art collector sought refuge in his art.

The philosopher Friedrich Nietzsche was the great exponent of art-making as a sublimated sexual act. Great artists have to be physically strong with lots of surplus sexual energy – 'without a certain overheating of the sexual system a Raphael is unthinkable'. Yet despite the artist's susceptibility to sensory stimulation and intoxication – 'how wise it is at times to be a little tipsy!' – he is often chaste: his dominant instinct 'does not permit him to expend himself in any casual way'.[5] So Raphael must have kept his mistress La Fornarina waiting while painting his madonnas. The Symbolist writer Albert Aurier despaired of modern artists ever being chaste: 'dirty sexuality' and 'filthy passion...like a leper stalks and kills the artists of our villainous epoch'.[6] The 'Choice of Hercules' had been transmuted into a choice between vicious women and virtuous art.

But the consequences of art-object fetishism could be suicidal madness rather than genius. Claude Lantier, the painter hero of Émile Zola's novel *L'Œuvre* ('The work', 1886), slaves away for years on his masterpiece, a large female nude, but can never satisfactorily complete it. His wife is horrified to realize her husband only loves 'this strange, nondescript monster on the canvas'. In frustration, he

punches the canvas, tearing a hole where the bosom/heart is, and he wonders how he could possibly 'have slain what he loved best in the world'.[7] He eventually hangs himself behind the picture.

In the twentieth century, Marcel Duchamp would be fascinated by the idea that modern man was alienated from woman, and thereby forced to be a bachelor. He clearly saw *Fountain* (1917), the infamous urinal, as a fetish to rival any piece of Sèvres porcelain: 'One only has for *female* the public urinal and one *lives* by it'.[8] The inability of the male to achieve coition with the female was the main subject of Duchamp's *The Bride Stripped Bare by Her Bachelors, Even* (1915–23), better known as *The Large Glass*. The 'bachelors' in the bottom half are unable to ignite the 'love gasoline' of the bride in the top half, and they are forced to 'grind their own chocolate'.

All these ideas inspired new kinds of 'marriage self-portrait' unprecedented both in their excruciating levels of intimacy and in their sheer quantity. It is never clear whether the partner/wife is a fertilizing muse or vampiric nemesis. The trend culminates in the 1920s and 30s with Pierre Bonnard's pictures of his untouchable wife Marthe, embalmed in the bath, and with Stanley Spencer's nude self-portraits of 1936–7, ogling his increasingly untouchable bisexual wife.

~

The Goncourt brothers' claim that women 'no longer possess the male imagination' is scarcely true of the Norwegian painter and printmaker Edvard Munch (1863–1944), for they are virtually the *only* things that possess his imagination. But women induce nightmares rather than dreams, and they cannot be exorcized.

Munch is one of the most prolific self-portraitists: if we include probable self-portraits in subject pictures, there are over seventy paintings, over a hundred drawings and watercolours, fifty-seven photographs and twenty prints. More exhibitions of his self-portraits have been mounted than for any other artist: at Oslo's National Gallery in 1927 and 1945; at the newly opened Munch Museum in 1963; and a touring exhibition of 2005. Most of the self-portraits were produced after 1902, the year in which Munch split up from the rich heiress Tulla Larsen, with whom he had had a stormy on-off relationship since 1898. He shot himself in the left hand at the final parting, having refused to marry her. He wrote to her explaining that 'my art is my greatest love'.

In four severely frontal and hieratic self-portraits of the 1890s, Munch places a female symbol directly over his head.[9] He is not just dominated by them, but

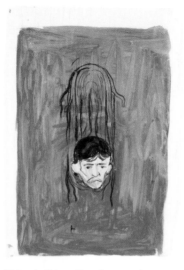

Edvard Munch, *Salome-Paraphrase*, 1894–8, watercolour,
Indian ink and pencil on paper

a part of them. So in the watercolour *Salome-Paraphrase* (1894–8), Salome is
'paraphrased' into a black waterfall of dark hair, cascading vertically down the
blood-red page, but curving in at the bottom to caress and hold Munch's jug-
eared moustachioed head, which sports a skew-whiff miffed expression. Salome
was a favourite type for the *femme fatale*, but this Salome is not just decapitat-
ing Munch, she is giving birth to him. Her cascading hair is a 'paraphrase' of
the female genitalia, and Munch is being born head first (his head is so small,
however, he must be premature, a miscarriage or an abortion).

To use Samuel Beckett's phrase, he is born astride the grave, but this is also
a rebirth, with Munch cast as a primordial being, situated in the very spot
where life is created. So *Salome-Paraphrase* represents the ultimate homecoming.
The hieratic and frontal nature of the self-portrait heads may be an allusion to the
'self-portrait' of Christ on Veronica's veil (see Chapter 1). The women positioned
above Munch take on the role of St Veronica, traditionally depicted holding her
cloth in front of her torso, with Christ's head covering her midriff. The legend
of St Veronica symbolizes something basic about what self-portraiture means for
Munch: the producer/catalyst is invariably a woman.

After the end of his relationship with Tulla Larsen, Munch makes himself
appear increasingly androgynous and hermaphroditic – below the neck.

Androgyny was a Symbolist ideal, an emblem of pure self-sufficiency. It was primordial insofar as Plato believed humanity had started out androgynous before splitting off into male and female; modern science, too, was showing the fundamental nature of androgynous organisms. Gauguin had imagined himself as supremely androgynous in his self-portrait for van Gogh with male and female qualities; Aubrey Beardsley depicted himself as a woman lurking below a big-breasted satyress in *Portrait of Himself in Bed* (1894); and from 1920–41, Marcel Duchamp had an alter ego Rrose Sélavy: he signed works in her name and dressed in women's clothing.[10]

Munch feminizes his body, but only below the neck. In *Self-Portrait in Hell* (1903) he stands, a naked Frankenstein's monster, before a flaming, cave-like landscape. His own jug-eared head – a peeling mask of burning red and orange – is placed on top of a golden girlish body with budding breasts. The 'join' is marked by a red slash across the neck. He would later make several androgynous self-portraits with full breasts. He looks like Ophelia in 1909, and then in *Androgynous Self-Portrait* (*c.* 1925), a grumpy old man in his sixties who has just

Edvard Munch, *Self-Portrait in Hell*, 1903,
oil on canvas

had a sex change operation and a jumbo breast enlargement. The latter was a proposed centrepiece for a (thankfully) rejected mural *The Human Mountain*, and was supposed to represent a new ideal, but Munch was infinitely more suited to dramatizing the collision rather than the coalition of the sexes.

Munch regularly treats his head as distinct from his body, and he may have been influenced by Jules Michelet's *The Mountain* (1868), a ruminative, rhapsodic book on natural history republished in 1885 and in 1896 with his book on insects. The great French historian makes a visit to some mud baths, standing in the hot mud with only his head exposed. Mother Earth caresses the body of her wounded child, restoring it to life and making it happy. They merge, his body becoming indistinguishable from her. But his exposed head is excluded, and its complaints irritated him: it complained that, by virtue of being unburied, it was 'no longer me'.[11] Munch's male head always looks out of sorts, and estranged from his debonairly androgynous body.

Munch had a high and scandalous profile in Germany in the 1890s, living there for several years and exhibiting. He had a considerable influence on the Prussian-born pioneer of Expressionism Lovis Corinth (1858–1925), who was equally haunted by the relationship between sex, debauchery and genius. Corinth was to become the most systematic 'tracker' self-portraitist of the early twentieth century, and one of the most successful German artists. He painted forty-two self-portraits, after 1900 painting one on each birthday. He made over thirty self-portrait prints, and many drawings. His autobiography, begun in 1906 and published posthumously in 1926, is illustrated by thirty self-portraits. A heavy-drinking depressive, he suffered a stroke in 1911, after which his painting technique became much looser.

Corinth's finest works are a series of self-portraits with his much younger wife Charlotte Berend, an art student he met in 1901 when she was twenty-one, and married two years later. By all accounts – including her own – her deft sense of humour and tact defused Corinth's dark nights of the soul when he claimed to love no one. He eventually painted forty-one pictures of her, and included her in twenty-nine genre scenes, producing a uniquely extensive and intimate record of their partnership.[12] Some of these pictures are uncomfortably ludicrous. In *The Artist and His Family* (1909), Charlotte sits serenely in the studio with their jolly baby, with Corinth standing behind, seemingly about to strike her over the head with his palette. In 1910–11, he made several pictures of old men in armour, but

there is no avoiding the Don Quixote aspects of *The Victor* where, with raised visor, he stiffly embraces the swooning, bare-breasted Charlotte. Corinth was drawn to the burlesque aspects of the bacchanalian, and it is hard not to see these as a new type of parodic self-portraiture (he is an heir to Denon and Courbet). Corinth identified with the Nietzschean *Übermensch* (superman), fighting to the death in the battle for existence. But in his pictures, he courts disaster and ridicule.

The finest self-portrait was painted three months after his marriage. A naked Charlotte, seen from the back, clings to the clothed Corinth, who is seen from the front, one hand resting on his heart, her head and the other arm resting on his shoulder. He stands to attention, bolt upright, eyes front, both arms raised and bent in a 'wing' position, holding paint brushes and palette. His role is usually described as protective, but this must be a 'Choice of Hercules' moment, when the future of his art and life hangs in the balance. (He had tackled this very subject in a drawing of 1895, where he is a knight in armour between a naked woman with a glass of wine, and a nun bearing a crown of thorns.)[13] The voluptuous

Lovis Corinth, *Self-Portrait with His Wife*, 1903,
oil on canvas

young Charlotte is preventing him from painting, even if only momentarily. At the base of Corinth's picture is an Egyptian-style gold border, decorated with winged figures, whose colour matches the golden background. The implication is that Charlotte will determine whether he ever again takes flight. Or are they both already trapped inside an Egyptian tomb of their own making? In Henrik Ibsen's last play, *When We Dead Wake* (1899), the sculptor Professor Rubek believes if he touches his model, or even desires her sensually, his artistic vision will be lost. Corinth tries not to touch or even look at Charlotte; but she is already too close for comfort.

⌒

The ominous, even overwhelming, presence of women in the work of both Munch and Corinth attests to male anxieties about changes in the status of women – changes that extended to art education as well. Women had been admitted to official and private art schools during the second half of the nineteenth century: Charlotte Berend was the first student to enrol at Lovis Corinth's private art school, and she exhibited her paintings and prints from 1906. But it is a German contemporary of Berend, Paula Becker (1876–1907), who would produce a new kind of self-portrait that turns the tables on male 'bachelor' artists, and instead parades female self-sufficiency and (pro)creative genius.

In the 1890s Becker enrolled at several art schools, and in 1898 went to live in an artists' colony in Worpswede, a farming village, where she met the painter Otto Modersohn whom she would marry in 1901, changing her surname to Modersohn-Becker. In 1899 she made the first of several extended visits to Paris, usually leaving Otto behind, and her art was increasingly influenced by Cézanne, Gauguin and van Gogh. In 1906 she went alone to Paris, the night after Otto's birthday, and seems to have had an identity and marriage crisis. Six days earlier she wrote to her friend the poet Rainer Maria Rilke: 'And now I do not know how to sign my name. I am not Modersohn, neither am I Paula Becker any more. I am myself, and I hope to become myself more and more. This is probably the final goal of all our struggles'.[14] Becker had always been a dedicated self-portraitist, usually depicting herself alone, outstaring us with a hieratic glare – and in one case with Munch's jug ears.

Shortly after her arrival in Paris, she wrote to Otto saying that she did not want to have his child. She immediately painted her largest, life-size self-portrait, inscribed Dürer-style: 'This I painted at the age of 30 on my sixth

Paula Modersohn-Becker, *Self-Portrait*, 1906,
oil on card

wedding anniversary P. B.' She stands before us, faintly smiling, naked down
to the waist (except for an amber-orange necklace), her hands placed above and
below a belly that looks very pregnant.

The picture, with its mottled green background, has given rise to all kinds of
speculation, but the pose, the simplified contours and almond-eyed physiognomy,
the tied-back hair, all evoke Raphael's famous portrait of La Fornarina. Whereas
that picture proclaimed the great artist's ownership of his model (he signed her
armband), Becker's self-portrait implies that this model is self-creating and indeed
self-reproducing. A perfect title for it would be Browning's line 'Why do I need
you?' – now addressed to her husband and the world at large. The marriage soon
resumed, however, and Modersohn-Becker tragically died three weeks after giving
birth to a daughter in November 1907.

Another option for the turn-of-the-century man of genius was masturbation (Wagner had warned Nietzsche's doctor that the philosopher masturbated too much; Duchamp's bachelors grind their own chocolate…). The specialist in this field was the Austrian Expressionist Egon Schiele (1890–1918). From around 1910 until 1912, when he was imprisoned for letting minors see his drawings, Schiele produced innumerable nude and semi-nude self-portraits, including several that showed him masturbating, brandishing a giant penis, or hermaphroditic with female genitalia. There are many other images of girls masturbating. His standard technique is to isolate a single, writhing figure, both gauche and lithe, against a blank ground. A major innovation was to make a series of double and triple self-portraits. In the *Self-Seers 1* (1910) two naked identical twins cling together, one behind the other – a self-sufficient artistic brotherhood. Yet they are joyless, orphaned marionettes.

In 1990, it was claimed that Schiele's 'narcissistic self-absorption – a recurring irritant to certain critics – is, in fact, a normal aspect of adolescence…much adolescent art is autobiographical'. The 'hermaphroditic quality of many of Schiele's nudes…underscores a sexual ambivalence that is not at all uncommon in males at Schiele's stage of development'.[15] These subjects had not been explored before in

Egon Schiele, *Self-Portrait in Black Cloak, Masturbating*, 1911,
gouache, watercolour and pencil on paper

such quantity and quality; while Rembrandt and Courbet's youthful self-portraits may be construed as narcissistic, they could scarcely be said to be obsessed by sex. Indeed, if anything, it is Schiele who, since his art was rediscovered in the 1960s,[16] has shaped our image of adolescence, rather than vice versa.

The French painter Pierre Bonnard (1867–1947) was perhaps the most home-and-family-fixated artist who ever lived. During the 1890s he painted over fifty pictures of his family in his parents' country home, in windowless interiors with the doors firmly shut. In 1893, he met Marthe de Méligny (1869–1942), who became his model and mistress, and whom he married in 1925. She would eventually appear in around 384 paintings, almost always in interiors, often nude and – after their marriage – soaking in the bath. 'I have all my subjects to hand', he said. [17] He was a modern version of the wife-fixated Andrea del Sarto: in 1913 Sigmund Freud's follower Ernest Jones had dubbed Sarto a repressed homosexual, with a love-hate relationship to his wife.[18]

Bonnard painted about twelve self-portraits, and drew several more. The independent self-portraits are generally bust-length, small-scale claustrophobic close-ups, all but one painted after meeting Marthe.[19] The only one painted pre-Marthe shows him as a bow-tied, besuited man of the world, standing upright, holding up his palette and brushes with the certainty of a samurai. Post-Marthe, they become constricted and he even invents a new imprisoned type – the self-portrait in the steamed-up bathroom mirror. Unlike Corinth, but like Ibsen's Professor Rubek, Bonnard is never shown touching his partner or looking at her.

The first paintings of Marthe soaking in her big bath date from 1925, the year of their marriage. Marthe was secretive: she had run away from home, changed her name, and pretended her immediate family were dead. She was also reclusive, rarely going out or receiving visitors. They never had children, so for most of the time, it was just them (and a cat). Marthe spent several hours each day soaking in the bath. Hydrotherapy was a recommended treatment for tuberculosis, and she may have suffered from this, though others suggested some nervous disorder. No one knew for certain. Bonnard only spoke openly about her condition in one letter of 1930: 'For quite some time now I have been living a very secluded life as Marthe has become completely antisocial and I am obliged to avoid all contact with other people…it is rather painful'.[20] These malaises may have played a part in

Bonnard starting an affair with Renée Monchat, whom he had met in 1918, but the relationship was abruptly terminated by her suicide in late 1924. Bonnard's marriage to Marthe the following year may have been intended to fill the void, and be a new start (though he never told his own family about the marriage).

Bathrooms were still a luxury in Europe, and when Marcel Duchamp went to New York he thought the plumbing (and bridges) the greatest works of American art. So what we see is a privileged technological Eden, a modern equivalent to the Roman baths in the historical fantasies of Lawrence Alma-Tadema. Bonnard's bathrooms are fashioned from blocks of cool and hot colours, laid down in shimmering patchwork mosaics. Whatever his domestic difficulties, Bonnard clearly luxuriated in the mystery of Marthe's condition and habits. He gives her a remembered, younger body.

Even though Marthe still seems to have been willing to pose naked for Bonnard, the pictures themselves suggest a tense relationship. The white enamelled bath is both a cocoon and sarcophagus for her inert, corpse-like body. The interior of the bath is the only place where shadows are allowed to spill. The painter's viewpoint is extremely high and bird's eye, as though Bonnard needs to dominate her – or to show how much she trusts him. Yet the overhead viewpoint might be predatory: Bonnard had painted a faun raping a nymph in 1907, and a red-hot, faun-like self-portrait in 1920.

Bonnard's presence is always felt, but in *Nude in the Bath* (1925) it is glimpsed. The bath rises vertically up the picture plane, with Marthe's inert extended body seemingly upended (her head and torso are elided). Bonnard stands near the foot of the bath, tall and attenuated in a mottled blue silk dressing gown, but all we see of him is a thin side-on sliver, from slippered foot to sleeved forearm. He cannot bring himself to look at his Ophelia. He appears to be drawing a self-portrait in a mirror. If his subsequent self-portraits of himself before a bathroom mirror are anything to go by, the result would not be pretty. In *The Boxer* (1931), he is a flat-faced homunculus throwing his emaciated arms around in a tantrum; in two self-portraits from 1938–40, he is a flayed, forlorn professor. Michelangelo's self-portrait as the flayed skin of St Bartholomew was first identified as a self-portrait by the psychoanalytically inclined Italian physician Francesco La Cava in a booklet published in 1925. For La Cava, Michelangelo was a near-suicidal tragic hero who veered between 'Dantesque anger' and 'infantile timidity'.[21] It is a good description of Bonnard in these self-portraits.

Marthe is, of course, a 'bride in the bath', and Bonnard stands by her feet. It is hard to think Bonnard was not aware of the irony. The notorious brides-in-the-bath

Pierre Bonnard, *Nude in the Bath*, 1925,
oil on canvas

murder case had ended with the hanging of George Joseph Smith in 1915. He had drowned three successive wives for their money, using disguise and aliases to conceal his tracks. He took them on honeymoon to rooms in different parts of England, waited until they were in the bath and dispatched them by suddenly yanking their legs up by the ankles. There were no signs of struggle, so their deaths by drowning were recorded as misadventure. The case was a landmark in legal history because of the use of forensic science and comparative cross-referencing between cases. But Bonnard will never do it. He is angry with Marthe, but infatuated and dependent on her too. She is his muse as well as his Medusa.

In this chapter we have been exploring how artists try to find an accommodation between sexual desire and genius, between human and artistic needs. In the final chapter we will see how the search for authenticity and integrity leads to a marginalization of the principal component of traditional self-portraiture – the face.

10.

BEYOND THE FACE: MODERN AND CONTEMPORARY SELF-PORTRAITS

MUCH OF THE POST-MEDIEVAL history of self-portraiture (as indeed of portraiture) is the history of the physiognomic likeness: in other words it is the history of individual faces and especially of the eyes, the so-called mirrors of the soul. The Medici (bust-length) self-portrait collection is the supreme manifestation of this fixation on artists' faces. In the late eighteenth and nineteenth centuries this also became a fixation on heads, due to the popular 'science' of phrenology, which read character into the 'bumps' on the cranium. Phrenologists believed that different brain functions were localized in anything up to forty zones, and the skull shaped by the brain activity taking place below. The term 'highbrow' derives from the phrenological belief that a high forehead denoted intelligence. Despite their differences, self-portraits of Runge, Canova, Courbet, van Gogh, Gauguin, Corinth, Schiele and Munch are united in showing a big flash of high forehead.

Self-portraiture in the twentieth century has been many things, but its most distinctive quality is its tendency to conceal or suppress the face and head, thereby thwarting traditional physiognomic/phrenological readings. Masks, mask-like faces and masquerade are a typical trademark of the modern self-portrait. By the same token, there has also been a shift in focus away from the face to the body, which is harder to individualize and memorize: full-length self-portraits, often naked, and self-portraits featuring fragments of the artist's body have proliferated,

John Coplans, *Self-Portrait* (*Back with Arms Above*), 1984, black-and-white photograph

especially in the last half century, and not just in Western countries. Painting's domination of self-portraiture has also been broken by sculpture, photography and video, media that have seemed more capable of fully and directly embodying the artist. These trends have their cultural origins in the late nineteenth century.

Self-portraiture has become more prevalent than ever. Not only have there been many serial and multiple self-portraitists, but a new type of specialist has emerged – the career self-portraitist, whose oeuvre consists almost entirely of self-portraits. There has also been ever-increasing interest in self-portraits by Old and Modern Masters, and a high value – spiritual and financial – attached to them. The 'rise' of self-portraiture, from the Renaissance onwards, has been made to seem inexorable in celebratory picture books such as *Fünfhundert Selbstporträts* (Vienna, 1936) and its recent reincarnation, *500 Self-Portraits* (London, 2000). The apotheosis of van Gogh, and his status as the world's most famous artist, would have been inconceivable without his self-portraits (three van Goghs were included in *Fünfhundert Selbstporträts*). His elevation to secular sainthood was confirmed when his shaven-headed *Self-Portrait Dedicated to Paul Gauguin* was the star lot in the Swiss auction of 'degenerate' works removed by the Nazis from German museums, held in Lucerne in 1939.[1] It is also in the twentieth century that the genre has received its own terminology in all European languages, with the 'self-portrait' finally supplanting the traditional 'Portrait of the Artist' and 'Portrait by/of Himself'. In the 1920s and especially the 1930s autobiographies of writers and artists start to be entitled 'a self-portrait'.[2]

Yet surprisingly few of the very best artists from around 1910–70 have made a big contribution to the genre. The most obvious excuse would be the rise of abstract and non-objective art, which precludes portraiture of any kind, however much we might be tempted to assume that 'every abstract painter paints himself'. Indeed, the most influential art theoretical text for the first half of the twentieth century, Wilhelm Worringer's *Abstraction and Empathy* (1908), insisted that abstraction comes from 'an urge to alienate oneself from individual being'.[3] He contrasted it with naturalism, which is 'objectified self-enjoyment' and involves empathy – a concept that had dominated late nineteenth-century aesthetics.[4] At a stroke, self-expression was only an option, rather than a necessity.

The 'urge' to abstraction has been felt in figurative art as well, and helps explain why some of the most important figurative artists, such as Henri Matisse, Pablo Picasso, Georges Braque, most of the Surrealists, Willem de Kooning, Robert Rauschenberg and Jasper Johns, have remained relatively aloof from the genre. Picasso is a telling example. His active interest in self-portraiture is pretty much

confined to his early years, as in his two Munchified 'searing stare' self-portraits from 1901 signed 'Yo Picasso' (I Picasso). This phase culminates in his mid-twenties with the primitivizing half-length *Self-Portrait with Palette* (1906) and a mask-like proto-Cubist head of 1907, the year of *Les Demoiselles d'Avignon*. From the 1920s onwards, the artist in the studio becomes a perennial subject, but it is almost always a generic or mythical artist, and usually in burlesque mode – above all in his *Raphael and La Fornarina* print series of 1968, where the great artist paints and copulates simultaneously, with Michelangelo and the pope looking on, amazed (and impotent) bystanders.

While Picasso's youthful production of self-portraits might seem to conform to the pattern of earlier periods, he had serious reasons for desisting. In 1908, he began his collaboration with Braque which resulted in the Cubist revolution. One of the most radical aspects of Cubism is its antipathy towards the idea of the artist as genius. Both artists made much of being worker-artists.[5] They regularly wore blue mechanic's outfits. Their dealer Daniel Kahnweiler, of whom Picasso made a great Cubist portrait, recalled them coming to the gallery one day 'cap in hand acting like labourers'. They immediately announced: 'Boss, we're here for our pay'. This was far more than just a pose: they worked together as collaborators until their paintings became almost indistinguishable, and gave up signing their work on the front of the canvas. Sometimes, they got Kahnweiler's assistant to sign their works on the back. The only form of writing that appeared on the front was stencilled letters or collaged newsprint. Picasso later explained that they hoped to make 'an anonymous art, not in its expression, but in its point of departure'. The collaboration reached its height in 1912 when they used ordinary 'found' materials to make collages and constructed sculptures. Their aspiration to be humble worker-artists was a radical updating of the cult of the anonymous medieval artisan and the artistic brotherhood. Picasso would subsequently quip that Braque had been his wife.

The approach Picasso and Braque were rejecting is exemplified by a book on portraiture published in 1908 by the German art historian Wilhelm Waetzoldt.[6] The longest chapter, taking up about a quarter of the book, is entitled 'The Psychology of Self-Representation', and is a celebration of individual genius. Every self-portrait is the product of the artist's 'inner compulsion', a manifestation of an 'intimate monologue, revealing the personality'.[7] Multiple self-portraits by the same artist illustrated the development of genius and the path of self-criticism. Rembrandt's self-portraits do not document Rembrandt's life, but the journey of his genius. The journey begins with the '*sturm und drang*' (storm and stress) of the

emergent years, when Rembrandt has 'tangled hair and a provocative student-like expression in his eye'. It ends with Rembrandt's soul sick with life, and engaged in a desperate struggle with the body.[8]

Waetzoldt's definition of self-portraiture represents the same Romantic ideal endorsed half a century earlier by the novelist Nathaniel Hawthorne in *The Marble Faun* (1860), a story of American artists in Florence and Rome. When a beautiful self-portrait is found on a female artist's easel, we are advised that in each of the Medici self-portraits

> there are autobiographical characteristics…traits, expressions, loftinesses, and amenities, which would have been invisible, had they not been painted from within.[9]

Waetzoldt was especially interested in tracking a complex and even neurotic psychological 'journey' through successive self-portraits, something that had been facilitated by the availability of black-and-white photographic reproductions. Illustrated books and museum picture libraries meant one could scan an artist's oeuvre at a glance, and line up all the self-portraits, something that Rembrandt himself could never have done with his paintings. (Waetzoldt's own book had eighty black-and-white reproductions.) The 'oeuvre overview' had previously been possible only in cases like Reynolds, where prints had been systematically made and sold during the artist's lifetime. In his second section on 'Artistic Individuality', Waetzoldt moves carefully from 'Youthful Portrait', to 'Early Maturity Portrait', through to adult portraits and 'Old Age Portraits'. He then discusses a trio of artists – Reynolds, Goya, Böcklin – who have depicted 'a life in self-portraits', and misquotes Oscar Wilde to assert: 'The artist's life is only self-development'.[10]

The Hawthorne-Waetzoldt 'tracker' approach remains the most popular way of thinking about self-portraits to this day. Nonetheless, we can say categorically that 1908 represents the high-water mark of the self-portrait as pure soul music. Not only does 1908 mark the beginning of Picasso and Braque's collaboration, and the publication of Worringer's *Abstraction and Empathy*, it is also the year of the mask.

MASKED SELF-PORTRAITS

In 1908, the Belgian poet Émile Verhaeren dubbed James Ensor (1860–1949) the 'painter of masks' in a monograph on his work. Interest in role playing was

nothing new ('All the world's a stage…'), and Rembrandt was of course famous for his big wardrobe. But the use of masks now came to symbolize the alienating and repressive condition of modern society, with its superficiality, materialism and pressure to conform. Courbet, in his letter of 1854 to Alfred Bruyas, famously said, 'Behind this laughing mask of mine which you know, I conceal grief and bitterness, and a sadness which clings to my heart like a vampire. In the society in which we live, it doesn't take much to reach the void'. A similar point is made in Baudelaire's 'Le Masque' (1859), a poem included in *Les Fleurs du mal*. Nietzsche, in *Beyond Good and Evil* (1886), insisted that 'every profound spirit needs a mask':

> even more, around every profound spirit a mask is growing continually, owing to the constantly false, namely *shallow*, interpretation of every word, every step, every sign of life he gives.[11]

Freudian psychoanalysis would give a new twist to the culture of masks, with its aim of stripping off the bourgeois masks of respectability to reveal the repressed unconscious and subconscious urges beneath.

Ensor had become the 'painter of masks' in 1888, when he started to go back over his earlier naturalistic work adding masks and skeletons.[12] He spent most of

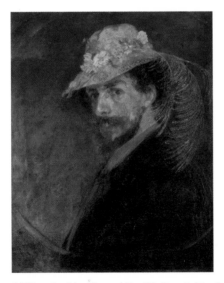

James Ensor, *Self-Portrait with a Flowered Hat (My Portrait Disguised)*, 1883/8,
oil on canvas

his life in his birthplace, the coastal town of Ostend, where his father's curiosity shop stocked masks for the annual carnival. He often visited marionette theatres and puppet shows. Over the course of a long career he painted 112 self-portraits, though only one, *Self-Portrait with a Flowered Hat (My Portrait Disguised)*, had been exhibited by 1900. It was painted in two stages, in 1883 and 1888, and then transformed again by being copied into another self-portrait of 1899, *Self-Portrait with Masks*. They are rather like revised editions of literary texts.

Ensor had first painted a side-on bust with him looking sharply at us over his left shoulder. It is heavily impastoed, a mixture of Courbet and Impressionism. But the pose, and the suddenness of the look, recall van Dyck's glancing-over-the-shoulder self-portraits, with bare head and high forehead. Van Dyck's exquisitely camp portraits of the Stuart court had for centuries been regarded as prophetic, because their melancholy mood seemed to prophesy the sitters' imminent doom.[13] Ensor's aping of the art of his great Flemish precursor fits in with his own frequent self-portrayal as an artistic aristocrat and doomed martyr – whether as Christ (*Calvary*, 1886) or a severed head being served up to art critics (*The Dangerous Cooks*, 1896).

When Ensor reworked his 1883 self-portrait in 1888, he added a woman's wide-brimmed hat decorated with flowers, and with purple feathers cascading down the left side like a lovelock. He also painted in a beard and a voluptuously upturned moustache. The hat is comparable to that worn by Elisabeth Vigée-Lebrun in the self-portrait painted in Brussels in 1782, which was itself inspired by Rubens's *The Straw Hat*. His 'disguise' transforms him into a classic androgyne, not Wildean but from an earlier century.

Finally, in 1899, as a farewell to the nineteenth century, we see him in the same pose and costume (though now deep red), in the midst of a dense Hogarthian crowd of masked figures, painted in bright clownish colours. Some grin; all have open mouths. We cannot be sure what his role might be. Is he their prisoner, the last real man in a nightmarish world of illusion? Is he the puppeteer, or are these his own masks? Since he looks the same age as in the 1883/8 self-portrait, we may further wonder if this is his real face or a mask of youth.

In his 1908 monograph, Verhaeren claimed that 'up close, one could discern his psychology just by analysing his self-portraits from different eras, and the elusive being that he is might be revealed better by this method than by examining the daily actions of his life'.[14] That elusiveness is seen in a number of caricatural self-portraits – as a June beetle, then one of the most destructive insects in Europe (1888); or as *The Man of Sorrows* (1891) wearing a grimacing Japanese Noh mask.

James Ensor, *Self-Portrait with Masks*, 1899, oil on canvas

At the same time, they may tell a larger truth. As Oscar Wilde wrote in *The Critic as Artist*: 'Man is least himself when he talks in his own person. Give him a mask, and he will tell you the truth'.

Ensor rarely discussed his self-portraits, but in a letter of 1894 he had already claimed to find himself elusive: 'I've tried several times to paint my portrait, but I've never managed to capture the resemblance'.[15] It is superficially similar to van Gogh's letter of 1889 when he is painting simultaneous self-portraits, and he confesses that it is not only difficult to know oneself, 'it's not easy to paint oneself either'. But whereas for van Gogh the elusiveness of a likeness marked a moment of acute crisis, for Ensor the elusiveness of his likeness is an existential necessity. His inability to 'capture the resemblance' underwrites his own freedom: by remaining in disguise he can escape capture in this decadent world. So we have here one of the chief paradoxes that stimulates the creation of multiple self-portraits by modern artists: they need to repeatedly remake themselves – '*My Portrait Disguised*' – in order to maintain their disguised condition. The mask, in Nietzsche's terms, has to keep on growing.

Picasso did not entirely renounce self-portraiture in the years after 1908: from 1911–16 he mechanically reproduced himself by taking several staged self-portrait photographs in his studio, though these were kept private and were not exhibited or reproduced until recently.[16] He variously wears workmen's clothes with cloth cap, Braque's military uniform, boxing shorts, and formal wear. Picasso clearly enjoyed ringing the costume changes. It is no coincidence that most were taken in 1915–16, at a moment when he was starting to work simultaneously in different styles, Cubist and Neoclassical. Tribal masks had already played a crucial role in the development of Cubism, enhancing his figures' mystery and malevolence, and we can see his interest in masks and in role playing as related. They render the self not just elusive but awesome.

Picasso explained his approach to art-making in an interview given in 1923, forcefully attacking the Romantic notion that an artist's oeuvre was an organic whole that gradually evolved, charting his personal 'journey':

Repeatedly I am asked to explain how my painting evolved. To me there is no past or future in art. If a work of art cannot live always in the present it must not be considered at all....When I hear people speak of the evolution

of an artist, it seems to me that they are considering him standing between two mirrors that face each other and reproduce his image an infinite number of times, and that they contemplate successive images of one mirror as his past, and the images of the other mirror as his future, while his real image is taken as his present. They do not consider that they are all the same images in different planes.[17]

What Picasso objects to is the way a spurious unity is imposed on an artist's oeuvre by extrapolating from something they have just made or said, and then judging the rest of their work according to this one template, which may well be ephemeral, marginal or mistaken. So because Picasso made Neoclassical works after the First World War, and in art generally there was a so-called 'return to order', the history of French art, including that of Cubism, was being rewritten to emphasize its rationalism and purity. Where Old Masters were concerned, the modern 'science' of connoisseurship was predicated on identifying archetypal features of an artist's work, and where these could not be found in a particular work, it had to be re-attributed.[18] The new 'science' of psychoanalysis was equally culpable insofar as one's lot was determined at birth and in childhood, in a punitive variation on the doctrine of Original Sin and the Romantic credo that the child is father to the man.

Picasso's interest in tribal masks had a huge impact on avant-garde culture, nowhere more so than at the Cabaret Voltaire in Zurich, the launch pad of the Dada movement. It was founded in 1916 by the poets Hugo Ball, Emmy Hennings, Tristan Tzara and Richard Huelsenbeck, and the painters Jean Arp, Marcel Janco and Hans Richter. Most of its members were in voluntary exile in neutral Switzerland from the First World War. Using Futurist shock tactics, but rejecting Futurism's love of machines and war, they organized anarchic theatrical performances and concerts, and published magazines. Many of the performers wore grimacing Cubist/tribal-style masks made by Janco from found materials.

For Ball, writing in his diary, the ripening of the 'individualistic-egoistic ideal of the Renaissance' had brought disastrous consequences: 'the accentuated "I" has constant interests, whether they be greedy, dictatorial, vain or lazy'. As a counter to this, the Dadaist 'loves the extraordinary, the absurd'. They wanted to revive the medieval practice of praising foolishness (i.e. Erasmus's *In Praise of Folly*) and of sending noble children 'to board with idiotic families so that they might learn humility'. For the Dadaist, life asserts itself in contradictions: 'Every kind of mask is therefore welcome to him, every play at hide and seek in which there

Man Ray, *Self-Portrait Assemblage*, 1916,
gelatin silver print

is an inherent power of deception'.[19] A self-portrait assemblage by the American photographer Man Ray is a fine example of this sensibility. A handprint raised in a 'stop' position is placed where the mouth should be, while the eyes are made from bells for a non-functioning doorbell: it's a 'no entry' self-portrait.

For Richard Huelsenbeck, writing in 1920, the Dadaist is 'entirely devoted to the movement of life' – and of personality. He exploits

> the psychological possibilities inherent in his faculty for flinging out his own personality as one flings a lasso or lets a cloak flutter in the wind. He is not the same man today as tomorrow, the day after tomorrow he will perhaps be 'nothing at all', and then he may become everything.[20]

One of the most assiduous players of hide-and-seek in the years after the First World War was the painter and printmaker Max Beckmann (1884–1950), who made over eighty self-portraits. Before around 1915, and his war-induced nervous breakdown, he is generally an eagle-eyed, upright observer; but then the eyes, face and body start to slide around, contort and dislocate; and he rings the costume

changes. He first took on the persona of the fool in the bust-length self-portrait on the cover of the portfolio *Hell* (1919), containing ten additional lithographs in which the artist takes us on a whistle-stop tour of the social and political horrors of post-war German society. Beckmann is a gibbering goblin-like figure dressed in fool's garb, Cubistically prickly and distorted, hands pinned to his chest like a foetus. An accompanying text blithely explains, in a fairground manner:

> Hell. (Great Spectacle in 10 images by Beckmann.) Honoured ladies and gentlemen of the public, pray step up. We can offer you the pleasant prospect of ten minutes or so in which you will not be bored. Full satisfaction guaranteed, or else your money back.[21]

The cover self-portrait is both passive and aggressive, babyish and malevolent, and the two self-portraits included as the first and last plates exhibit these qualities too. In the first plate, he is a bewildered bowler-hatted salary man asking the way home, and in the last he is engaged in gesticulating debate with his mother about religion as his son plays with grenades. A different kind of aggression is on view in

Max Beckmann, *Self-Portrait,*
cover of the portfolio *Hell,* 1919, lithograph

the luridly sleazy painting *Self-Portrait with Champagne Glass* (1919), and another kind of passivity in the almost lyrical *Self-Portrait as a Clown* (1921), where his gestures have an almost elfin delicacy and he shares his armchair with a kitten. Beckmann would surely have sympathized with British painter William Orpen's reported response to criticism of his portrait of Archbishop Lang (1924): 'I see seven Archbishops; which shall I paint?'[22] The creation of multiple portraits is, of course, only really feasible with self-portraiture (or photography).

In several self-portraits of the early to mid-1920s, Beckmann explores something totally new to portraiture: shyness, introversion. He is even awkward, embarrassed in *Carnival, Double Portrait* (1925), where he poses in harlequin costume with his much-loved new wife. The psychologist Carl Jung, in an essay of 1921 on aesthetics, had built on Worringer's distinction between abstraction and empathy to claim that the artist with an 'urge to abstraction' is an introvert, who separates himself from the alien world around him, and the artist with an 'urge to empathy' is an extrovert, who animates the surrounding world with himself.[23] The extrovert artist is manifested in Beckmann's largest self-portrait to date, the more-than-life-size *Self-Portrait in Smoking Jacket* (1927), which has the black-and-white colour scheme and frontality of a studio photograph of a film star. It was bought a year later by the National Gallery in Berlin, criticized for being an expression of Nietzsche's superman ideology, made the centrepiece of a Beckmann room in 1933, and finally confiscated and sold off by the Nazis after Beckmann was branded a 'degenerate' artist.[24]

Beckmann's self-portraits have been seen in Waetzoldtian terms: in 1984, for example, it was said that 'in human terms, Beckmann's self-portraits are a sequential revelation of self; in artistic terms, of style and substance'.[25] But when Beckmann discussed his art in a 1938 lecture in London, he emphasized the perpetual elusiveness of self: 'Self-realization is the urge of all objective spirits. It is this self that I am searching for in my life and my art....As we still do not know what this self really is...we must peer deeper and deeper into its discovery. For the self is the great veiled mystery of the world'.[26] And then again in a diary entry for 4 May 1940: 'I have tried my whole life to become a kind of "self"'.[27] Beckmann still clung to the idea that selfhood did exist, but this statement indicates a modern approach to self-portraiture predicated on the idea that the self is elusive and veiled. And that becomes the excuse for continuing obsessively to stalk the quarry.

The writer, photographer and sculptor Claude Cahun (1894–1954) is the great veiled mystery of French interwar culture, both in terms of her art and her life. Cahun played with issues of identity in a series of photographic self-portraits, though only one was published in her lifetime (1930). Most of her work was destroyed by the Nazis when she was arrested for resistance work on Jersey, but it seems she began taking her photographs during the First World War. Although she also took photographs of enigmatic still-life arrangements, and made Surrealist objects in the 1930s, she is the first example of a specialist, career self-portraitist. She and her self-portraits have, however, only been properly published and exhibited in the last twenty years.[28]

Cahun's first acts of masking were to change her name. Born into a prominent Jewish family of writers and publishers in Nantes, she was christened Lucy Schwob. Her uncle Marcel Schwob was a famous Symbolist poet and friend of Oscar Wilde (he edited Wilde's play *Salomé*). Lucy changed her name to Claude Courlis (Curlew) and then Daniel Douglas (after Lord Alfred Douglas), finally opting for Claude Cahun in around 1920. Claude is a unisex name, and until recently many assumed from her published writings that she was a man. She moved to Paris in the early 1920s with her stepsister and lifelong lover Suzanne Malherbe (pseudonym Marcel Moore). There, she was active in avant-garde and leftist cultural circles, and in the 1930s participated in the Surrealist movement. She never fully recovered from her incarceration by the Nazis in 1944–5, but carried on making self-portraits until her death in Jersey in 1954.

Cahun often confuses her gender and age by appearing with her hair cut short or shaved, and keeping her (small) breasts clothed or concealed. In one of the earliest surviving self-portraits, she adopts the conventions of studio photography by standing before a floral curtain and striking an *all'antica* pose. She wears a tasselled headband, a skimpy top, and puts one hand behind her head in a way that suggests both an archer about to draw an arrow and Michelangelo's *Dying Slave*. She parodies the homoerotic nude boy photographs of Wilhelm von Gloeden and Louise Biender-Mestro. There is nothing sensuous or glamorous about her photograph. The composition is angular, ascetic, Gothic-Cubistic. Her naked arms are thin and her headband is not so much bacchanalian as a crown of thorns. But her sideways gaze is coolly inquisitorial, that of a militant martyr – perhaps even a suffragette.

When she is at her most girly – wearing dresses, kiss curls, or skimpily clad – she repulses the viewer by putting on white face paint or a carnival mask. She has other weapons at her disposal, too. Face-painted with kiss curls, she sits sexily

in shorts on a table, but balances weightlifting barbells across her thigh. English language graffiti adorns her tights and top: 'I AM IN TRAINING DON'T KISS ME'. In another self-portrait, she lies sleeping in the shelving area of a large Victorian wardrobe: different versions of Claude Cahun are pulled out on a daily basis like items of clothing.

In 1914 Cahun published a series of essays on masks and in 1926 she published *Carnaval en chambre* (Carnival in the room) in which she discussed the 'charm of the mask'. With her various masks, she creates 'several ways of being, thinking and even feeling'. But if the mask is put on 'too heavily', it 'bites your skin', and 'with horror you see that the flesh and its mask have become inseparable'. Try and remove the mask, and you risk damaging your soul.[29] Hence the importance of changing the mask every day. In her only self-portrait published in her lifetime, printed in the journal *Bifur* in 1930, her shaved head is distorted anamorphically into a Brancusi-style egg shape, and in another her head appears enclosed inside a glass bell jar. One of Constantin Brancusi's ovoid sculptures

Claude Cahun, *Self-Portrait*, c. 1932,
black-and-white photograph

Käthe Kollwitz, *Self-Portrait with Hand to Her Forehead*, 1925–30,
etching

was called *The Newborn* (1915), and each time we see Claude Cahun she is born again, all the better to taunt and tease.

Cahun's account of the mask that is put on too heavily, so that flesh and mask become inseparable, would be a good description of the almost immutable self-portraits by the German artist Käthe Kollwitz (1867–1945). She lived with her doctor husband in an impoverished district of Berlin, and is best known for her prints of the poor and downtrodden urban proletariat. She also made well over a hundred self-portrait prints and drawings, and two sculptures. Apart from an early drawing of herself laughing (*c.* 1888) – a laughing mask – she invariably depicted herself sombrely expressionless, often with the head hieratically isolated as though the likeness were taken from a death mask. In several works – the earliest from 1893, the latest from 1938 – her face is partially masked by her hand, further concealing and erasing it. Her doubleness is disconcerting: she is both unflinching witness and petrified victim, alive and dead, individual and anonymous, present and absent, sighted and blind.

~

When Picasso complained about the reductiveness of evolutionary theories of art, he was objecting to the pressure for art and artists to conform to a preconceived type. This was already an issue with the Medici self-portrait collection where the celebration of individual style, physiognomy and genius vied with the mapping of period styles and regional schools; the standardized picture sizes and frames created even more homogeneity.

But the mirror metaphor Picasso used to make his point was very modern. The infinite regress effect of multiple mirrors had become increasingly common during the nineteenth century, as new technologies increased the size and clarity of mirror glass, while drastically reducing the price. One of its most spectacular manifestations was in the new department stores. In Zola's novel *The Ladies' Paradise* (1883), mirrors lining the walls of a department store 'reflected and multiplied the [mannequins] without end, peopling the street with these beautiful women for sale, each bearing a price in big figures in the place of a head'.[30] The mirror was no longer just a means of knowing oneself, or of knowing how little one knew oneself – it also challenged one's sense of uniqueness and individuality (as did the headless shop mannequins).

A photo booth was actually designed to create multiple images of the sitter, who sat in a circle of mirrors, which multiplied the image so it looked as though five clones were sitting round a table, with the one in the central foreground seen from the back.[31] The Italian Futurist painter and sculptor Umberto Boccioni used one of these photographs for *I-We-Boccioni* (1907), and so too did Marcel Duchamp for *Five-Way Portrait of Marcel Duchamp* (1917). Both artists wore anonymous black suit and tie. The result was analogous to Boccioni's technique of showing simultaneous and sequential images of the same person or object. He signed his surname across the figure seen from the back, as if to emphasize his indifference to the viewer – and unwillingness to show his face. Futurist simultaneity influenced Duchamp's early paintings, and he had also started to produce his 'readymades', individual mass-produced items such as *Bottle Rack* (1914). But this photograph is unusual, unique even in his oeuvre, in multiplying and, as it were, 'mass-producing' the same entity.[32]

It is the Belgian Surrealist René Magritte (1898–1967) who is the great poet of the anonymous, cloned self-portrait. The mannequin man in the bowler hat, black overcoat, and suit and tie first appears in 1926–7, and is usually either seen from the front or the back. Magritte only started posing for photographers in a bowler hat in 1938, and he made portraits of other people wearing bowler hats (without being much good at 'likenesses'),[33] so we cannot say for certain that the

man in the bowler hat is his alter ego. Indeed, in most of his seven bona fide self-portraits, which tend to be dull conceptual one-liners, he is bare-headed. But it is clear that the Bowler-Hatted Man (BHM) is Everyman, Magritte included. More conclusively, the first time BHM appears, seen bolt upright from the back next to a river in *The Musings of a Solitary Walker* (1926), with a levitating nude female corpse in the foreground, it is a meditation on the death of his mother by drowning when he was a child.

The next time BHM appears, in duplicate, in *The Meaning of Night* (1927), is a variation on the same theme. This time the twins stand almost back to back on a beach, hands in pockets, with a fragmented female mannequin, clothed in silk stockings and fur dress, floating in from the right. The previous year Magritte had made designs for a furrier's catalogue,[34] and the duplication, in reverse, must surely have been inspired by the effect of full-length mirrors in a shop. It mimics the way in which a person standing in between two mirrors placed opposite each other will see reflections of both their back view and front view.

The face of the BHM at the front is like a white Japanese mask, but with the eyes closed (in this respect, Magritte is the heir of Ensor). He is a sleepwalker, and this his dream. This 'out-of-body' experience, where the sleeper is duplicated and transformed into a sleepwalker, suggests man is now an automaton, who exists in a permanently unconscious state. The same anonymous figures reappear again and again, and in his later years Magritte repeated the same pictures with small variations, backdating them.

Magritte also pursued stylistic and technical anonymity, a pathological neatness, as he explained to an interviewer: 'I always try to make sure that the actual painting isn't noticed, that it is as little visible as possible. I work rather like the sort of writer who tries to find the simplest tone, who eschews all stylistic effects'.[35] When in 1963 his lawyer asked for a self-portrait, Magritte agreed, even though the idea of a self-portrait presented him with a 'problem of conscience'.[36] The 'problem' was that of presenting what Hugo Ball had called the 'assertive "I"'. The following year he painted a BHM with a large apple hovering in front of his face, masking it – and called it *The Son of Man* (1964). It was a near copy of a gouache with a different title. The biblical symbolism seems obvious: original sin led to the (metaphorical) blinding and masking of man, and a loss of individuality. At the same time, we are witnessing a miracle, a suspension of the (Newtonian) laws of gravity: there is a kind of imaginative freedom and transcendence in this weight-less world where nothing is fully seen or known. Works such as this would have a huge influence on Neo-Dada, Pop and Conceptual art in the 1960s and 70s.

René Magritte, *The Musings of a Solitary Walker*, 1926, oil on canvas

Magritte's work chimed with an era in which concepts of genius and authorship were routinely challenged – the so-called 'death of the author'.[37]

In retrospect, the Mexican serial self-portraitist Frida Kahlo (1907–54) appears as a bridge between early twentieth-century masking culture and the late twentieth-century obsession with the body of the artist. This, allied to the fact that she is a woman exploring her own identity, is one of the main reasons why she has loomed ever larger in the art world since being 'rediscovered' in the late 1970s and early 1980s. In her work, an expressionless, mask-like face surmounts a body to which many things can and do happen – mostly involving suffering. The face first appears in 1926, and remains little changed or aged thereafter. A good parallel for this radiantly beautiful and virtually shadowless face is that of Queen Elizabeth I, the 'Virgin Queen', in her standardized bejewelled state portraits. Kahlo's face has the distinctly and defiantly modern touch of being that of a hermaphroditic 'wo-man' with conjoined heavy eyebrows and moustache. The face remains the same even when stylized tears are allowed to fall, and even when in 1943 a round hole is opened up in her forehead to reveal a skull and her husband Diego Rivera (frontal lobotomies were introduced in the mid-1930s). Her face is a mask of stoicism and scientific objectivity as well as of repressed feeling. Rivera and his friends called her 'the great concealer'. The action takes place beyond and especially below the face.

Kahlo's art is aggressively autobiographical, with the main topics being her complicated medical history; her intense, torturous relationship with the muralist Rivera; her childhood and family, particularly her photographer father who was steeped in German Romanticism. She initially trained to be a doctor, and spent a great deal of time being treated by doctors. At the age of six, polio left her right leg lame and deformed, and then in 1925 a tram ploughed into the bus in which she was travelling, smashing her pelvis and damaging her spine. She started painting self-portraits while recuperating, with a mirror hung from her four-poster bed. All her life, she suffered chronic pain, and had to have several further operations on her leg and spine. Her right leg was eventually amputated. Through all this, she had a chaotic if exciting love life. She married Rivera twice, and his infidelities – even with her own sister – caused more anguish. Because of her damaged pelvis, she was unable to give birth, and had several miscarriages. But it was only after her marriage in 1929 that her painting came of age, and was exhibited and sold.

Kahlo could easily have become a third generation Expressionist. Her litany of woe is even more picturesque than that of Munch or Corinth. She could have let it all hang out, in the manner of Irving Stone's van Gogh, immortalized in his best-selling biographical novel, *Lust for Life* (1934): 'He was spilling out a year of his life blood with every convulsive painting that he tore from his vitals'. Kahlo said little about her work, but when she did – in a letter of 1939 – she made her self-portraits sound straightforwardly self-expressive, painted from deep inside: they were 'the most sincere and real thing that I could do to express how I felt about myself and what was in front of me'.[38] Yet what gives her best work its impact is not its transparency, but its intricate play of polarities – between face and body, female and male, European and Mexican.

The Two Fridas (1939), painted during her divorce, shows two mirror-image versions of the artist, sitting on a bench, with a stormy backdrop. One wears Mexican, the other European, clothes. Kahlo owned vast quantities of clothes and jewelry, some of it Pre-Columbian, and three hundred garments remain in the last house she shared with Rivera, now a museum. Apparently Rivera preferred the 'Mexican' Frida, and the Mexican one holds his portrait miniature. Frida's heart is exposed – twice over. A vein passes from the portrait miniature, elegantly winds round the 'Mexican's' left arm in the style of Elizabethan jewelry, before entering her heart; another vein passes like an intercontinental telephone cable from her heart across to that of 'European' Frida. They do not simply rely on communication through the tongue or eyes. Euro-Frida's heart is cut open to reveal a cross-section and the vein that trails down her arm is severed. She holds up the cut end with forceps, and lets blood drip into the lap of her white dress. It is a variation on the mystical Catholic cult of the Sacred Heart of Jesus, which was inspired by a female mystic's vision in which Christ held out his own heart to her. But here their hearts are offered to each other.

We may see Kahlo's vitals, but even here there is nothing convulsive or out of control. She studied medicine, and in her self-portraits she is doctor as well as patient. The blood flow is being managed. Her body is filtered through the cool medical eye. The hearts are in no way individualized. They are textbook illustrations. This conjoined body is a machine for living in. The Dadaists had popularized the idea of the mechanized body, with works such as Francis Picabia's technical illustration of a spark plug drily entitled *Portrait of an American Girl in a State of Nudity* (1915). But it is Kahlo who imbues the idea with pathos. The overriding feeling of *The Two Fridas* is of solidarity, stoicism and of transfusion: they hold hands, and look as regally immovable as a seated statue of Queen Victoria.

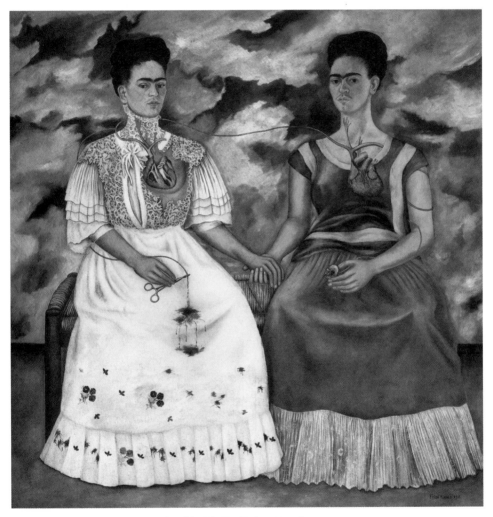

Frida Kahlo, *The Two Fridas*, 1939, oil on canvas

Frida Kahlo, *What I Saw in the Water*, 1938,
oil on canvas

The potentially destructive and overwhelming aspects of female biological functions are explored in *My Birth* (1932), one of a series of childhood self-portraits, where her mother's upper body is shrouded in a Magrittean white sheet as she gives birth to a daughter in a desolate empty room. This is one of her bleakest works. Another 'decapitating' work, *What I Saw in the Water* (1938), is more exuberant. Here Kahlo is upstaged by her own feet in a bird's-eye view of the plug end of a bath. Her toes project above the water, casting solid reflections. Her right foot had just been operated on, and a long bloody scar travels down from the big toe. The foot is deformed (from childhood polio) and blood drips onto it from two capillaries projecting mysteriously from the overflow. Blood-red nail varnish on the toes completes the raw yet exotic effect. It may be inspired by Bonnard's *Nude in the Bath* (1925; see Chapter 9), yet it also recalls *The Big Toe*, an illustrated

essay of 1929 by the dissident Surrealist Georges Bataille in which, as part of his crusade to rehabilitate our low bestial nature, he explored the mixture of disgust and desire elicited by the part of our anatomy that is mired in the ground.

Here Kahlo recasts the Narcissus myth. It is her toes, rather than her face, that are reflected in the water. Floating around like so many bath toys are miniature islands of incident, mostly over her right leg, where a bird is impaled on a tree, and a skyscraper plunges into the mouth of a volcano. Over Kahlo's right knee, her parents pop up from behind some leaves, cardboard cut-out figures in a Douanier Rousseau jungle (another self-taught artist). She looks down into the water, and finds an almost Proustian flow of memories and dreams.

THE WHOLE-BODY SELF-PORTRAIT

Where once full-length self-portraits were rare outside of group portraits or multi-figure narratives, they are now commonplace. If we exclude works like Caravaggio's *Sick Bacchus*, or Michelangelo's 'flayed-skin' self-portrait (see Chapter 5), where the artist gives his own features to another, nude self-portraits were virtually non-existent before 1900, limited to a few drawings, 'topless' bust-length images, and a single full-length 'topless' painting.[39] Only Dürer, in a full-length drawing, left us an image of his genitals (the testicles possibly enlarged by syphilitic orchitis).[40] It may be that similar images by other artists have been lost, but it seems unlikely there would be many missing, for self-portraiture is rarely the 'experimental' or 'confessional' art form of myth. But in the first decade of the twentieth century, Munch and Schiele changed everything – for better and for worse. Munch even took numerous nude self-portrait photographs, was the first artist to make self-portraits holding the camera at arm's length, and planned a never-realized autobiography illustrated by his photographs.[41] Modersohn-Becker, in 1906, is the first female artist to depict herself naked – down to the waist (see Chapter 9).

Nietzsche's *The Birth of Tragedy* (1872) is one of the seminal texts for the modern body cult in its more brazen manifestations, and his influence spans Freud and the whole of the twentieth century, especially from the 1960s when there was an upsurge of interest in his work. Here a new 'Choice of Hercules' is envisaged, with ecstatic alcohol-fuelled dancing now seen as the virtuous option. Nietzsche rejects a cultural universe of measured and calm restraint, as favoured by Winckelmann, and presided over by the repressive sculptor god Apollo (or rather, by the veiled Queen Victoria). Instead, he calls for 'a new world of symbols', orchestrated by Dionysus, the Greek equivalent of the Roman Bacchus:

the entire symbolism of the body is called into play, not the mere symbolism of the lips, face, and speech but the whole pantomime of dancing, forcing every member into rhythmic movement.[42]

There is, crucially, something depersonalizing about this emphasis on the body, for it diverts attention away from the face and eyes, which are the prime locus of individuality. So it is the corollary to the culture of masks, and Greek tragedy was, of course, performed by masked actors. Nietzsche exalted Dionysiac dithyrambic dancing because it involved a merging of the self in a same-sex group of anything up to fifty dancers.

Although Nietzsche dismissed what he considered the shallow narcissism of contemporary artists – 'with fifty mirrors around you, flattering and repeating your opalescence!'[43] – the culture of the full-length mirror played a big part in this new symbolism of the body. In 1870, a French book on bathrooms by the Countess of Gencé said you could never have too many mirrors because 'one has to be able to see oneself from head to toe, in every direction'.[44] A formal photograph of Egon Schiele shows him standing smartly dressed in his studio in front of a huge floor-to-ceiling mirror, staring into it, like a dancer at the bar.[45] His highly polished patent leather shoes catch the light, upstaging his face. The photographer Eugène Atget and his equipment are reflected in the glass windows of Parisian shop fronts and in the mirror that fills a fireplace in the Austrian Embassy (his coat and hat are also reflected). The final, catastrophic scene of Max Beckmann's play *The Hotel* (1924) takes place in a large room 'with numerous large mirrors' in which the doomed hero sees himself multiplied from all sides.[46] This scenario seems to prophesy the cumulative impact of exhibitions by serial self-portraitists.

A pantomimic form of self-portraiture centred on the artist's body began to emerge in some force in the mid-1950s, in reaction to abstract painting, especially the large-scale American varieties. Abstract art was the most prestigious art form in the non-Communist world from around 1950–65, and associated with freedom of expression (the Nazis and Soviets had banned it). The key catalyst was the photographs and films of Jackson Pollock at work, crouching and scurrying over his vast canvases laid on the floor, flicking and pouring paint straight from a can. The critic Harold Rosenberg, in a celebrated essay 'The American Action Painters' (1952), claimed that the canvas was 'an arena in which to act', and the picture the record of 'an event': 'A painting that is an act is inseparable from the biography of the artist....The new painting has broken down every distinction between art and life'.[47]

Eugène Atget, *The Austrian Embassy, 57 Rue de Varenne*, 1905, albumen silver print

For Rosenberg, this act was not a mundane daily diary, but a quasi-mystical existential experience in which the 'cosmic "I"' achieves self-realization. Attention was, however, shifting to the activities of individual artist while actually making the work, and Pollock would become the only artist more influential via images of him at work than for any of his actual artworks.

The images of Pollock, and Rosenberg's essay, inspired a wide range of art performance events in which painters and sculptors interacted with artworks and environments. In the mid-1950s, members of the Japanese Gutai group (meaning 'body tool') staged performances in which Saburo Murakami jumped through a series of a paper screens; Kazuo Shiraga writhed around in a pool of mud, wrestling with it, leaving the imprint of his body; and Shozo Shimamoto made paintings by throwing and shooting the paint. The only residue of these energetic performances tended to be documentary photographs. Jiro Yoshihara's 'Gutai Manifesto' (1956) praised Pollock for revealing 'the scream of the material itself', and for allowing the 'innate beauty' of the materials to re-emerge from behind 'the mask of artificial embellishment'. Ruins 'welcome us unexpectedly with warmth and friendliness'.[48] They wanted to be, as it were, figures in a ruined landscape, and felt alienated by the slickness of the Japan that was being rebuilt after the war.

The ritualized performances of the Vienna Actionists of the 1960s were deliberately shocking and shamanistic, involving a Dionysian disembowelling of animals, immersion in blood and entrails, and self-mutilation. They too were

Günter Brus, *Untitled*, 1965,
mixed media on board mounted on wood

intended as a protest against the repressive taboos of modern society. For *Self-Painting, Self-Mutilation* (1965), Günter Brus painted himself and his clothes white, with a jagged black vertical line down the middle of his head and body like a fault line. He walked through the middle of Vienna, a mummified yet grinning Frankenstein's monster, before being arrested for disturbing the peace. The next day he made a decidedly un-comic collage documenting the Action, with photographs interspersed with pins, razor blades and a penknife. In 1968, after performing obscene acts while singing the Austrian national anthem, Brus left the country in order to escape a six-month sentence.

The 'cosmic "I"' was less evident than the 'bathetic "I"'. Allan Kaprow, a pioneer of New York Happenings, wrote in 1958 that with Pollock 'the so-called dance of dripping, slashing, squeezing, daubing, and whatever else went into a work placed an almost absolute value on the diaristic gesture....Pollock could truthfully say that he was "in" his work'.[49] This 'diaristic' ethos was taken *ad absurdum* in Jim Dine's *The Smiling Workman* (1960), which lasted thirty-two seconds and was performed in New York. Dine came on stage dressed in a red smock with his hands and feet painted red, and eyebrows and mouth painted black. He stood in front of a large canvas, on which he had previously daubed a patch of

white paint surrounded by his own white handprints. Using three pails of blue, orange and red paint, he scrawled 'I LOVE' (in blue) followed by 'WHAT I'M' (in orange). He then drank the red paint (actually tomato juice), and hurriedly scrawled 'DOING HELP', before pouring the unused paint over his head and jumping through the canvas.

Despite the documentation of artists' actions, as late as 1970 the American critic Max Kozloff could still begin an essay with an obituary for self-portraiture: 'Self-portraits are defunct in modern art. Liquidated along with the larger idea of genre, they are among those subjects no one expects to see any more.'[50] Yet this apocalyptic opening was for dramatic effect, as Kozloff was in fact announcing a revival that had begun in the early 1960s. He entitled the essay 'The Division and Mockery of the Self', an allusion to R. D. Laing's influential book on mental illness *The Divided Self* (1960). 'It's surprising', Kozloff wrote, 'to find in the work of certain undemonstrative Americans of the early 1960s distress signals that are auto-biographical in character.... an effigy, or occasionally an anxious physical trace of the artist, haunts some recent painting and sculpture.'[51]

He was referring to the appearance of body fragments in a few works by some Neo-Dada and Pop artists: Jasper Johns, Robert Rauschenberg and Robert Morris. In the early 1960s, Johns had made the so-called *Skin* series of drawings and prints. He had applied baby oil to his head and hands, then pressed himself up against a sheet of paper tacked to a wall, rolling his head so that even his ears made a mark. He went over the oiled patches in charcoal to create an impression. These works were to have culminated in a hollow rubber cast of his own head, stretched out on a board, then cast in bronze. Instead, he made a series of litho-graphs, and finally *Diver* (1962–3), a large charcoal image in which impressions of his feet appear at the top, and his hands at the bottom. The never-realized 'stretched' sculpture would have been a kind of homage to Michelangelo's flayed self-portrait, perhaps timed to coincide with the fourth centenary of his death in 1964. Kozloff called it 'the poignant imprint, the Marsyas complex'. Veronica's sudarium also comes to mind.

The body or trace of the artist was present in a variety of forms at an exhibi-tion in 1963 in New York by the sculptor and performer Robert Morris, engaging wittily with identity, autobiography and virility. The best known is the *I-Box*, a functional small painted plywood cabinet with a chalky pink door in the shape of an 'I'. The door opened to reveal a photograph of the artist standing naked, with a broad grin and partial erection. *Portrait* was a set of grey-painted bottles con-taining his own blood, sweat, sperm, saliva, phlegm, tears, urine and faeces; *Card*

File was a wall-mounted card index system recording the protracted process of its own making: 'On trip to find file met Ad Reinhardt on corner of 8th Street and Broadway. Talked with him until 5:30 by which time it was too late to continue trip….'; *Self-Portrait (EEG)* was an electroencephalogram reading of his own brainwaves; and there were three plaster casts of brains, presented in glass cases, one covered in silver leaf, another in dollar bills, and a third in wax. In 1963–4, Morris also made works involving casts of his own feet and hands, such as *Untitled (Stairs)* where flaps lift up on the treads of a set of three wooden stairs to reveal Morris's footprints cast in lead.[52]

These kinds of self-referential relics are certainly a legacy of the cult of the artist, with Dürer's hair, death mask and hand casts, taken from his exhumed body, being the first notable examples. Casts of artists' hands and faces had been included in one-artist museums during the nineteenth century, and body parts had been preserved, such as Canova's heart and right hand. Two of the most famous living artists had recently made life casts taken from their own body parts. Picasso had made *Arm* (1959/61), a bronze forearm vertically raised with the fingers parted. It was an artist's equivalent of a saint's arm reliquary – yet it is unclear whether he is 'waving or drowning'. Marcel Duchamp had made *With My Tongue in My Cheek* (1959), a plaster cast of his chin, lips and cheek (bloated by a walnut), which was placed on a profile drawing showing the rest of his head. In the early 1960s, the Italian Neo-Dadaist Piero Manzoni (1933–63) sold limited-edition thumbprints, tin cans of his own excrement, and balloons filled with his own breath and fixed to a signed wooden base.

All these works (perhaps with the exception of Picasso's *Arm*) question Romantic notions of artistic genius and individuality, while mining a deep seam of mock-heroic self-portraiture, where the artist sets himself up as clown, fool and martyr. For Max Kozloff, it was murder most foul: 'enigma, dismemberment, depersonalization, self-estrangement, cruelty and dread.…The idea of art as, in any sense, a personification of the artist, died of murder'.[53] At its most extreme, the Japanese Conceptual artist On Kawara reduced – or refined – himself down to a series of dates, maps and statements. Never photographed, never revealing his date of birth, he made identical *Date Paintings* (1966–), simply inscribing the date; he made maps of journeys, *I Went* (1968–9); and sent postcards and telegrams announcing 'I am still alive' (1969–).

In 1963 Rudolf and Margot Wittkower published their coolly exhaustive and now classic study of the artist, *Born under Saturn: The Character and Conduct of Artists*, with topics like 'misers and wastrels', 'weird hobbies', 'genius and

madness', 'celibacy, love and licentiousness', and 'works as keys to the character of artists'. It concluded with a brisk exposition and dismissal of psychoanalytic approaches, and of the experimental psychologist Ernst Kretschmer's differentiation between pycnic, leptosomatic and athletic physical types, and cyclothymic and schizothymic temperaments. Artists such as Morris, Manzoni and Kawara might almost be providing material for future students of the artist's body, brain and behaviour.

Increasingly during the 1970s, these conceptual games concerning the 'death of the author' were being played in deadly earnest. 'Marsyas' performances involving self-mutilation, feats of endurance, obscenity and near-death would become widespread. The Yugoslavian artist Marina Abramović (b. 1946) risked her life on several occasions. Like a latter-day Christian martyr, she regarded her performances as ecstatic purification rituals. She induced seizures after taking drugs for schizophrenia; she passed out after lying inside a ring of burning petrol in the shape of a Communist star into which she had thrown nail and hair clippings. In a Naples gallery, she stood beside a table covered in seventy-two objects – many offensive and poisonous – and invited spectators to use them on her 'as desired. I am the object'. After six hours, her clothes had been sliced off with razor blades, and she had been cut, painted, pricked with rose thorns, and a loaded gun placed against her head.

For a decade, Abramović collaborated with the German performance artist Ulay, and their work had a sadomasochistic edge. They attempted to merge their identities hermaphroditically, and wore identical clothing. In one work they joined their open mouths together and inhaled each other's exhaled breath until they collapsed unconscious due to lack of oxygen.

~

In 1976, the American critic Rosalind Krauss wrote an essay entitled 'Video: The Aesthetics of Narcissism', in which she attacked the prevalence of video art which was fixated on the artist's body: 'Self-encapsulation – the body or psyche as its own surround – is everywhere to be found in the corpus of video art'. She singled out video pieces by Vito Acconci in which he merely pointed at the camera, and by Lynda Benglis in which profile mirror images 'perform an auto-erotic coupling'.[54] Later in the decade Christopher Lasch, in his best-selling polemic *The Culture of Narcissism: American Life in an Age of Diminishing Expectations* (1979), complained of pathological narcissism in the 'theater of everyday life' where everyone

is surrounded by mirrors. He cited an account by the bewigged multiple self-portraitist Andy Warhol of his daily encounters with his bathroom mirror:

> Day after day I look in the mirror and I still see something – a new pimple....I dunk a Johnson and Johnson cotton ball into Johnson and Johnson rubbing alcohol and rub the cotton ball against the pimple.... And while the alcohol is drying I think about nothing.

Having covered the pimple with 'flesh-coloured acne-pimple medication', Warhol looks into the mirror to find the trademark mask:

> It's all there. The affectless gaze....The bored languor, the wasted pallor.... The graying lips. The shaggy silver-white hair, soft and metallic.... Nothing is missing. I'm everything my scrapbook says I am.[55]

Narcissism had actually become a key concept in countercultural circles since the publication of Herbert Marcuse's *Eros and Civilization: A Philosophical Inquiry into Freud* (1955). Whereas in psychoanalysis, narcissism was merely an early developmental stage that needed to be grown out of, Marcuse made Narcissus the key to the liberation of the self (along with Orpheus, who sang to the birds).[56] Marcuse's Narcissus challenges the repressive capitalist culture of toil, progress and productivity (as well as reproduction). He overcomes the opposition between man and nature, and when he dies he continues to live as a flower; he does not love only himself – he is not simply autoerotic – because he does not know that the image he loves is his reflection. His libido is extended outwards, giving him an oceanic feeling that overflows and extends to objects.[57] Jasper Johns's *Skin* series, and especially *Diver*, may be an early attempt to capture the ecstatic nature of narcissism.

Marcuse's Narcissus would later become an icon for the flower-power generation. The Japanese artist Yayoi Kusama, then based in New York, was photographed lying voluptuously in her installations *Narcissus Garden* (1966) and *My Flower Bed* (1965–6), the first consisting of some 1,500 reflective plastic balls (offered for sale), the second a pink biomorphic environment made from mattress springs and stuffed fabric gloves. Even in 1974 the Italian critic and curator Lea Vergine could still write in her catalogue *The Body as Language ('Body Art' and Performance)*: 'Narcissus projects himself outside of himself in order to be able to love what is inside of himself'.[58] The desire for self-projection beyond the limits of the body gave rise to a wide range of prosthetic clothing sculptures, none more beguiling and bathetic

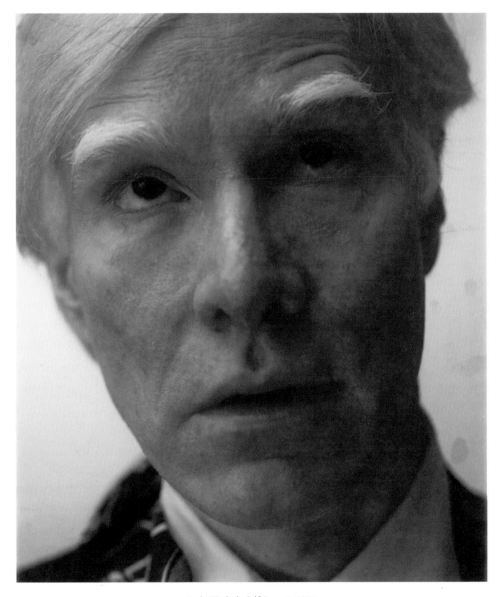

Andy Warhol, *Self-Portrait*, 1979,
dye diffusion print

than those of the German sculptor Rebecca Horn (b. 1944). After the 'purifying' experience of being hospitalized for a year due to lung poisoning, Horn devised a series of outsize costumes in the early 1970s – *Finger Gloves, Unicorn* and *Arm Extensions* – that extended her reach by several feet, while at the same time restricting other movements. Both active and passive, gesticulating and swaddled, she hoped for an almost mystical union with the macrocosm: 'you crave to grow out of your own body and merge with the other person's body, to seek refuge in it'.[59]

What Kozloff called the 'poignant imprint' has been one of the most important types of narcissistic self-projection (the 'imprint' includes photographs as well as prints and casts). The most versatile exponent is the Italian artist Giuseppe Penone (b. 1947). His earliest works were made in 1968 in the Garessio forest, near the northern Italian town where he was born, not far from the French border. *Maritime Alps – It will continue to grow except at that point* (1968–78) consisted of a steel cast of his right hand placed around a tree trunk, as if grasping it. As the tree grew, it gradually enveloped his hand. He eventually made an X-ray of the tree with the hand hidden inside, like an alien foetus, or cancerous growth. Here, the hand of the artist is and is not in control of his chosen medium, nature. In the 1970s, Penone projected slides of photographs of his skin, fingerprints and eyelids onto gallery walls, massively magnifying them, sometimes tracing the configurations in charcoal. His body, by virtue of being exploded and flayed, was transformed into a dappled leafy landscape, giving an 'oceanic feeling'. He lived in Turin, and may well have been influenced by the full-length Turin Shroud.

In Penone's series *Soffio* (Breath, 1978), six large clay gourds were modelled into what Penone imagined to be the balloon shape made by his exhaled breath. At the top of each gourd projects a cast of the interior of the artist's mouth, to indicate the place where he 'blew'. Bodily functions – ingesting, biting and breathing – are emphasized at the expense of the face and head. The indentation in the side of the gourd is the impress of his body as he leaned up against it to breathe into it. The lumps flanking the river bed made by his body, which resemble vertebrae in a spinal column, are meant to represent the eddies of air bouncing off his body. Penone saw these sculptures in primordial mythical terms, leaving the impress of his body in mud: 'Myth tells us that Prometheus made men of mud and water while Athena blew into them the breath of life'.[60]

Ever since the discovery of Pompeii and Herculaneum, however, life casts have evoked imprisonment, suffocation and perverse eroticism as much as the preservation and reproduction of the individual. As early as 1804, the writer Chateaubriand observed of the impression of a young woman's breasts preserved

Giuseppe Penone, *Soffio 4*, 1978,
fired clay

in lava: 'Death, like a sculptor, has moulded his victim'.[61] Freud took Pompeii as an analogy for repression, 'by which something in the mind is at once made inaccessible and preserved'. In his essay 'The "Uncanny"' (1919), he discussed the analogous fear of being buried alive, which is 'only a transformation of another fantasy which had originally nothing terrifying about it at all, but was qualified by a certain lasciviousness – the fantasy, I mean of intra-uterine existence'.[62] There is something wildly erotic about *Soffio*: the bodily pressure, heavy breathing and presence of a mouth on an initially wet object that becomes redolent of man-sized female genitalia; and then there is the uncanny sense that *Soffio* is both a womb and a tomb for the adult artist. It stands in a long line of 'strange, nondescript monsters' towards which the 'chaste' artist directs his sexual energies. Only now, it is also the artist's double: 'every painter rapes himself'.

The most successful of the 'poignant imprinters' is undoubtedly the British sculptor Antony Gormley (b. 1950). His work is seen to best effect in *Another Place* (1997), first installed on a pleasure beach in Cuxhaven, northern Germany, and then re-sited permanently on a beach near Liverpool, England. One hundred identical cast iron figures, standing bolt upright, line the shore, between 50 and 250 metres apart (some 164 to 820 ft), and anything up to one kilometre (over half a mile) out to sea. Each figure faces the horizon and their heads are all aligned at the same height. At high tide, the furthest of what he calls these 'cloned foreign

bodies'[63] are almost completely submerged. It perfectly evokes that quintessence of modernity – the narcissistic oceanic feeling.

Like most of Gormley's work, the figures are cast from his own body (initially with his wife doing the casting). The end product conceals as much as reveals his athletic and apparently well-endowed 6-foot-4-inch frame. Gormley's basic size and shape is registered, but the surface of the sculptures is schematic, and the seams between the various welded sections are left visible. When the cast is made, the artist is mummified in plastic sheeting, cloth, plaster and clay, and when his head is cast, he uses a breathing tube (the process recalls the self-swaddling and mummification performed by the Vienna Actionists, but without the hysteria or violence). With these sculptures, a double immersion and masking takes place – of the artist's body during the making process, and of the body casts in the sea.

Despite the manifest excellence of Gormley's body, he claims for it an 'average' non-perfection that gives it universality:

> This sculpture exposes to light and time the nakedness of a particular and peculiar body, no hero, no ideal, just the industrially reproduced body of a middle-aged man trying to remain standing and trying to breathe, facing a horizon busy with ships moving blocks of coloured containers around the planet.[64]

Antony Gormley, *Another Place*, 1997,
cast iron, installation view, Crosby, Merseyside, UK

Here the medieval modesty topos is recast, and static meditation contrasted with busy brash commerce. Yet reproduction on this industrial scale creates a silent anonymous standing army, an ascetic new race, occupying the pleasure beaches. The effect is analogous to the suspended armies of bowler-hatted men populating Magritte's late work.

Many of the leading male purveyors of body art and of the 'poignant imprint' had fine athletic figures; the self-portrait photographs of the critic and curator John Coplans (1920–2003) were intended as a riposte and antidote. Although their roots lie in beautiful body fragments, sculpted by light, so beloved of Surrealist photographers, and in Performance art, Coplans's have a matter-of-fact quality and elephantine scale that is unique. He is not just fat, he is old – and headless.

Born in London, Coplans moved to the United States in 1960, after seeing a show of Abstract Expressionist painting. His first photographs were taken in 1941, while serving in the Second World War. He took up photography again in 1978, encouraged by his photographer friend Lee Friedlander, but it was only when he started making naked self-portraits in 1984 that he came to international attention.

Having struck a pose against a matt white background, his body was scanned by a video monitor connected to a television set and having found a view he liked, an assistant would take a positive/negative Polaroid picture. The negative was used to make enlarged gelatin silver prints, often life-sized and over, and often in series. Coplans twists, compresses and kneads his rotund, sagging flesh and creased skin as though it were a lump of recalcitrant clay. Each hair, each blemish, each bit of dry and cracked skin is coaxed into visibility. Coplans made two books focusing on particular body parts, *Hand* (1988) and *Foot* (1989), and in 1990 – probably as a riposte to Jeff Koons's *Made in Heaven* self-portrait series – he started to show himself reclining as well as standing.

Coplans omits his head in order to 'remove all references to my current identity...I become immersed in the past...I travel down my genes and visit remote ancestors, both male and female'.[65] There is a primordial feel to many of these images, especially works like the minimalist *Self-Portrait (Back with Arms Above)* of 1984, where he reduces his back to a rectangular flat-pack, with his clenched fists poking out the top. His incessant body moulding is both comic and moving, as though he were raging against the dying of the light, trying to begin his body again from scratch, trying to get a snug fit: 'I'm using my body and saying, even though it's a seventy-year-old body, I can make it extremely interesting. That keeps me alive and gives me vitality'.[66] *Clenched Thumb, Sideways* (1988), part of the *Hand* series, can be compared with Rodin's heroic 'self-portrait' *Hand of God*,

a right hand clutching writhing nude figures, perfect specimens. Coplans swaddles his thumb with his swollen fingers, with only its dirty Caravaggio fingernail face peeking out.

In the 1970s and 80s there had been a revival of interest in Rodin, especially his fascination with fragments. Coplans's cropped *Self-Portrait Three Times* (1987) revisits Rodin's *Three Shades*, while the front figure recalls Rodin's nude studies for *Monument to Balzac*. Two English translations were published of the rhapsodic essay on Rodin by the Austrian poet Rainer Maria Rilke (1875–1926).[67] Partly inspired by Rodin's *Walking Man* (a headless version of his *St John the Baptist*), Rilke believed Rodin had imbued the entire human body with an eye-like expressiveness. He refers to a conversation about a scene in Dante where Pope Nicholas III, as punishment for simony, is placed head first in a hole, with flames rising from the soles of his exposed feet:

> when he read of the weeping feet of Nicolas the Third, he found that he already knew there could be weeping feet, that there is a weeping of the whole body, of the whole person, and that every pore can bring forth tears.

At the same time, Rilke downgrades, or defaces, the face:

> Life showing in the face, full of reference to time and as easily read as on a dial, was, when seen in the body, less concentrated, greater, more mysterious. There it wore no disguise…leaving the stage of the face, it let fall its mask.[68]

～

The artist's relationship to their own sexuality has been a fertile theme for self-portraiture since around 1900, and a major driver for full-length and nude self-portraiture. From the 1970s there was renewed exploration of the sexuality of the artist, but with a darker, harder and more sadomasochistic edge than was always evident in the 'swinging' sixties. The mood was informed in part by political disillusionment in the wake of the Vietnam war and the protests of 1968, and by severe economic problems. Feminism and gay activism were increasingly in the cultural mix, providing their own forms of defiance and scepticism.

The world depicted by the career self-portraitists Gilbert & George became progressively bleaker during the course of the 1970s, when they made their finest

John Coplans, *Self-Portrait Three Times*, 1987,
Polaroid / gelatin silver print

work. They met while studying sculpture at art school in London in 1967 – 'it was love at first sight'. This was the year of Magritte's death, and they soon adopted a Magrittean garb of repressed anonymity – tight-fitting grey flannel suits. Dubbing themselves 'living sculptures', they were a brotherhood of artists, their doubleness, gayness and greyness in marked contrast to the leading lights in the British school of sculpture, Anthony Caro and Henry Moore. They made their name with *The Singing Sculpture* (1969), a performance piece in which they stood side by side on a wooden box and repeatedly sang a music-hall vagrants' song, 'Underneath the Arches', their faces and hands covered in metallic make-up, moving like automatons. The song is about *sleeping* under the railway arches where 'we dream our dreams away', so they remained within the Surrealist sleep-walker orbit.

In their subsequent multi-part photo pieces, divided into a cage-like minimal-ist grid, the two clerkish gents appeared with solemn or quizzical expressions, or with mock outrage, surrounded by dystopian images of London, and the male working-class youths near where they live in impoverished East London. They are outspokenly conservative (admirers of Margaret Thatcher and the Queen) and the frisson of their work comes from being uncertain if they are voyeurs, cruisers

or prurient moral policemen. Unlike Wackenroder's Raphael and Dürer, they never held hands or touched, except in their less successful recent works. The *Dirty Words Pictures* (1977–8), made in the year of the British Queen's Silver Jubilee and the heyday of punk, featured obscene graffiti found in doorways near where they lived juxtaposed with images of London landmarks – policemen, soldiers, beggars and youths – as in *Are You Angry or Are You Boring?* Women are conspicuous by their absence. Despite the London settings, their particular brand of localism has a distinctly Italian feel (Gilbert is Italian). Male-dominated scenes on the impoverished periphery of a big city were the preserve of the Italian Communist writer and film director Pier Paolo Pasolini, who dubbed these youths *ragazzi di vita* (boys of life). Pasolini, who was gay, idolized these youths in his films (and was eventually murdered by one of them). Gilbert & George have instead remained – even in 1995, when they removed their suits – eccentric bystanders, unreliable eyewitnesses.

Whereas Gilbert & George wore the same uniform, the careers of Sophie Calle (b. 1953) and Cindy Sherman (b. 1954) have been built on endless subterfuges and disguises. The Paris-born Calle began pursuing male strangers in the street in 1979, surreptitiously taking photographs and jotting down notes. The notes are woven into diary-form narratives, poignant, pathetic, comic and menacing. The photographs are exhibited next to the text and turned into books. For *Suite vénitienne* (1980) she followed a man she briefly met at a party in Paris to Venice, where she trails him, wearing an assortment of wigs and clothes and taking photographs. A typical entry in her logbook goes as follows:

> I'm afraid he'll turn abruptly and see me crouching in the garbage. I decide to pass silently behind him and wait a little further along. Quickly, with head lowered, I cross the bridge. Henri B. doesn't move. *I could touch him.* [p. 48]

Calle provides maps of her journeys, and is private eye, groupie, stalker, sado-masochist. In *The Shadow* (1981), her mother engaged a private eye to follow her for a day, with his photographs and Calle's narrative being exhibited. The invasion of privacy – Calle's as well as her victims' – is edgily embarrassing for the viewer/reader (one unfortunate victim whose diary she found in the street sued her for invasion of privacy). But she thrives on turning the tables, and testing the boundaries between genius and lunacy, between a destructive narcissism and one that reaches out.

Gilbert & George, *Are You Angry or Are You Boring?*, 1977,
mixed media

A more refined edginess pervades the contemporary work of the American photographer Cindy Sherman. She became the darling of Postmodernists and some feminists, her work seen as a critique of media constructions of feminine identity (or a manifestation of them). She is essentially an impersonator, inserting her disguised self into various unpopulated settings. From small black-and-white beginnings, her photographs have ballooned to over life-size, becoming more luridly glossy in the process. The main attraction of the camera for Sherman is that it lies.

Claude Cahun is an obvious photographic precursor, and so too is the little known Gertrud Arndt who made of series of 'masked' self-portraits at the Bauhaus in 1930.[69] But we should not forget the monologues of the well-known American impersonator Ruth Draper (1884–1956). Draper's *Three Women and Mr Clifford* (1929) was discussed and Draper depicted in action by Ernst Gombrich in an essay first published in 1972, 'The Mask and the Face', which Sherman could have read.[70] The sketch consists of Draper's impersonations of a businessman's wife, mistress and secretary, as they each give a very different perspective on him. Unlike Draper, however, Sherman resists the notion that she identifies with her characters. They are closer to being dispassionate portraits rather than self-portraits.

Sherman made her name with a series of sixty-nine black-and-white photographs, *Untitled Film Stills* (1977–80). She staged tableaux in which she wore 1950s- and 60s-style make-up, wigs and clothes, and mimicked the poses and scenarios from period films, generally those associated with the New Wave. Despite the variety of costume and location, the similarities between individual pictures are more discernible than the differences. Sherman's girls are always alone (except for one sleeping sunbather, her face covered by a hat), and never on the phone. They are always clothed, even if only in underwear. The presence of unseen others is implied either by the intimate positioning of the camera, or by a sudden glance out of shot. The prevailing mood is one of existential malaise or yearning, but it is rarely at the expense of beauty, hygiene, neatness or morality. The young women are too absent-minded to be deeply scared or depressed, and their vulnerability is rarely less than sexy. It is highly controlled angst. No one works. None is an addict. Only six cigarettes are being smoked, but each is a one-off: there is no sign of a cigarette packet or a used ashtray. No inhaling is shown. Only four glasses of alcoholic drink are present, and there are no signs of binge drinking – except for two empty cans of Dr Pepper in a beach scene. Only twice are tears shed, yet both weepers remain bolt upright. Sherman did go on to make dirty and violent

sex-crime tableaux after 1985, but she distanced and abstracted everything by using glossy mannequins and artificial disco lighting: in this later series she is the Arcimboldo of obscenity, always managing to make it look fruity.

Sherman recently explained the almost classical restraint of her *Untitled Film Stills*:

> What I didn't want were pictures showing strong emotion. In a lot of movie photos the actors look cute, impish, alluring, distraught, frightened, tough, etc., but what I was interested in was when they were almost expressionless.[71]

They were not self-expressive either, as she pointed out in a 1983 interview:

> Once I'm set up, the camera starts clicking, then I just start to move and watch how I move in the mirror. It's not like I'm method acting or any-thing. I don't feel that I *am* that person....And the one thing I've always known is that the camera lies.[72]

In the mid-1970s, the American academic Stephen Greenblatt coined the term 'self-fashioning' to describe what he saw as the necessarily 'theatrical' way in which Renaissance courtiers had to operate at court, adopting behavioural 'masks' to conceal their real feelings. It was an elaborate attempt to export post-Nietzschean masking culture far back into history. Greenblatt claimed that Castiglione's great conduct book, *The Courtier*, 'portrays a world in which social frictions, sexual combat, and power are all carefully masked by the fiction of elegant *otium* [leisure]'.[73] In Sherman's world, even angst has become an elegant leisure activity, an exquisite commodity mask to wear.

In the 1990s two very different artists, Jeff Koons (b. 1955) and Tracey Emin (b. 1963), made declamatory self-portraiture in which all masks and taboos were supposedly off. It coincided with a glut of confessional autobiographical writing and reality TV shows. Both had their own sloganeering philosophies of love, a form pioneered by the messianic German Performance artist and utopian preacher Joseph Beuys. Their work, in its stridency and biographical explicitness, marked the climax of the post-1960 exploration of the body and image of the artist.

In 1990, Koons announced in an interview:

> My art and my life are totally one....I have my platform, I have the attention, and my voice can be heard. This is the time for Jeff Koons.[74]

His work of the early 1980s had not involved self-portraiture, but had both celebrated and mocked consumer commodity fetishism, starting with brand new Hoovers exhibited in perspex display cases. He moved on to luridly coloured, life-sized porcelain sculptures of celebrities, such as *Michael Jackson and Bubbles* (1988). The latter was reputed to be the largest porcelain piece ever made: 'it shrinks 17% when it's fired and gives a kinda tight sexual feeling'.[75] He made 'self-portrait' posters for a themed show called 'Banality', and included a youthful self-portrait: he is the cherubic child pushing the pig's bottom in *Ushering in Banality* (1988). From 1989–91, in a series called *Made in Heaven*, we saw a naked adult Koons in action again and again, with Italian porn star Ilona Staller (La Cicciolina). Porn stars had taken part in Performance art during the 1970s, 'highlighting' the sex industry. *Made in Heaven* was a multimedia extravaganza consisting of cheesy hyperreal posters, photo-paintings and sculptures (glass, marble, polychrome wood and plastic). The happy and equally athletic couple, both perfect and sweatless specimens, are a new Raphael and La Fornarina. They explore what Milton, in *Paradise Lost*, termed 'the Rites mysterious of connubial love' (they had a spectacular wedding in 1991, a son in 1992, and parted soon after). *Made in Heaven* garnered oceans of publicity but – for obvious reasons – did not sell as well as previous work.

Koons was evidently challenging the pained pieties of so much modern 'body' art, whereby the body tended to be fragmented, damaged (often literally and dangerously) and/or masked. Even the bust-length self-portraits of Koons's biggest artistic forebear in embracing mass culture, Andy Warhol, made sporadically throughout his career, tend to be fidgety exercises in neurotic concealment (not just of acne, pimples and baldness). But this studied awkwardness is true too of earlier male artists who have depicted themselves with wives and mistresses: Munch, Corinth and Bonnard were not exactly brimful with joy. In the 1980s, the Italian Neo-Expressionist painter and serial self-portraitist Francesco Clemente (b. 1952) had been a prominent figure in New York, depicting himself as a Schiele-style malevolent clown ripe for sadomasochistic dismemberment. For Koons, Modernism – by which he probably means modern art – is 'a kind of masturbation' – sex without love: 'Sex with love is a higher state'.[76] He insisted on the total lack of concealment and shame.[77] So Koons is, at the very least, doing something new: he's a monogamous bacchanalian artist selling a perfect lifestyle, with all the slick urbanity of Ralph Lauren.

The photo-paintings, despite being set in saccharine dioramas, and the abundant use of lighting and make-up, are just too literal minded – and pornographic

– to be interesting. The sculptures are far more impressive, because of their greater levels of abstraction and self-containment. *Jeff and Ilona* (1990), a huge poly-chromed limewood sculpture nearly 3 metres long and over 1.6 metres wide (some 9½ ft long and over 5 ft wide) was first displayed at the Venice Biennale sur-rounded by garish photo pieces. In that context, one could see it in the tradition of the Venetian 'al fresco' reclining nude, with Jeff leaning over a swooning Ilona, with a satyr-like quiff. They lay on a dark rocky 'bed', surrounded and seem-ingly protected by a giant gilded serpent. It was carved and painted by German craftsmen. But it is not viscerally sensuous or sinuous, in the manner of Rodin's *The Kiss*, or even Penone's *Soffio*. The surfaces are shiny, hard and cold. The sex is mostly staged on hard and/or abrasive surfaces. The glass versions are like ice flows, and one of the white marble busts even sprouts crystals. It is a rewriting of the Pygmalion myth. Instead of Galatea stepping off her pedestal and coming to warm transitory life, Pygmalion has climbed onto to Galatea's pedestal to share her sterilely statuesque utopia.

Jeff Koons, *Jeff and Ilona* (*Made in Heaven*), 1990,
polychromed wood

Tracey Emin, *Everyone I Have Ever Slept With 1963–95*, 1995,
appliquéd tent, mattress and light (destroyed 2004)

The British artist Tracey Emin is in many ways the archetypal modern career self-portraitist. She is self-conscious to a fault, almost from the start treating herself as a historical figure, curating the bad, mostly sexual-medical bits of her own life, half wanting what the psychologists would call 'closure', but doomed to repeat her mistakes endlessly – in prickly Schiele-style drawings, text-laden embroideries and garrulous films. She stalks her past in a Calle-like manner, but even more so than Courbet in his early self-portraits, she is incessantly imagining her own death and her own mausoleum, full of opaque yet moralizing inscriptions that will save the world: 'THE LAST GREAT MOMENT IS LOVE; DON'T DIE JUST KEEP LOVING', etc.

Her first gallery exhibition was entitled 'Tracey Emin: My Major Retrospective 1963–1993', and in 1995 she opened The Tracey Emin Museum in a disused shop near London's Waterloo Station. In the same year she made her finest work, *Everyone I Have Ever Slept With 1963–95* (destroyed 2004), a blue domed two-person tent – embroidered on the inside with seventy-five names, male and female. It is Emin's mobile Pantheon, Tempio and kinship self-portrait. She

did not, however, identify these people as friends or family sharing a bed, lovers or strangers, welcome or unwelcome. So we cannot say whether she is like the novelist Gabriel García Márquez's fourteen-year-old heroine Eréndira, whose grandmother punishes her for accidentally burning down her house by setting her up as a prostitute in a tent. Or whether she feels about these people what Marinetti said about museums in the *Futurist Manifesto*: 'Museums, cemeteries!... Public dormitories where you sleep side by side for ever with beings you hate or do not know'. But the tent's transience is liberating, too. David Hockney inscribed one of his 'Love' paintings: 'I will love you at 8pm next Wednesday'. Here Emin, so often bogged down by biographical and emotional baggage, showed how to travel lightly, and stay elusive.

Since the Koons-Emin explosion of the 1990s (and Emin's autobiographical sloganeering continues unabated), there has been an understandable lull in the production of self-portraits by gallery artists. The Chinese artist Zhang Huan (b. 1965) is a case in point. He made his name with militant initiation/endurance nude performances with shaved head; these had photographic and sculptural residues. But in 2005 he gave up performance, and started to produce giant paintings made from ash, with little or no self-portrayal.

However, one of Huan's best self-portraits, *Foam* (1998), may be a pointer to a future direction in self-portraiture. In a series of photographs of his foam covered head, Huan's mouth is open to reveal family photographs, old and new, stuffed between lips and teeth. He is like a drowning man whose whole life passes before him, but in this case he only retains his memories of his family.

Zhang Huan, *Foam*, 1998, performance photographs

Tatsumi Orimoto, *Art Mama: In the Box*, series, 1997–2007,
colour photograph

Not much has been seen of the artist as 'family man' in the twentieth century, but this anthropological type also appears in the recent work of Japanese Performance artist Tatsumi Orimoto (b. 1946). When his mother, who had always supported and subsidized his career in art, was diagnosed with Alzheimer's, he moved into her flat to look after her, and incorporated her into his absurdist yet moving *Art Mama* performances. They may stand together in Beckettian oil drums, or in a cardboard box shared with a neighbour; more recently he holds and hugs her, and pushes her wheelchair. The citizens of Nuremberg, who displayed Dürer's self-portrait next to his portrait of his elderly mother, might have understood if not quite approved.

NOTES

1 J. J. Pollitt, *The Art of Ancient Greece: Sources and Documents*, Cambridge, 1990, p. 54.
2 Ibid., p. 227.

1.
MEDIEVAL
ORIGINS
Pages 16–29

1 *Rule of St Benedict*, ch. LVII, 'Concerning Craftsmen in the Monastery'; cited by J. Alexander, *Medieval Illuminators and Their Methods of Work*, New Haven, 1992, p. 5.
2 For a survey of these issues, S. Perkinson, *The Likeness of the King: A Prehistory of Portraiture in Late Medieval France*, Chicago, 2009; J-C Bonne, L'Image de soi au Moyen Âge (IXe–XIIe siècles)...', in *Il ritratto e la memoria*, vol. 2, ed. A. Gentili et al., Rome, 1993, pp. 37–60; H. L. Kessler, *Seeing Medieval Art*, Toronto, 2004, p. 33ff. The lack of medieval portraiture is a theme of the writings of E. H. Gombrich.
3 Plotinus, *The Enneads*, trans. S. MacKenna, London, 1991; E. Panofsky, *Idea: A Concept in Art Theory*, New York, 1968, pp. 25–32; M. Barasch, *Theories of Art: From Plato to Winckelmann*, New York, 1985, pp. 34–42.
4 Plotinus, *Enneads*, V: 8.1, p. 411; this trans. by Panofsky, *Idea*, p. 26.
5 Ibid., I: 6.8.
6 Ibid., VI: 4.10.
7 K. Gschwantler, 'Graeco-Roman Portraiture', in *Ancient Faces: Mummy Portraits from Ancient Egypt*, ed. S. Walker, London, 2000, p. 19; *The Greek Anthology*, trans. W. R. Paton, London, 1917, vol. 3, pp. 336–7, #605, 'γραψαμενα' /painted.
8 Plotinus, *Enneads*, I: 6.9.
9 H. Belting, *Likeness and Presence*, trans. E. Jephcott, Chicago, 1994, p. 208ff.
10 Ibid., p. 215ff and pp. 541–4 (texts).
11 Perkinson, *Likeness of the King*, p. 68ff.
12 By Lomazzo and Marino. G. P. Lomazzo, *Idea del tempio della pittura*, ed. R. Klein, vol. 1, pp. 65–7; for Marino, J. Hall, *The World as Sculpture*, London, 1999, p. 43.
13 E. R. Curtius, *European Literature and the Latin Middle Ages*, London, 1953, pp. 83–5 and pp. 407–13.
14 Theophilus, *On Diverse Arts*, ed. and trans. C. R. Dodwell, Edinburgh, p. 14ff.
15 M. Camille, *Image on the Edge: The Margins of Medieval Art*, London, 1992, pp. 24–6.
16 Hugh of St Victor, *Didascalion*, trans. J. Taylor, New York, 1961, bk 1: 9, p. 56.
17 N. Coldstream, *Medieval Craftsmen: Masons and Sculptors*, Toronto, 1991, p. 16.
18 E. M. Jónsson, *Le Miroir: Naissance d'un genre littéraire*, Paris, 1995, 2nd edn 2004, pp. 165–8; *Mirror of the Church* (1103–5) by Honorius Augustodunensis, cited in Jónsson; G. Evans, *Alan of Lille, The Art of Preaching*, Kalamazoo, 1981, pp. 62–3.
19 V. W. Egbert, *The Medieval Artist at Work*, Princeton, 1967, p. 30.

20 R. W. Gaston, 'Attention and Inattention in Religious Painting of the Renaissance', in *Renaissance Studies in Honour of Craig Hugh Smyth*, Florence, 1985, ed. A. Morrogh et al., vol. 2, p. 256.
21 Augustine, *The Confessions*, trans. P. Burton, London, 2001, p. 250, bk 10: 35.57.

2.
A CRAZE
FOR MIRRORS
Pages 30–49

1 See, from countless examples, A. Bond and J. Woodall, eds, *Self Portrait: Renaissance to Contemporary*, London, 2005, pp. 18–19.
2 The bibliography on mirrors is vast. I have drawn especially on *Miroirs: Jeux et reflets depuis l'antiquité*, Paris, 2000; S. Melchior-Bonnet, *The Mirror: A History*, London, 2001; B. Goldberg, *The Mirror and Man*, Charlottesville, 1985.
3 C. Harrison et al., eds, *Art in Theory: 1648–1815*, Oxford, 2000, pp. 557–8.
4 Pliny the Elder says glass mirrors were invented by the inhabitants of Sidon in Lebanon.
5 Melchior-Bonnet, *The Mirror*, pp. 13–15; *Miroirs*, p. 102ff.
6 J. Woods-Marsden, *Renaissance Self-Portraiture*, New Haven, 1998, p. 31.
7 Jónsson, *Le Miroir*; Goldberg, *Mirror and Man*, p. 112ff; H. Grabes, *The Mutable Glass: Mirror-Imagery in Titles and Texts of the Middle Ages and English Renaissance*, Cambridge, 1982.
8 Melchior-Bonnet, *The Mirror*, pp. 54–7.
9 D. Thornton, *The Scholar in His Study: Ownership and Experience in Renaissance Italy*, New Haven, 1998, p. 171.
10 Goldberg, *Mirror and Man*, p. 113.
11 Ibid., p. 7ff.
12 Ibid., pp. 4, 6, 19.
13 M. Baxandall, *Giotto and the Orators*, Oxford, 1971, p. 66ff.
14 Ibid., p. 71.
15 E. H. Gombrich, 'Giotto's Portrait of Dante?', in *New Light on Old Masters*, London, 1986, pp. 10–31.
16 H. B. J. Maginnis, *Painting in the Age of Giotto*, University Park, PA, 1997, ch. 1.
17 R. and M. Wittkower, *Born Under Saturn: The Character and Conduct of Artists*, New York, 1963, p. 8.
18 J. Pope-Hennessy, *Italian Gothic Sculpture*, London, 1996, p. 235.
19 M. Warnke, *The Court Artist*, Cambridge, 1993, pp. 4–6; A. Martindale, *The Rise of the Artist in the Middle Ages and Early Renaissance*, London, 1972, ch. 2.
20 Perkinson, *Likeness of the King*, p. 109ff.
21 N. Mann, 'Petrarch and Portraits', in *The Image of the Individual: Portraits in the Renaissance*, ed. N. Mann and L. Syson, London, 1998, pp. 15–20.
22 Gombrich, 'Giotto's Portrait of Dante?', p. 30.
23 Dante, *Convivio*, 1: 2.
24 H. D. Austin, 'Dante and Mirrors', *Italica*, vol. 21, no. 1, March 1944, pp. 13–17. See also J. L. Miller, 'The Three Mirrors

of Dante's Paradiso', *University of Toronto Quarterly*, no. 46, 1977, pp. 266–71; S. A. Gilson, 'Light Reflections, Mirror Metaphors, and Optical Framing in Dante's Comedy', *Neophilologus*, vol. 83, no. 2, pp. 241–52.
25 The first is Purgatory 25: 25ff; the last Paradise 15: 113–4.
26 Genesis 29: 16ff, 30: 17ff, 49: 31.
27 Dante, *Convivio*, 4: 22: 10–11.
28 S. K. Scher, ed., *The Currency of Fame: Portrait Medals of the Renaissance*, London, 1994.
29 C. Grayson, 'A Portrait of Leon Battista Alberti', *Burlington Magazine*, xcvi, 1954, pp. 177–8.
30 See A. Grafton, *Leon Battista Alberti*, London, 2000, pp. 17–18.
31 Ibid., pp. 100–1.
32 Leon Battista Alberti, *The Family in Renaissance Florence*, trans. R. N. Watkins, Columbia, 1969, pp. 110–15.
33 Grafton, *Alberti*, p. 220.
34 Leon Battista Alberti, *On Painting*, trans. C. Grayson, London, 1991, bk 2, #25, p. 60.
35 Ibid., bk 2, #26, p. 61.
36 Hall, *Sculpture*, pp. 141–2.
37 Alberti, *On Painting*, bk 3, #52, p. 87 and #62, p. 95.
38 Philostratus, *Eikones*, bk 1, #23; cited by L. Vinge, *The Narcissus Theme in Western European Literature up to the Early 19th Century*, Lund, 1967, p. 29.
39 Alberti, *On Painting*, bk 2, #46, p. 83.
40 D. Lomas, *Narcissus Reflected*, London, 2011, p. 22.
41 G. Barbieri, *L'inventore della pittura: Leon Battista Alberti e il mito di Narciso*, Vicenza, 2000; 'Dossier: les destins de Narcise', in *Albertiana*, vol. 4, 2001, with essays by H. Damisch and M. Brock, p. 161ff; C. Baskins, 'Echoing Narcissus in Alberti's Della Pittura', in *Oxford Art Journal*, no. 16, 1993, pp. 25–33.
42 P. Sohm, *The Artist Grows Old: The Aging of Art and Artists in Italy 1500–1800*, New Haven, 2007, p. 44ff.
43 Woods-Marsden, *Renaissance Self-Portraiture*, pp. 71–7.
44 Ibid., p. 74.
45 Alberti, *The Family*, p. 266.
46 Cited by Sohm, *Artist Grows Old*, p. 45.
47 M. Eliade, *Le Chamanisme*, Paris, 1968, p. 179.
48 Alberti, *On Painting*, bk 3, #63, p. 95.

3.
THE ARTIST
IN SOCIETY
Pages 50–73

1 Martindale, *Rise of the Artist*, pp. 43–5.
2 M. Zink, 'Les toiles d'Agamanor et les fresques de Lancelot', *Littérature*, 38, 1980, pp. 43–51; Perkinson, *Likeness of the King*, pp. 174–8.
3 K. M. Figg and R. B. Palmer, eds, *Jean Froissart: An Anthology of Narrative and Lyric Poetry*, New York, 2001, pp. 565–7.
4 Perkinson, *Likeness of the King*, pp. 255–6.
5 Ibid., p. 163.

6 M. Keen, *Chivalry*, New Haven, 1984, p. 30.
7 C. M. Richardson et al., eds, *Renaissance Art Reconsidered*, Oxford, 2007, pp. 193–4; M. de Montaigne, *Essays*, trans. M. A. Screech, London, 1991, p. 742.
8 Jacobus da Voragine, *The Golden Legend*, trans. W. G. Ryan, Princeton, 1993, vol. 2, pp. 260–5. He was also known as Jude and Lebbaeus.
9 P. Schmidt, 'The Hand as a Mirror of Salvation', in P. Parshall et al., *The Origins of European Printmaking*, Washington, 2005, no. 92, pp. 292–5.
10 J. Hall, *The Sinister Side: How Left-Right Symbolism Shaped Western Art*, Oxford, 2008, pp. 218–9.
11 Voragine, *Golden Legend*, vol. 2, p. 260.
12 Woods-Marsden, *Renaissance Self-Portraiture*, pp. 43–5.
13 M. Warner, *Alone of All Her Sex: The Myth and Cult of the Virgin Mary*, London, 1976, pp. 121–76.
14 Ibid., pp. 154–7.
15 Egbert, *Medieval Artist*, p. 72, illus. xxvi.
16 A. Kahn, 'Rogier's St Luke: Portrait of the Artist or Portrait of the Historian?', in *Rogier van der Weyden: St Luke Drawing the Virgin*, Turnhout, 1997, p. 20.
17 J. H. Marrow, 'Artistic Identity in Early Netherlandish Painting' in *Rogier van der Weyden: St Luke Drawing the Virgin*, p. 53.
18 I. Severin, *Baumeister und Architekten: Studien zur Darstellung eines Berufsstandes in Porträt und Bildnis*, Berlin, 1992.
19 E. H. Gombrich, *The Story of Art*, London, 1989 (15th edn), p. 215.
20 M. V. Schwarz, ' Peter Parler im Veitsdom', in *Der Künstler über sich in seinem Werk*, ed. M. Winner, Weinheim, 1992, pp. 55–84.
21 M. Levey, *Painting at Court*, London, 1971, p. 24ff, to which much of the following is indebted.
22 Martindale, *Rise of the Artist*, p. 37.
23 E. Panofsky, 'Facies illa Rogeri maximi pictoris', in *Late Classical and Mediaeval Studies in Honour of Albert Mathias Friend*, Princeton, 1954, pp. 392–400.
24 C. Reynolds, 'Self-Portrait and Signature in the Brussels "Justice Scenes": Rogier van der Weyden's Fame and the Status of Painting', in *Rogier van der Weyden in Context*, ed. L. Campbell et al., Paris, 2012, pp. 79–92.
25 J. Hopkins, *Nicholas of Cusa's Dialectical Mysticism: Text, Translation and Interpretative Study of De Visione Dei*, Minneapolis, 1988, p. 117.
26 Perkinson, *Likeness of the King*, pp. 77–8, p. 83.
27 *The Postilla of Nicholas of Lyra on the Song of Songs*, trans. J. G. Kiecker, Milwaukee, 1998, pp. 37–9. Nicholas's Bible commentary (1330s) was still the standard account in the fifteenth century. *Glossa Ordinaria: Pars 22 in Canticum Canticorum*, ed. and trans. M. Dove, Turnhout, 1997, p. 98ff.
28 Origen, *The Song of Songs: Commentary and Homilies*, trans. R. P. Lawson, London, 1957, pp. 106–13.
29 R. Krautheimer, *Lorenzo Ghiberti*, Princeton, 1982, p. 7.
30 G. Vasari, *Lives of the Painters, Sculptors and Architects*, trans. G. de Vere, London, 1996, vol. 1, p. 306.
31 Hall, *Sinister Side*, pp. 215–6.

32 E. Wind, *Pagan Mysteries in the Renaissance*, London, 1967, pp. 177–90.
33 Alberti, *On Painting*, p. 78.
34 G. W. McClure, *Sorrow and Consolation in Italian Humanism*, Princeton, 1991, p. 108.
35 D. Landau and P. Parshall, *The Renaissance Print*, New Haven, 1994, p. 57.
36 J. Woodall, 'Love is in the Air. Amor as Motivation and Message in Seventeenth-Century Netherlandish Painting', *Art History*, 19, no. 2, 1996, pp. 208–64.
37 Wittkower, *Born Under Saturn*, pp. 93–4.
38 F. Zöllner, '"Ogni pittore dipinge sé": Leonardo da Vinci and "Automimesis"', in *Der Künstler über sich in seinem Werk*, ed. M. Winner, Weinheim, 1992, p. 138.
39 A. Pellizzari, *I trattati attorno le arti figurative*, Rome, 1942, vol. 2, p. 130.
40 Zöllner, '"Ogni pittore dipinge sé"', p. 147; Gasparo Visconti, *I canzonieri per Beatrice d'Este e per Bianca Maria Sforza*, ed. P. Bongrani, Milan, 1979, pp. 117–8. The translation is mostly Martin Kemp's.
41 M. Kemp, ed., *Leonardo on Painting*, New Haven, 1989, p. 120. See also M. Kemp, 'Ogni pittore dipinge se: A Neoplatonic Echo in Leonardo's Art Theory?', in *Cultural Aspects of the Italian Renaissance: Essays in Honour of Paul Oskar Kristeller*, ed. C. Clough, Manchester, 1976, pp. 311–12.
42 Kemp, ed., *Leonardo on Painting*, p. 120.
43 Kemp, 'Ogni dipintore dipinge se', p. 311.

4.
THE RENAISSANCE ARTIST AS HERO
Pages 74–101

1 D. Karl, 'Il ritratto commemorativo di Giotto di Benedetto da Maiano nel Duomo di Firenze', in *Santa Maria del Fiore: The Cathedral and Its Sculpture*, M. Haines, ed., Fiesole, 2001, pp. 129–47; A. Nagel, 'Authorship and Image-Making in the Monument to Giotto in Florence Cathedral', *Res*, no. 53/54, 2008, pp. 143–51.
2 L. Syson and D. Thornton, *Objects of Virtue*, London, 2001, ch. 1.
3 Nagel, 'Authorship and Image-Making', p. 154.
4 J. DellaNeva, ed., *Ciceronian Controversies*, Cambridge, MA, 2007, p. 3.
5 Two in the destroyed Ovetari chapel and one in the panel *Presentation in the Temple* (Berlin).
6 Woods-Masden, *Renaissance Self-Portraiture*, pp. 85–95.
7 Ibid., p. 90.
8 Ibid., p. 92.
9 J-C Klamt, 'Artist and Patron: The Self-Portrait of Adam Kraft in the Sacrament House of St Lorenz in Nuremberg', in *Showing Status*, ed. W. Blockmans and A. Janse, Turnhout, 1999, pp. 415–43.
10 Alberti, *On Painting*, trans. J. R. Spencer, New Haven, 1966, p. 39; J. Hall, *Michelangelo and the Reinvention of the Human Body*, London, 2005, p. 39.
11 R. Brandl, 'Art or Craft? Art and the Artist in Medieval Nuremberg', in *Gothic and Renaissance Art in Nuremberg, 1300–1550*, New York, 1986, p. 51ff.

12 M. Rogers, 'The Artist as Beauty', in *Concepts of Beauty in Renaissance Art*, ed. F. Ames-Lewis and M. Rogers, Aldershot, 1998, pp. 93–106.
13 W. Stechow, ed., *Northern Renaissance Art 1400–1600*, Evanston, 1989, p. 112.
14 W. M. Conway, ed. and trans., *The Writings of Albrecht Dürer*, New York, 1958, pp. 53, 57–8.
15 Ibid., pp. 48–9.
16 J. L. Koerner, *The Moment of Self-Portraiture in German Renaissance Art*, Chicago, 1993, ch. 5, and *passim*.
17 Stechow, ed., *Northern Renaissance Art*, p. 112.
18 Koerner, *Moment of Self-Portraiture*, p. 169.
19 Ibid., p. 170.
20 Translations taken from Dove, ed. and trans., *Glossa Ordinaria*.
21 J-L Chrétien, *Symbolique du corps: La tradition chrétienne du Cantique des Cantiques*, Paris, 2005, ch. 9.
22 Koerner, *Moment of Self-Portraiture*, p. 70.
23 R. Kahsnitz cat. entry in *Gothic and Renaissance Art in Nuremberg*, p. 130.
24 J. Cage, ed. and trans., *Goethe on Art*, London, 1980, p. 137.
25 See J. Hall forthcoming article on 'dramatized' signatures.
26 J. Ruskin, *Modern Painters*, vol. 2, London, 1891, pt 3, ch. 5, p. 85.
27 E. Kris and O. Kurz, *Legend, Myth and Magic in the Image of the Artist*, New Haven, 1979, p. 13ff; I. Taddei, *Fanciulli e giovani: Crescere a Firenze nel Rinascimento*, Florence, 2001. There was less interest in the achievements of girls.
28 E. G. Holt, *A Documentary History of Art*, vol. 1, Princeton, 1947, p. 153, 'The Second Commentary'.
29 C. Grottanelli, 'Bambini e divinazione', in *Infanzie: Funzioni di un gruppo liminale dal mondo classico all'età moderna*, Florence, 1993, pp. 1–30.
30 *The Etymologies of Isidore of Seville*, trans. S. A. Barney et al., Cambridge, 2006, II, 1, XI, ii.
31 Taddei, *Fanciulli e giovani*, p. 68.
32 D. Hess and T. Eser, eds, *The Early Dürer*, London, 2012.
33 R. G. Witt, *In the Footsteps of the Ancients*, Boston, 2003, p. 118; Hess and Eser, eds, *Early Dürer*, pp. 276–9.
34 Taddei, *Fanciulli e giovani*, p. 37.
35 Hess and Eser, eds, *Early Dürer*, p. 262.
36 Vasari, *Lives*, vol. 1, p. 641.
37 Augustine, *City of God*, Harmondsworth, 1984, bk 16, p. 710.
38 Hall, *Michelangelo*, p. 93ff.
39 J. C. Nelson, *Renaissance Theory of Love*, New York, 1958.
40 M. Ficino, *Commentary on Plato's Symposium on Love*, trans. S. Jayne, Dallas, 1985, pp. 58, 66.
41 D. Ekserdjian, *Parmigianino*, New Haven, 2006, p. 130, figs 135–6.
42 The shadows round his chin and cheekbone are no different in appearance to those round his left eye and forehead – they are not stubble.
43 Hall, *Sinister Side*, pp. 211ff, 293–7.
44 Woods-Marsden, *Renaissance Self-Portraits*, pp. 187–213.
45 F. Caroli, *Sofonisba Anguissola e le sue sorelle*, Milan, 1991, pp. 217–18.
46 Cited by B. Boucher, *Italian Baroque Sculpture*, London, 1998, p. 57.
47 Caroli, *Sofonisba*, pp. 37–8; first cited by

Filippo Baldinucci, *Notizie dei professori del disegno da Cimabue in qua*, vol. 1, Florence, 1681, pp. 624–7.
48 H. Sanson, *Women, Language and Grammar in Italy*, Oxford, 2011.
49 Woods-Marsden, *Renaissance Self-Portraits*, p. 203.
50 Ibid.

5.
MOCK-HEROIC
SELF-PORTRAITS
Pages 102–29

1 Cited by L. Campbell, *Renaissance Portraits*, New Haven, 1990, pp. 195–6 and n. 20, p. 268. I have translated the first part.
2 For earlier artist-entertainers, Martindale, *Rise of the Artist*, pp. 50–2.
3 G. Briganti et al., *I Bamboccianti*, Rome, 1983, p. 132.
4 Michelangelo, *The Poems*, trans. C. Ryan, London, 1996, nos 5, F3 and 4.
5 Kemp, ed., *Leonardo on Painting*, pp. 38–9; Hall, *Sculpture*, ch 1.
6 L. Barkan, *Michelangelo: A Life on Paper*, Princeton, 2010, pp. 85–92.
7 Michelangelo, *Poems*, pp. 158–9, no. 173; pp. 194–4, no. 242.
8 Kris and Kurz, *Legend, Myth and Magic*, p. 99ff.
9 Boccaccio, *The Decameron*, trans. G. H. McWilian, Harmondsworth, 1972, pp. 493–5.
10 Vasari, *Lives*, vol. 2, p. 741.
11 M. M. Ede, in Campbell et al., *Renaissance Faces: Van Eyck to Titian*, London, 2011, p. 265.
12 W. Wallace, *Michelangelo: The Artist, the Man, and His Times*, Cambridge, 2010, p. 148; see also p. 396, Subject Index, 'Age / Old Age'.
13 Hall, *Michelangelo*, p. 210.
14 F. La Cava, *Il volto di Michelangelo scoperto nel giudizio finale: un drama psicologico in un ritratto simbolico*, Bologna, 1925. A print of the *Last Judgment* (1564) inscribes Michelangelo's name next to the flayed face.
15 Voragine, *Golden Legend*, p. 115, quoting St Theodore.
16 Michelangelo, *Poems*, no. 94.
17 Ibid., no. 152.
18 Hall, *Michelangelo*, p. 205.
19 J. Wasserman, *Michelangelo's Florentine Pietà*, Princeton, 2003; Hall, *Michelangelo*, pp. 210–12.
20 L. Freedman, *Titian's Independent Self-Portraits*, Florence, 1990; J. Fletcher, '"Fatto al Specchio": Venetian Renaissance Attitudes to Self-Portraiture', *Fenway Court*, Boston, 1992, pp. 44–60; Woods-Marsden, *Renaissance Self-Portraiture*, pp. 159–67.
21 The number and dating of self-portraits is disputed. Only two survive, in Berlin and Madrid. See D. Jaffé, ed., *Titian*, London, 2003, cat. 28, for C. Hope's dating and identification. Self-portraits seem to have been painted for Paolo Giovio's collection of portraits (by May 1549 – perhaps the one in Berlin); for the patron Gabriel Vendramin (before 1552, when he died); for Emperor Charles V in March 1550 (lost); for the future Philip II in 1552–3 (lost).

22 Sohm, *Artist Grows Old*, p. 3ff, 53–7, 83–4.
23 J. Fletcher in *Titian*, ed. Jaffé, p. 188, n. 80; with other references to old age.
24 Ibid., p. 39.
25 Sohm, *Artist Grows Old*, pp. 87–8.
26 C. Campbell in *Titian*, ed. Jaffé, p. 158.
27 D. Benati, ed., *Annibale Carracci*, Milan, 2006, p. 72ff; Woods-Marsden, *Renaissance Self-Portraiture*, pp. 241–53.
28 Early commentators credit Annibale with the invention of caricature, but only caricatures by Agostino have been securely identified.
29 Malvasia, cited in Wittkower, *Born Under Saturn*, pp. 113–5.
30 Ibid., p. 102ff.
31 M. Winner, 'Annibale Carracci's Self-Portraits and the Paragone Debate', in *World Art: Themes of Unity in Diversity*, ed. I. Lavin, University Park, PA, 1989, p. 510.
32 Vinge, *Narcissus Theme*, pp. 149–50.
33 T. D. Kaufmann, *Arcimboldo: Visual Jokes, Natural History, and Still-Life Painting*, Chicago, 2009.
34 J. Hall, 'Still Alive: Arcimboldo', *Times Literary Supplement*, 5 November 2010.
35 C. Hope, 'Historical Portraits in the Lives and in the Frescoes of Giorgio Vasari', in *Giorgio Vasari tra decorazione ambientale e storiografia artistica*, Florence, 1985, pp. 322, 336.
36 W. Prinz, *Vasaris Sammlung von Künstlerbildnissen*, Florence, 1966.
37 Vasari, *Lives*, vol. 1, p. 29.
38 Pliny, 7: 205; 35: 15. R. Rosenblum, 'The Origin of Painting: A Problem in the Iconography of Romantic Classicism', *Art Bulletin*, December, 1957, p. 279, n. 6.
39 L. de Girolami Cheney, *The Homes of Giorgio Vasari*, New York, 2006.
40 L. Syson in *Currency of Fame*, ed. Scher, pp. 112–5, considers it a self-portrait.
41 E. Panofsky, 'Erasmus and the Visual Arts', *Journal of the Warburg and Courtauld Institutes*, 32, 1969, pp. 200–27.
42 *The Essential Erasmus*, trans. J. P. Dolan, New York, 1964, pp. 35, 108–9, 126–7, 169.
43 G. Bora, 'Towards a New Naturalism', in *Painters of Reality*, New York, 2004, pp. 150–1.
44 R. Klein and H. Zerner, eds, *Italian Art 1500–1600*, Evanston, 1989, p. 131.
45 G. Mancini, G. Baglione and G. P. Bellori, *The Lives of Caravaggio*, London, 2005, p. 92. For the autobiographical nature of his art, C. Strinati, ed., *Caravaggio*, Rome, 2010, pp. 21–2; M. Fried, *The Moment of Caravaggio*, Princeton, 2010.
46 *Lives of Caravaggio*, p. 41. For debate as to whether the latter is a self-portrait, Fried, *Moment of Caravaggio*, pp. 9, 247.
47 Dante, *Convivio*, pt 4, canto 3, v. 52–5.
48 H. P. Chapman, *Rembrandt's Self-Portraits: A Study in Seventeenth-Century Identity*, Princeton, 1990, p. 20.
49 Another source is a figure in Raphael's *Judgment of Paris*. K. Christiansen in *Painters of Reality*, p. 41. For convex mirror symbolism, W. S. Melion, 'Benedictus Arias Montanus and the Virtual Studio as a Meditative Place', in *Inventions of the Studio*, ed. M. Cole and M. Pardo, Chapel Hill, 2005, pp. 98–107.
51 Campbell, *Renaissance Portraits*, p. 102.

6.
THE ARTIST'S
STUDIO
Pages 130–61

1 See R. Wittkower, *Architectural Principles in the Age of Humanism*, London, 1973, p. 10; J. Chipps Smith, *German Sculpture of the Later Renaissance*, Princeton, 1994, p. 37.
2 Hall, *Sculpture*, part 1.
3 Montaigne, *Essays*, p. lix; see also II: 18, p. 755, where Screech translates '*peint*' as portrays. www.lib.uchicago.edu/efts/ARTFL/projects/montaigne/, II: 18, p. 665.
4 Ibid., p. 742.
5 Ibid., p. 755.
6 Lomazzo, *Idea del tempio della pittura*, vol. 1, pp. 65–7.
7 J. Lichtenstein, *The Eloquence of Colour: Rhetoric and Painting in the French Classical Age*, trans. E. McVarish, Berkeley, 1993, pp. 130–5.
8 *The Philosophical Works of Descartes*, trans. E. S. Haldane and G. R. T. Ross, Cambridge, 1931, vol. 1, pp. 311–12.
9 N. Penny, *National Gallery Catalogues: The Sixteenth Century Italian Paintings*, vol. 2, London, 2008, pp. 224–7; R. Lauber, 'Per un ritratto di Gabriele Vendramin', in *Figure di collezionisti a Venezia tra cinque e seicento*, ed. L. Borean and S. Mason, Udine, 2002, pp. 25–71; C. Whistler, 'Uncovering Beauty: Titian's Triumph of Love in the Vendramin Collection', *Renaissance Studies*, vol. 6, 21, 2011, pp. 218–42.
10 Fletcher, 'Fatto al specchio', pp. 54–5.
11 C. Whistler's phrase.
12 M. T. Osborne, *Advice-to-a-Painter Poems: 1633–1856*, Dallas, 1949.
13 For the studio, S. Alpers, *Rembrandt's Enterprise: The Studio and the Market*, Chicago, 1988; and S. Alpers, *The Vexations of Art*, New Haven, 2005.
14 K. Christiansen and J. W. Mann, eds, *Orazio and Artemisia Gentileschi*, New York, 2001, p. 322.
15 M. Garrard, *Artemisia Gentileschi: The Image of the Female Hero in Italian Baroque Art*, Princeton, 1989, pp. 141–71.
16 Christiansen and Mann, eds, *Orazio and Artemisia*, p. 420.
17 Ibid., p. 417.
18 R. M. Smuts, *Court Culture and the Origins of a Royalist Tradition in Early Stuart England*, Philadelphia, 1987, p. 121.
19 O. Millar, 'Abraham van der Doort's Catalogue of the Collections of Charles I', *The Walpole Society*, 37, 1958–60. See also F. Haskell, 'Charles I's Collection of Pictures', in *The Late King's Goods*, ed. A. MacGregor, London, 1989, pp. 203–31.
20 Christiansen and Mann, eds, *Orazio and Artemisia*, p. 418; C. Ripa, *Iconologia*, ed. P. Buscaroli, Milan, 1992, p. 357.
21 Kemp, ed., *Leonardo on Painting*, pp. 201–2, 222.
22 J. Hall, 'Look of Self Love', *Times Literary Supplement*, 6 January 2006.
23 Michelangelo, *Poems*, no. 235, p. 191.
24 H. Brigstocke, *Drawings by Nicolas Poussin from British Collections*, Oxford, 1990, no. 24, where it is accepted as autograph.
25 Hollar's print of the supposed original, then in Antwerp, was published in 1650. R. Verdi,

Nicolas Poussin, London, 1995, no. 63, pp. 269–70.

26 The print is very rare, however.

27 Hall, *Sinister Side*, p. 304.

28 A. Mérot, *Nicolas Poussin*, London, 1990, p. 311.

29 T. Puttfarken, *The Discovery of Pictorial Composition*, New Haven, 2000, p. 209, and for Delacroix's criticism of 'miserable pictures'.

30 E. J. Sluijter, 'Vermeer, Fame and Female Beauty: The Art of Painting', in *Vermeer Studies*, ed. I. Gaskell and M. Jonker, New Haven, 1998, p. 226ff.

31 P. Sohm, *Pittoresco: Marco Boschini, His Critics and Their Critiques of Painterly Brushwork*, Cambridge, 1992; M. Boschini, *La carta de l navegar pitoresco*, ed. A. Pallucchini, Venice, 1966.

32 Sluijter, 'Vermeer, Fame and Female Beauty', pp. 268–9.

33 M. de Winkel, 'The Interpretation of Dress in Vermeer's Paintings', in *Vermeer Studies*, ed. I. Gaskell and M. Jonker, New Haven, 1998, p. 333.

34 J. Anderson, *Giorgione*, Paris, 1997, p. 74.

35 Campbell, *Renaissance Portraits*, p. 217.

36 M. Foucault, *The Order of Things: An Archaeology of the Human Sciences*, trans. A. S. Smith, New York, 1970, pp. 7–9.

37 J. Brown, 'On the meaning of *Las Meninas*', in *Images and Ideas in Seventeenth-Century Spanish Painting*, Princeton, 1978, p. 94.

38 J. Elliott, 'Appearance and Reality in the Spain of Velázquez', in D. Carr, *Velázquez*, London, 2006, p. 18.

39 Foucault, *Order of Things*, p. 4.

40 M. Kemp, *The Science of Art*, New Haven, 1990, pp. 104–5.

41 G. Bartram, *Albrecht Dürer and His Legacy*, London, 2002, no. 18, pp. 89–90; K. Andrews, 'Dürer's Posthumous Fame', in *Essays on Dürer*, ed. C. R. Dodwell, Manchester, 1973, pp. 88–90.

42 E. Harris, *Velázquez*, Oxford, 1982, p. 214.

43 S. L. Stratton-Pruitt, ed., *Velázquez's Las Meninas*, Cambridge, 2003, p. 1.

44 C. Wright, *Rembrandt: Self-Portraits*, London, 1982, p. 26.

45 L. de Vries, 'Tronies and Other Single-Figured Netherlandish Paintings', *Leids Kunsthistorisch Jaarboeck*, 8, 1989, pp. 185–202.

46 C. Ford, 'Works Do Not Make an Oeuvre: Rembrandt's Self-Portraits as a Category', in *Rethinking Rembrandt*, ed. A. Chong and M. Zell, Amsterdam, 2003, p. 122.

47 Chapman, *Rembrandt's Self-Portraits*, p. 46.

48 H-J Raupp, *Untersuchungen zu Künstlerbildnis und Künstlerdarstellung in den Niederlanden im 17. Jahnhundert*, Hildesheim, 1984.

49 C. Brown, *Anthony van Dyck, 1599–1641*, New York, 1999, no. 1, pp. 94–5; it is dated later in S. J. Barnes et al., *Van Dyck: A Complete Catalogue of the Paintings*, New Haven, 2004, sec. I: 99, but if so, he made himself look much younger than he was, and did so again in I: 159, 160 and II: 26.

50 Hall, *Sinister Side*, ch. 15, pp. 278–87.

51 De Winkel in *Rembrandt by Himself*, ed. C. White and Q. Buvelot, London, 1999, p. 62, and nos 11, 14a, 23, 25, 30, 31, 32, 38.

52 F. Baldinucci, *Notizie de' professori del disegno da Cimabue in qua* (1681–1728), Florence, 1975, vol. 5, p. 308.

53 Bartram, *Albrecht Dürer and His Legacy*, p. 266ff.

54 K. van Mander, *Dutch and Flemish Painters*, trans. C. van de Wall, New York, 1969, p. 40.

55 White and Buvelot, eds, *Rembrandt by Himself*, nos 63 and 65, pp. 187–8, 190–1.

56 C. Lloyd and S. Thurley, *Henry VIII: Images of a Tudor King*, London, 1990; X. Brooke, *Henry VIII Revealed*, London, 2003.

57 O. Bätschmann and P. Griener, *Hans Holbein*, London, 1997, p. 200; Van Mander, *Dutch and Flemish Painters*, pp. 86–8.

58 Montaigne, *Essays*, I: 39, p. 270.

59 Vasari, *Lives*, vol. 2, p. 746.

60 F. Baldinucci, *The Life of Bernini* (1682), trans. C. Engass, University Park, PA, 1966, p. 76; Hall, *Sinister Side*, pp. 22–3.

61 C. and A. Tümpel, *Rembrandt: Images and Metaphors*, London, 2006, p. 252ff.

62 White and Buvelot, eds, *Rembrandt by Himself*, no. 82, pp. 216–19.

63 Hall, *Sinister Side*, p. 159ff.

64 White and Buvelot, eds, *Rembrandt by Himself*, no. 85, pp. 226–8; E. van de Wetering, *A Corpus of Rembrandt Paintings, IV: Self-Portraits*, Dordrecht, 2005, no. 28, pp. 578–87.

65 Hall, *Sculpture*, p. 42ff; arguments put forward in pt 1.

66 M. Sframeli, 'Consecrated to Eternity by Their Own Hands: Leopoldo de' Medici's Collection of Self-Portraits', in *Artists' Self-Portraits from the Uffizi*, London, 2007, p. 25.

67 W. Prinz, 'La collezione degli autoritratti', in *Gli Uffizi: Catalogo generale*, Florence, 1979, pp. 766–8.

68 Prinz, 'La collezione degli autoritratti', p. 768.

69 F. Moücke, *Serie di ritratti degli eccellenti pittori…*, Florence, 1752–62, vol. 2, p. 147ff; F. B. Salvadori, 'Carlo Lasino e gli Autoritratti di Galleria', *Mitteilungen des Kunsthistorischen Institutes in Florenz*, 27, 1984, pp. 109–31.

70 Moucke, *Serie di ritratti degli eccellenti pittori*, vol. 3, p. 85.

7.
AT THE CROSSROADS
Pages 162–85

1 F. Borzello, *Seeing Ourselves: Women's Self-Portraits*, London, 1998, pp. 81–2.

2 N. Penny, *Reynolds*, London, 1986, p. 22.

3 D. Mannings, *Sir Joshua Reynolds: A Complete Catalogue of His Paintings*, New Haven, 2000, no. 11, p. 48.

4 For example, engraving by Nicolas Dorigny, 1705.

5 Penny, *Reynolds*, p. 20.

6 J. Richardson, *Essay on the Theory of Painting*, London, 1725, pp. 248–63; S. H. Monk, *The Sublime*, Ann Arbor, 1960.

7 An engraving by Gribelin after Matteis's painting was included with the essay in the third volume of the revised edition of Shaftesbury's *Characteristics of Men, Manners, Opinion, Times* (1714). Most of the essay is in E. G. Holt, ed., *A Documentary History of Art*, vol. 2, New York, 1958, pp. 242–59.

8 Winckelmann would transform the *Laocoon* into Shaftesbury's Hercules: J. J. Winckelmann: *History of the Art of Antiquity*, trans. H. F. Mallgrave, Los Angeles, 2006, pp. 313–14.

9 Vinge, *Narcissus Theme*, p. 277ff.

10 D. Hume, *A Treatise on Human Nature*, Edinburgh, 1739, 1: 4: 6.

11 W. Pressly, *James Barry: The Artist as Hero*, London, 1983, p. 34.

12 O. Bätschmann, *The Artist in the Modern World*, Cologne, 1997, pp. 26, 246, n. 69.

13 W. H. Curran. See Pressly, *James Barry*, p. 151.

14 J. J. Winckelmann, trans. Mallgrave, p. 323.

15 Ibid. The studies were in the drawing collection of Cardinal Albani.

16 He is only rivalled by the short-lived Raymond La Fage (1656–84).

17 Pliny's *Natural History* was usually published as extracts, or in selected volumes. In 1772, a two-volume French translation of the books on art was published with notes by the sculptor Falconet: 'Tom 1' may refer to this edition.

18 The coat appears to be made from sheepskin, with an attached fur collar.

19 R. de Piles, *Cour de Peinture par des Principes*, Paris, 1708, p. 265; English trans. (London 1743), pp. 161–2.

20 M. Heard, *Phantasmagoria*, Hastings, 2006, p. 73.

21 A. Bostrom, *Messerschmidt and Modernity*, Los Angeles, 2012.

22 Heard, *Phantasmagoria*, pp. 41–2.

23 E. J. Clery, *The Rise of Supernatural Fiction*, Cambridge, 1995, p. 38.

24 Bätschmann, *Artist in the Modern World*, pp. 21–3; Hall, *Sculpture*, pp. 142–3.

25 F. Yates, *The Art of Memory*, Harmondsworth, 1969, pp. 155–62.

26 J. Wilton-Ely, *The Mind and Art of Giovanni Battista Piranesi*, London, 1978, p. 107.

27 W. Rehm, *Götterstille und Göttertrauer*, Bern, 1951, pp. 101–82.

28 He told Nicolai that animals kept their lips tightly pressed, and this gave them supernatural powers. M. Pötzl-Malikova and G. Scherf, eds, *Franz Xaver Messerschmidt*, New York, 2010, p. 210.

29 *Diderot's Selected Writings*, trans. D. Coltman, New York, 1966, p. 325.

30 J. López-Rey, *Goya's Caprichos*, Westport, 1970, vol. 1, p. 78.

31 Cited by Sohm, *Artist Grows Old*, p. 45.

32 'The author dreaming. His only purpose is to banish harmful ideas commonly believed, and to perpetuate with this work of Caprichos the solid testimony of truth.'

33 A. Perez Sanchez and E. Sayre, *Goya and the Spirit of Enlightenment*, Boston, 1989, no. 38, pp. 84–5.

34 M-A Dupuy, *Dominique-Vivant Denon: L'Oeil de Napoléon*, Paris, 1999, nos 34 and 35, pp. 86–7.

35 British Museum inv. no. 1871,0812.2111.

36 *Galerie du Musée Napoléon*, Paris, 1807, vol. 4, no. 44, pp. 7–8 (J. Lavallée).

37 Ibid., vol. 2: Champaigne, Dujardin, van Dyck; vol. 3: del Sarto; vol. 4: Romain, Poussin, Rembrandt; vol. 5: Rembrandt, Tintoretto; vol. 7: Dou; vol. 8: Bourdon; vol. 10: Garofalo.

38 H. Williams, *A Historical Ethnography of the Académie Royale (1648–1793)*, PhD thesis, Courtauld Institute of Art, University of London, 2010, p. 239 and Appendix 9, p. 283.

39 Ibid., p. 239.
40 A. Graves, *The Royal Academy of Arts: A Complete Dictionary of Contributors*, London, 1906, vol. 6, p. 277.
41 F. Haskell, *The Ephemeral Museum*, New Haven, 2000, p. 46ff.
42 Ibid., pp. 52–3. No. 79 was a painted design for a stained-glass window in which Reynolds is one of the shepherds worshipping Christ; no. 84 – *Portrait of Sir Joshua Reynolds* – was the RA self-portrait.
43 J. Newman in Penny, *Reynolds*, pp. 344–54.
44 Forty-nine landscapes by Joseph Vernet were exhibited in Paris in 1783: Haskell, *Ephemeral Museum*, pp. 15–19, 167 n. 40. William Blake exhibited sixteen paintings in his home in 1809; see K. Stefanis, http://www.tate.org.uk/research/publications/tate-papers/reasoned-exhibitions-blake-1809-and-reynolds-1813.
45 L. Jordanova in Bond and Woodall, *Self-Portrait*, pp. 50–1.
46 Mannings, *Sir Joshua Reynolds*, Appendix 1, pp. 591–2.
47 1815: *Dutch and Flemish Schools*, no. 30; owned by the Earl of Ilchester. Nine Rembrandt self-portraits are listed in C. White et al., *Rembrandt in Eighteenth Century England*, New Haven, 1983, pp. 106–7.
48 E-F Gersaint, P-C-A Helle and J-B Glomy, *Catalogue raisonée de toutes les pièces qui font l'œuvre de Rembrandt*, Paris, 1751, xxiv–xxvi and no. 4; A. Bartsch, *Catalogue raisonée de toutes les estampes qui forment l'œuvre de Rembrandt…*, Vienna, 1797, xxi and xxiii. See also A. McQueen, *The Rise of the Cult of Rembrandt*, Amsterdam, 2003.
49 E. Fromentin, *The Masters of Past Time*, trans. A. Boyle, Oxford, 1981, pp. 223–4.
50 1818, no. 48, 'His own portrait in the character of Paris' (now Wallace Collection); 1820, no. 73, Royal Collection.
51 The change in sensibility would be maintained in the new catalogue of the Uffizi collection, *Reale Galleria di Firenze illustrata: Ritratti di pittori* (4 vols, 1817–32). Although there are only a few more illustrations than in the first catalogue (249 vs 220) eleven artists have more than one self-portrait reproduced. Annibale Carracci has an astonishing five, all 'varied in period and execution' (vol. 2, p. 86).

8.
COMING HOME:
INTO THE NINETEENTH
CENTURY
Pages 186–215

1 M. Whinney, *Sculpture in Britain 1530–1830*, London, 1988, p. 319.
2 J. Dalloway, *Anecdotes of the Arts in England*, London, 1800, pp. 408–9.
3 Vinge, *Narcissus Theme*, p. 277ff.
4 Hall, *Sculpture*, p. 45.
5 Cage, ed., *Goethe on Art*, pp. 103–12.
6 J. Traeger, *Philipp Otto Runge und sein Werk*, Munich, 1975, no. 345.
7 T. Lubbock, 'Great Works: We Three', *The Independent*, 4 December 2009 (online).
8 H. Honour, *Romanticism*, Harmondsworth, 1979, p. 253.
9 S. Symmons, *Goya and the Pursuit of Patronage*, London, 1988, pp. 94–6.
10 P. Fisher, *Making and Effacing Art*, New Haven, 1991, p. 17.
11 Goethe, *Elective Affinities*, trans. R. J. Hollingdale, Harmondsworth, 1971, p. 170.
12 U. Kuhlemann, in Bartrum, *Dürer and His Legacy*, pp. 45–9; J. Bialostocki, *Dürer and His Critics*, Baden-Baden, 1986, ch. 5.
13 E. G. Bouwers, 'A Papal Pantheon? Canova's Illustrious Italians in Rome', in *Pantheons*, ed. R. Wrigley and M. Craske, Farnham, 2006, pp. 132–60.
14 *Antonio Canova*, Venice, 1992, p. 341ff; *Antonio Canova: Arte e Memoria a Possagno*, Ponzano, 2004.
15 Information from Hugh Honour.
16 P. Chu, ed. and trans., *The Letters of Gustave Courbet*, Chicago, 1992, p. 122.
17 M-T de Forges, *Autoportraits de Courbet*, Paris, 1973.
18 D. de Font-Réaulx et al., *Gustave Courbet*, New York, 2008, pp. 412–13.
19 E. Billeter, *Self-Portrait in the Age of Photography*, Houston, 1986, p. 102. The first surviving photographic self-portrait may be by the American Robert Cornelius (1839).
20 G. W. F. Hegel, *Aesthetics: Lectures on the Fine Arts*, trans. T. M. Knox, Oxford, 1975, pp. 788, 813.
21 Font-Réaulx et al., *Gustave Courbet*, p. 214.
22 P. Mainardi, *Art and Politics of the Second Empire*, New Haven, 1987, p. 33ff.
23 Font-Réaulx et al., *Gustave Courbet*, pp. 220–25; K. Herding, *Courbet: To Venture Independence*, New Haven, 1991, pp. 45–61; H. Toussaint, *Gustave Courbet 1819–1877*, London, 1977, pp. 241–77.
24 Herding, *Courbet*, pp. 55–6.
25 Chu, ed., *Letters of Gustave Courbet*, pp. 131–3.
26 A. Bowness, *Courbet's L'Atelier du Peintre*, Newcastle, 1972, p. 11.
27 M. Fried, *Courbet's Realism*, Chicago, 1990, p. 324, n. 22.
28 Ibid., pp. 159–61.
29 Canova's tomb in the Frari, Venice, may also be relevant: allegorical figures representing the arts proceed through a central door in a pyramid.
30 T. J. Clark, *Image of the People: Gustave Courbet and the 1848 Revolution*, London, 1973, p. 21.
31 Letter 119. References are to the letter numbers in http://vangoghletters.org/vg/letters.html.
32 Letter 515.
33 Letter 288.
34 Letter 495.
35 Letter 811.
36 Letter 547.
37 See letter 681.
38 O. Boers, *De gevelstenen van Amsterdam*, Amsterdam, 1992, p. 291. I am grateful to Paul Taylor for helping me unravel this print. For the house, J. Smith, *A Catalogue Raisonné of the Works of the Most Eminent Dutch, Flemish, and French Painters*, vol. 7, *The Life and Works of Rembrandt van Rhyn*, London, 1836, p. 25 (note).
39 For Rembrandt self-portrait, see letter 649.
40 C. Vosmaer, *Rembrandt: Sa vie et ses œuvres*, 2nd edn, La Haye, 1877, p. 20.
41 Letter 578.
42 Letter 626.
43 C. Gere, *The House Beautiful: Oscar Wilde and the Aesthetic Interior*, Aldershot, 2000, p. 28.
44 Letter 677.
45 Letter 515.
46 Manet appears in *Music at the Tuileries*, included in the show.
47 *Wilhelm Wackenroder's Confessions and Fantasies*, trans. M. H. Schubert, University Park, PA, 1971, pp. 81–2, 108–15.
48 Letter 719.
49 Letter 704.
50 Ernest Ponthier de Chamillard. Letter 698.
51 Letter 677.
52 D. W. Druick and B. Salvesen, *Van Gogh and Gauguin: The Studio of the South*, London, 2001, p. 210.
53 Cage, ed., *Goethe on Art*, pp. 31–7.
54 Letter 800.
55 R. Brettell et al., *The Art of Paul Gauguin*, Washington, 1988, pp. 125–7.
56 Did the name Prado also make him think of the museum – full of pictures of martyrdoms?
57 D. L. Silverman, *Art Nouveau in Fin-de-Siècle France*, Berkeley, 1989, p. 21.
58 Ibid., p. 35.
59 B. Thomson, ed., *Gauguin by Himself*, p. 105, 'Notes on Art at the Universal Exhibition'.
60 Druick and Salvesen, *Van Gogh and Gauguin*, pp. 279–81.
61 At this time Gauguin included the *Self-Portrait Jug* in a still-life painting, 'infantilizing' it by showing it in profile, dwarfing it with a vase of blooms, and putting poppies in it.
62 J. Richardson, *A Life of Picasso, 1881–1906*, vol. 1, London, 1991, p. 461.

9.
SEX AND
GENIUS
Pages 216–29

1 G. Tinterow and P. Conisbee, eds, *Portraits by Ingres*, New York, 1999, p. 107.
2 C. Lombroso, *The Man of Genius*, New York, 1984, pp. 13–14. See also J. Lethève, *Daily Life of French Artists in the Nineteenth Century*, London, 1972, pp. 185–6.
3 Ibid., p. 36.
4 Ibid., p. 63ff.
5 F. Nietzsche, *The Will to Power*, trans. W. Kaufmann and R. J. Hollingdale, New York, 1968, nos 800, 807 and 815.
6 A. Sturgis et al., *Rebels and Martyrs*, London, 2006, p. 174.
7 É. Zola, *The Masterpiece*, trans. T. Walton, Oxford, 1993, pp. 124, 284.
8 Box of Notes 1914. M. Sanouill, ed., *Duchamp du Signe: Ecrits*, Paris, 1975, p. 37.
9 I. Müller-Westermann, *Munch by Himself*, London, 2005, pp. 26–33, cat. nos 4, 5, 10, 11.
10 D. Ades, 'Duchamp's masquerades', in *The Portrait in Photography*, ed. G. Clarke, London, 1992, pp. 94–114.
11 J. Michelet, *Le Montagne*, Paris, 1868, pp. 113–15.
12 C. Berend-Corinth, *Die Gemälde von Lovis Corinth*, Munich, 1958.
13 Ibid., p. 37, fig. 1.
14 B. Uhde-Stahl, *Paula Modersohn-Becker*, Stuttgart, 1989, p. 100.
15 J. Kallir, *Egon Schiele: The Complete Works*, London, 1990, pp. 69, 72.

16 W. G. Fischer in Kallir, *Egon Schiele*,
 pp. 252–5.
17 S. Whitfield, *Bonnard*, London, 1998,
 pp. 9–10.
18 E. Jones, 'The Influence of Andrea del
 Sarto's Wife on His Art', in *Essays in
 Applied Psycho-Analysis*, London, 1951,
 pp. 226–44.
19 N. Watkins, *Bonnard*, London, 1994, pp.
 11–14.
20 Whitfield, *Bonnard*, p. 27.
21 La Cava, *Il volto di Michelangelo*.

10.
BEYOND
THE FACE:
MODERN AND
CONTEMPORARY
SELF-PORTRAITS
Pages 230–76

1 S. Barron, *Degenerate Art*, Los Angeles,
 1991, pp. 140–1. The auction included two
 self-portraits each by Beckmann and Corinth,
 and one by Hofer, Modersohn-Becker and
 Schmidt-Rottluff. The 'Degenerate Art'
 exhibition had included self-portraits by
 Beckmann, Corinth, Freundlich, Hebert,
 Hechrott, Kirchner, Schmidt-Rottluff
 and Kokoschka.
2 The OED first records its use of self-portrait
 in 1831, but Royal Academy catalogues
 and auction catalogues never seem to use
 the term in the nineteenth century.
 Selbstbildnis and *selbstporträt* appear in
 the late nineteenth century. *Autoportrait*
 appears in French dictionaries for the
 first time in 1928.
3 W. Worringer, *Abstraction and Empathy*,
 trans. M. Bullock, London, 1953.
4 M. Barasch, *Modern Theories of Art, 2:
 From Impressionism to Kandinsky*, New York,
 1998, pt 2.
5 Hall, *Sculpture*, p. 190ff.
6 W. Waetzoldt, *Die Kunst des Porträts*, Leipzig,
 1908, p. 309ff; Bätschmann, *Artist in the
 Modern World*, pp. 115–16.
7 Waetzoldt, *Die Kunst*, p. 312.
8 Ibid., pp. 313, 343, 321.
9 N. Hawthorne, *The Marble Faun*,
 Harmondsworth, 1990, p. 49.
10 Waetzoldt, *Die Kunst*, p. 360ff.
11 *Basic Writings of Nietzsche*, trans. W.
 Kaufmann, New York, 1968, #40, p. 240–1.
12 S. M. Canning, 'James Ensor: Carnival of the
 Modern', in *James Ensor*, New York, 2009,
 p. 36.
13 F. Haskell, *History and Its Images*, New
 Haven, 1993, pp. 391–4.
14 Cited by L. Madeline in 'Ensor is Eternal:
 The Painter and His Image', in *James Ensor*,
 p. 114.
15 Ibid.
16 A. Baldassari, *Picasso and Photography*,
 Paris, 1997.
17 C. Harrison et al., eds, *Art in Theory
 1900–1990*, Oxford, 1992, pp. 211–12.
18 E. Wind, *Art and Anarchy*, London, 1985,
 p. 30ff.
19 R. Motherwell, ed., *The Dada Painters and
 Poets*, New York, 1951, pp. 51–4.
20 Ibid., p. 43.
21 M. Beckmann, *Self-Portrait in Words*,
 ed. and trans. B. C. Buenger, Chicago,
 1997, p. 187.

22 E. Gombrich, 'The Mask and the Face', in
 Art Perception and Reality, Baltimore, 1972,
 p. 3, n 8.
23 Barasch, *Modern Theories of Art*, 2,
 pp. 175–6.
24 C. Schulz-Hoffmann and J. C. Weiss, eds,
 Max Beckmann: Retrospective, St Louis,
 1984, p. 239.
25 J. Burke in ibid., p. 68.
26 Beckmann, *Self-Portrait*, p. 303, 305–6.
27 Schulz-Hoffmann and Weiss, *Max Beckmann:
 Retrospective*, p. 20, n 8.
28 R. Krauss and J. Livingstone, *L'Amour Fou:
 Photography and Surrealism*, New York, 1985,
 p. 205, is one of the earliest. F. Leperlier,
 Claude Cahun, Paris, 1992;
 L. Downie, ed., *Don't Kiss Me: the Art
 of Claude Cahun and Marcel Moore*,
 London, 2006.
29 M. A. Caws, *Surrealism*, London, 2004,
 pp. 241–2.
30 Cited in Melchior-Bonnet, *The Mirror*,
 p. 98. See also I. Armstrong, *Victorian
 Glassworlds*, Oxford, 2008, pp. 103–5.
31 Ades, 'Duchamp's masquerades', pp. 98–9.
32 That is, until he made *Boite-en-Valise*.
33 D. Sylvester, *Magritte*, London, 1992,
 p. 150.
34 S. Whitfield, *Magritte*, London, 1992,
 no. 18.
35 Ibid., p. 28.
36 Ibid., no. 124.
37 Barthes, 'The Death of the Author' (1967);
 Foucault, 'What Is an Author?' (1969);
 J. Derrida, *Memoirs of the Blind: The Self-
 Portrait and Other Ruins*, trans. P-A Brault
 and M. Naas, Chicago, 1993, p. 62.
38 Letter to Carlos Chavez, 1939. *The Letters of
 Frida Kahlo*, ed. M. Zamora, San Francisco,
 1995, pp. 104–5.
39 Drawings by Dürer and Pontormo; painting
 by Victor Emil Janssen (1828).
40 B. Sewell, *Evening Standard*, 13 Dec. 2002:
 http://www.standard.co.uk/home/the-genius-
 of-durer-7428306.html.
41 C. Chéroux, in *Edvard Munch: The Modern
 Eye*, London, 2012, p. 62.
42 *Basic Writings of Nietzsche*, p. 40.
43 F. Nietzsche, *Thus Spoke Zarathustra*,
 trans. R. J. Hollingdale, Harmondsworth,
 1961, p. 142.
44 Melchior-Bonnet, *The Mirror*, p. 96.
45 Kallir, *Egon Schiele*, p. 6.
46 Beckmann, *Self-Portrait in Words*, p. 264.
47 H. Rosenberg, *The Tradition of the New*,
 London, 1962, pp. 35–47.
48 A. Munroe, ed., *Japanese Art after 1945:
 Scream Against the Sky*, New York, 1994,
 p. 370.
49 A. Kaprow, 'The Legacy of Jackson Pollock',
 in *Essays on the Blurring of Art and Life*,
 Berkeley, 1993, pp. 3–4.
50 M. Kozloff, 'The Division and Mockery of
 the Self', *Studio International*, January 1970,
 pp. 9–15.
51 Ibid.
52 K. Paice, in *Robert Morris: The Mind/Body
 Problem*, New York, 1994, nos 25–6, 40–4,
 58–62.
53 Kozloff, 'Division and Mockery of the Self',
 pp. 9, 15.
54 R. Krauss, 'Video: The Aesthetics of
 Narcissism', *October*, 1, Spring 1976,
 pp. 50–64.
55 C. Lasch, *The Culture of Narcissism*, New

York, 1979, p. 93; A. Warhol, *The Philosophy
 of Andy Warhol*, New York, 1975, pp. 7–10.
56 Lomas, *Narcissus Reflected*, pp. 121–5.
57 H. Marcuse, *Eros and Civilization*, New York,
 1955, p. 158ff.
58 L. Vergine, *Body, art e storie simili. Il corpo
 come linguaggio*, Milan, 1974, p. 33.
59 *Rebecca Horn: Bodylandscapes*, London, 2005,
 p. 190.
60 G. Celant, *Penone*, Milan, 1989, p. 90.
61 Hall, *Sculpture*, p. 318ff.
62 The Pelican Freud Library, 14: *Art and
 Literature*, Harmondsworth, 1985, pp.
 366–7.
63 A. Gormley, in *Follow Me*, ed. M. Goldner,
 Stade, 1997, p. 40.
64 Ibid.
65 *John Coplans: A Self-Portrait, 1984–1997*,
 New York, 1997, p. 138.
66 *A Body: John Coplans*, New York, 2001,
 p. 175.
67 W. Tucker, *The Language of Sculpture*,
 London, 1974.
68 R. M. Rilke, *Rodin and Other Prose Pieces*,
 London, 1986, pp. 10, 11. See Rilke's essay
 on '(Faces)' from *The Notebooks of Malte
 Laurids Brigge*; R. Brilliant, *Portraiture*,
 London, 1991, p. 113.
69 E. Respini, *Cindy Sherman*, New York, 2012,
 p. 22.
70 Gombrich, 'The Mask and the Face', p. 9.
71 *The Complete Untitled Film Stills: Cindy
 Sherman*, New York, 2003, p. 8.
72 Respini, *Cindy Sherman*, p. 23, quoted from
 G. Marzorati, 'Imitation of Life', *Art News*,
 September 1983, p. 81.
73 S. Greenblatt, *Renaissance Self-Fashioning*,
 Chicago, 1980, p. 162.
74 *The Jeff Koons Handbook*, London, 1992,
 p. 120.
75 J. Hall, 'They Call It Puppy Love', *Guardian*,
 29 October 1992.
76 A. Muthesius, ed., *Jeff Koons*, Cologne, 1992,
 p. 156.
77 Ibid., p. 130.

SELECTED BIBLIOGRAPHY

For particular artists, see relevant endnotes, and the artist entries in *Oxford Art Online*.
For visual databases, see collection websites of major museums.

GENERAL SURVEYS AND PICTURE BOOKS

500 Self-Portraits, introduction by J. Bell, London, 2000
Billeter, E., ed., *Self-Portrait in the Age of Photography*, Houston, 1986
Bond, A., and J. Woodall, eds, *Self-Portrait: Renaissance to Contemporary*, London, 2005
Borzello, F., *Seeing Ourselves: Women's Self-Portraits*, London, 1998
Brooke, X., *Face to Face: Three Centuries of Artists' Self-Portraiture*, Liverpool, 1994
Calabrese, O., *Artists' Self-Portraits*, New York, 2006
Cumming, L., *A Face to the World: On Self-Portraits*, London, 2010
Goldscheider, L., ed., *Fünfhundert Selbstporträts*, Vienna, 1936
Levey, M., *The Painter Depicted*, London, 1981
Moücke, F., ed., *Serie di ritratti degli eccellenti pittori dipinti di propria mano…*, 4 vols, Florence, 1752–62
Reale Galleria di Firenze illustrata: Ratratti di pittori, 14 vols, Florence, 1817–33
Winner, M., ed., *Der Künstler über sich in seinem Werk*, Weinheim, 1992

CULT OF THE ARTIST

Kris, E., and O. Kurz, *Legend, Myth and Magic in the Image of the Artist*, New Haven, 1979
Wittkower, R. and M., *Born Under Saturn: The Character and Conduct of Artists*, New York, 1963

THEMES AND THEORIES

Hall, J., *The World as Sculpture: The Changing Status of Sculpture from the Renaissance to the Present Day*, London, 1999
Klein, D., *St Lukas als Maler der Maria*, Berlin, 1933
Martin, J. J., *Myths of Renaissance Individualism*, Basingstoke, 2004
Melchior-Bonnet, S., *The Mirror: A History*, London, 2001
Murray, P., ed., *Genius: The History of an Idea*, Oxford, 1989

Porter, R., ed., *Rewriting the Self: Histories from the Renaissance to the Present*, London, 1997
Sturrock, J., *The Language of Autobiography*, Cambridge, 1993
Taylor, C., *Sources of Self: The Making of Modern Identity*, Cambridge, MA, 1989
Vinge, L., *The Narcissus Theme in Western Literature up to the Early 19th Century*, Lund, 1967

MIDDLE AGES

Alexander, J., *Medieval Illuminators and Their Methods of Work*, New Haven, 1992
Belting, H., *Likeness and Presence: A History of the Image before the Era of Art*, trans. E. Jephcott, Chicago, 1994
Egbert, V. W., *The Medieval Artist at Work*, Princeton, 1967
Martindale, A., *The Rise of the Artist in the Middle Ages and Early Renaissance*, London, 1972
Perkinson, S., *The Likeness of the King: A Prehistory of Portraiture in Late Medieval France*, Chicago, 2009

1400–1700

Alpers, S., *Rembrandt's Enterprise: The Studio and the Market*, Chicago, 1988
Ames-Lewis, F., *The Intellectual Life of the Early Renaissance Artist*, New Haven, 2000
Bartram, G., *Albrecht Dürer and His Legacy*, London, 2002
Campbell, L., *Renaissance Portraits*, New Haven, 1990
Fletcher, J., '"Fatto al specchio": Venetian Renaissance Attitudes to Self-Portraiture', *Fenway Court*, Boston, 1992, pp. 44–60
Goffen, R., 'Signatures: Inscribing Identity in Italian Renaissance Art', *Viator*, no. 32, 2001, pp. 303–70
Koerner, J. L., *The Moment of Self-Portraiture in German Renaissance Art*, Chicago, 1993
Mann, N., and L. Syson, eds, *The Image of the Individual: Portraits in the Renaissance*, London, 1998

Prinz, W., *Vasaris Sammlung von Künstlerbildnissen*, Florence, 1966
Scholten, F., 'Johan Gregor van der Schardt and the Moment of Self-Portraiture in Sculpture', *Simiolus*, vol. 33, no. 4, 2007/8, pp. 195–220
Sohm, P., *The Artist Grows Old: The Aging of Art and Artists in Italy 1500–1800*, New Haven, 2007
Warnke, M., *The Court Artist: On the Ancestry of the Modern Artist*, Cambridge, 1993
White, C., and Q. Buvelot, eds, *Rembrandt by Himself*, London, 1999
Woods-Masden, J., *Renaissance Self-Portraiture: The Visual Construction of Identity and the Social Status of the Artist*, New Haven, 1998

1700–1900

Bialostocki, J., *Dürer and His Critics*, Baden-Baden, 1986
Lethève, J., *Daily Life of French Artists in the Nineteenth Century*, London, 1972
Lombroso, C., *The Man of Genius*, New York, 1984
Salvadori, F. B., 'Carlo Lasino e gli Autoritratti di Galleria', *Mitteilungen des Kunsthistorischen Institutes in Florenz*, 27, 1984, pp. 109–31
Sturgis, A., et al., *Rebels and Martyrs: The Image of the Artist in the Nineteenth Century*, London, 2006

MODERN AND CONTEMPORARY

Bätschmann, O., *The Artist in the Modern World*, Cologne, 1997
Bonafoux, P., *Je par soi-même: L'Autoportrait au XXe siècle*, Paris, 2004
La Cava, A., *Il volto di Michelangelo scoperto nel giudizio finale: un drama psicologico in un ritratto simbolico*, Bologna, 1925
Jones, A., *The Artist's Body*, London, 2000
Lomas, D., *Narcissus Reflected: The Myth of Narcissus in Surrealist and Contemporary Art*, London, 2011
Waetzoldt, W., *Die Kunst des Porträts*, Leipzig, 1908

ACKNOWLEDGMENTS

I am hugely indebted to everyone at Thames & Hudson, especially Jacky Klein. My agent Caroline Dawnay made the project possible. Emma Barker, Emma Clery, John Gash, Paul Hills, Hugh Honour, Alice Hunt, Sally Korman, Peter Mack, James McConnachie, David Owen, François Quiviger, Charles Robertson, Paul Taylor, Marjorie Trusted, Paul Williamson and Alison Wright made valuable suggestions. I hope that all other debts are acknowledged in the notes. The research was carried out courtesy of the Warburg Institute, Winchester School of Art (Southampton University), Courtauld Institute of Art and British Library.

My greatest debt is, as always, to my family: sadly my uncle André Syson (1936–2013) and my mother-in-law Susan Salaman (1936–2012) are no longer with us. This book is dedicated to three wonderful children – Benjamin, Joshua and Alice – who always keep me on my toes.

PICTURE CREDITS

By Page Number
Dimensions are given in cm followed by inches, height before length before width.

1, 107 Thomas Patch, *Self-Portrait as an Ox*, 18.5 × 34.9 (7¼ × 13¾). British Museum, London. **2 (detail), 208** Vincent van Gogh, *Self-Portrait at the Easel*, 65 × 50.5 (25⅝ × 19⅞). Van Gogh Museum, Amsterdam (Vincent van Gogh Foundation). **6 (detail), 156** Rembrandt, *Self-Portrait*, 112.1 × 81 (44⅛ × 31⅞). Kunsthistorisches Museum, Vienna. Photo Austrian Archives/Scala Florence. **12** Bak, *Self-Portrait with His Wife Taheri*, 63.5 × 29.4 × 15.6 (25 × 11⅝ × 6⅛). Ägyptisches Museum und Papyrussammlung, Berlin. **17, 26** Father Rufillus of Weissenau, *Self-Portrait Illuminating the Initial 'R'*, Fondation Martin Bodmer, Cologny, Geneva (Cod. Bodmer 127). **20** Master of St Veronica, *St Veronica with the Sudarium*, 44.2 × 33.7 (17⅜ × 13¼). National Gallery, London. **23** St Dunstan, *Self-Portrait Worshipping Christ*, Bodleian Library, Oxford (Ms. Auct. F. 4. 32, f.1). **28** Hildebertus, *Self-Portrait with His Assistant Everwinus*, Metropolitan Library, Prague (A. XXI/1, f.153v). **30 (detail), 41** Jan van Eyck, *The Arnolfini Portrait*, 82.2 × 60 (32⅜ × 23⅝). National Gallery, London. **33** *Marcia Painting Her Self-Portrait*, Bibliothèque Nationale de France, Paris (Ms. Français 12420, f.101v). Photo akg–images. **39** Giotto, *Prudence*, Scrovegni Chapel, Padua. **42** Jan van Eyck, *Portrait of a Man (Self-Portrait?)*, 33.1 × 25.9 (13 × 10¼). National Gallery, London. **45** Leon Battista Alberti, *Self-Portrait*, overall (irregular oval) 20.1 × 13.6 (7⅞ × 5⅜). National Gallery of Art, Washington D.C. Samuel H. Kress Collection (1957.14.125). **50 (detail)** Taddeo di Bartolo, *The Assumption and Coronation of the Virgin*, Duomo di Montepulciano. Photo Lensini, Siena. **54** Taddeo di Bartolo, *The Assumption and Coronation of the Virgin*, Duomo di Montepulciano. Photo akg–images/Erich Lessing. **57** Rogier van der Weyden, *St Luke Drawing the Virgin and Child*, 137.5 × 110.8 (54⅛ × 43⅝). Museum of Fine Arts, Boston. **59** Peter Parler, *Self-Portrait*, St Vitus Cathedral, Prague. Photo akg–images/Erich Lessing. **63** Self-portrait detail from the Trajan tapestry, after Rogier van der Weyden's *Scenes of Justice*. Bernisches Historisches Museum, Brunswick. **66** Raphael, *Self-Portrait*, 47.3 × 34.8 (18⅝ × 13¾). Uffizi, Florence. **66** Lorenzo Ghiberti, *Self-Portrait with Turban*, detail of the north doors. Baptistery, Florence. **67** Lorenzo Ghiberti, *Self-Portrait* and *Portrait of His Son Vittorio*, detail of the eastern doors. Baptistery, Florence. Photo © Silva Danielsson. **69** Filarete, *Self-Portrait with His Workshop*, relief on interior of doors to the porch of St Peter's, Rome. Photo Archivio Vasari, Rome. **71** Israhel van Meckenem, *Self-Portrait with His Wife Ida*, 13 × 17.5 (5⅛ × 6⅞). British Museum, London. **74 (detail), 84** Albrecht Dürer, *Self-Portrait*, 66.3 × 49 (26⅛ × 19¼). Alte Pinakothek, Munich. Photo Roger-Viollet/Topfoto. **79** Andrea Mantegna, *Self-Portrait*, Mantegna Chapel, Sant'Andrea, Mantua. 2013 Photo Scala, Florence. **80** Adam Kraft, *Self-Portrait*, St Lorenz Church, Nuremberg. Photo akg–images/Erich Lessing. **83** Albrecht Dürer, *Self-Portrait*, 52 × 41 (20½ × 16⅛). Museo Nacional del Prado, Madrid. **87** Perugino, *Self-Portrait between Famous Men of Antiquity*, Sala dell'Udienza, Collegio del Cambio, Perugia. **91** Albrecht Dürer, *Self-Portrait at the Age of Thirteen*, 27.5 × 19.6 (10⅞ × 7¾). Graphische Sammlung Albertina, Vienna. **93** Michelangelo, *Study for a Bronze David*, 26.4 × 18.5 (10⅜ × 7¼). Musée du Louvre, Paris. **94** Giorgione, *Self-Portrait as David*, 52 × 43 (20½ × 16⅞). Herzog Anton Ulrich Museum, Brunswick. **96** Raphael, *Self-Portrait*, 47.3 × 34.8 (18⅝ × 13¾). Uffizi, Florence. **97** Parmigianino, *Self-Portrait in a Convex Mirror*, diameter 24.1 (9½). Kunsthistorisches Museum, Vienna. **101** Sofonisba Anguissola, *Self-Portrait Holding a Medallion*, 8.3 × 6.4 (3¼ × 2½). Museum of Fine Arts, Boston. **102 (detail), 127** Caravaggio, *Self-Portrait as Sick Bacchus*, 67 × 53 (26⅜ × 20⅞). Galleria Borghese, Rome. **106** Michelangelo, *Sonnet with Self-Portrait Caricature*, Casa Buonarroti, Florence. **109** Giovanni Caroto, *Portrait of a Red-Headed Youth Holding a Drawing*, 37 × 29 (14⅝ × 11⅜). Museo di Castelvecchio, Verona. **111** Michelangelo, *Last Judgment* (detail), Sistine Chapel. Vatican Museums, Vatican City. **113** Titian, *Self-Portrait*, 96 × 75 (37¾ × 29½). Gemäldegalerie, Staatliche Museen, Berlin. **115** Titian, *Self-Portrait*, 86 × 65 (33⅞ × 25⅝). Museo Nacional del Prado, Madrid. **116** Annibale Carracci, *Self-Portrait*, 13.5 × 10.8 (5⅜ × 4¼). The J. Paul Getty Museum, Los Angeles. **117** Annibale Carracci, *Self-Portrait with Other Male Figures*, 60 × 48 (23⅝ × 18⅞). Pinacoteca di Brera, Milan. **119** Annibale Carracci, *Self-Portrait on an Easel in the Studio*, 42.5 × 30 (16¾ × 11¾). State Hermitage Museum, St Petersburg. **121** Giuseppe Arcimboldo, *Self-Portrait as a Man of Papers*, 44.2 × 31.8 (17⅜ × 12½). Musei di Strada Nuova, Palazzo Rosso, Gabinetto Disegni e Stampe, Genoa. **122** Giorgio Vasari, *Self-Portrait*, Sala Grande, Casa Vasari, Florence. Kunsthistorisches Institut in Florenz – Max–Planck–Institut. **124** Giovanni Paolo Lomazzo, *Self-Portrait as the Abbot of the Accademia della Val di Blenio*, 55 × 43 (21⅝ × 16⅞). Pinacoteca di Brera, Milan. **129** Caravaggio, *David with the Head of Goliath*, 125 × 100 (49¼ × 39⅜). Galleria Borghese, Rome. **130 (detail), 143** Jan Vermeer, *The Art of Painting*, 120 × 100 (47¼ × 39⅜). Kunsthistorisches Museum, Vienna. **135** Artemisia Gentileschi, *Self-Portrait as the Allegory of Painting*, 98.6 × 75.2 (38⅞ × 29⅝). Royal Collection, London. **139** Nicolas Poussin, *Self-Portrait*, 78 × 65 (30¾ × 25⅝). Gemäldegalerie, Staatliche Museen, Berlin. **140** Nicolas Poussin, *Self-Portrait*, 98 × 74 (38⅝ × 29¼). Musée du Louvre, Paris. **146** Diego Velázquez, *Las Meninas*, 318 × 276 (125¼ × 108⅝). Museo Nacional del Prado, Madrid. **149** Lucas Kilian, *Double Portrait of Albrecht Dürer*, 44.2 × 27 (17⅜ × 10⅝). British Museum, London. **153** Rembrandt, *Self-Portrait with Curly Hair and White Collar*, 5.6 × 4.9 (2¼ × 1⅞). British Museum, London. **159** Rembrandt, *Self-Portrait*, 114.3 × 94 (45 × 37). Kenwood House, London. **162 (detail), 171** James Barry, *Self-Portrait with Dominique Lefèvre and James Paine the Younger*, 60.5 × 50 (23¾ × 19¾). National Portrait Gallery, London. **164** Angelica Kauffman, *Self-Portrait Hesitating between the Arts of Music and Painting*, 147 × 216 (57⅞ × 85). Nostell Priory, Wakefield. **166** Sir Joshua Reynolds, *Self-Portrait*, 71.5 × 58 (28⅛ × 22⅞). Uffizi, Florence. 2013 Photo Scala, Florence/courtesy of the Ministero Beni e Att. Culturali. **167** Sir Joshua Reynolds, *Self-Portrait*, 63.5 × 74.3 (25 × 29¼). National Portrait Gallery, London. **168** Jonathan Richardson, *Self-Portrait Wearing a Cloth Hat*, 30.3 × 23.2 (11⅞ × 9⅛). The J. Paul Getty Museum, Los Angeles. **173** Johan Zoffany, *Self-Portrait with Hourglass*, 87.5 × 77 (34½ × 30). Uffizi, Florence. **175** Franz Xaver Messerschmidt, *The Vexed Man*, 39.4 × 27.3 × 26 (15½ × 10¾ × 10¼). The J. Paul Getty Museum, Los Angeles. **180** Francisco Goya, *Self-Portrait*, frontispiece of *The Caprichos*, 21.9 × 15.2 (8⅝ × 6). Private collection, USA. **182** Dominique-Vivant Denon, *Memories of Vivant Denon Evoked by Father Time*, Bibliothèque Nationale de France, Paris. **186 (detail), 198, 203 (details)** Gustave Courbet, *The Painter's Studio, A Real Allegory Defining Seven Years of My Artistic and Moral Life*, 361 × 598 (142⅛ × 235⅜). Musée d'Orsay, Paris. **188** Anne Seymour Damer, *Self-Portrait*, height 60 (23⅝). Uffizi, Florence. Photo Gabinetto Fotografico. Courtesy Ministero per i Beni e Att. Culturali/SSPSAE/Polo Museale, Florence. **191** Philipp Otto Runge, *We Three* (destroyed 1931), 100 × 122 (39⅜ × 48). Hamburg Kunsthalle. Photo akg–images. **193** Francisco Goya, *Self-Portrait*, 86 × 60 (33⅞ × 23⅝). Musée des Beaux-Arts, Agen/Giraudon/Bridgeman Art Library. **194** Francisco Goya, *Self-Portrait with Dr Arrieta*, 117 × 79 (46¼ × 31⅛). Institute of Arts, Minneapolis. **197** Antonio Canova, *Self-Portrait*, Fondazione Canova, Possagno. Photoservice Electa/Universal Images Group/SuperStock. **200** Gustave Courbet, *The Desperate Man*, 45 × 54 (17¾ × 21¼). Private collection. **201** Gustave Courbet, *The Meeting*, 129 × 149 (50¾ × 58⅝). Musée Fabre, Montpellier. **206** *Rembrandt's Woning*, 24.4 × 17.8 (9⅝ × 7). Amsterdam City Archives. **208** Vincent van Gogh, *Self-Portrait at the Easel*, 65 × 50.5 (25⅝ × 19⅞). Van Gogh Museum, Amsterdam (Vincent van Gogh Foundation). **210** Vincent van Gogh, *Van Gogh's Chair*, 93 × 73.5 (36⅝ × 28⅞). National Gallery, London. **211** Vincent van Gogh, *Gauguin's Chair*, 90.5 × 72 (35⅝ × 28⅜). Van Gogh Museum, Amsterdam (Vincent van Gogh Foundation). **213** Paul Gauguin, *Self-Portrait Jug*, height 19.5 (7½). Design Museum, Copenhagen. **214** Paul Gauguin, *Head with Horns*, 22 × 22.8 × 12 (8⅝ × 9 × 4¾). The J. Paul Getty Museum, Los Angeles. **215** Paul Gauguin, *Self-Portrait Jar*, 28 × 23 (11 × 9). Musée d'Orsay, Paris. **216 (detail), 233** Lovis Corinth, *Self-Portrait with His Wife*, 101 × 90 (39¾ × 35⅜). Kunsthaus, Zurich. **220** Edvard Munch, *Salome-Paraphrase*, 46 × 32.6 (18¼ × 12¾). © The Munch Museum/The Munch–Ellingsen Group, BONO, Oslo/DACS, London 2014. **221** Edvard Munch, *Self-Portrait in Hell*, 81.6 × 65.6 (32⅛ × 25¾). © The Munch Museum/The Munch–Ellingsen Group, BONO, Oslo/DACS, London 2014. **226** Paula Modersohn-Becker, *Self-Portrait*, 101.5 × 70.2 (40 × 27⅝). Kunstsammlungen Böttcherstrasse/Paula Modersohn-Becker Museum, Bremen. **226** Egon Schiele, *Self-Portrait in Black Cloak, Masturbating*, 47 × 31 (18½ × 12¼). Graphische Sammlung Albertina, Vienna. **229** Pierre Bonnard, *Nude in the Bath*, 103 × 64 (40½ × 25¼). Private collection. © ADAGP, Paris and DACS, London 2014. **230** John Coplans, *Self-Portrait (Back with Arms Above)*, 121.3 × 93.5 (47¾ × 36¾). Tate, London. © The John Coplans Trust. **235** James Ensor, *Self-Portrait with Flowered Hat (My Portrait Disguised)*, 76.5 × 61.5 (30⅛ × 24¼). Stedelijk Museum voor Schone Kunsten, Ostend. © DACS 2014. **237** James Ensor, *Self-Portrait with Masks*, 117 × 82 (46⅛ × 32¼). Menard Art Museum, Komaki–City, Aichi, Japan. © DACS 2014. **240** Man Ray, *Self-Portrait Assemblage*, 9.5 × 7 (3¾ × 2¾). The J. Paul Getty Museum, Los Angeles. © Man Ray Trust/ADAGP, Paris and DACS, London 2014. **241** Max Beckmann, *Self-Portrait*, cover of the portfolio *Hell*, 87.3 × 61.2 (34⅜ × 24⅛). Museum of Modern Art, New York. © DACS 2014. **244** Claude Cahun, *Self-Portrait*. Courtesy the Jersey Heritage Collections. **245** Käthe Kollwitz, *Self-Portrait with Hand to Her Forehead*, plate size 15.4 × 13.4 (6⅛ × 5¼). Photo courtesy The Whitley Art Gallery, www.thewhitleyartgallery.com. © DACS 2014. **248** René Magritte, *The Musings of a Solitary Walker*, 139 × 105 (54¾ × 41⅜). Private collection. © ADAGP, Paris and DACS, London 2014. **251** Frida Kahlo, *The Two Fridas*, 172.7 × 172.7 (68 × 68). Museo de Arte

Moderna, Mexico City. © 2014. Banco de México Diego Rivera Frida Kahlo Museums Trust, Mexico, D.F./DACS. **252** Frida Kahlo, *What I Saw in the Water*, 91 × 70.5 (35⅞ × 27¾). Private collection. © 2014. Banco de México Diego Rivera Frida Kahlo Museums Trust, Mexico, D.F./DACS. **255** Eugène Atget, *The Austrian Embassy, 57 Rue de Varenne*, 22.1 × 17.6 (8¾ × 6⅞). The J. Paul Getty Museum, Los Angeles. **256** Günter Brus, *Untitled*, 77 × 77 (30⅜ × 30⅜). National Gallery of Scotland, Edinburgh. Photo courtesy Heike Curtze Gallery. © Günter Brus. **261** Andy Warhol, *Self-Portrait*, 81.9 × 55.9 (32¼ × 22). The J. Paul Getty Museum, Los Angeles. © 2014 The Andy Warhol Foundation for the Visual Arts, Inc./Artists Rights Society (ARS), New York. **263** Giuseppe Penone, *Soffio 4*, 148 × 72 × 65 (58¼ × 28⅜ × 25⅜). Photo Paolo Mussat Sartor. © ADAGP, Paris and DACS, London 2014. **264** Antony Gormley, *Another Place*, 100 elements: each 189 × 53 × 29 (74⅜ × 20⅞ × 11⅜). Crosby, Merseyside, UK. © the artist. Courtesy White Cube. **267** John Coplans, *Self-Portrait Three Times*, 8.9 × 11.4 (3½ × 4½). The J. Paul Getty Museum, Los Angeles. © The John Coplans Trust. **269** Gilbert & George, *Are You Angry or Are You Boring?*, 241 × 201 (95 × 79). © Gilbert & George. Courtesy White Cube. **273** Jeff Koons, *Jeff and Ilona (Made in Heaven)*, 167.6 × 289.6 × 162.6 (66 × 114 × 64). Edition of 3 plus AP. © Jeff Koons. **274** Tracey Emin, *Everyone I Have Ever Slept With 1963–95* (destroyed 2004), 122 × 245 × 215 (48 × 96½ × 84½). Photo Stephen White. Courtesy White Cube. © Tracey Emin. All rights reserved, DACS 2014. **275** Zhang Huan, *Foam*, Courtesy the artist and Pace Gallery. © Zhang Huan. **276** Tatsumi Orimoto, *Art Mama: In the Box*, 60.5 × 75.6 (23⅞ × 29¾). Series of 3. Edition of 20. Courtesy DNA, Berlin. © Tatsumi Orimoto.

INDEX

Page numbers in **bold** refer to illustrations